The Moralizing Prints of

CORNELIS

ANTHONISZ

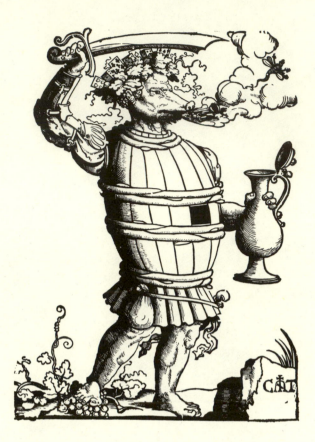

The Moralizing Prints of

CORNELIS ANTHONISZ

Christine Megan Armstrong

PRINCETON UNIVERSITY PRESS

PRINCETON, NEW JERSEY

Library of Congress Cataloging-in-Publication Data
Armstrong, Christine Megan, 1951–
The moralizing prints of Cornelis Anthonisz / Christine Megan Armstrong.
p. cm.
Bibliography: p.
Includes index.
ISBN 0-691-04062-1 (alk. paper)
1. Antoniszoon, Cornelis, b. ca. 1499—Criticism and interpretation. 2. Bible—Illustrations.
3. Art and morals. I. Title.
NE1154.5.A58A88 1990 88-34199
769.92'4—dc19

This book has been composed in Linotron Trump Medieval
Designed by Frank Mahood

Clothbound editions of Princeton University Press books are printed on acid-free paper, and binding
materials are chosen for strength and durability. Paperbacks, although satisfactory for personal
collections, are not usually suitable for library rebinding

Printed in the United States of America by Princeton University Press,
Princeton, New Jersey

To my parents

Contents

List of Illustrations

Abbreviations:

B. A. Bartsch, *Le Peinture-graveur*, Vienna, 1803–1821.

G. M. Geisberg, *The German Single-Leaf Woodcut: 1500–1550*, rev. and ed. by W. Strauss, New York, 1974.

H. F.W.H. Hollstein, *Dutch and Flemish Etchings, Engravings, and Woodcuts ca. 1450–1700*, Amsterdam, 1949–.

N. Hedwig Nijhoff-Selldorff and M. D. Henkel, *Nederlandsche Houtsneden 1500–1550*, ed. by Wouter Nijhoff, The Hague, 1933–1939.

Acknowledgments

My interest in Cornelis Anthonisz began on an afternoon spent alone with half a dozen solander boxes in the print study room of the Rijksmuseum. But the evolution of this interest into a course of research, of this research into a dissertation, and, finally, of the dissertation's metamorphosis into a book owes a great deal to others. Above all, acknowledgment must go to my adviser, Professor John Rupert Martin, whose professional guidance has proven as invaluable as his continuing enthusiasm and encouragement. I am also greatly indebted to Professor William S. Heckscher for his unequaled wisdom and generosity—without him, this book would never have been written. Professor E. de Jongh first brought Cornelis's name to my attention. Dr. I. H. van Eeghen, Professor Herman Pleij, Professor James Parente, Professor William Bouwsma, Professor Walter S. Gibson, Professor Peter Parshall, Professor Jan de Vries, Dr. Jan Piet Filedt Kok, and Professor Robert Koch each provided great assistance at various stages of this undertaking. Eric Van Tassel has been unwavering in his support as an editor. Professor Anneke Prins helped to steer me through some of the more treacherous Middle Dutch passages. I would also like to thank the staffs of the following institutions: the Kunsthistorisch Instituut of the Rijksuniversiteit, Utrecht; the Rijksprentenkabinet, Amsterdam; the Library of the Universiteit van Amsterdam; the Rijksbureau voor Kunsthistorische Documentatie, The Hague; and the Marquand Library of Princeton University. Financial support was provided by the Spears Fund of Princeton University, by the Department of Art and Archaeology, and by the ITT International Fellowship Program. Lynda Emery offered her consummate skills as typist and humorist and her admirable stoicism and patience in the face of endless revisions. Shari Taylor Kenfield took on the daunting task of ordering the illustrations.

To these numerous essential participants in the endeavor, I would like to extend my deepest thanks.

The Moralizing Prints of

CORNELIS

ANTHONISZ

CHAPTER

1 Introduction

Netherlandish woodcuts have always been among the more slighted stepchildren of art-historical scholarship. Even those of Lucas van Leyden—a figure of the greatest importance by any standards—have yet to be examined at length and independently of his engravings, drawings, and paintings. Such neglect is certainly due, in part, to long-held assumptions regarding the preeminence of German artists in this medium, although there are, admittedly, additional obstacles to their study.

The third quarter of the fifteenth century witnessed the production of some remarkable woodcut illustrations in the Netherlands, beginning with blockbooks like the *Ars Moriendi* and the *Biblia Pauperum*. But this production was relatively small, and by the start of the sixteenth century it had begun to show a significant decline in quality, while the output of single sheets was even more limited. During these years the Netherlands had very little in the way of a well-established or widespread practice of artists designing woodcut images—a situation very different from that which existed in Germany, where the woodcut would enjoy a rich, uninterrupted, and comparatively well-documented tradition from the later 1400s on.[1]

The major exception was Jacob Cornelisz van Oostsanen, whose first signed and dated woodcuts—a suite on the *Life of the Virgin*, from 1507—were doubtless inspired by early printings of Dürer's series on the same theme.[2] In fact, the mass publication in 1511 of Dürer's *Life of the Virgin, Apocalypse, Large Passion*, and *Small Passion* prompted a new burst of activity in the medium throughout the north, and it was at this point that Lucas also took up the woodcut, his first major effort being the *Power of Women* series from about 1512.[3] Both Jacob Cornelisz and Lucas continued to design illustrations and single-sheet woodcuts into the 1520s, the majority of them religious or at least biblical in nature. Dating from 1518–c. 1523, for example, is a series of *Christ and the Apostles* by Jacob Cornelisz; dating from 1520–1523 are his more than sixty illustrations of the *Passion*; also from about 1523 is his series of *Prophets*.[4] Lucas's oeuvre similarly includes, among other things, missal and Bible illustrations, devotional images featuring the Virgin, a frieze showing the *Twelve Kings of Israel* from c. 1515–1517, and a series of *Sibyls* from 1528–1530.[5]

3

Alongside their considerable corpus, a small number of equally interesting wood-cuts were designed by such artists as Jan Gossaert and Jan Swart van Groningen. A few others have been attributed to such artists as Jan Wellens de Cock and Jan van Scorel; many others are known only as the work of monogrammists such as the Masters AP or AC, or remain entirely anonymous. Following the deaths of Jacob Cornelisz and Lucas in 1533, however, woodcut production in the Netherlands over the next twenty years would be clearly dominated by Cornelis Anthonisz, a figure who remains perhaps the most neglected of all in this most neglected field.

Much of what research has been done on Cornelis Anthonisz concerns his map-making and was undertaken by historians of cartography. In several articles in *Het Boek* and *Oud-Holland* (1932–1933 and 1939), Nicolaas Beets attempted to estab-lish an oeuvre of paintings, arguing that Cornelis was responsible for four panels at Hampton Court representing events from the reign of Henry VIII, and for two mural paintings in the castle at Cowdry; the latter were destroyed in a fire in 1793 and are known only from engravings, which show that they were also scenes from Brit-ish history.[6] Neither these nor his attributions to Cornelis of a number of portraits of British noblemen have found support, nor is there any reason to accept Beets's claim that Cornelis had at least one and possibly a second period of activity in England. In his *Noord-Nederlandsche Schilderkunst* (1939), G. J. Hoogewerff as-signed still other portrait paintings to Cornelis; most can be firmly rejected, along with his attribution of a *Judith with the Head of Holofernes* in the National Gallery at Ottawa.[7] To date, no more than three paintings can be accepted with certainty, while it would appear that no drawings at all have survived.[8]

So far as Cornelis's noncartographical woodcuts are concerned, they naturally take up a good portion of Wouter Nijhoff's *Nederlandsche Houtsneden 1500–1550* (1933–1939), which remains the major publication on its subject.[9] Although invalu-able as a survey of the woodcut production of this period—complete with facsimile reproductions—the authors make no effort to provide a comprehensive treatment of any of the artists whose works are covered, their entries being limited to the most basic data regarding possible attributions, subject matter, and sources. In 1972 the Rijksmuseum assembled an exhibition of *Vorstenportretten uit de eerste helft van de 16de eeuw*, including more than fifty examples of Cornelis's princely por-trait woodcuts; the catalogue offers a helpful discussion of his important contribu-tion to this particular genre, along with a good deal of information regarding indi-vidual prints.[10]

There has been, finally, one attempt at a monographic study by F. J. Dubiez, whose *Cornelis Anthoniszoon van Amsterdam* (1969) again devotes much of its attention to the maps and charts, while the rest of his oeuvre is handled in the most cursory and elliptical fashion; the commentary and catalogues are chaotically or-ganized, and there are numerous errors in the description and interpretation of im-ages and transcription of texts.[11]

Clearly, there is the need for a coherent survey of Cornelis's career in its entirety. To this end, I have included an updated biography, based on the relatively few legitimate documents that do survive and pruned of several persistent misconceptions encountered throughout the earlier literature. In addition, I have tried to furnish a concise but reasonably complete account of the full range of his accomplishments as a painter and graphic artist. At the same time, I have chosen to concentrate on what surely remains the most intriguing portion of his oeuvre. Unlike his predecessors Jacob Cornelisz and Lucas, Cornelis was also responsible for a significant body of woodcuts that present a variety of moralizing themes, often in an elaborately allegorical guise. Indeed, much of the imagery strikes us, at first, as obscure—a term often applied in the past to the engravings of his contemporary Maarten van Heemskerck.[12] But just as recent studies have increasingly disproved this judgment with regard to the latter, so, too, it is hoped, its basic inaccuracy will become equally apparent during the course of our examination of Cornelis.

Even though Cornelis's output of woodcuts does appear to be far larger than that of any other Dutch or Flemish artist active at the time, it is still quite small. Including the cartographical publications, there are fewer than a hundred works in toto; of these, fewer than two dozen can be classified as didactic and/or allegorical. The explanation for his relatively limited oeuvre remains conjectural. As is the case with quite a few printmakers of that time (Dürer being a notable exception), many of Cornelis's works survive today in only a few or even in unique impressions—perhaps, in part, because editions may have been small to begin with; perhaps because, over the years, little care was taken to preserve individual impressions of woodcuts by artists of lesser renown. It is thus quite probable that still other woodcuts by Cornelis have perished entirely. Yet it is also possible that he never designed many more than now survive, the bulk of his time perhaps being devoted to mapmaking or other pursuits. Whatever the case, and however artificial the limits of his oeuvre as known today, this very compactness has much to recommend it. The iconographically complex designs of a prolific inventor like van Heemskerck can be treated only piecemeal. Those of Cornelis, on the other hand—equally complex but far fewer in number—afford a rare opportunity to examine the complete range of one artist's imagery at a single sitting, so to speak, but in some depth. My aim, then, has been to provide a full-length likeness of Cornelis the moralist, set within a landscape of the artistic, cultural, social, and historical factors that informed his art.

Aside from the hope that this study may help to redress the continuing imbalance of scholarship on German as opposed to Netherlandish woodcuts, why should Cornelis Anthonisz merit our attention? He had no pupils that we know of, and his sphere of influence was apparently limited; among the few surviving works that clearly reflect his style are two woodcuts published by Pieter Warnersz of Kampen (see note 27, chap. 6). Nor can we argue that he was an artist of extraordinary skill, talent, or vision.

Still, Cornelis was an artist who consistently demonstrated considerable pictorial ingenuity and wit (see, for example, his *Nabal, Ceres, and Bacchus*, figure 18; *Demon of Drink*, figure 21; *Fable of the Father, Son, and Ass*, figure 23a–b; *Flighty Youth*, figure 24a–b; and *Sinte Aelwaer*, figure 28). Other of his works are striking in their graphic force, monumentality, and power (see, for example, *Allegory of Transitoriness*, figure 14; *The Fall of the Tower of Babel*, figure 26; and *The Last Supper*, figure 31).

Moreover, it is also my hope that an examination of his oeuvre may add to our understanding of an area that has only quite recently stirred scholarly interest—namely, prints clearly aimed at a broad, popular audience (often the case with Cornelis's), as opposed to those appealing to an elite, humanistically oriented audience.

Finally, we will come to see him as an active participant in many of the changes in the artistic climate brought about by the Reformation, through its rejection of a mediating clerical hierarchy and its emphasis on a direct, personal relationship between the layman, God, and the ethical precepts of his Scripture.

In part because nearly half of Cornelis's moralizing prints can be dated only tenuously, I have organized this book into chapters whose sequence was determined by thematic rather than chronological considerations; each one deals either with an individual work or with two or more closely related works. The progression is basically from profane to sacred subject matter, though needless to say the boundary-line between these two categories is often far from distinct. I should add, finally, that it seemed essential to include a transcription and translation of all of the texts attached to these works. In the case of those that are reasonably short, both the original and my English rendering will appear together; in the case of lengthier pieces, the original texts will be found in the Appendix.

CHAPTER

2 Historical Background

Amsterdam and the Netherlands

While his city would remain overshadowed by Antwerp until the end of the six-teenth century, Cornelis Anthonisz's Amsterdam already held the promise of fu-ture supremacy.[1] The disadvantages of its site—far back from the sea, on marshy soil, and reached via inconveniently shallow waters—were offset by the fact that they also rendered the port defensible against attack from all sides, and that com-munications by river and canal with adjoining regions of the Netherlands, Ger-many, and France were unrivaled. Making the most of these features, the city had developed a thriving trade by the early 1500s and was famous for the number and size of its ships. Never to become an industrial center like Haarlem or Leiden, Am-sterdam instead founded its initial fortunes on fishing, the Baltic trade, and the carriage, storage, and marketing of grain and naval supplies. With the fall of its rival to the south, Amsterdam would later appropriate much of Antwerp's former busi-ness in banking and commodities as well. Still less than a third the size of Antwerp, its population was about 30,000 at mid-century but would rise to 100,000 by its end.[2]

Within this setting of comparatively modest yet growing prosperity was a small though energetic group of humanists: most notably Alardus Aemstelredamus (1491–1544), whose major works include an edition of the complete writings of Rodolphus Agricola; Cornelis Crocus (c. 1500–1550), rector of the Oude Zijde school, Latin grammarian, and author of the enormously successful play, *Comoe-dia Joseph*; and Johannes Sartorius (c. 1500–1570), who taught Latin and Hebrew and who produced, among other writings, a Dutch translation of Erasmus's *Ada-gia*.[3] The type of the *mercator sapiens* was represented by Pompeius Occo (c. 1482–1537), a learned banker whose library—Amsterdam's largest—had more than a thousand volumes.

Many of the city's scholars were also actively involved in debate on current the-ological matters and gave vocal support to a range of doctrinal positions. As was true elsewhere in the Netherlands, the municipal government seems to have been, at least at first, far from uniformly rigorous in enforcing those anti-Protestant de-crees issued by the Emperor Charles V through his regents Margaret and Mary—partly from a desire to resist Hapsburg attempts at limiting its long-enjoyed inde-

pendence, partly because many of the city authorities were themselves evangelical sympathizers.[4] Even the *Schout* (sheriff) Jan Huibrechtsz, who served from 1518 to 1534, was known to have decidedly unorthodox inclinations.[5] In October 1520 an imperial decree from Antwerp ordered the burning of Lutheran books. The Edict of Worms, enacted in May 1521, banned Luther from all of Charles's dominions. In April 1522 Charles actually set up a branch of the papal inquisition in the Netherlands. Also in 1522 the Amsterdam publisher Doen Pietersz came out with the earliest edition of a gospel translated into Dutch and annotated in a decidedly Protestant spirit. Over the next five years, Pietersz followed with other Bible editions based on Luther's, one even with his prologue and commentary. Yet regardless of the many proclamations specifically forbidding such material, city officials apparently took no punitive action.[6]

The very first martyrs to the Protestant cause were executed at Brussels on July 1, 1523. Their confession of faith, made in sixty-two articles, helps to illustrate the direction of early reformed thought in the Netherlands. In such statements as "if the sinner trusts his sins are forgiven, they will be forgiven," or "every Christian who has humbled himself has been freed of punishment and guilt without certificates of indulgences," we can detect the influence of Lutheranism. But when the witnesses went on to claim that "the body of Christ is not being sacrificed but partaken in his memory," they gave voice to a belief with its own independent and, indeed, indigenous history.[7] The first major link in the evolution of what came to be known as Sacramentism was Wessel Gansfort (c. 1420–1489), who propounded an interpretation of the Lord's Supper according to which its purely spiritual aspect had far greater significance than any physical consumption of the elements.[8] Erasmus also took up this theme and, in fact, went even further than Gansfort in emphasizing the Supper's commemorative element over and above its liturgical representation of the body and the sacrifice.[9] This was, of course, part and parcel of Erasmus's general devaluation of all the externals of worship—images, relics, outward observances and ceremonies, and the clerical hierarchy—in favor of a simple, interior piety based on the imitation of Christ and his ethical precepts as set forth in Scripture. Discursively in works like the *Adagia*, the *Moriae Encomium*, and the *Colloquia*, more obviously in writings like the *Enchiridion*, and most concisely in the prefaces, annotations, and paraphrases of the New Testament, Erasmus developed a program for religious renewal that he hoped would set his Church back on the true path from which it had deviated.[10]

Together with a figure like Gansfort, Erasmus belonged to that group of northern Christian humanists who believed in amelioration rather than schism. However critical of current abuses, they never proposed any radical changes in theology nor in the basic ecclesiastical structure. Alongside this prevailing moderation, however, there also ran more extreme views—focused particularly on the sacraments and above all on the Eucharist—which underlay the incidents of blasphemy documented throughout the Low Countries from the later fifteenth century on. Typical is the 1519 record concerning a housewife in Antwerp, a certain Kathelyne, who

was sentenced to make a pilgrimage to Rome for her mockery of the Host.[11] These widespread popular feelings would receive a definitive formulation at the hands of Cornelis Hoen, court lawyer at The Hague, who in his *Epistula Christiana Admodum* of c. 1520 went a step beyond his fellow countrymen Gansfort and Erasmus. Taking the word "est" in the crucial phrase "Hoc est corpus meum" to mean "signifies" rather than a literal "is," Hoen rejected transubstantiation and the doctrine of the Real Presence, and saw the Mass instead as an exclusively commemorative service—views for which he was eventually brought to trial.[12]

In Amsterdam, Catholic orthodoxy found its champions in Cornelis Crocus and Alardus, who produced a number of writings on the eucharistic question. In his 1523 *Ritus Edendi Paschalis Agni*, for example, Alardus compared this new heresy to the plagues of Egypt and called for increased devotion to the city's very own miraculous Host. First administered to an invalid in the mid-fourteenth century, it was still intact after having been vomited up, thrown away, and subjected to fire, and was finally housed in its own chapel—known as the Heilige Stede, or Holy Place—and was honored in an annual procession.[13] Not surprisingly, it became a favorite target of reform-minded citizens; Johannes Sartorius, whose 1525 treatise *De Sacra Eucharistia* would earn him, like Hoen, a term in prison, spoke of going to the Heilige Stede "to hear the dog bark, when the monk Cornelis of Naarden was to preach."[14]

Sacramentist views filtered into Switzerland and Germany, where the more cautious Luther, always unwilling to abandon his belief in a Real Presence, opposed them with a vehemence equal to that of the Catholics. Other reformers, however—including Carlstadt, Oecolampadius, and Zwingli—enthusiastically adopted a purely symbolic and commemorative interpretation of the Supper. Meanwhile, such attacks on the Eucharist had prepared the way for a movement that would focus on another sacrament: rejection of traditional infant baptism in favor of adult baptism, as the essential sign of a voluntary covenant with God, was the common belief of a heterogeneous assortment of sects brought together under the collective label of Anabaptism.[15] Their first conventicle was organized at Zurich in 1525, but within a few years a very different, eschatologically oriented variety spread north under the apostolate of Melchior Hoffmann from Strassburg. Anabaptism gained adherents among many former Sacramentists, and for the next three decades became, in its many guises, the predominant form of Protestantism in the Netherlands.

Among Hoffmann's followers, two cities were seen as having been divinely chosen for major parts in a final drama that would usher in the Lord's kingdom on earth. One was Münster in Westphalia, which would be briefly occupied and controlled by the radicals in 1534 until their defeat by combined Catholic and Lutheran forces. The other was Amsterdam, where a congregation had been established by the Melchiorite Jan Volkerts in about 1530. On March 21, 1534, several Anabaptists marched through Amsterdam's streets, waving swords and announcing the day of judgment with cries of "Repent!" and "Woe, woe to all godless!" On

9

February 10, 1535, seven others ran unarmed and without clothes to proclaim the "naked truth" of the new Eden. Next came the attempt of forty Anabaptists to take over the Stadhuis on the evening of May 10, 1535. After occupying it for one night, all were killed in the counterattack, along with at least one magistrate who had been favorably disposed to the evangelical cause.[16] This bloody event soon brought an end to the municipal government's permissiveness. A more pacifistic strain of Anabaptism was still practiced, but now underground, and those officials with unorthodox leanings would be forced out of office by about 1538. Sartorius was exiled from Amsterdam soon after the town-hall episode (and thereupon became head of the Latin school at Noordwijk), while the former *Schout* Jan Huibrechtsz was banned in 1540.[17] Harsher punishments, including execution, became more commonplace. It was a city that Charles's son, Prince Philip, could look upon with approval during his visit in 1549, when the decorations set up in honor of this occasion included a triumphal arch bearing an inscription that proclaimed the defeat of the Anabaptists and a representation of "Faith, holding down Error and Heresy."[18] Calvinism made no headway here until mid-century, and Amsterdam would remain at least nominally Catholic until 1578, long after most other towns had deserted Philip.[19]

At the beginning of the sixteenth century Amsterdam occupied the same rather secondary position artistically as it did in other aspects of cultural life, without any firm local tradition on which to build. The first figure of real importance would be Jacob Cornelisz van Oostsanen (c. 1472–1533). Noted above in connection with his woodcuts, he was equally industrious in his output of paintings and designs for stained glass and embroideries, all of which were carried out in a spaceless, crowded, ornate late Gothic manneristic style. By the end of the third decade, the city's somewhat provincial and conservative outlook would relax, largely in response to the work of Jan van Scorel (1495–1562), who had returned from Italy in 1524.[20] More or less permanently settled at Utrecht by 1530, he seems to have been a pupil in Jacob Cornelisz's studio in about 1512. Following the death of his old master, van Scorel was the one chosen to execute major church commissions, along with another outsider, Maarten van Heemskerck. Amsterdam's own artists, passed over when it came to large altarpieces, developed different specialties.[21] Jacob Cornelisz's son Dirck (c. 1497–1567), for example, is known to us only as a portraitist. His 1529 panel of seventeen military guildsmen is among the earliest surviving examples of that uniquely Dutch form, the *doelenstuk*; while previous groups like van Scorel's *Jerusalem Pilgrims* remained conceptually tied to donors' likenesses, Dirck Jacobsz's is based on an essentially secular notion of male camaraderie.[22]

The Life and Works of Cornelis Anthonisz

Cornelis Anthonisz turns out to have been a member of the city's artistic first family. Documents of 1533, 1546, and 1551 list a certain "Cornelis Thonisz" (a stan-

10

dard variant of "Anthonisz," which explains the letters "CT" of his monogram)
among the heirs of Jacob Cornelisz van Oostsanen's long undivided estate. Because
it was then a fairly common name, I. H. van Eeghen of the Amsterdam Archives
attempted to determine whether this "Cornelis Thonisz" could be identified as our
painter-printmaker. She discovered that he was, indeed, the son of one of Jacob's
two daughters and may well have been apprenticed in his grandfather's studio
alongside his uncle Dirck.[23]

It is quite likely that Cornelis adopted the St. Anthony's bell-and-staff motif
(CAT) from his father. (The "sz" at the end of many Dutch male surnames was the
abbreviation for "zoon" or "son of.") But nothing else is known regarding his par-
ents, his youth, or any siblings. Nor is there any proof of his birth date, which can
be placed only in the neighborhood of 1505. However, city records do attest to the
fact that by 1527 Cornelis had married Geert Jans (1492–1559), a former Beguine
whose father, Jan Diert, was a priest of the Nieuwe Kerk. In September of that year,
Cornelis would be named guardian of the four minor children of his deceased
brother-in-law. Geert's sister Mary was the widow of a certain Jan Dircks, perhaps
either a teacher or instructor of penmanship. According to van Eeghen, this might
explain the name of his house, "De Schrijvende Handt" (the Writing Hand). Follow-
ing Jan Dircks's death, "De Schrijvende Handt," located "achter de Nieuwe Kerk"
(behind the Nieuwe Kerk), became Cornelis's residence and workplace.[24]

A document of March 27, 1533, in which Cornelis is mentioned as the buyer of
a "coets" (bed) at a public sale, is the first to name him as a painter.[25] The year
1533 is also the date of his earliest extant work, a signed panel known by the title
De Braspenningsmaaltijd, in the Amsterdams Historisch Museum (figure 1). It is
another civic-guard portrait, of the *Voetboogdoelen* (crossbowmen). In addition to
the *Voetboogdoelen*, Amsterdam had two such military guilds: the *Handboogdoe-
len* (longbowmen) and the *Kloveniersdoelen* (harquebusiers), the latter represented
in Dirck Jacobsz's 1529 group portrait. Cornelis's group is identified by the inclu-
sion of two crossbows and by the image of St. George, the crossbowmen's patron
saint, in a medallion at the upper right; the particular company is identified by a
large letter "H" (or possibly a "G") that appears at the center of the painting's lower
edge. According to E.R.M. Taverne, *braspenning* was the current term for a gold-
piece of a certain worth; the painting's acquired title thus refers to the cost of the
banquet.[26] A sheet of paper tacked to a wall at the upper left bears the monogram
and date. Directly below is a young man holding up a pen; his frequent identifica-
tion as the artist's self-portrait seems to have been inspired by Houbraken's unver-
ifiable claim that Cornelis was a member of the *Voetboogdoelen*.[27] Christiaan
Tümpel identifies this figure as the company's *secretaris*.[28] Van Eeghen notes, how-
ever, that the militia groups had no permanent secretaries. She also observes that
the pose could well be a play on the name of Cornelis's home and workplace, "the
Writing Hand." Moreover, the subject appears to be in his late twenties or early
thirties. In short, the identification of this figure as a youthful self-portrait is by no

11

means unreasonable.[29] The *Braspenningsmaaltijd*'s flattened forms, stiff poses, and emphasis on contours are all typical of the "Amsterdam style" practiced by his two kinsmen. But at the same time it represents a significant departure from the usual format for militia groups. With an arrangement no doubt inspired by Last Suppers, Cornelis has gathered the guildsmen around a table at the banquet held annually on their patron saint's feast day—a new narrative approach that unites the men in common action.[30]

After 1533, most other documents will concern Cornelis's employment as a mapmaker. His next extant autograph painting is, in fact, a plan of Amsterdam that seems to indicate familiarity with Jacopo de' Barbari's 1500 woodcut of Venice and Hans Weiditz's 1521 woodcut of Augsburg. Signed and dated 1538, the panel was commissioned by the local government, which paid him 36 guldens and placed it in the Stadhuis (figure 2).[31] In 1541 city accounts record him as having received ten guldens for a map of the North Sea and the Zuider Zee.[32] In 1544 Cornelis did a second version of his city from the same high angle, but now in a woodcut on twelve sheets (figure 3). A text at the upper right dedicates it to the emperor, the city council, and "all lovers of art"; he then identifies himself as the publisher and gives the address and name of his shop: "achter die nieuwe Kerck," "inde schrijvende handt."[33] Cornelis's two Amsterdams would appear to be the oldest surviving bird's-eye-view town panoramas in the northern Netherlands, and he continued to play an active role in the early development of Dutch cartography. The importance of his contribution is difficult to assess, however, since much has been lost, including a *Map of Europe* praised by Abraham Ortelius.[34]

What remains is the 1543 *Caerte van Oostland*, issued the same year the emperor granted him publishing rights. It is a woodcut on nine sheets showing the northern Netherlands, Germany, and the Scandinavian countries in far greater detail than previous maps of the area (figure 4). City records show that in November 1543 he received two guldens, sixteen stuivers for two portions of this work.[35] Also surviving is his *Onderwijsinge van der Zee* of about 1544, a seventy-six page navigation handbook including woodcut coastal profiles, assorted diagrams, and a frontispiece of ships in full sail (figure 5).[36] A second group of city payments to Cornelis, dating from 1544, 1547, 1548, and 1551, all concern maps he made in connection with the Lastage, a municipal district that sued to obtain voting rights on the Amsterdam town council.[37] His last recorded effort in this vein was a plan of the small city of Weesp near Amsterdam, again on panel. Now known only from photographs (the original having been destroyed by fire in 1968), it was apparently commissioned—by which side is unclear—in connection with a dispute between the governing council and a local convent over the construction of two new streets. Cornelis's painting, dating from 1551, showed how the proposed streets would have run.[38]

Although his mapmaking would suggest at least some seafaring experience, there is no indisputable evidence of any travel, nor any clear indication from any of his

noncartographical works, of firsthand knowledge of far-off places or monuments. In a document of February 1539, a certain "Cornelis Thonisz" arranged for the disposal of his property before a trip to be taken in the service of the emperor. This was long thought to be our Cornelis's will, drawn up in anticipation of his presumed journey to Algiers with imperial forces in 1541.[39] Charles V's disastrous expedition against the Turks was even represented by Cornelis in a woodcut dated 1542 (figure 6). Further evidence uncovered by van Eeghen proves, however, that the will was actually drawn up for one of his fellow townsmen of the same name.[40] It is quite possible that the print was not our artist's eyewitness rendering but rather an image based on accounts or sketches passed along to him. Cornelis surely was in his native city for at least part of 1549, when he and the artist Herman Posthumus were each paid 33 guldens for work on Prince Philip's triumphal entry into Amsterdam; the exact nature of their contribution remains unknown.[41] It is not even certain that Cornelis accompanied the Dutch troops who took part in Charles V's more successful attack on the French town of Terwaen in 1552–1553. Cornelis recorded the siege in another woodcut, but here, too, his information may well have been secondhand (figure 7). There are no works dated after *Terwaen*, and a document from the fall of 1553 provides a terminus ante quem for his death by virtue of its reference to an annuity for Cornelis's apparently childless "widow," Geert Jans.[42] We should also note, finally, that four houses were registered under his name in 1553. In all probability, they came from the well-to-do family of his wife; it is unclear how long they had been his property prior to his death.[43]

The greatest number of works associated with Cornelis Anthonisz are princely portrait woodcuts. The Renaissance cult of personalities and a growing sensitivity toward the propagandistic possibilities of "the media" combined to give rise to this form during the early sixteenth century. Rulers learned the value of wider recognition, while the people wanted likenesses, however remote or fanciful, of those in power. Such engraving and woodcut portraits had appeared in Italy and Germany by the fifteenth century. Netherlandish examples came more slowly, the earliest of note being Jacob Cornelisz van Oostsanen's 1518 *Lords and Ladies of Holland* (figure 10).[44] Its cortege of thirty-four riders ends with Charles V and thus proclaims his lordship over Holland. Such ancestral processions, particularly when they extended back to early Christian or even ancient times, had the special attraction of further legitimizing an individual's claim to authority. Cornelis did two of these genealogies. From about 1549–1550 are thirty men and women on six sheets, again the *Lords and Ladies of Holland*, now missing one sheet of figures and a presumably appended text (figure 8a–b).[45] Conceived as a sequel to this was his *Lords of Brederode*, dated 1550–1551: twenty men on four sheets, beginning with Zyphridus of the eleventh century and ending with Reynout III van Brederode, to whom the work is dedicated (figure 9).[46] Both series are identically conceived, with some of the poses in the first even being repeated in the second. He may have adopted the vertical arrangement of coats-of-arms, figures, and biographies from Jacob Cornelisz, 13

although Cornelis's leggy, almost balletic figures are otherwise far from his predecessor's stiff little dolls.

From about 1538 to 1548, Cornelis was also involved in the creation of perhaps forty single-sheet equestrian portraits of various European kings, princes, and noblemen, with a general reference to models like the *Triumphal Procession of Maximilian* by Dürer and several collaborators and *Turkish Riders* of 1526 by Jan Swart. There are, in addition, nearly twenty related standing and half-length figures. Many of the heads, poses, and mounts were borrowed from prints by Dürer, Cranach, or Ostendorfer; others echo portrait drawings and paintings by Clouet, Holbein, or Joos van Cleve. Only a handful out of the entire group actually bear Cornelis's monogram, for example, *Johannes III of Portugal* (figure 11). But nearly all carry the address of either Hans Liefrinck (1518–1573) or Sylvester van Parijs (active c. 1528–before 1573) of Antwerp—at that time the major center for book and print publishing in the Netherlands. Apparently some of the designs were cut and printed in Amsterdam; the impressions were sent to Antwerp for hand-coloring and distribution by Liefrinck and van Parijs, who affixed their names. In other cases, the cutting itself may have taken place in Antwerp, with only the preliminary drawing being sent on from Amsterdam. There was also considerable recycling of the images in copies and copies-after-copies—a confused state of affairs that usually forbids any positive claims as to authorship and is of little help in establishing a chronology for Cornelis's oeuvre.[47]

Efforts to trace the course of his stylistic development are limited, in any event, by the comparatively modest number of less than one hundred extant works, even including the portraits and cartographical productions. A further difficulty in the analysis of his growth as a graphic artist is the total lack of drawings. Still, it is apparent that his overall debt to the prints of Jacob Cornelisz and Lucas van Leyden amounts to little more than the appropriation of a few isolated motifs—surprising not only in the light of his relationship to the former but also because these two would have provided the most significant native models for the medium of woodcut. Instead, he appears to have experimented at first with an aggressively Italianate manner particularly reminiscent of the kind practiced by Jan Gossaert in a woodcut like the *Hercules and Deianeira* of c. 1517–1523 (figure 12). Cornelis's *Marcus Mutius Scaevola* of 1536 (figure 13) and his 1537 *Allegory of Transitoriness* (figure 14) both include similarly vigorous, strongly muscled figures, in the first case complete with contrapposto, antique armor, and a background of classical buildings.

This youthful Romanism was soon abandoned in favor of less heroic types. *The Good Shepherd with Sinners* of 1540, for example, represents Christ, David, the publican, and the Prodigal Son as rather thickset, plebeian figures, the first three enveloped in coarse, weighty robes (figure 15). Perhaps from the same period is another group of woodcuts with horizontal formats and compositions in which the central figure is flanked by a secondary pair: *Patience, Satan, and Sin* (figure 16), *Truth, Hate, and Fear* (figure 17), and *Nabal, Ceres, and Bacchus* (figure 18). In its

unpretentious stolidity, *Demon of Drink* seems related to this group as well (figure 21).

On the other hand, his 1539 etching and woodcut of *Concord, Peace, and Love* represent first steps in the direction of the more relaxed and fluid line and more graceful Scorelesque figures that constitute Cornelis's most characteristic style (figures 19, 20). The high altar painted by van Scorel in about 1527–1529 for the Oude Kerk in Amsterdam has perished, but there are several extant workshop pieces, of identical composition, that may well be replicas of its central *Crucifixion* scene (figure 22).[48] Whether these replicas do, in fact, record a work that would have been directly available to him, or whether they are instead copies after some other lost original in a different location, they offer a clear illustration of Cornelis's debt to his more renowned manneristic colleague. We might compare the slender, graceful form and serpentine pose of Liefde in Cornelis's woodcut version of *Concord*, for example, to the woman who appears beside the cross of the good thief; likewise, *Concord*'s elegant, bearded male figure is closely related, as a type, to the men who appear at the *Crucifixion*'s far left.

At the same time, however, Cornelis would show little of van Scorel's interest in landscape. The type of expansive view featured in so many of the latter's compositions is entirely absent from Cornelis's oeuvre. Similar views were featured in a number of Netherlandish woodcuts dating from the earlier 1520s, designed by such artists as Jan Wellens de Cock, Frans Crabbe, Nicholas Hogensberg, and Jan Swart van Groningen.[49] But Cornelis apparently had no interest in pursuing this development. His environments are often minimal; when more elaborate, they tend to be architectural rather than natural. In keeping with one of his primary concerns—to convey a moralizing message effectively—what space there is is occupied mostly by his figures, who remain close to the picture plane. The outdoor setting of the *Fable of the Father, Son, and Ass* of 1544 is hardly more than a backdrop of several tree trunks, scattered mountains, and an intermittent city view (figure 23a–b); the comparably friezelike *Flighty Youth* would seem to date from about the same time but reduces its setting even further to a narrow strip of ground (figure 24a–b). The pirouetting personifications in his 1546 *Misuse of Prosperity* are confined to an airless framework of alternating columns and termlike forms, whose lyre-shaped and strapwork bases suggest the influence of Cornelis Floris and other early practitioners of the Netherlandish grotesque (figure 25a–g).[50]

In the following two years Cornelis produced his only other known etchings apart from the 1539 *Concord*: a 1547 *Fall of the Tower of Babel* (figure 26) and a 1548 bust-length *Charles V* (figure 27).[51] A number of undated works are difficult to place more specifically than in the 1540s or early 1550s: his *Sinte Aelwaer* (figure 28) and *Winged Pig* (figure 29), an anatomical woodcut showing the *Arterial System of the Human Body* (figure 30),[52] a chiaroscuro woodcut of *The Last Supper* (figure 31), and two complex memento-mori images, *The Ages of Man* (figure 32) and *Deathbeds of the Righteous and Unrighteous* (figure 33).

15

The remarkable growth of mass communication across western Europe from the late fifteenth century on included not only printed texts and printed pictures but also, of course, combinations of texts and pictures—the latter almost always in woodcut, which could be run through a press at the same time as movable type. Along with illustrated books and pamphlets were unbound sheets bearing a text of some length and an image, generally on one side only. Possessing the informational advantages of a form that was visual as well as verbal, and usually in the vernacular, broadsheets, unlike illustrated books, could still be quickly and cheaply produced.[53] Like other types of prints, broadsheets could be bought directly from the publisher's shop but were also sold by traveling peddlers who carried them from town to town. All these features rendered them especially suited to newsworthy subjects, and indeed there are countless sixteenth-century examples that depict and describe battles, crimes, Turkish atrocities, abnormal births, exotic races, celestial phenomena, and the like—as, for example, in a sheet issued at Nuremberg in 1534 concerning the execution of a murderer at Regensburg (figure 36).[54]

Broadsheets would also become an effective weapon in Protestant, especially Lutheran, hands—Luther himself being opposed to idolatry, of course, but firmly committed to a belief in the pedagogical value of art. While the importance of the printed word for the dissemination of Reformation ideas has long been recognized, not until rather recently has attention been focused on the movement's visual propaganda.[55] When joined together on broadsheets, text and image could convey the new, evangelical message with graphic force and, at the same time, linguistic precision in an inexpensive and easily circulated manner. In one example by Erhard Schön from 1532 (G.1140), God the Father clears his vineyard of the many wicked "fruits" of Catholic practice—rosaries, reliquaries, indulgences, clerical habits, etc.——while to the left a Lutheran preacher points to the vineyard's real "fruit," the crucified Christ; captions within the image and the text below clarify this contrast between true and false religion. Nonpartisan moralizing was another popular theme for broadsheets on such standard topics as the transience of earthly existence, assorted human failings, and relations between the sexes—as in an example from 1530 with verses that elaborate on the twelve characteristics of a wicked wife, and a woodcut that shows her brawling with her unhappy husband (G.1179).

Many were hastily conceived and anonymous, with crude images and merely serviceable annotations. This proved more and more the case during the course of the seventeenth century, which saw an ever-widening gap between an uneducated public that bought increasingly inferior woodcuts and educated groups that came to prefer "fine" prints, which had become essentially synonymous with engravings and etchings.[56] But particularly during the first half of the sixteenth century, and especially in the north, the woodcut broadsheet would also develop into a definite hybrid of considerable aesthetic merit, with obvious appeal for reasonably sophisticated if not learned audiences. Sometimes the image was designed to illustrate a preexisting text, or, alternatively, an author would supply the commentary for a

preexisting print. Other broadsheets are clearly collaborative efforts, where words and image were conceived and designed in conjunction. It is often impossible to determine whether it was the artist, author, or xylographer-publisher who provided the impetus for the creation of individual broadsheets. And just as was the case in the production of prints without any text, these roles could even overlap; the artist might be the publisher, the publisher might write the accompanying text, etc.

In Germany, such figures as Dürer, the Cranachs, the Behams, Burgkmair, Pencz, and Schön were all involved in the production of broadsheets. Sebastian Brant composed the texts—in Latin as well as in his native tongue—for more than twenty extant broadsheets that interpret an assortment of misbirths and celestial events.[57] Conrad Celtis also wrote verses, again in Latin, for a number of broadsheets in praise of the Virgin Mary and various saints, among other subjects. The author most closely associated with the broadsheet was the Nuremberg shoemaker-*Meistersinger* Hans Sachs (1494–1576), who wrote the texts, in his native tongue, for perhaps more than two hundred fifty broadsheets, many of them on behalf of the Lutheran cause. A large share of his work has come down to us in broadsheet form.[58]

In the Netherlands, it was Cornelis Anthonisz's oeuvre that most consistently featured this union of word and woodcut image. Aside from the brief identifying annotations on his siege scenes and single-sheet portraits, and the lengthier biographies on the *Lords of Brederode* (and presumably at one time the *Lords and Ladies of Holland*), the majority of his allegories include inscriptions, while four have texts of over a hundred lines. These four and at least seven additional works by Cornelis were all issued by Jan Ewoutsz (active c. 1535–1564), who monopolized Amsterdam's small publishing trade after Doen Pietersz's death, just as Cornelis monopolized its printmaking after Jacob Cornelisz's death. Ewoutsz's partnership with Cornelis can be traced from 1536—the date of the *Marcus Mutius Scaevola*—through the next fifteen years and actually seems to have represented a substantial part of his business. Not until 1546, in fact, did he acquire a privilege to issue books, most of which are slender manuals listing the relative values of various currencies.[59] In 1558 he came out with a reprint of Cornelis's nautical guide, the *Onderwijsinge van der Zee*. One more volume published by Ewoutsz—his 1550 reprint of Eyke von Repgow's *Saksenspiegel*—contains a woodcut that could be associated with Cornelis; the knight on its title page bears a distinct resemblance to several figures in his *Lords and Ladies of Holland* and *Lords of Brederode* from the same period (figure 34).[60] The only additional book illustration that can be connected with Cornelis is a woodcut of *Saint Olaf* bearing his monogram and the date 1539. It is known only from a mysterious, unidentified photocopy in the Amsterdam Rijksprentenkabinet, reproducing what appears to be a bound page (figure 35).[61]

Though not nearly as tangled a situation as in the case of his single-sheet princely portraits, Cornelis's other woodcuts also leave quite a few unanswered questions 17

with regard to the number and identity of hands that took part in their production. Those signed C&T but also bearing the address of "Jan Ewoutzoon figuer snijder," were probably cut, after Cornelis's design, by Ewoutsz. Included in this group are *City of Algiers*, *Fable of the Father, Son, and Ass*, *The Flighty Youth*, *The Misuse of Prosperity*, and *Sinte Aelwaer*. Others lack an address but incorporate Ewoutsz's own motif—a compass flanked by the letters "J" and "E"—into the image, along with Cornelis's. These, too, were probably cut by Ewoutsz and include *Marcus Mutius Scaevola*, *Allegory of Transitoriness*, *Nabal*, *Ceres, and Bacchus*, and *Truth, Hate, and Fear*. Most numerous are the woodcuts that bear a C&T monogram but no other identifying marks or inscriptions. At least a few of these may have survived only in impressions that were issued without their original addresses (as is doubtless true, for example, of his *Lords and Ladies of Holland*), or even without their original cutters' monograms (there are, for instance, impressions of the *Allegory of Transitoriness* from which Jan Ewoutsz's motif has been entirely removed).[62]

The *figuursnijder*'s skill was one, however, that Cornelis could certainly have acquired in his grandfather's studio. The text that accompanies his *Last Supper* seems to identify him explicitly as its cutter; and it is surely possible that he did execute many of his own blocks. We might add that, like so many of the princely portraits, a number of Cornelis's moralizing woodcuts were also passed on to a *Briefmaler* and hence are known today in hand-colored as well as in uncolored impressions; others, however, survive only in uncolored examples and may never have been issued in any but their black-and-white form. So far as Cornelis's ventures into etching are concerned, the freedom and spontaneity with which *The Fall of the Tower of Babel* and *Concord, Peace, and Love* are executed strongly suggest that neither one involved a copyist; his *Charles V*, though somewhat more dry in feeling through having been reinforced with the burin, is also most likely autographic.

CHAPTER

3 Outcasts

It has often been observed that a rapid expansion of the economy coincided with the sudden prevalence of certain related themes in sixteenth-century Dutch and Flemish art. Mercantile activity, industry, banking, and monetary speculation developed at an enormous rate throughout Europe, in the Netherlands, and, most particularly, in Antwerp, whose "golden age" extended from about 1500 to 1560. Tension between this commercial revolution and the teachings of Christ made greed, avarice, and prodigality major topics for contemporary moralists. The portrayal of ill-matched couples, tax collectors and usurers, or misers and Death was, to at least some degree, a response to these prevailing conditions. And while the Reformation certainly bestowed greater status on Scripture in its entirety, there was also particular enthusiasm for subjects like the Calling of Matthew or the Prodigal Son. If his native city could not yet rival its neighbor to the south, Cornelis Anthonisz still participated in the timely struggle to define a proper attitude toward material wealth.[1]

Sorgheloos

In one series of six woodcuts with a text of one hundred thirty lines, we follow the decline and fall of a profligate named Sorgheloos, or Careless (figure 37a–f).[2] A bellows in the last scene bears the date 1541 and the monogram of Jan Ewoutsz, whose address—"aen die oude side in die kerckstraet . . . inden vergulden Passer" (on the old side, on Kerckstraet, at the Golden Compass)—is printed below.[3] Otherwise unsigned, the designs for *Sorgheloos* can be confidently attributed to Cornelis Anthonisz.[4] Although this claim rests to some degree on its having been published by his longtime associate, the connections with a number of autograph works are obvious. Five of the prints employ elaborate yet shallow architectural settings, usually open to one side to reveal secondary figures or moments in the narrative—much the same organizing principle as governs his *Dives and Lazarus* from the same year (figure 38).[5] Its physical types are also characteristic of Cornelis. The chubby, round-featured child from his *Allegory of Transitoriness* (figure 14) and *Aelwaer*'s distinctive "broken-nosed" saint (figure 28) both have their counterparts in several

19

scenes (see Sorgheloos and Weelde in figure 37b and Weelde in figure 37d). The faithful man of his *Deathbeds of the Righteous and Unrighteous* (figure 33) turns up as Sorgheloos in episode six, while Weelde seems a close relative of Cornelis's *Isabelle of Portugal* (figure 39), *Madame d'Etampes* (figure 40), or the Mary of Burgundy from his *Lords and Ladies of Holland* (figure 9b).[6]

The tighter line and descriptive complexity that mark the series as a whole are largely a reflection of specific models. Like his *Allegory of Christianity* (figure 41), after an engraving by Hans Sebald Beham (figure 42), *Sorgheloos* appropriated not only individual figures but also the manner in which they were represented. Dürer's landscapes of the 1490s had a clear effect upon scene one; Famine from *The Four Horsemen* (figure 43) provided inspiration for Sorgheloos and his mount, while *Knight and Landsknecht* may have suggested his upraised arm, Ghemack running alongside, and their dogs (figure 44).[7] The second scene's Ghemack, together with the third scene's Weelde, Sorgheloos, and musicians, were all lifted from Jörg Breu the Younger's *Venetian Banquet* of about 1539–1540 (figure 45). The third scene's fool and embracing couple and the fifth scene's Ghemack were all taken from Hans Schäufelein's *Princes' Wedding Dance* series of about 1531–1535 (figure 46a–c).[8]

As Konrad Renger has observed in his *Lockere Gesellschaft*—a study of the merry-company theme in sixteenth-century Netherlandish art—*Sorgheloos*'s greatest resemblance, in terms of its actual story and subplots, is to a group of influential tondi usually associated with the Leiden artist Pieter Cornelisz Kunst (figure 47a–l). Three are pen-and-ink drawings dated 1517 and usually accepted as by Pieter Cornelisz's own hand; another drawing and eight paintings are copies, by at least two other hands, after lost originals. Although the exact sequence is not entirely clear, there are eleven different scenes (probably out of an original twelve), which seem to represent: (1) the Prodigal's birth, (2) the Prodigal feasting, (3) the Prodigal in wealth, (4) the Prodigal dancing, (5) the Prodigal gambling (known in two versions), (6) the Prodigal expelled from the inn, (7) the Prodigal turned away from a rich man's door, (8) the Prodigal in poverty, (9) the Prodigal wandering, (10) the Prodigal greeted by his father, (11) the Prodigal's homecoming.[9]

Mediaeval representations gave the same amount of attention to each episode derived from Luke 15:11–32.[10] The youth would first be shown receiving his patrimony and then leaving for distant lands. The parable itself provided few particulars regarding the next period of "riotous living" (verse 13), save for what could be inferred from the jealous elder brother's later remark in verse 30 ("But as soon as thy son is come, who hath devoured his substance with harlots . . ."); not until the thirteenth century do we find portrayals of the Prodigal gaming or feasting, quite sedately, with one or two courtesans.[11] He would then appear tending pigs, as in verse 15, and, finally, returning to a benevolent father who orders a celebration and the slaughter of a fatted calf. This equal narrative distribution is still found in series such as Hans Sebald Beham's from 1540 (figure 48a–d). From the early decades of the sixteenth century, however, there was also an unprecedented pictorial focus—

especially in the Netherlands—on the Prodigal's revelries. Pieter Cornelisz's series, for example, sets at least three of its scenes in the tavern. By the 1530s his "riotous living" was well established as an essentially independent subject. In woodcuts by Jörg Breu the Elder from c. 1530 (figure 49) or by Beham from c. 1535 (G.219–220), for example, the parable's other episodes are reduced to small vignettes in the distance.[12] And in a panel dated 1536 by the Antwerp master Jan Sanders van Hemessen, the Prodigal's carousing occupies the foreground of an open classical hall. His companions include several prostitutes, an old procuress, a gambler, and a bagpiper; only in the background do we see the swineherd and homecoming episodes (figure 51).

During this same period there arose, in addition, a type of *non*scriptural "merry company": scenes of drunken men and loose women with no directly identifiable reference to the parable or, indeed, to any other biblical story. In *Sorgheloos*, for instance, the protagonist's tale ends with his ruin; the critical swineherd and homecoming scenes are omitted, thus eliminating any direct link to Luke 15. In a single woodcut from about 1518–1520 by Lucas van Leyden, the feckless youth is being fleeced by a thieving courtesan and procuress and observed by a fool whose inscription advises: "Acht, hoet varen sal" (Watch how this will turn out) (figure 50). Two other panels by Jan van Hemessen feature brothels or inns with male main characters, although, again, neither appears to be the Prodigal himself.[13] Also by Lucas van Leyden are at least five panels dating from the 1510s and early 1520s featuring groups of card- or chess-playing men and women. Lacking the clearly distinguished protagonist of his woodcut, these more decorous and enigmatic images are still most likely moralizing in intent.[14] In a woodcut of about 1540 by the Dutch Monogrammist AP, a tavern space is expanded to include several large gatherings of carousing couples (H.9). Dating from around the same time are the half-dozen or so "merry companies" associated with the Brunswick Monogrammist (who has been varyingly identified as either van Hemessen or Jan van Amstel).[15]

The natural tendency to progress from one form of concupiscence to another—from overeating and drinking to immodesty and lechery, to gaming, idleness, and excessive sleep—was a fact that had been observed since the very earliest discourses on sin, as had the particular concentration of such activities in certain locales, namely, the public house or brothel. The related manifestations of and settings for sensual pleasure had become a standard literary theme long before they were exploited for images of the Prodigal Son or merry companies. But it is hardly surprising that during the course of the fifteenth century and particularly throughout the sixteenth century, there was a marked proliferation of writings that closely parallel the representation of these subjects in art. In *Des Coninx Summe*, the Dutch adaptation from 1408 of Laurent Gallus's influential *Somme le Roi*, the tavern is described as "des duvels scole ende des duvels kerc ende des duvels apoteke" (the devil's school, and the devil's church, and the devil's pharmacy). There, it continues, one learns how to booze and throw dice, curse and quarrel, lie and cheat, steal 21

and murder. The tavern-goer gambles away his inheritance and possessions, be-friends whores, alienates his relatives, and ends up as a thief.[16] About eighty years later, Sebastian Brant's *Narrenschiff* would include a very similar enumeration in its chapter "Von Völlerei und Prassen" (Of Gluttony and Carousing), which places the burden of blame on drink:

> For wine's a very harmful thing,
> A man shows no sound reasoning
> Who only drinks for sordid ends,
> A drunken man neglects his friends
> And knows no prudent moderation,
> And drinking leads to fornication. . . .
> Through wine a wise man comes to prate
> And sets a fool's cap on his pate. . . .
> Man would not be a slave, in fine,
> If he disowned the demon wine:
> Are wine and sumptuous food your itch?
> You'll not be happy, not get rich
> Woe's him and woe's his father too,
> He'll have misfortunes not a few
> Who always gorges like a beast
> Proposing toasts at every feast,
> And would with others glasses clink;
> The man whose joy is endless drink
> Is like a man who falls asleep
> Defenseless on the ocean deep. . . .[17]

Alongside such obviously moralizing denunciations of debauchery, we also find a body of writings whose approach toward the same subject was long understood in a very different light. Providing a vivid chronicle of the lives of assorted miscreants and ne'er-do-wells, these writings consist of mostly anonymous vernacular verses. Some are first-person narratives; others are composed in forms characteristic of actual civic and religious organizations: prayers, litanies, sermons, charters, and so on. Scholars since the later nineteenth century came to attribute a considerable degree of autobiographical authenticity to such so-called "vagabond verses." G. Kalff, T. Enklaar, and others claimed that their authors were educated vagrants—students, dispossessed clerics, minstrels, etc.—who had shaped themselves into guilds complete with pseudo-popes, bishops, abbots, and mock-secular officials.[18] Though its origins extend back to the early Middle Ages and across all of western Europe, this type of verse seems to have been especially favored in the Netherlands, where many examples were collected and printed in book form starting in the first half of the sixteenth century. One important publication is the

Veelderhande geneuchlijcke dichten, tafelspelen, ende refereynen (Assorted Pleas-

ant Poems, Table-plays, and Refrains), whose first edition (now lost) probably dated from the early 1500s. Its contents include poems with titles like "The Peasant's Pater Noster," "The Right Way to the Poor House," "Of Bacchus, the Drunkard's God," and "Of Bad Beer, Which is Weak and Watery."[19] In a typical piece from another collection, the so-called *Antwerps Liedboek* of 1544, the chorus reads:

> Hi laet ons drincken en clincken
> En laet ons maken den dobbelen haen
> Mijn keelken moet wijnken drincken
> Al sou mijn voetken baeruoets gaen

> (Hey, let us drink and clink glasses
> And let us throw the dice
> My gullet must have wine
> Even if my feet have to go bare)[20]

The recurring cast of characters includes idle monks, lascivious nuns, nobles who fail to live within their means, quacks, beggars, unfaithful wives, slugabeds, musicians and other entertainers, and, very often, young men who squander their parents' earnings. These and other sorts are all named in the early fifteenth-century poem *De Blauwe Schuit* (The Blue Boat), which employs the same nautical metaphor as Brant's *Narrenschiff* and is written in the form of a charter; among its passengers are youths

> Die niet en sorghen noch en sparen
> Ende grof en grotelic vertaren
> Dat hem van haer ouders is bleven,
> Ende niet veel daerom en gheven
> Hoe onnuttelic sij't overbringhen,
> Ende dobbelen, spelen ende singhen. . . .
> Ende die niet en sorghen nacht noch dach
> Voer al haer goet is wechghebract
> Mit vrouwekyns of mit lichten wiven,
> Of mit buverien te driven. . . .

> (Who neither take care nor save
> And coarsely and freely spend
> What their parents have left them,
> And who don't consider very much
> How uselessly they waste it,
> And play dice, game, and sing. . . .
> And who never take care, neither night nor day
> Before all their goods are gone
> With little women or hussies
> Or devote themselves to roguery. . . .)

23

We are told further that they sleep until noon, never work, and fail to invest or save their money—and for all these reasons are honorable members of the guild of the Blue Boat.[21]

According to the "autobiographical" interpretation, such writings were actually parodying celebrations of the wild and wandering lives led by their inn-frequenting authors—often impoverished because of their dissolute habits, yet possessing a degree of moral freedom beyond the reach of established burgers. More recently, however, the literary historian Herman Pleij has amended this romantic notion of footloose poets thumbing their swollen red noses at social convention. He argues that the guilds, rather than being real, were purely literary devices originally tied to pre-Lenten carnival festivities, with their temporary overthrow of the establishment and traditional mocking of sacred and secular institutions.[22] Many of the Dutch pieces employ certain turns of phrase and rhyme schemes typical of the *rederijkers* (rhetoricians)—those amateur writers who would collectively assume such a leading role in the cultural life of the Netherlands from the early fifteenth through the seventeenth centuries.[23]

By the late 1400s nearly every significant town had one or more *rederijker kamer* or chamber. In the Amsterdam of Cornelis's time there were two whose mottoes were "In Liefde vierich" (Burning in Love) and "In Liefde bloeyende" (Blooming in Love).[24] Drawing their members from many different social groups, but with a large proportion of shopkeepers, artisans, and craftsmen, the *rederijkers* were responsible for a vast outpouring of vernacular poetry and plays and programs for public occasions. "Vagabond verses" were, then, more likely the product of this ever more visible, and settled, urban middle class. Far from representing the spontaneous outpourings of latter-day bohemians, "vagabond verses" were much more likely meant as satirical criticisms of those who failed to practice moderation, diligence, and thrift. Far from representing the rueful self-mockery of social outcasts, their protagonists' frequent complaints of disease, destitution, and general misery were much more likely meant as warnings on the awful consequences of intemperance.[25]

The sixteenth century also witnessed a proliferation of plays on the subject of the Prodigal Son and other reckless young men, especially in the form of Latin school drama. Written by teachers for the linguistic instruction and moral edification of their pupils, Latin school plays began with medieval Italian imitations of classical works, but would achieve their greatest success in Germany and the Netherlands. Adopting the styles of Plautus, Terence, and Seneca, school drama dealt with mythological themes and, increasingly, with biblical stories like those of Joseph, Susannah, or the Prodigal—the latter being an ideal cautionary tale for young performers and audiences.[26]

Particularly influential was the play *Acolastus* by Guglielmus Gnapheus, who taught at The Hague until 1536, when he was obliged to leave the country on account of heretical views. Written in 1529 and dedicated to Johannes Sartorius, *Acolastus* (whose interpretation of the parable is itself unorthodox) went through

nearly fifty editions before 1585.[27] Its title character (whose name is derived from a Greek word meaning "intemperate") leaves home after receiving his inheritance from his father, Pelargus, and promptly takes up with two parasites named Pamphagus and Pantolabus. All three end up at a tavern, where Acolastus first meets the whore Laïs and then loses all of his money at cards. Stripped of his clothes and expelled from the tavern, he must tend pigs for a peasant before being recognized by his father's friend Eubulus and brought home for a family reunion.

Similarly inspired by the parable is *Asotus Evangelicus*, whose author was the 's-Hertogenbosch schoolmaster Georgius Macropedius.[28] Written in about 1507 and first published at Cologne in 1537, this play opens with the departure of an aged father, Eumenius. His household immediately becomes the setting for all sorts of vices at the instigation of a wicked servant, Comasta, his friend Colax, and the irresponsible younger son Asotus (from another Greek word meaning "intemperate" or "dissipated"), who first appears singing and carrying a falcon on one arm. Returning unexpectedly, the horrified parent complains that his place has been turned into a bordello. While the devils Belial and Astaroth await their chance to snare him, Asotus, comforted by two prostitutes, prepares to leave home. After a year of unhappy wandering, he returns and is forgiven, despite the objections of his older brother. Macropedius also introduced what would prove to be a popular variation on this theme with his *Rebelles* of 1535 and his *Petriscus* of 1536, perhaps the earliest examples of a type of play that dealt with wayward students who fail to heed their wise instructors and hence are ruined—often, again, as a result of drink, gaming, and whores. A German version of this same subject is Jörg Wickram's *Der Jungen Knaben Spiegel* of 1553, in which the sons of a knight and a burgher both have the same teachers but follow different paths; the former, lazy and dissolute, ends up as a wandering minstrel, while the latter becomes a famous doctor.[29]

The rather haphazard preservation of *rederijker* plays until the later sixteenth century makes their contribution with respect to Prodigal Sons and other spendthrifts more difficult to evaluate. Known only from a fragmentary Antwerp edition of 1540 is *De Historie van den Verloren Sone*, a combination of prose passages and dramatic dialogue.[30] Here the Prodigal is befriended by two vagabonds, Verdorven Kint (Depraved Child) and Roeckeloose (Reckless). Those allegorical plays (*spelen van sinne*) that were a *rederijker* specialty always include at least one such pair among their numerous personifications (known as *sinnekens*).[31] After spending all at a brothel, Verloren Sone steals from his father's silver chest and resumes his wild ways. But when the money runs out a second time, he is stripped of his clothing and evicted, then becomes a swineherd, and finally returns home. Apart from reworkings of the parable itself, many *spelen van sinne* make use of a tavern setting, where their protagonists fall prey to various sinister forces but are saved at the last moment. In one, for example, Mensche (Man) is led to an inn by a couple of *sinnekens* called Vieryghe Lust (Burning Passion) and Verdwaesde Jongheyt (Foolish Youth) and nearly ruined by the innkeeper, Der Zonden Voetzele (Nourishment of

25

Sin).[32] Spongers, fools, wicked companions, loose women, and a host of unsavory details about loose living are standard features in these works. Apart from a 1552 copy after Breu's *Prodigal Son* (figure 49), in which every figure is identified as a character from *Acolastus*, the pinpointing of specific literary sources remains a hazardous business.[33] Yet as *Sorgheloos* itself will show, the narrative wealth of such plays—like the narrative wealth of "vagabond verse"—had a clear and lasting impact upon the representation of carousing Prodigals and merry companies.

Sorgheloos is the only one of Cornelis's works to identify the author of its accompanying text. The "Jacob Jacobzoon Jonck" named in line 130 was an Amsterdam *rederijker* known from three surviving plays; his contribution in this case lends added support to the argument that the series as a whole was conceived and designed locally.[34] Jacobz's verses follow a formula in which the protagonist describes his various activities and is then criticized in admonitory stanzas. The first print (figure 37a) shows our splendidly dressed hero riding before a lush, mountainous landscape on a fine horse. He urges on the lady Weelde, with her falcon, and the footman Ghemack. Below we read:

> 1 I, Careless, set out on the hunt, graceful and merry
> With Luxury, my darling, whom I love
> Ease, my page, is also very elegant
> By these two my heart and soul are supported
> 5 For I take delight in looking at both of them
> Therefore, no trouble can grieve me
> If I can only gain the good favor of those two
> They drive burdens and sorrow away from me
> I don't value earthly goods, though my parents saved them
> 10 I want to spend it courting, drinking and paying out
> For if the goods diminish, the days shorten too
>
> You young men of proud posture
> Don't be like Careless, but live in moderation
> And remember life here will not last long
> 15 And the careless ones will be cursed by God
> And they won't become men of status
> Yes, a moment of joy will be followed by a thousand sighs
> But dispense charity to the poor with your money
> In that way the righteous fruit will grow out of you
> 20 Luxury and Ease won't flee from you when you do this
> But your money will increase from then on
> So meditate a little about your old age

There are several examples dating from the thirteenth century on in which the Prodigal Son is represented as a hunter. The hunt had been employed since early mediaeval times as a metaphor for mankind's pursuit of various goals.[35] But it was

also perceived as a merely frivolous and expensive habit—even worthy of its own chapter in the *Narrenschiff*:

> Aye, hunting can be quite inane,
> One spends much time with little gain;
> Although it's meant for sport and pleasure
> It's sumptuous beyond all measure
> The many kinds of dogs you need
> Are quite expensive in their feed,
> The dogs and hunting birds you've got
> Have little use but cost a lot. . . .
> Some handy hunters even score
> When hunting lion, bear, or boar,
> Or chase the chamois to his haunt
> But in the end they'll suffer want.[36]

Hunting was often mentioned in a single breath along with more obviously dissolute activities. In the *rederijker* Cornelis Everaert's *Tspel van Jonckheyt ende Redene* of 1539, for example, young rakes are advised to "caetsen, scieten, vlieghen, jaeghen/steken, breken, scermen, tornyeren/dobbelen, spelen, ghesellich bieren" (chase, shoot, go falconing, and hunt/to thrust, smash, fence, and tourney/to gamble, game, and convivially drink).[37] *Sorgheloos* seems to have both meanings in mind. The title character is actually beginning a life journey, yet simultaneously indulges in the first of several decadent activities that lead to his final impoverishment—and in this connection the choice of a model as familiar as Dürer's horseman Famine from the *Apocalypse* was surely a deliberate irony.

Renger has noted how in both Dutch and German the Prodigal Son's designation—*verloren Zoon* and *verlorene Sohn*, respectively—suggested that he would be found again, just like the lost sheep and drachma of Luke's related parables (chap. 15:3–10). Originally, *sorgheloos* had simply meant free from care or without fear. But by the sixteenth century it would take on decidedly negative connotations of thoughtlessness, rash imprudence, negligence, and laziness—so that our protagonist's name does nothing to hint at eventual salvation.[38] The word turns up in several familiar contexts. "The Right Way to the Poorhouse" from the *Veelderhande geneuchlijcke dichten*, for instance, refers to *sorgelosen* who spend their money at disreputable inns, while one *rederijker tafelspel* concerns a certain Sorgeloos Ghepijns (Careless Thinking), who complains that his wife and children are like a ball and chain when he wants to go drinking. A *rederijker* chamber in Veurne called itself Sorgheloosen and had as its motto "Aerm in de borse" (Poor in the purse).[39] And in an anonymous engraving published by Hieronymus Cock, Master Sorghelos Leven (Careless Living) and his wife, Verlega (Dissolute), preside over a cobbler's shop whose apprentices have abandoned their work (H.5).[40] Cornelis provides his Sorgheloos with two companions who clearly recall the traditional spong-

27

ers of Prodigal plays and particularly the *rederijker* convention of wicked *sinne-kens* who work as partners in an effort to destroy the hero. The term Ghemack implies ease, comfort, and convenience. Weelde, or Luxury, corresponds in a general way to personifications of Riches, Pride, and Frau Welt by virtue of her sumptuous dress and seductive beauty.[41]

By the second scene (figure 37b) our trio has reached the inevitable inn, here a quite elaborate Renaissance-style structure. A serving-boy pours wine while a maid brings in a pie; through an archway at the right is a hearth, with another customer. The accompanying text reads:

> Hey, let us now pay up and drink
> For we're sitting in the house of Wastefulness
> 25 Oh Luxury, my love, do be cheerful
> There is enough to drink and to eat here
> And Ease, my page, leave all burdens behind you
> Because in my purse there are still many pounds
> And my enterprises are for the benefit of both of you
> 30 Because love for both of you has wounded my heart
> My body is healthy; stuff your bellies round
> At this moment do not weep or worry
> If the money runs out I still have credit
>
> My young friends all, listen to my tale
> 35 Be moderate in your young proud lives
> Because living like that is foolishness
> One may drink wine and beer
> And love Luxury in moderation
> But don't lodge in the house of Wastefulness
> 40 For intemperance will come to a downfall, as you see here daily
> You may also desire Ease
> But in gaining it you could consume it
> So may you be master of your own will
> Because a few worldly goods are soon shat away

With his other senses aroused by overindulgence in food and drink, Sorgheloos dances next in a scene (figure 37c) clearly related to the corresponding Prodigal Son tondo (figure 47d). The text continues:

> 45 Hey, piper, play. The meal is finished
> We have to dance and prance a while now
> For I'll pay you a good reward
> Luxury and I, Careless, the two of us
> Will lift a leg to divert the burdens

50 So that Ease, my page, may see some pleasure
So strike up a tune among the fools here
Even if I wouldn't keep a penny in my purse
For disaster in the purse follows success with women
So let us dance and court and find pleasure
55 Even if happiness turns into unhappiness

You young flowers, whether boy or girl
Take example from the life of Careless here
And remember the word the Bible tells us
People sat to eat and they rose up proudly
60 To dance and play; do not follow them though
But be extremely grateful for his gift
You must make good cheer honorably
And graciously come together
And dance with good measure, not simply waste all
65 So remember my lesson and my good rules
It's better to take an example than to be an example

Dancing had long been denounced in sermons and moralizing writings that would invariably cite its practice by the Amalekites, by Salome, and especially by the Israelites around the Golden Calf (as alluded to in lines 58–60).[42] According to the *Narrenschiff*, it was devised by the Devil, who thereby "stirs up pride, immodesty, / and prompts men ever lewd to be."[43] In Frans Hogenberg's etching *Stultorum Chorea* (H.48), every dancer represents a different sin, and each is dressed as a fool—a type whose role in both literary and pictorial merry companies is sometimes that of an enthusiastic participant, sometimes that of a detached and mocking observer of human frailities.[44] Behind Cornelis's fool (who seems more the latter kind), we see Sorgheloos, Weelde, and Ghemack dining once again; off to the left is a curtained bed, an unmistakable reference to carnal lust.

By the fourth scene (figure 37d) Sorgheloos has turned to gambling, with cards, money, and dice spread across the table. Our hero hands a purse to Weelde while lamenting his financial ruin in the verses below:

Oh cruel Fortune, how hard you are on me
that all of my inheritance has disappeared
My heart suffers severely inside me
70 For Luxury my love wants to desert me
With Ease my page, they are proud in their hearts
For Poverty and Want start to draw me in
Instead of good, evil is sent to me
Because I cannot make any more payments

29

75 Oh, my money, my pledges, all my beautiful coats
I lost them all with a throw of the dice
But what do I care, if I can but dance with Luxury in my shirt

You young spirits, be pleasingly moderate
In your life, that will not last long
80 Don't gamble so rashly for nobles or ducats
Pay attention to Careless, who is pictured here
And lead a pure life
As Christians should do with a fervent heart
Don't take the Word in your mouths, but live according to the Scripture
85 You shouldn't learn evil, soon enough it will come
Accept marriage with joyful hearts
So your heart is not stolen by any lovers
For they know soon what is hidden there

The two new figures ready to replace Weelde and Ghemack are Pover (Poverty) and Aermoede (Want), obviously related to an old man and woman in the Pieter Cornelisz series who likewise appear once the Prodigal's luck has changed (figure 47g).[45] Ragged beggars often turn up in tavern scenes, both as reminders of the merrymakers' indifference to suffering (à la Dives and Lazarus) and as premonitions of the libertine's unavoidable fate. Their presence as a definite couple is unusual, however, and once again suggests a relationship to *sinnekens*. Standing beside them is a third new character, a well-dressed young man labeled Lichte Fortune (Fickle Fortune). He repeats Aermoede's pointing gesture toward the coins and cards on the table, and has a strange container slung from one shoulder.

There are more than a dozen examples of this canister-carrying figure in Dutch and German art of the period, often among "merry companies." In Jan van Hemessen's *Prodigal Son* of 1536 (figure 51), for instance, he appears at the far side of the table, apparently in conversation with one of the women. Bernet Kempers has offered a reasonable case for his identification, beginning with a tondo in Antwerp—one of twelve small proverb paintings generally attributed to Bruegel the Elder (figure 52).[46] It shows a ragged fellow drinking from an oversized glass; on his back is a large cylindrical container, out of which fall small rolled-up wafers or crullers. An inscription added in the seventeenth century translates: "To gamble immoderately and drink till drunk / makes one poor, dishonors one's name and brings ruin." It was customary at the time to gamble with a crullerman (*oblieman*) for his wares, a practice suggested by the Augsburg 1513 edition of Thomas Murner's *Schelmenzunft*, a catalogue of various follies clearly indebted to Brant. Murner devotes one chapter to yet another bogus guild of good-for-nothings, the Order of Hyppenbüben (*Hippen* being a type of cruller); the accompanying woodcut illustration shows a canister-carrying figure throwing dice into the air (figure 53). Pieter Cornelisz's series also includes this character in a composition clearly analogous to *Sorgheloos*'s

fourth scene; and in the Basel version (figure 47e), little wafers lie on the table before the Prodigal and his mistress. Bernet Kempers also notes the soldier's costume worn by several of these figures—sometimes dapper, sometimes tattered. Apparently the crullerman's attributes and those of the mercenary would occasionally mingle, since both were equally disreputable nomadic occupations. Lichte Fortune's leather cap, his short and snugly fitting doublet, his half-hidden feathered hat, his weapons, and his slit clothing all mark him as a military man.[47] A wandering soldier, peddler, gambler, and tavern-frequenter, he underscores the danger of failing to provide for the future and, appropriately, drops out of the story after this single appearance; from now on Aermoede and Pover will be Sorgheloos's sole companions.

In the fifth scene (figure 37e) our protagonist appears stripped of his fine coat and dressed only in a shirt and tattered breeches. His loss of clothing—mentioned, too, in lines 75–77—is a detail that apparently reflects what was then a common occurrence. Contemporary ordinances related to gambling often mention the wager of clothes as well as money, and it also seems to have been customary for tavern-owners to confiscate the clothes of nonpaying guests.[48] This particular misfortune took place, we recall, in both *Acolastus* and *De Historie van den Verloren Sone* and was a standard topos in Prodigal-type dramas. The subjects of "vagabond verse" regularly complain of the same problem; passengers aboard *De Blauwe Schuit* who have squandered all their possessions on carousing and gaming must "comen weder naect thuus" (come home naked).[49] And in another poem from the *Veelderhande geneuchlijcke dichten* we are told that "Ghij moet u klederen eerst verdrincken" (You must first drink away your clothes) before being admitted to the guild of scoundrels.[50]

Abandoned by Weelde and Ghemack, the ragged Sorgheloos is now being evicted—a task usually assigned to the innkeeper or whores in dramatic and pictorial versions of the Prodigal's downfall. Here it is Aermoede who acts as a sort of bouncer, brandishing a pair of tongs while Pover gnaws on Sorgheloos's shoulder— a reversal of the male/female roles in the corresponding tondo (figure 47g). Both are literal portrayals of popular figures of speech concerning the bite or blows of poverty. In one piece from the *Antwerps Liedboek*, for example, a dissolute young woman weeps because "Pover . . . bijt ons aermoede smijt ons" (Poverty bites us, Want strikes us).[51] Sorgheloos uses nearly the same phrase in line 96:

> Alas! What should I do
> 90 Luxury and Ease are deserting me
> Desperation completely attacks me inside
> For on those two I had put all my hopes
> They would not hear me if I called
> My generosity towards them is all forgotten
> 95 That's because my purse won't open any longer
> For Poverty bites me, I'm struck by Want

31

Oh, if I had anything I would eat it
While recently I knew not what I would like
Now I sleep in the straw with vagrants

100 Truly, joy ends in sorrow
As Solomon explains very well
So everyone should aim somewhat
To live in moderation and prepare for his end
So that in the hereafter you will not regret your beginning
105 Together with Careless, as each one can see
For women's hearts did not seem to him so capricious
That little in them can be trusted; here
They fill a cap-full with their faithless words
But in the end heavy sorrow follows
110 Because the heart often doesn't accord with words

Our story ends with Sorgheloos, in the left background, being turned away from a rich man's door and shoved along by Pover while bearing Aermoede on his shoulders (figure 37f)—just as in the tondo (figure 47h). To drag along or carry poverty was yet another standard metaphor, employed in proverbs like "Die de weeldeniet verdragen kan, moet de armoe slapen" (He who cannot support luxury must haul poverty).[52] Sorgheloos's new home is a miserable scullery that again recalls a scene from the earlier series (figure 47i). Poor kitchens were also commonly encountered in contemporary drama and verse. Among the anonymous satirical poems collected by Jan van Stijevoort in his 1524 *Refereinenbundel* is one that describes a pauper's wedding, where there is neither bread, butter, nor cheese, and where "pover ter kuekene wort gesent" (poverty was sent to the kitchen).[53] *Sorgheloos*'s text continues:

Oh, how sadly I have incurred Want here
And Poverty keeps pushing me from behind
Friends and relatives start turning away from me
Thus have I brought myself to confusion with my bad management
115 The dog and the cat sing in harmony
The cat sits in the cupboard, the dog licks the pot here
And Want's cooking can drive you to distraction
With straw, old chairs and wooden shoes we maintain the fire
Because peat and wood are too expensive for us
120 Yes, with stinking smelts and a rancid, bad herring
Must Careless now satisfy himself

Sorgheloos is finally at work, carrying a bundle of straw to put on the fire, in addition to the broken furniture and clogs beside Aermoede. Along with ragged dress, straw was one of Poverty's more common attributes; it formed the seat and canopy

of her triumphal cart, for example, in Holbein's painting of 1532–1536 for the London Guildhall (now known from seventeenth-century copies).[54] "To sit on straw" or "to carry straw" were current expressions meaning that one had fallen on hard times.[55] Sorgheloos already complained of having to sleep on straw "with vagrants" in line 99. Using straw for fuel was also a common conceit implying penury. In another poem from the *Veelderhande geneuchlijcke dichten*, a poor household is said to cook the fish with it ("met stroo ziedet die visch").[56] Further signs of our protagonist's sorry condition are the cat and dog. Both were included in the corresponding tondo, but without any special occupation; here the one sits in a cupboard while the other licks a pot—each a literal representation of a popular expression that signified an empty larder and impoverishment.[57] The text cites both in line 116 and then mentions "stinking smelts" and "rancid herring" in line 120—a reference to the fish on a grill by the hearth and on the table before Pover. Smelts were regarded as meager and unpalatable, while herring had equally bad connotations; it was Lenten fare but at the same time an attribute of pre-fast celebrations.[58]

Also on the table is an animal's leg bone, cloven-hoofed and still with some flesh attached, just as it appeared near Aermoede in the fifth scene, and on a platter in the second scene. This was another type of food that seems to have acquired general implications of immorality and folly.[59] Fish and leg bones appear together in Hieronymus Cock's engraving after Bosch of a merry company in a mussel shell (H.27); one figure toward the right even uses a cloven foot to strum a bellows that he holds as if it were a lute—the bellows being a standard symbol of empty-headedness and intemperance that also appears in *Sorgheloos*'s last scene, where it bears, we recall, Jan Ewoutsz's monogram.[60]

The closing stanza sums up *Sorgheloos*'s message:

> Everyone take this in graciously now
> It is shown here with the spark of love
> Because everyone should avoid a life like that
> 125 Everyone take this in graciously now
> We're not talking about honest good cheer
> Drinking a happy glass with friends and relatives
> Everyone take this in graciously now
> It is shown here with the spark of love
> 130 By one named Jacob Jacobzoon Jonck

The phrase "elck neemt in danck" (lines 122, 125, and 128) is common in *rederijker* verse.[61] It alternates with assurances that this counsel is charitably offered, a final warning against the life pictured above, and qualified acceptance of "good cheer." Prudent management of funds is advised throughout, with Weelde and Ghemack both characterized as desirable companions if strictly controlled (lines 20–21, 37–44). Money should be closely guarded; otherwise one cannot become a man "of status" (line 16). Loose behavior is denounced because it displeases God (lines

33

14–15, 82–84, 102–4), but also because it leads to the squandering of financial resources. If a place in heaven is deemed crucial, so, too, is a solid position in this world.

The Flighty Youth

Another riches-to-rags career is more concisely outlined in Cornelis's *Flighty Youth*, printed on four joined sheets, signed CÂT on the third, and again published by Jan Ewoutsz (figure 24a–b).[62] During the sixteenth century, interest in proverbs and figures of speech took the form of countless literary compilations and an equally impressive number of visual anthologies, ranging from the most modest broadsheets to a work like Bruegel's panel in Berlin. Many popular expressions could be couched in entirely naturalistic pictorial terms: the "dog licking the pot" and "cat in the cupboard," for example, are both easily incorporated into *Sorgheloos*'s scullery scene. Others—such as Pover's bite or the field with eyes and wood with ears in an anonymous Dutch woodcut from 1546 (figure 54)—combined their homely truths with undeniably striking imagery and were thus particularly appealing to those artists who had inherited a certain Boschian taste for the fantastic and grotesque.[63]

The *Flighty Youth* is a verbal and visual play on several related sayings having to do with birds. First in line is a well-dressed fellow with an incongruous pair of wings and his right foot stuck in an egg. Portions have been torn away from the only extant impression with text; all that remains of the opening words are ". . . uyt den dop / . . . als beghin / . . . en" (out of the shell / . . . as a beginning / . . .). *Pas uit den dop komen*, or to have just come out of the shell, was a figure of speech applied to inexperienced and vulnerable young people.[64] Cornelis's character is thus identified as one more senseless rake heading for disaster. Eggshells and eggs themselves had a strong proverbial connection to money; the expression *nest ei* (nest egg) seems to have been known then, while *op de eieren zitten* (to sit on eggs) meant that one's money was secure, and *dopmaker* (shellmaker) was a term commonly applied to spendthrifts.[65] One peom from Jan van Stijevoort's *Refereinenbundel* describes a ruined profligate as having been "soe net als een eij ghepelt" (peeled clean as an egg); a similar allusion was probably intended in the background of Jan van Hemessen's *Tavern Scene* in the Karlsruhe Kunsthalle, where a woman holds up an egg before a male customer.[66] Eggs were also standard symbols of folly, an association for which there was even a linguistic rationale in Dutch; *door* (fool) came to be used interchangeably with *dooier* (yolk).[67] This connotation is unmistakably illustrated in one engraving from another series of proverbs whose designs have been attributed to Bruegel; here a tippling jester sits upon an enormous cracked shell (figure 55).

The second character in Cornelis's woodcut is an older man with two coin-filled sacks and a chest, but his even more fragmentary caption provides no identifica-

tion: "Ick . . . / kisten . . . / Jaer . . ." (I . . . / chests . . . / year . . .). Perhaps he represents someone who managed wisely and still has bags full of gold; perhaps he is the father from whom our youth demands a Prodigal Son's patrimony. The boy turns up next wearing a plumed hat and gold chains, once again equipped for the hunt with a hooded falcon and a prancing horse reminiscent of those in Cornelis's equestrian portraits. He explains: "Ick mach rijden / vlieghen of gaen / Tot niemants dienst en derf ick staen" (I may ride, fly, or walk. I need not be in anyone's service). But as with Sorgheloos, such costly tastes quickly take their toll. In his third appearance, even though still richly dressed and with an elegant dog, he complains: "So plach ick oock / maer nu ist ghedaen / Mijn vlercken verruyden te voet moet ic gaen" (That's what I used to do, but now it is finished. My wings are molting, I must go on foot). The following stage represents his total ruin. Now wingless, haggard and unshaven, barefoot and in the inevitable rags, supported by a crutch and leg brace, he tells us: "om dat ic vliegen wilde eer ic vlogelen had tot mijnder onbaten / Daerom ben ic van al mijn vrienden verlaten" (Because I wanted to fly before I had wings, to my detriment, that is why all my friends have left me). "To fly before having wings" was a saying applied, much like "just out of the egg," to inexperienced and immature youths, particularly those whose aspirations were unrealistically high.[68] The verb *vliegen* (to fly) could mean to hunt with falcons, to squander, or to harbor great pretensions, while "to lose one's feathers" or "to lose one's wings" meant to suffer loss or damage.[69]

Feathers and wings could also symbolize folly—one of the earliest examples being the Arena Chapel's figure of *Stultitia*, who has a feathered headdress. The archetypal fool Nemo is given feathers or wings in several sixteenth-century woodcuts, while on the title page from Ulrich von Hutten's *Nemo II* (Leipzig, 1518) he wears a nesting owl on his head—the same bird found beside our protagonist in his fourth incarnation. Their preference for the dark, their unpopularity among other animals, and their solitary existence caused owls to be linked with unrepentant sinners and vagrants as well as fools—as in the Master AP's *Tavern Scene*, where an owl appears at the center of a large escutcheon above the fireplace (H.9). They were, in addition, birds of ill omen and death.[70]

The youth's crippled condition is, in part, an emblem of moral malfunctioning. Like many other contemporary portrayals of the lame, misshapen, or diseased, he illustrates that ever-popular notion of the body as a mirror of its soul's health.[71] But his leg brace and crutch also suggest the hindrance of poverty—as do the shackles he wears next, labeled "ongheluck" (bad luck). Poverty's inhibiting or crippling effect was often represented by means of bound or otherwise hampered hands and feet.[72] The girl in the *Antwerps Liedboek* who complained, earlier, about poverty's bite and the blows of want also noted ironically that she and her companions must now "danssen op cruycken" (dance on crutches).[73] And in Adriaen van de Venne's painting (Oberlin, Allen Memorial Art Museum) of a wretched man carrying an old hag (an arrangement already seen in *Sorgheloos*), the banderole translates: "It is

35

miserable legs that have to bear Poverty."[74] The sky above Cornelis's youth has now clouded over with the help of "quade Fortuin" (bad fortune). Wrapped for protection in a short cloak, he explains: "om dat ick oyt ongeluck niet en heb gepast / Heeft my quade fortuyn verrast" (Because I have not looked out for bad luck, misfortune has surprised me). Fortune's wind, another standard topos, would be filled with coins, crowns, or flowers when favorable; when adverse, it would be a blast of rain or hail—though in this case tiny skulls render the effect still more sinister.[75] Last in line is a figure whose function and costume clearly bring to mind an established type in *rederijker* drama. Dressed in scholar's robes and pointing heavenward, he delivers the concluding moral: "Die vlieghen wil eer dat hy vlogelen heeft / Tis recht dat hy in armoede sneeft" (He who wants to fly before he has wings, it is right that he fall in poverty). Similarly, *spelen van sinne* often ended with characters identified as doctors and given names like Redene (Reason) or Wijsen Raet (Wise Counsel), who would step in to offer the audience a final message.[76] Here, as in *Sorgheloos*, the message is one with little sympathy for those thoughtless young men who squander rather than save.

CHAPTER

4 Troublemakers

Sinte Aelwaer

In our earlier discussion of "vagabond verse," we noted its original ties to carnival celebrations and their characteristic parodying of sacred and secular institutions. Mock masses, religious processions, triumphal entries, and tournaments were all enacted within the context of the carnival season's temporary license and inversion of accepted social hierarchies.[1] The correspondingly parodied literary forms included, as we also noted, testaments, charters, litanies, sermons, hymns, and prayers—such prayers and hymns often being addressed, in turn, to equally bogus saints. Popular religion had always assigned dubious roles to many officially recognized saints and invented quite a few others never acknowledged by the Church itself. Some actual saints were honored by special-interest groups on the basis of their names. Vincent, for instance, was the winemakers' protector; Lucy and Clara were prayed to in the event of eye disease; Lambert could help the lame. Others were simply created to fill particular functions without having any basis in historical fact, such as Saint Criard, who helped to quiet crying children.[2] There was also, however, a long-standing European folk tradition for saints not seriously venerated but rather purely comical. It is this kind that turns up repeatedly in the literature of drunkards and other scoundrels, whose Netherlandish representatives honor such characters as Sinte Luyaert (Lazy) or Sinte Noywerc (Neverwork).[3]

A similar mock saint and her own mock guild are the subject of another woodcut published by Jan Ewoutsz (figure 28), signed with Cornelis's monogram and accompanied by a refrain of one hundred thirty lines—a poetic form especially favored by the *rederijkers*, in which each stanza ends with the same line. Above the image we read: "Elck dient sinte aelwaer met grooter begheert / die van veel menschen wordt gheeert" (Everyone serves Saint Quarrelsome with great desire, who is honored by many people). Below we see a sour-faced, middle-aged, haloed woman riding a donkey. Clutching a small pig under one arm and holding a cat aloft in the other, she also supports a large bird on her head.[4] The text explains:

> 1 Clergyman, layman, come one and all
> To call on this great saint
> Patroness of poor and rich
> Noble, commoner. It would be to your advantage

⁵ Saint Quarrelsome she is called, understand the meaning well
So bring her your offerings out of love
Because she had reigned from the beginning of the world
East, west, south, north, in all lands
Where two come together, open your minds
¹⁰ There she is in the middle, as is proven
Illuminate her. Let your light burn
And light a candle for her daily
So that you may become like her
This is well-meant advice for you
¹⁵ Her grace won't lack for you
Do look up to her with your eyes
Wherever you are, everywhere
Praise great Saint Quarrelsome

She sits on an ass
²⁰ Who does not hurry and maintains his stride
So it is the same, as everyone may know
With Quarrelsome's children, understand this well
They want to be right, whether justly or unjustly
Nobody wants to give it up
²⁵ They don't wonder what hinders or benefits
Even if they always live in discord
This aforesaid worthy saint
Under one arm she holds a pig
And with the other hand she lifts up a cat
³⁰ For the confirmation of Quarrelsome
A pig must grunt in all places
Which means all discord
By the yowling of cats one can perceive
The wrangling of quarrelsome people
³⁵ Wherever I go, north or south
I have to call on her, early or late
Praise great Saint Quarrelsome

On Saint Quarrelsome's head sits a bird
Called a magpie, who always chatters
⁴⁰ Just so is a quarrelsome man who never shuts up
Who never has anything good to say
Whether he is right or wrong, his tongue always rattles
With little sense, a curse on his teeth
So it must be a very disagreeable talker
⁴⁵ Who always wants to win and not to lose
Among the thousands of Walloons and Frisians

Saint Quarrelsome is known very well
I know people who blew Saint Quarrelsome's horn so strongly
That they were doomed in the end
50 But in Amsterdam, the city here
Saint Quarrelsome is much honored
Her picture is printed with love
She is honored by many in their hearts
Don't you think I guess the truth?
Praise great Saint Quarrelsome

"Saint Aelwaer is beginning to make much noise in our house."
Said a man with strange manners
When he was seen arriving home drunk in the evening
He hits his shoes against the threshold
60 But the next day, early in the morning, before noon
One hears Saint Quarrelsome lift up her head
Then he's silent and doesn't have so much courage
to dare speak a word in answer
While dozing he thinks over his failures
65 How he can't pay his spiritual debt
That's why she has to preach a curtain lecture
But the faith in it is hard to find
Saint Quarrelsome's spirit is also seen to come down often
Where they clink mugs
70 Beer and wine won't be left to stand and go flat
Till they sing about my lord of Valckensteyn
All this religion of Saint Quarrelsome's things
I have to proclaim, wherever I sit or stand
Praise great Saint Quarrelsome
75 At bordellos Saint Quarrelsome is often stationed
Where the helpful little women of the guild live
Little sisters and brothers also get her grace
Little Lollards and Beguines, she can prove it
These people and Quarrelsome don't do each other harm
80 But each wants to be considered the favorite child
They arrange, as much as they can, to make themselves appear better
So that they may be considered so by the father
Saint Quarrelsome also shows her considerable powers well
To dice-throwers, cardplayers and singers
85 That those heads stand and smoke, must also be smoothed over
Cheaters, tric-trac players also have her manners
Rederijkers, musicians complain much, with reason
Organists, harpists, all players together
How they are forgotten in villages and towns

39

90 Because of Saint Quarrelsome's grace, which they took from her
But all these others must strive to be grateful
For Saint Quarrelsome's mercy, which does not do them damage
Praise great Saint Quarrelsome

The Abbot of Grim-mountains with Sir Argument-corner
95 Lifted her up and canonized her
With Doctor Mulish. But by a sly trick
It was not done to honor Saint Quarrelsome fully
They also organize a high-standing guild
So that the relics won't lose their worth
100 This benefit can be denied for a mortgaged guilder
One could well pay this guild with it
Come Norwegians, Danes, Germans and Walloons
This grace you can achieve all together
Singing we will bring her into the church with honor
105 Whoever will die in this guild
You can inherit for yourselves an eternal memory
Your children's children will still reap the benefit
Saint Quarrelsome's spirit will also die for it
With the dew of her grace she shall sprinkle them
110 In testimony to her, don't be reluctant
God knows that I don't despise her
Praise great Saint Quarrelsome

Out text ends with a customary *rederijker* address to a prince, the titular head of a chamber:

Prince, nations of people are hard to sum up
And almost impossible, if one sees it well
115 If anyone wasn't mentioned then
Lawyers, barristers, we bid you not to be offended
Or whomever, Pieter or Griet
Of Saint Quarrelsome's guild, understand this explanation
So you may be regarded as her rightful servants
120 You need not go to Rome or Cologne for it
Her mild grace is always near you
She won't spare it for anyone in the world
However great or powerful or rich he is
So I want to end with a joyful heart
125 Saint Quarrelsome's legend, so sweet to hear
Because few in this world are free
In whatever condition they are born
If there is anyone who has lost her grace

One could regain it with prayer
130 Praise great Saint Quarrelsome.

A comparable career is described in a *spel van sinne* entitled *Van nyeuvont, loosheit ende praktike*, which was published at Antwerp in about 1500—a rare example of a *rederijker* play that was not only printed but even accompanied by woodcut illustrations.[5] It concerns the scheme of Artful Trickery to canonize Vrou Lorts (Deceit) and to promote her cult with the help of Fraud and Cunning. One illustration shows the image of Lorts upon an altar, worshiped by a kneeling congregation; another represents Meest Elck (Almost Everyone) before her picture (figure 56a–b). There are additional references to Vrou Lorts in other contemporary writings, where she is identified as the mother of a certain Sinte Reynuyt (Cleaned-out or All-Gone). The special patron of bankrupt spendthrifts, Reynuyt was also the subject of several works, including a piece in the *Veelderhande geneuchlijcke dichten* and a mock sermon by the *rederijker* Matthijs Castelein.[6] From these sources we learn how Reynuyt's followers reach his shrine, once again by boat. This pilgrimage to Reynuyt's sanctuary was actually represented in a lost series of sixteenth-century tapestries and in a fragmentary panel at Munich.

Aside from a drawing in Vienna, the most elaborate extant portrayal is a woodcut from about 1525–1530 by an anonymous Leiden artist; it was issued originally at Amsterdam by Doen Pietersz along with an eight-stanza explanatory text, which urges many characters already familiar from *Aelwaer*'s text and other "vagabond verses" to join in on the sacred journey (figure 57).[7] To the left, we see a makeshift tavern with merrymaking couples and a canister-carrying figure very much like *Sorgheloos*'s Lichte Fortune. Toward the right are other well-known types: beggars, young men with falcons and dogs, a fellow on horseback with his lady and a page, and in the foreground a scholarly sort with an open book, perhaps playing a role similar to that of the last figure in *The Flighty Youth*.[8] The ship itself has docked behind, followed by smaller sculls filled with good-for-nothing artisans and clerics. Votive-sellers hawk their wares to pilgrims approaching Reynuyt's chapel, where he sits enthroned, holding tankards.

The word *aelwaer* has a particularly complex linguistic history. In Old High German, *alawâr* meant all true; later it took on connotations of simplicity and innocence and then of simple-mindedness or folly. By the sixteenth century its Dutch form had acquired a more precise sense: stupidly rash or foolishly complaining and wrangling.[9] Cornelius's personification is, then, the patron of squabblers and arguers. Singled out for her protection are the man returning home besotted, his scolding wife (lines 56–67), and frequenters of inns in general (lines 68–71). The "little women," or whores of bordellos, are her followers (lines 75–76), along with Lollards and Beguines (line 78), lay orders having a reputation for loose morals.[10] Gamblers, musicians, singers (and even *rederijkers*) are also included (lines 83–92)—again, many of the same characters we first met in connection with *Sorghe-*

41

loos. The focus on quarreling recalls, moreover, the notion that contention and vio-lence were among the usual components of carousing. Walloons, Frisians, Norwe-gians, Danes, Germans, lawyers, and barristers (lines 46, 102, 116) are also urged to sign up for her guild if they haven't already.

This inventory of social groups actually exemplifies a certain literary convention, of mediaeval origins, in which different types, classes, professions, and even nation-alities were systematically enumerated. In some cases, each group was associated with its own particular vice, from the king's refusal to heed good counsel to the baker's tendency to short-weigh his customers. In other cases, the focus was on one specific fault shared by many groups, such as pride or dishonesty, or prodigality, as in *De Blauwe Schuit* and the *Ship of Sinte Reynuyt*, or argumentativeness, as in *Sinte Aelwaer*.[11] In works like *De Blauwe Schuit* or *Sinte Reynuyt*, of course, the emphasis tended to be on lower social levels—or, perhaps more accurately, on those who had fallen to a lower level as a result of their spendthrift ways. But member-ship policies were by no means restrictive. *Aelwaer*'s text opens, for instance, with an invitation to clergymen and laymen, poor and rich, noblemen and commoners (lines 1–4). The guild that they can join for a certain sum (line 100) was, we know, a standard metaphorical device. It is also clear, however, that the text's unknown author intended a sardonic reference to actual religious confraternities. Confrater-nities of this sort guaranteed such benefits as medical and financial assistance, an honorable burial, prayers and masses for one's soul, and care of one's widow and children. But the membership fees encouraged abuses; unscrupulous recruiting agents traveled from place to place, often bearing spurious relics. Profits were high and fraud widespread—just as portrayed in *Van nyeuvont, loosheit, ende prak-tike*.[12] Aelwaer's three promoters are given equally questionable motives. They canonize her, we are told, "by a sly trick" rather than out of a desire to honor her fully (lines 94–97). And they organize the guild "so that the relics won't lose their worth" (line 99).

The *Reynuyt* woodcut's narrative wealth is replaced, in *Aelwaer*, by an iconic simplicity obviously indebted to the format employed by devotional broadsheets like Dürer's *Saint Sebaldus*, for example, with its accompanying text by Conrad Celtis (figure 58). *Aelwaer*'s text tells how she is particularly venerated at Amster-dam, where, in a witty allusion to the image itself, "her picture is printed with love" (line 52). *Aelwaer*'s first animal attribute is an ass "die niet haest uut sinen treet en gaet" (who does not hurry and maintains his stride—line 20), a common expression for obstinacy.[13] Asses were normally linked with stupidity and stub-bornness: "to ride on an ass" or "to sit on an ass," as our saint does, was a standard phrase meaning to become angry.[14] Brant's *Narrenschiff* used the illustration of a fool riding an ass for one chapter on bad wives and another on ready anger, where it is observed that a fool "rides asses every season / Who rages much without a reason"; the woman shown clutching its tail is thus the shrew who gives her hus-band no rest and, at the same time, a personification of Wrath (figure 59).[15]

42

Clearly related to this image is a woodcut for the chapter on anger from the first German edition of Petrarch's *De Remediis Utriusque Fortunae* (Augsburg, 1532), for which Brant had acted as an adviser (figure 60).[16] In an anonymous woodcut of about 1516 from Strassburg she is identified as Frow Seltenfrid (Seldom-at-peace), also a common folk character (figure 61). A free copy of this image, attributed to Ernard Schön, shows Seltenfrid once more grasping the tail and brandishing a distaff as her quarrelsome followers mount and dismount (G.1161).[17] If drunkenness and carousing were predominantly masculine vices, talkativeness and squabbling were primary female traits, at least according to current literature on the subject of women.[18] Seltenfrid and Aelwaer both participate in the theme of wicked women who are forever attempting to dominate and corrupt men—the same notion that lay behind such popular subjects as Solomon and the idols, Aristotle and Phyllis, Virgil in a Basket, the struggle over trousers, and the old wife beating the devil. In connection with Aelwaer's canonized status we might also recall Saint Margaret of Antioch, victorious over Satan and transformed into Dulle Griet, the battling shrew, as portrayed by Bruegel.[19]

Aelwaer's second attribute is a pig, generally identified with gluttony, stupidity, and sloth but also with viciousness, anger, noisiness, and contention. *Schreeuwen als een varken* (to squeal like a pig) was an expression applied to those who created a great disturbance, while in German *Sau* was a slang term for a scolding or reprimand.[20] Aelwaer's third attribute was perceived in an equally negative light; demonic, bloodthirsty, cunning and at the same time foolish, cats were specifically associated with quarrels, particularly marital ones, and with complaining wives. Current superstition held that the yowling of cats preceded an argument. If one dreamt about cats, a quarrel would follow; and if a wedding procession passed a cat, or if a cat sat on the altar during the ceremony, the marriage would be filled with strife.[21]

Aelwaer's fourth mascot, a magpie, was the most notorious chatterbox of all, a standard symbol for deceit and loquacity.[22] It is probable that the bird's position was meant as a jocular allusion to that especially appropriate event, the Pentecost, when Christ's apostles received the gift of tongues. Representations of this moment usually showed the Holy Ghost, in the form of a dove, hovering directly over the Virgin's head. Aelwaer's position on the back of an ass is another apparent irreverence, related not only to the folklore of anger but also, of course, to the standard iconography of the Flight into Egypt; Mary, that model of womanly virtue, is replaced by the personification of an especially feminine vice. Her mount is, moreover, an exact (if reversed) quotation of the ass in *The Flight into Egypt* from Dürer's *Life of the Virgin* series (figure 62). As with the pentecostal magpie, Cornelis's reference is at least to a general pictorial tradition. At the same time he chose as his model a particular image that would by then have attained almost canonical status. Like *Sorgheloos*'s adoption of *The Four Horsemen*'s Famine—another image whose

43

recognition factor would have been high—*Aelwaer*'s ass may well have had even more specific ironic intentions.

Analogous double entendres are scattered throughout the accompanying text. Lines 9 and 10—"Where two come together . . . there she is in the middle"—are obviously derived from Matthew 18:20: "For where there are two or three gathered together in my name, there am I in the midst of them."[23] The Dutch verb *vergaderen* (line 9), moreover, could mean either to come together or to gather but also to fight, while to be *int middel* (line 10) could suggest mediation but also troublesome interference.[24] In line 11 the exhortation to "let your light burn" ("U licht laet branden") was doubtless inspired by those words from the Sermon on the Mount: "So let your light shine before men, that they may see your good works" (Matthew 5:16).[25] The term *lollen* meant to yowl when applied to cats (line 33) but also meant to pray or murmur softly, while contemporary authors often played upon its similarity to the name of the Lollards—the *lollaertkens* of line 78.[26] In line 72, *dingen* meant things, matters, or affairs in a general sense but also referred to litigation.[27] The word *bordeus* in line 75 appears in other texts in the sense of *bordeel* (bordello) and, at the same time, as a reference to the French city Bordeaux.[28] *Grimberghen* (line 94) translates as Grim-mountains but was also the name of an actual Flemish city. Wordplay of just this kind is characteristic of many of the pieces in the *Veelderhande geneuchlijcke dichten* or the *Antwerps Liedboek* and was a natural corollary of the essentially parodying nature of "vagabond verse" as a genre.[29] In his pentecostal magpie and Marian ass, Cornelis found pictorial equivalents for the puns, paraphrases, and parodying nature of *Aelwaer*'s text.

Fable of the Father, Son, and Ass

Stripped of its harness and Mariological allusions, a plumper version of Dürer's ass appears at the opening of Cornelis's woodcut *Fable* of 1544 (figure 23a–b). The narrative as a whole—concerning a father and son and their frustrating if instructive progress along a public highway—is based on an anecdote of uncertain though probably Oriental origin. The earliest-known account is that in the *Speculum Exemplorum* of Jacques de Vitry (d. 1240); over the next three centuries it would be repeated, with minor variations, in such works as Ulrich Boner's *Der Edelstein*, John Bromyard's *Summa Praedicantium*, Giovanni Francesco Poggio's *Facetiae*, and Sebastian Brant's *Esopi Appologi*.[30] These and other authors tell how a father sets out with his boy and his ass, sometimes, it is specified, to go to market. In a series of episodes whose sequence can vary, the hapless travelers are offered entirely contradictory counsel. When the father rides, he is told that it is cruel to make his boy walk; when the two change places, they are promptly told that the child must be horribly spoiled to allow his parent to walk. Then they both walk and are ridiculed for having an ass without using it; when both ride, they are accused of cruelty to animals for burdening the poor beast so heavily. Next they carry the ass them-

selves and thereby become an even greater laughingstock; the story often ends with them killing the creature in utter despair at ever being able to please their critics—the moral being that we cannot satisfy everyone and should aim, rather, to satisfy our own consciences in accordance with God's word and with what we believe to be right.

The single most influential body of fables in the West was that attributed to Aesop, as transmitted through the collections of Phaedrus (first century A.D.), Babrius (second century A.D.), and several other late antique compilators. There is reason to assume that many of their most ancient manuscript editions were adorned with cycles of illustrations; at any rate, a tradition for fable illustration can be traced back to illuminated codices from as early as the sixth century.[31] During mediaeval times, fables came to be represented singly as well as in cycles, and on church portals, pulpits, and choir stalls as well as in manuscripts. Beginning in the later fifteenth century, of course, there was also a steady stream of printed collections, still predominantly Aesopic, in both Latin and the vernacular; many were provided with woodcuts, generally one to accompany each fable.[32] The story of the father, son, and ass turns up infrequently, however, among these illustrated editions. This is partly because of its non-Aesopic origin and comparatively late entrance into the fabular canon and partly, no doubt, because it was not easily distilled into a single image (unlike, for example, the ever-popular fable of the fox and stork) but rather depended upon multiple scenes for an effective telling. At any rate, the Basel, 1501 printing of Brant's *Esopi Appologi* is, to my knowledge, the only northern European edition from either the fifteenth or sixteenth century to include a representation of this particular tale.[33]

Succinct, moralizing yet often humorous, with considerable narrative interest and—like many proverbs—with potential for a striking pictorial presentation, fables seem ideally suited to the aims and requirements of the broadsheet form. From the first half of the sixteenth century there are a number of extant German examples that combine fables, as told by Hans Sachs, with woodcuts by various artists. Dating from about 1530, for instance, is a sheet in which the *Meistersinger*'s account of the ass in a lion's skin is combined with a woodcut by Georg Pencz (G.1004).[34] Sachs relates the fable of the father, son, and ass in another poem that describes the faultfinders not simply as "people" or "the world," as in earlier versions; now they are specifically characterized, in the manner of estates literature, as a soldier, an old woman, a peasant, a beggar, a nobleman, and finally a hunter. Published as a broadsheet in 1531, Sachs's version was accompanied by a woodcut by Erhard Schön in which only two encounters are depicted. Beginning at the right background, father and son first meet the soldier, then a less readily identifiable figure. In the foreground they then carry the ass; finally, in the left background, they kill it (figure 63).[35] Also dating from the 1530s is a series of woodcuts, without any text, by Hans Schäufelein. Here the critics include an entourage of nobles toward whom the father tips his hat, a man with a staff and a feathered cap and a

45

female companion in a long cloak, a couple bearing eggs and a goose, a scholarly type and a gentleman, and, finally, two well-dressed younger men (B.105–109).[36]

Cut from four blocks and designed as a continuous frieze, Cornelis's *Fable* measures approximately 148 centimeters in length when fully assembled. Many of his woodcuts are on a large scale. The *Marcus Mutius Scaevola*, *Algiers*, *Terwaen*, and *The Last Supper* all measure over fifty centimeters in either their height or width. *The Flighty Youth* is about 115 centimeters long, while the (incomplete) *Lords and Ladies of Holland* and the *Lords of Brederode* measure, respectively, about 230 and 170 centimeters in length. All extant examples of *Sorgheloos* consist of separate sheets, but its frame was clearly planned so as to permit them to be joined; the result would have been about 171 centimeters long. Treated in the same way, *The Misuse of Prosperity* would extend about 196 centimeters.

Already noted as one of the models for Cornelis's *View of Amsterdam* (108 by 105 centimeters) is the *View of Venice* (139 by 282 centimeters), designed by Jacopo de'Barbari and underwritten by the Nuremberg merchant Anton Kolb—a remarkable work that undoubtedly did much to effect the widespread development of the woodcut medium along unprecedentedly monumental lines during the first half of the sixteenth century. In 1500, the year in which the view of Venice was published, de'Barbari and Kolb both entered the service of Maximilian I, and it has been conjectured that their proven talents in this connection may have been applied toward some comparable multiblock project on the emperor's behalf.[37] In any event, within the next ten or so years Maximilian did commission the extraordinary *Triumphal Arch* and *Triumphal Procession*. And at about the same time, Titian designed his earliest graphic creation, the ten-block *Triumph of Christ* which measures 38 by 266 centimeters.[38]

City views, battle scenes, and ancestral, allegorical, or other types of processions and "lineups" were subjects that naturally lent themselves to a sizable presentation—generally long and narrow, though battles and cities also encouraged the use of a squared format. Woodcut's emulation of monumental art forms would become more evident in the following decade, particularly in Italy. Two notable examples are Titian's famous *Submersion of Pharaoh's Army in the Red Sea* (122 by 221 centimeters) and Girolamo da Treviso's *Susannah and the Elders* (47 by 107 centimeters), both from c. 1514–1515. In terms of their subject matter, their attempt at pictorial unity, and their size and format, both are clearly imitative of easel painting.[39] Needless to say, the dimensions of such works would have made it difficult to appreciate them properly in any horizontal position, whether bound into collectors' albums or loose, and it is most likely that they were, for the most part, meant to be hung on walls.[40] Prints seem to have been employed as a modest form of interior decoration since the time they were first produced. Visual evidence to this effect is provided by quite a few interior scenes, ranging from a studio copy of the *Mérode Altarpiece*, with its addition of a small image of Saint Christopher above the fireplace, to a canvas by Jan Steen in which an equestrian portrait (very much

46

like the kind produced by Cornelis) is tacked to a door.[41] Interiors with representations of prints on a monumental scale are harder to come by. But in one panel by the Brunswick Monogrammist, we find what is certainly meant to be a lengthy woodcut attached to the wall of an alehouse (figure 64).[42]

Cornelis was by no means exceptional among his compatriots in his predilection for the larger format—a fact that has been curiously overlooked in the literature and one that calls for considerably more investigation. Of the several hundred independently issued prints (as opposed to book illustrations) by artists other than Cornelis in Wouter Nijhoff's *Nederlandsche Houtsneden 1500–1550*, for instance, more than half are at least fifty centimeters in either width or height or in both dimensions; many are considerably larger. German artists certainly continued to design on a grand scale long after the projects for Maximilian. To cite just one example, Jörg Breu the Elder's *Investiture of King Ferdinand I* of 1536 was composed from eighteen blocks and measures about 200 by 300 centimeters.[43] But a survey of Geisberg's *German Single-Leaf Woodcut 1500-1550* reveals proportionately far fewer large-scale works than in the Netherlands. By the most generous estimate, only about one eighth of all the prints reproduced qualify as such. The favored format was clearly that of the single-block woodcut, generally measuring under 35 by 25 centimeters—a preference that may, in part, have been conditioned by Germany's undiminished output of illustrated books, which imposed inevitable limits on the size of the images within.

By the same token, the more limited production of illustrated books in the Netherlands may, in a sense, have given its artists greater license to design on a larger scale with greater frequency.[44] As might be expected, one of the earliest examples is a panorama: an anonymous 220-centimeter-long *View of Antwerp* from 1515.[45] The theme of a cortege was taken up by both Lucas van Leyden and Jacob Cornelisz van Oostsanen: the former's *Twelve Kings of Israel* and *Nine Heroes* from 1515–1517 and the latter's 1518 *Lords and Ladies of Holland* are among the lengthier Dutch responses to Maximilian's *Triumphal Procession*.[46] Especially popular in the Netherlands was the woodcut series joined by means of ornamental borders so as to create an extended composite—as in both *Sorgheloos* and *The Misuse of Prosperity*. Lucas and Jacob Cornelisz seem to have inaugurated this fashion with several works published by the Amsterdam printer Doen Pietersz. Lucas's *Small Power of Women* was first issued as six individual scenes in about 1516–1520. Soon thereafter he designed an architectural frame that allowed them to be pasted together, resulting in a print approximately 138 centimeters long.[47] Even after the addition of a framework, such woodcuts would presumably have had the special advantage of being marketable both as separate sheets and as lengthy wall hangings. In addition to monumental woodcuts of the "panoramic," "processional," and "serial" kind, Netherlandish artists also took up what might be designated the "easel painting" type. At about 67 by 48 centimeters, Lucas van Leyden's *Tavern Scene* is actually larger than all but one of his merry-company panels, while the Master AP's

version of this theme measures 58 by 70 centimeters. The largest, most elaborate Dutch example of this sort is, however, *Sinte Reynuyt*, at 74 by 116 centimeters.

There are several surviving impressions of the *Fable of the Father, Son, and Ass*. One, in the Rijksprentenkabinet, bears Jan Ewoutsz's address and a twenty-line text and lacks the fourth, final sheet (figure 23a–b). A second, complete example, in the Bibliothèque Royale at Brussels, has sixty-six lines of verse whose message is substantially the same, the major difference being that here many of the characters are actually given names (figure 65). A third, in the Albertina, is also complete, but without any text. Neither the Brussels nor the Albertina example identifies its publisher; the worm-eaten condition of their blocks indicates that both are later, though still probably sixteenth-century, impressions.[48] In the Amsterdam impression, the first two faultfinders remark:

> 1 That man must be foolish or very confused
> To let the boy ride the ass
> Because he is old and slow; it seems completely senseless
> That he doesn't let the boy walk alongside
> 5 He should mount the ass himself

After trading places so that the father can ride, the two travelers encounter a second couple, while the text continues:

> The child must go on foot here
> The old man has made himself comfortable on the ass
> The poor boy sheds tears of grief
> I think that the old man is lazy
> 10 He should be ridiculed by everyone

The next critics complain:

> Keyaert has never produced more foolish people[49]
> They let the ass go empty
> And both go on foot
> They can hardly stand from exhaustion
> 15 It's really foolish of them

Both riding, father and son finally meet a pair who protest:

> What's going on? Hear my testimony
> These people are completely merciless
> They are both seated on the ass
> That poor beast is quite overloaded
> 20 It wouldn't hurt you to walk

Missing from this impression is the fifth and final scene, in which the father and son carry the ass, as a solitary figure, a bearded old man, looks on. In the Brussels

example, he is identified as "een Wysen," who tells us that we cannot satisfy every-one but should aim instead to satisfy God. His role is to deliver the moral of the story, much like the scholarly type who stepped in at the close of *The Flighty Youth*, though his fanciful robes and turban impart a less contemporary tone to the image.

Also meant as generic exotics, it seems, are the two peculiar characters of the father and son's second encounter. In the Brussels impression, these two characters are identified as Griet—as we know, a name connoting shrewishness—and Hans Haneveer—*haneveer*, or cock feather, being a term applied to argumentative, com-bative men.[50] Yet there are other details that give Cornelis's second couple a decid-edly foreign appearance. His cloaked figure (of indeterminate gender) also wears a hood, with strange lettering on a square of cloth or paper affixed above the brow—a kind of headdress often given to Jewish types (like the figure at the left of Dürer's *Christ among the Doctors*—figure 66).[51] The other figure's hat, moreover, bears an odd design of interlocking circles; its tall, tapering shape and narrow, upturned brim are also unusual. With this and his sweeping mustache, he vaguely resembles a Turk more than anything; we might compare him, for example, to the Ottoman warrior in a woodcut by Erhard Schön (figure 67).

But if Cornelis's portrayal of these two and the wise man suggest some far-off, fictive time and place, his other couples are decidedly familiar, contemporary char-acters (figure 23a–b). The first pair are a maidservant and her well-dressed young mistress, in whose shadow she stands. Both are members of the notoriously quer-ulous female sex despite their difference in station, and hence ideally suited to the role of meddlesome critics. (In the Brussels impression, they are identified as Bri-gitte and Joffvrouw Klaps, or Miss Gossip.) The third couple are a fully armed sol-dier and his female camp follower, who carries a bundle and rests her hand on his shoulder. (In the Brussels impression, she is identified as Zantippe, another famous shrew's name.) In *Sorgheloos*, we recall, Lichte Fortune's military garb alluded to the abrupt changes in circumstance endemic to this calling. During the sixteenth century most soldiers were itinerant professionals, national standing armies being a later development. Though the German and Swiss bands were especially famous, mercenary ranks were drawn from all nationalities and generally attracted a large number of men from the lower classes, along with criminals, fugitives, political exiles, and impoverished noblemen. Left without a means of support whenever and wherever hostilities ended, discharged mercenaries tended to beg and rob their way across the countryside. They also frequented taverns, where recruiting agents often stationed themselves, and for such reasons earned a generally unsavory reputation as well as an honored place in many merry companies and other images of dissolute types. The *Ship of Sinte Reynuyt*, for example, once existed in an alternate version, now known only from a fragment, which included, at the far left, an entire party of mercenaries and camp followers.[52] Needless to say, they also had particular asso-ciations with violence and contention; the deadly sin of wrath was commonly per-

49

sonified as a soldier, as was Choler. In Pieter de Jode's engravings of the four temperaments, *Cholericus* shows a contemporary mercenary with a female companion, and other soldiers razing and burning a village in the background (H.103).[53]

Cornelis's fourth and final pair are peasants, complete with a cage of fowl. In our examination of *The Flighty Youth*, we noted a number of proverbial expressions linking birds with ambition, profligacy, and folly. Here, however, they play a somewhat different role in conjunction with the girl's loutishly grinning male companion and his obscenely hidden hands; one is tucked inside his shirt, the other inside his pants at the crotch. The same pose appears in a later engraving after the Haarlem artist Claes Clock (figure 68); here the man is approached by a lady who asks, in the inscription below, "How much does this bird cost, bird-seller?" He replies that it is already sold, "To a fair inn-keeper whom I 'bird' [*vogel*] all year long." In both Germany and the Netherlands the verbs *vögeln/vogelen* meant to hunt or sell birds and also to have sex, while the noun *vogel* was a standard slang term for the male organ.[54] The numerous contemporary images of rustic types with explicitly sexual birds or other erotic symbols are but one manifestation of what was, in fact, a prevailing image of the peasantry as course, ill-mannered, and stupid. And after the German Peasants' War in 1524–1525, their more disturbing potential for violence was also increasingly emphasized.[55] Hans Sebald Beham's *Country Wedding* engraving series of 1546, for instance, ends with three scenes that show peasants feasting, then brawling, and finally lovemaking and vomiting (figure 69, B.161–163). Rather than the unspecified "people," or representative cross section of humanity, that act as critics in other renditions of the tale, Cornelis's two women, his military pair, and peasants thus suggest what was perhaps a more deliberate selection of "appropriate" social types. Not unlike *Sinte Aelwaer*, the *Fable* serves as a general indictment of mankind's contrary, contentious nature, while singling out certain groups who were, at this time, particularly associated with unacceptable, aggressive behavior.[56]

CHAPTER

5 Upstarts

The familiar themes of ascendant sin, Fortune, and society's sorry state are taken up again in Cornelis's *Winged Pig* (figure 29). Set in a landscape with buildings clustered toward the background, a pig equipped with two raised wings is balanced upon a transparent globe topped by a cross; a second, wingless pig feeds from a trough at the lower right. At the upper left is Cornelis's monogram; surviving impressions do not identify the publisher, nor is there any original accompanying text.[1]

The *Narrenschiff*'s chapter "Von groben Narren" (Of Coarse Fools) is illustrated by an analogous image of a sow with a crown on its head (figure 70). Brant's text complains:

> A new Saint Ruffian now holds sway
> Men celebrate him much today
> And honor him in every place
> With words and ways that spell disgrace.
> And make a jest of ribaldry,
> Though belted not with decency.

Now that this new mock saint Grobian reigns, Herr Ehrenwert (Sir Decency) had died. The fool wags the sow's head so that the bell around her neck will ring, and the ship is held firm in the curl of her tail. Wisdom lives in exile, continues Brant; "the sow alone now wears the crown." Men live in drunken debauchery, and the greatest buffoons are most applauded:

> Now grossness everywhere has come
> And seems to live in every home,
> And sense and prudence both are dead.[2]

Thomas Murner's *Schelmenzunft* includes a similar denunciation of crude behavior in a chapter illustrated with a woodcut that shows a pig's actual coronation (figure 71). Both fool and pig reappear in the 1531 German edition of the *De Officiis* (figure 72). Illustrating the chapter wherein Cicero refutes Epicureanism's doctrine that all good consists of pleasure, the woodcut itself is explained by a caption printed 51

above: "Wer das Höchst will aus Woolust machen / Der kront ein Schwein in wüster lachen" (He who wants to elevate voluptuousness crowns a sow in vulgar laughter).[3]

An age-old complaint concerning Fortuna—repeated by the likes of Boethius and Petrarch, among others—was her protection and advancement of the undeserving.[4] In his *Encomium Moriae*, Erasmus notes how "she always has been most hostile to the wise. But she brings all her gifts to fools, even while they are asleep."[5] This idea was exploited with a vengeance in emblem literature. Guillaume de la Perrière's *Théâtre des Bons Engins* (Paris, 1539), for example, sets an ass upon elegant cushions and tells how in some places dull and slow-moving asses are given miters and crosiers, while horses must bear the burdens—so pride and stupidity go together. In La Perrière's *Morosophie* (Lyon, 1553), another ass looks down from a palace window at Minerva, locked outside; so are our castles and palaces controlled by similarly crude and unworthy princes, while wisdom is excluded. An ape dressed in king's robes appears in Zincgreff's *Emblematum Ethico-Politicorum Centuria* (Heidelberg, 1619), along with the explanation that a fool remains a fool even though he may carry a scepter. When pigs turn up in the same context, it is usually with a gold ring through the snout, again as in La Perrière's *Théâtre*. In Rollenhagen's *Emblematum Centuria Secunda* (Arnhem, 1613), the same image is provided with the motto "Indignum Fortuna Fovet" (Fortune favors the unworthy).[6] In Jean Cousin's 1568 manuscript *Livre de Fortune*, the goddess showers her blessings upon three unworthy characters, who are then compared to a wallowing sow drawn on the facing page with the motto "Amica luto sus" (The sow loves the mud).[7]

The image that comes closest to Cornelis's (and that quite possibly descended from it) is, however, a rooting pig from Roemer Visscher's *Sinnepoppen* (Amsterdam, 1614), with a motto reading: "Als my Fortuijn tot hoogheydt voert / Soo laet ick gheen dreck ongheroert" (When Fortune elevates me, then I leave no filth untouched). The epigram explains that when wretched fellows are by some chance made rulers over a country, they do not know how to behave and foul everything (figure 73).[8] World spheres were standard symbols of power and dominion; balanced atop them, the pigs of Cornelis and Roemer Visscher recall the conceit of Fortuna's wheel, upon which men turned as their status grew better or worse—the uppermost position representing greatest wealth and influence. They also bring to mind the convention of Fortuna herself, standing on a globe. The fact that Cornelis's pig is winged reminds us, furthermore, of the proverbial association between flight and overly high human aspirations, as represented in his *Flighty Youth*. At the same time, this attribute was also characteristic of Fortuna herself.[9]

With its most unlikely ability to fly, Cornelis's pig is, in addition, an inhabitant of the "world upside down," a conceit having its origins in classical *adynata* or *impossibilia*—literary devices that upset or denied natural law. Phrases like "angling in the air" or "hunting in the sea" were used by ancient writers for rhetorical effect to emphasize the abnormality of an interpersonal or social situation or to

strengthen the force of an oath, as in Euripides' "the stars will descend on earth, the earth will rise into the sky" (before a single word favorable to you passes my lips). Many images of a topsy-turvy world—particularly those that involved animals acting out of character—were favored throughout mediaeval times, especially in the context of manuscript drôlerie.[10] During the first half of the sixteenth century, world-upside-down motifs occasionally appeared as independent subjects in prints, "reversed" hunts being perhaps the most often encountered. A woodcut by Georg Pencz from about 1535 shows rabbits capturing and cooking two sportsmen and their hounds; when the block was reprinted along with an explanatory text by Hans Sachs in 1550, the rabbits were equated with exploited and heavily taxed subjects who eventually turn and take revenge on their overlords (figure 74).[11] In another, anonymous woodcut from the 1520s, sheep, identified as true Christians, are shown in pursuit of wolves, whose tiara, cardinal's hat, and bishop's miter identify them as the Catholic hierarchy.[12]

By the later 1500s the world upside down would become as popular a subject as the proverb, although at this point it was more common to present many examples together. One woodcut published at Amsterdam in about 1595 is typical in its assemblage of over thirty motifs on a single sheet (figure 75). We see a king going on foot while a peasant rides, a wife going to war while her husband stays home, a blind man leading a man who can see, sheep shearing the shepherd, a wagon pulling oxen, hens eating a fox, ships sailing on land, and the like. In most collections of world-upside-down motifs, the creatures with wings are fish. Yet to judge from its continued existence in the language, at least, the idea of a winged pig was hardly exclusive to Cornelis (consider Lewis Carroll's Duchess, who answers Alice's insistence on her right to think with the remark "just about as much right . . . as pigs have to fly").[13]

It is more than likely that Cornelis was aware of a motif as recurrent as the crowned sow. But while the *Narrenschiff*, *Schelmenzunft*, and *De Officiis* illustrations represent simple criticisms of coarse or "voluptuous" behavior and the widespread emulation thereof, the *Winged Pig*, with all its allusions to Fortune and earthly dominion, has a different emphasis. Whether it was aimed at a certain target—as identifiable as in the "papal wolves" woodcut or in the second edition of Pencz's "hunting rabbits"—is unclear from the image itself. As it survives today, Cornelis's woodcut is concerned, in a general fashion, with foolish, brutish, "swinish" men who attain power and an elevated position. The topsy-turvy world associations of the improbable wings suggest that this situation is unnatural. But by virtue of its participation in the "Indignum Fortuna Fovet" tradition, the *Winged Pig* implies, at the same time, that such unworthy men are granted far too much success far too often.[14]

6 Virtues in Exile

Concord, Peace, and Love

When brutishness reigns, it is only natural that all good human qualities are obliged to resign their posts and retreat. Cornelis produced two compositions on this theme of banishment: *Concord, Peace, and Love*—done as an etching and again in woodcut—and *Truth, Hate, and Fear*.[1] The etching of *Concord, Peace, and Love* sets its personifications before a backdrop of hills and vaguely antique architecture (figure 19). At the left is Paeis, or Peace, unusually portrayed as a bearded man in fur-trimmed robes; the caption beside him asks, "Eendracht slaep dij" (Concord, are you sleeping?). To the right, Liefde, or Love/Charity, is given her customary child and cornucopia, and replies, "Wat sou sij slapen sij es doot" (Why should she be sleeping? She is dead). At her feet are the artist's monogram and the date "in augusto 1539" (with the month printed backward). The object of their speculations is a young woman, with her eyes closed, lying on the ground beside a tree. She answers, "Of ick slaepe of doot ben ick seght u claerlick op mij en acht noch gheestelick noch waerlick" (Whether I sleep or whether I am dead, I tell you clearly, neither clergyman nor layman thinks of me). Responsibility for her neglect is thus evenly distributed. The phrase "gheestelick . . . waerlick," already encountered in the first line of *Aelwaer*'s text, was a standard figure of speech meaning everyone, or the world at large.[2] The woodcut version is virtually identical, save for some changes in the landscape and the fact that Eendracht has two children at her side; the differences in its inscriptions are negligible (figure 20).

In images of the putto with a skull or the Christ Child stretched across Mary's lap, sleep is employed as a prefiguration of death. The sleeping nymph or Venus so favored by Venetian artists embodies more ambiguous notions of terrestrial love, growth, abundance, and quietude. When practiced by the likes of Sloth, Melancholy, Foolish Virgins, lazy housemaids, or peddlers with apes, sleep suggests moral failure. Or again sleep can be one means of indicating that a figure has been rendered impotent, like the dozing Mars who remains oblivious to all war cries.[3] Personifications are also killed off entirely, of course—like Eendracht herself, if we are to believe Liefde. In an anonymous Dutch woodcut of about 1530–1540, for example, a weeping crowd surrounds murdered Justice (N.185).[4]

Barthel Beham's image of an outdoor nude with a child and a lamb curled up

nearby (figure 76) recalls such innocently dreaming Venetian nymphs as those portrayed in engravings by Agostino Veneziano or Giulio Campagnola (figure 77), but her hands and feet are shackled, while the pair of scales identifies her as yet another Justice. Gustav Pauli was the first to suggest that Beham's work, dated 1525 in its original state, referred to legal proceedings begun the same year against Barthel, his brother Hans Sebald, Georg Pencz, and the Saint Sebaldusschule rector Hans Denck. Accused of anarchistic and atheistic leanings, he and the others were temporarily exiled from Nuremberg, whose battlements and towers, in fact, resemble the print's background architecture. Beham's Justice is not only unconscious and immobilized but also, by implication, in exile—evicted from the city and forced to remain outside its walls.[5]

This topos had been applied, since classical times, to an entire host of virtues and, less often, vices. The banishment of such personifications as Friendship, Labor, or Chastity is a constant theme in the work of Beham's fellow townsman Hans Sachs. In a 1535 broadsheet with a woodcut copied after Peter Flötner, Sachs's text condemns humanity's rejection of Brotherly Love; wandering near a forest, the horrified poet finds her with her feet cut off by fleeing Self-Interest (G.821).[6] Another broadsheet, with a 1534 text again by Sachs, tells how he came across Frau Pax, battered and tearful in a ruined, isolated temple; it is known today from a 1632 printing, with an engraving possibly copied after an original woodcut by Erhard Schön.[7] The loss of Peace and Concord was especially mourned by Erasmus, who gave voice to strongly pacifistic sentiments in numerous writings. His *Querela Pacis* of 1517 even makes use of the banishment device; Dame Peace complains of having been turned away by Christians, cities, common folk, noble courts, learned men, the clergy, and married couples.[8] *Rederijker* drama also sent countless characters into exile. A 1526 *spel van sinne* by Cornelis Everaert, of Bruges, features Restless Time, Willing Labor, and People of Trade looking for, again, Peace, "a woman very splendidly dressed." The same unsuccessful quest is the subject of another play, dated 1551, by the Amsterdam *rederijker* Jan Thonisz; searching for Peace, Man is instead lured to the Castle of Darkness by evil spirits.[9]

Particularly in the light of her role as the representative of concord, our Eendracht seems another not-too-distant northern cousin of those nudes who also reclined outdoors—and whose associations with ideas of peace and tranquillity are actually specified in Pomedelli's 1510 engraving of such a figure, labeled Quies (see my note 3, Meiss). At the same time, her setting is characteristic of virtues in exile. Like Beham's *Justice* and Flötner's *Brotherly Love*, Eendracht appears in an open landscape with a distant town. And while the etched version shows this architecture basically intact, the woodcut has pronounced ruins that, if not merely picturesque, might have been meant to imply a city's decline and decay after Concord's departure.

Naturally enough, banished virtues were traditionally represented as more or less isolated and alone, save for the narrators, like Hans Sachs, who encountered them.

But in Cornelis's image two additional personifications are present, and they both engage in dialogue with Eendracht—features that again suggest the adaptation of specifically dramatic conventions. In this regard, the choice of figures and their gender may be significant, too. While the notion of one virtue or vice as the parent of another was certainly universal, it would also become a favorite device in *rederijker* drama. A play of about 1579 by Lauris Jansz, for instance, features Goetheijt (Goodness) and Liefde as the father and mother of Eendracht, whom they try to marry to Veel Volcxs (Many People); to their daughter's dismay, however, the prospective bridegroom elopes with Discoort (Discord) instead.[10] It is not at all unreasonable to see Cornelis's paternal Paeis, maternal Lidefde, and maidenly Eendracht as reflections of a similar familial formula.[11]

Truth, Hate, and Fear

Concord's idyllic setting and slightly awkward intimations of southern sensuality are exchanged, in *Truth, Hate, and Fear*, for a decidedly bourgeois domesticity (figure 17). With Cornelis's monogram in a prominent shadow-casting cartouche placed at center stage, and Jan Ewoutsz's motif of a compass flanked by the initials "J" and "E" in a window medallion at the right, there are identifying labels but no other text. Waerheyt (Truth) lies in bed, with her infant, Kennisse (Knowledge), in a cradle nearby. They are flanked by Haet (Hate) and Vreese (Fear). A contemporary cityscape can be seen through an opening at the left.

The Greek idea that she must be brought up from the depths and the Latin conceit that her father was Saturn were combined, in the Renaissance, to form the subject of Truth unveiled or liberated by Time—thus Truth's recurring appearance among banished virtues was only natural.[12] But instead of the usual splendid nude with a sun or mirror and a palm or laurel crown as attributes, Cornelis's Waerheyt is an unpretentious *huisvrouw* in rumpled bedclothes. The padlock on her mouth, an emblem of silence, was normally given to personifications of Secrecy or Taciturnity, to "wise women" who knew how to keep quiet, and to Nemo when he could not defend himself against idle servants' accusations ("Who left the food to burn?" "Nobody").[13] But Truth with sealed lips is a rarity, one of the few other examples being the Warheit in a curious woodcut usually associated with the Dürer school (figure 78). Friezelike in format, the work bears an inscription to the effect that it reproduces an old piece of tapestry discovered at Schloss Michelfeldt in 1524; fragments of this tapestry, dating from the late fifteenth century, are still extant. The inscriptions explain that the images show how men from days past felt about villainies that are now a daily occurrence. The wheel of Jungfrau Zeit, with virtuous birds perched on the bottom and evil birds on top, has been stopped by a wicked fox. A peasant, artisan, nobleman, burgher, and knight bemoan the unhappy situation of Justice, Truth, and Reason, shut up in stocks by the enthroned judge, Deceit; while he reigns, the infant Piety lies asleep at his feet. Two figures repre-

senting secular and spiritual law, an advocate and a canon, pay homage to the judge, while Eternal Providence, with flaming eyes, offers a last comment.[14] Cornelis's awareness of this print is suggested not only by Waerheyt with her padlock but also by his portrayal of Kennisse.

If Waerheyt was meant to be Kennisse's mother, the status of Vreese is less clear. Seated on a chest to the right, he looks equally helpless in a soft peaked hat and long gown, with one bare foot poking out. He seems part of the household, but the role of husband to Truth and father to Knowledge would make little sense. With an anxious stare and open mouth, Vrese strikes a pose that might have been intended as a sign of his spiritual and moral inertia and inability to defend Waerheyt and Kennisse. Despair and cowardliness were closely associated with Acedia, who frequently crosses her arms in a similar fashion.[15] Vreese's snail, a fainthearted creature because it crawls on its stomach and hides in its shell when attacked, was also an attribute of Sloth by virtue of its slow pace.[16] Perhaps, as one cause of the suppression of Truth and Knowledge, Fear was meant to be half of another *sinneken*-like team, whose other representative is Haet.

Rushing in to attack from the left, Cornelis's Haet appears in characteristic armor, while his dog was a common attribute of Envy and Anger.[17] Representations of Time unveiling Truth often showed her rescue opposed by the likes of Anger, Hypocrisy, Envy, Discord, or Calumny—as, for instance, in the *Emblemata* of Hadrianus Junius (ed. princeps Antwerp, 1565), where the latter three appear.[18] Less typical, however, are Haet's peculiarly shod feet; the left wears a patten and a knee-high covering, but the right has a spur and full-length, buttoned legging. Ripa describes Discordia as an "infernal fury" with variegated hair, dressed in different colors.[19] There would even have been a natural association between the image of mismatched garb and the words for discord in Dutch and German, *tweedracht* and *zwietracht* (*twee/zwie* = two; *dracht/tracht* = dress, garb).[20]

At the same time, divided clothing also had obvious possibilities with regard to matters of social class. Niklaus Manuel's drawing of a Swiss mercenary contrasts a flamboyantly dressed left side with a miserably tattered right (figure 79)—a reference to the vagaries of this profession, as already noted in connection with *Sorgeloos*'s Lichte Fortune. In an anonymous German woodcut printed together with a Hans Sachs poem of 1543, divided dress suggests the adoption of inappropriate class values: a "wise fool" warns the Church of its growing worldly power and wears half a cleric's robe, half secular garb (G.1577).[21] *Rederijker* theater seems to have used the same trick. In one play, for instance, a character named Volc van Allen Staten (People of All Estates) was to be costumed "half as a nobleman and half as artisan."[22] In the *Blazon des Hérétiques* of 1524, a strongly anti-Lutheran pamphlet by the French author Pierre Gringore, a title-page woodcut shows a man holding a banner in his right hand and a spade and hoe in his left (figure 80). One leg covering is a knight's, the other a manual laborer's; one arm is mailed, the other has an ordinary sleeve. An accompanying text explains that Heresy itself is hereby por-

trayed, and that among its worst results is the destruction of the existing social order—an order whose dissolution is symbolized by the incongruous combination of a nobleman's and a peasant's attributes.[23]

The fact that Cornelis's *Haet* is divided only up to his knees is not atypical. Contemporary proverbs and images indicate that there was a particularly close association between social status and footgear. The swift change in a soldier's circumstances could be expressed by his feet alone, as in Urs Graf's drawing of a Swiss mercenary and a seductive nude accompanied by the inscription "Rotat fatum omne" (Fate turns all) (figure 81).[24] Bruegel gives footwear a major role in his *Invidia*, which features several people trying on shoes in a shop toward the right; behind them, a strange vegetative structure is topped by two legs, one wearing a boot and spur and the other only hose, in what was perhaps meant as a play on class envy related to adages like "the man in boots doesn't know the man in shoes" (H.130).[25] We might also recall that a leather boot—the *Bundschuh*—had served as the symbol of the German peasants' movement since the early sixteenth century.

Among Hans Sachs's several variations on the theme of Truth in exile is a poem issued as a pamphlet in about 1537 and illustrated with an anonymous woodcut (figure 82). The author tells how he was pulled underwater by a mermaid and led to a crystal room where Fraw Warheyt lay in bed with a padlocked mouth. Sent to earth by her father, Jupiter, she had been attacked by all classes, who silenced her and threw her into the sea, where she continued to dwell. The illustration shows her beaten by a scholar with an open book, a councillor with a scroll, a peasant with a pitchfork, and a monk.[26]

If the infant Kennisse and Waerheyt's padlocked mouth both recall the *Michelfeldt Tapestry*, other elements of *Truth, Hate, and Fear* suggest some relationship to Sachs's piece as well. Cornelis's choice of an interior setting (unusual for "banished virtues"), the attacking figure with class connotations, a Waerheyt in bed and with locked lips are all details that correspond quite closely to the *Meistersinger*'s story—more closely, indeed, than they do to its accompanying woodcut. It is possible, of course, that at some point the poem was published with a different image, one closer to Cornelis's and offering him more in the way of direct pictorial inspiration. On the other hand, he may have looked to the text alone. The dissemination of countless broadsheets with woodcuts by much-copied masters like Erhard Schön or Hans Sebald Beham and texts by Sachs made it inevitable that Dutch artists would become familiar with Sach's work in its own right. Jan Ewoutsz's most important successor as a publisher of broadsheets in the Netherlands was Peter Warnersz of Kampen (active 1544–1566), whose output includes several examples in which the texts are direct translations from Sachs. His *Death and the Lovers*, for instance, was copied after a Beham woodcut, while its accompanying verses are based on Sach's "Gespräch zwischen dem Tod und zweyen Liebhabenden" (N.220–221).[27]

In one *rederijker* play from the later 1530s—a play that Cornelis himself could

58

very well have known—Amsterdam is personified as a sick and bedridden woman. The plot of this *Spel van sinnen van den Siecke Stadt* concerns a good priest, Schriftuerlicke Predicatie (Scriptural Preaching), who has been forced to flee because power is now in the hands of repressively orthodox authorities—which did indeed become the case, as we recall, following the Anabaptists' attempted takeover of Amsterdam in 1535. The *sinnekens* Hypocrisije, who represents the local clergy, and Tyrannije, who represents the municipal government, form an alliance with Sulck veel (Many Such), a rich Catholic layman who has abandoned his wife, Vreese des Heeren (Fear of the Lord), and taken up with the whore Financije (Finance). As a result of these goings-on, the city lies gravely ill. Finally, however, the citizen Gemeente (The Community) and the artisan Meer dan Een (More than One) summon the doctor Wijse Beraedinge (Wise Counsel) and complain to him that Schriftuerlicke Predicatie and the *rederijkers* have been persecuted and driven away. The doctor prescribes a curbing of the abuses of Hypocrisije, Tyrannije, and Sulck veel; good priests must be protected and false religion denied—only then will the city recover her health.[28]

Such decidedly topical applications of the conceit of banished or otherwise incapacitated characters are not unusual. We have already noted one example, of a rather personal bent, in Beham's engraving of *Justice*. And among Hans Sachs's many variations on this theme is a poem in which he comes across yet another personification of Truth imprisoned in an isolated temple. Here he is told, however, that her patched and faded gown represents the Interim—that is, the Augsburg Interim of 1548, the doctrinal formula set forth by Charles V but opposed by all of the more Protestant parts of his realm.[29] Just as was the case with Cornelis's *Winged Pig*, it remains an open question whether *Concord, Peace, and Love* and *Truth, Hate, and Fear* once had specific, timely intentions. There is, indeed, the possibility that the *Winged Pig, Truth,* and the woodcut version of *Concord* were originally printed along with explanatory texts, perhaps of a more pointed nature. It was a common fate of broadsheets to have their woodcuts and texts separated and for the blocks to be republished with different texts (as in the *Fable of the Father, Son, and Ass*) or none at all. But in and of themselves, *Truth* and *Concord* are simply generalized allegories on the discord and deception prevalent throughout society—from the man in pattens to the man in spurs, from "clergymen" to "laymen."

7 Carnal Weakness

The Misuse of Prosperity

Known today from only fragmentary examples, the 1546 *Misuse of Prosperity* consisted originally of seven sheets, with two figures on each, and a text of one hundred twenty-six lines (figure 25a–g).[1] Published by Jan Ewoutsz and signed five times with Cornelis's monogram, the series is neatly summed up in a sentence running along the top of sheets four and five:

> Mit Figuren wt ghesproeken / hoe een mensche dicwils sijn voerspoet misbruyckt / ende daerom van God ghestraft woort / ende patientich lijdende / wederom van God ontfermt wort.

> (With figures it is shown / how a man often misuses his prosperity / and so is punished by God / and suffering patiently / is again pitied by God.)

While most of the thirteen personifications are common ones, with traits conforming to already well-established norms, several have attributes even more out of the ordinary than those Cornelis gave to Truth. Eendracht carried nothing at all when we met her last in *Concord, Peace, and Love* but generally had the same equipment as Peace, or else a fasces or pomegranate to suggest the idea of social harmony and active cooperation. Now she supports a millstone, which can be found in Valeriano's *Hieroglyphica* (ed. princeps Basel, 1556) as a symbol of the "commerce of human life."[2] Like the miniature city (not identifiable) in her right hand, however, its appearance here is most unusual. She describes herself below:

> 1 I, Concord, have power, take notice
> To carry towns and move millstones
> Yes, I am an invincible one for all enemies
> But sighing and weeping will overwhelm those who crush my followers
> 5 And they will lose their refuge with great shame
> As has become clear in various lands
> But whoever loves me and keeps me in mind
> He must lock up Discord
> Or otherwise he'll find himself deceived in the end

Next comes Pax, with her usual olive branch, cornucopia, and crown of wheat sheaves:

> 10 I, Pax or Peace, was brought forth
> By Concord, my mother, highly praised
> All fruits sown by her I bring to perfection
> Townsman or villager, poor or rich, they are gladdened by me
> Even the melancholic mind is gladdened by me
> 15 For to such people the olive-branch returns
> Which the dove brought to Noah long ago
> I don't care about the disciples of Mars even if they are dissatisfied
> But all who love peace, rejoice with me.

The third figure, Diligentia, has her customary spur and whip and is winged[3]:

> Then come I, called Diligence or industry
> 20 Everyone who does not want to be ashamed needs me
> Because I can drive on the lazy one with my whip
> I'm also spurred on my feet, as is becoming
> To wipe sleep from the eyes of the sleepy ones
> For it is only because of me that these people prosper
> 25 And procure thereby the means to live in their old age
> So those, men or women, who chase my people away are fools
> For he who works hard, God will give him food

Gheluck is poised on her globe while grasping a sail filled with flowery wind:

> If the industrious one does his best
> Then I, Good Fortune, come, who started him off in this way
> 30 So that Fortune's wheel will turn altogether in his favor
> Yes, so suddenly coming to him before he expects it
> And I will come to load him with great riches
> Which is a delight to industrious minds
> But Good Fortune is no inheritance; I escape all those
> 35 Who don't observe how my winds blow
> And those who don't think of their poor brothers in their happiness

Splendidly dressed Rycdom stands beside an overturned sack of gold, with a purse in one hand and a coin in the other[4]:

> In Good Fortune have I, Riches, my foundation
> I am pleasing to all people
> Very pleasant is my habitation in all regions
> 40 But woe to him who, through my power, deceives his fellow man
> Or causes him any anger; he will weep for my sake
> Or those who don't lend their ears to the cries of the poor

They will be crying with the Rich Man but won't be heard
Thus even if I lead you in lush meadows, don't become foolish
 through me
45 But live your life always according to God's word

The sixth woman, Leecheyt, or Idleness, is given a very specific interpretation; holding cards and a backgammon board, she speaks of gaming's temptations:

From Riches I follow, Idleness, behold
For many I am more or less the gate of hell
But clearly everyone still loves me greatly
Dice-games and cards, playing 'gaertkaerte' openly
50 These must be done daily, I tell you plainly
Playing tric-trac and games of love, they are in everyone's nature,
 with pleasure
And they don't think that they waste their precious time with them
If the trifling word is a deadly crime to God
Then oh woe to my disciples, according to the writings of the
 evangelists

Gulsicheyt, accompanied by a pig, drinks from a large pitcher:

55 I, Gluttony, clearly result from Idleness
As the pig filthily digs in the mud
Thus my pupils do in all their behavior
Boozing, gorging, puking, shitting boorishly
What else is the life of the glutton
60 By overburdening nature they forsake this world
They kill off their own lives freely without fail
Take an example from all those who have come to their downfall
 through me
And especially take care of your soul—I must descend to Hell

The daughter of Gluttony and granddaughter of Idleness is Oncusheit, or Unchastity. Lust was typically shown as a nude or seductively dressed woman embracing a man, with a goat, rabbit, stag, or pig; snakes and toads bit her breasts, while during the sixteenth century she was frequently characterized as Venus herself. Here she has a bear, usually associated with Ira but said to be libidinous by Rhabanus Maurus, Hildegaard von Bingen, and Saint Bonaventure.[5] The plume she holds is another unusual feature, though its presence can probably be explained in terms of Unchastity's power to move her admirers—much like Ripa's personification of the Five Senses, who similarly wears a feather headdress to suggest that they are blown about just as easily.[6] Oncusheit's most remarkable attribute, her milk-giving breast, was almost always a virtuous one: we think of Maria lactans, Caritas, Sapientia, Natura, and the like. Here it was perhaps inspired instead by an image found in

62

Proverbs 7:18, where a harlot tempts a young man with the words "Come, let us be inebriated with the breasts." Oncusheit's text reads:

> I, Unchastity, am lovely to behold
> 65 Each lascivious man loves me with unflagging ardor
> For they consider me a candy-box—sweet to use
> I resemble the purse; you can hardly distinguish it from me
> For I know how to embrace my followers in my arms
> But if I have the fish in my net
> 70 And death approaches—I tell you clearly
> Then, alas, they have to dive, not knowing where they are going
> For I have damnation in my womb

Unchastity is followed by Envy, typically an old woman gnawing on a heart, bitten by serpents or provided with Medusa locks. Here, however, she holds an uncharacteristic fishing rod and skull. Christ's call to Peter and Andrew to become "fishers of men" (Matthew 4:19, Mark 1:17) had been represented in early Christian art in scenes of the apostles fishing for souls with nets and hooks. This subject would resurface during the seventeenth century when the anglers became opposing groups of Protestants and Papists, while in emblem literature it often took the lighter form of Cupid casting for hearts.[7] In Nydicheit's hands the rod assumes more sinister connotations, recalling a verse from Ecclesiastes (7:27):

> And I have found a woman more bitter than death, who is the hunter's snare, and her heart is a net, and her hands are bands. He that pleaseth God shall escape from her: but he that is a sinner, shall be caught by her.

In Ripa, the fishing rod is an attribute of both Fraud and Self-Interest; like men who lure fish with worms only to catch them, their actions and intentions differ. Picinelli's *Mundus Symbolicus* (Cologne, 1694) lists the hook as a symbol of the worldly and sensual pleasures with which souls are snared by Satan.[8] But if Nydicheit's rod identifies her as the same sort of angler, the snake at her feet labeled Sapienza remains a puzzle—unless it was meant to show that even wise and prudent men can fall prey to this sin, as suggested in line 77. In line 47, Leecheyt had identified herself as the "gate of hell." In line 76, Nydicheit expands upon the same metaphor: she is "the door of death, the gate of hell." Like Oncusheit's breast, these phrases seem to have been inspired by Proverbs 7; verse 27 reads, "Her house is the way to hell, reaching even to the inner chambers of death" (cf. also Proverbs 2:18; 5:5). Nydicheit's skull, an attribute that had no traditional, specific association with Envy, was perhaps meant to reinforce this characterization:

> I, Envy, cruel in my intent
> Bring many in such great torment
> 75 Whomever I can reach with my fishing rod
> I am the door of death, the gate of hell

I must be on the lookout to destroy the just
I have no pleasure in any kind of thing
So everyone, I warn you, beware of me
80 My rod stings sharper than dragon's poison
So woe to those whom I come to disturb

The tenth figure, Oerloghe, is a female warrior with a sword and burning torch.[9] Her costume is adorned with double-headed eagles in what may well have been meant as a less than complimentary reference to the notably unpeaceful reign of the Hapsburg Charles V. She announces:

I, angry War, furious in deed
Full of betrayal, I am completely hard-hearted
Each growing seed I can destroy
85 Envy is my foundation to the right degree
I use no moderation, anyone may annoy me
I burn, I steal, I kill, I plunder, even destroy ramparts
But the previous sins are the causes
That I reign though I cause many innocent people to weep
90 For I am mostly an instrument of revenge

Aermoede is now provided with a crutch and a bandaged arm:

When War is dragging on
Then I, Want, come to everyone's door
So well that no one looks at me gladly with his eye
Yet many have to lodge me and pay dearly for their wealth
95 Because through War wealth has almost all flown away
Though some are haughty of heart they can't really do
 anything
So in fortunate times take care of your goods
So you won't marry me, Want, from whom everyone flees,
 truly
Because I have to feed myself from door to door

Patiencia appears next, with several standard attributes: clasped hands, a sheep (decked out here as the Lamb of God), a burning heart being beaten by a triple-headed hammer, and a truncated column (symbol of fortitude) that serves as a sort of anvil.[10] The text explains:

100 I, Patience, live always on hope
Knowing well that nobody can escape God's hand
Oh! How my heart urges me toward the common welfare

> Oh Lord, if you would only listen to the cries and calls
> Of your poor sheep; I would be so glad to see it
> 105 For my heart is heavy because of this
> But for upright love I will lovingly bear it
> Knowing well that God will preserve his own people
> So I, Patience, subdue my desires

Blyschap, or Joy, then plays a harp as the Dove of the Holy Ghost hovers nearby[11]:

> From Patience comes solace, which brings joy to all
> 110 And almost rejuvenates the old gray ones
> So all should love my joy
> But blessed is he who uses me for virtues
> So that they may gain eternal joy after this
> But he who sets his mind on earthly joy
> 115 As the rich man did, he'll lament it later
> So walk and run for the eternal joy
> To the sensible enough is quickly said

Last in line is the resurrected Christ:

> Keep this conclusion in your mind
> He who dies a Christian will rise in glory
> 120 But he who begins without Christ will end up in Death's misery
> So, oh man, remember that you are God's own chalice
> Realize that you descend from Divine origin, understand me
> well
> So put yourself to everything you undertake
> Let Christ be always your beginning, middle and end
> 125 Thus, oh Lord, release the fetters of sin from all
> And let us be, hereafter, with You, like those we know of

The Misuse of Prosperity's implied view of history as a full circle forever repeating itself actually dates from antiquity, when it found its most complete explanation in Book VI of Polybius's *Histories*. First, according to him, a single leader dominates; then comes monarchy, degenerating into tyranny, which is overthrown by an aristocracy whose excesses are resented by the masses; they establish popular rule, giving rise to another demagogue, and so on.[12] When medieval authors traced a city or state's cyclical progress, they spoke less of governmental forms per se and more in economic and ethical terms. In his commentary on the *Divine Comedy*, for example, Francesco da Buti (1324–1406) provided an illustration that was supposed to represent the course of events in towns and provinces.[13]

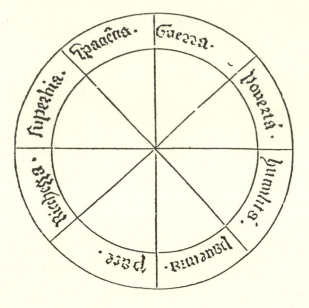

Buti's circular layout clearly reveals the influence of a certain variant on the wheel of Fortune. During the twelfth century, Hugo da Folieto had adapted Boethius's metaphor of Fortuna's wheel to the narrower sphere of cloister life. He described the rise and fall of unworthy clerics on a "rota falsae religionis," whose rim was inscribed with six particularly monastic vices (Craftiness, Avarice, Pride, Carelessness, Idleness, Want); by the same token, there was also a "rota verae religionis," with good monks and corresponding virtues.[14] Wheels of vice and virtue continued to appear in many forms in manuscripts, paintings, and prints of later centuries. In one woodcut illustration from a moralizing tract published at Augsburg in 1477, for instance, each vice occupies a different section within the wheel, which revolves to cast its sinners into hell.[15] So far as our "societal cycle" is concerned, literal diagrams like Buti's remain an exception. But verses on this theme have been traced as far back as the thirteenth century. The Elizabethan writer George Puttenham attributes a comparable sequence to Jean de Meun (b. c. 1260) and then gives its English version:

> Peace makes plentie, plentie makes pride,
> Pride breeds quarrell, and quarrell brings warre:
> Warre brings spoile, and spoile povertie,
> Povertie pacience, and pacience peace,
> So peace brings warre, and warre brings peace.[16]

From the fifteenth century on, similar formulas were employed repeatedly by poets, dramatists—and even by a political theorist of the stature of Machiavelli, whose

66

History of Florence (ed. princeps 1532) refers to the changes undergone by a province:

> For virtue begets tranquillity, tranquillity
> idleness, idleness disorder, and disorder ruin.
> And similarly of ruin is born order, of order
> virtue, from which comes fame and good fortune.[17]

Two early pictorial examples are couched in thoroughly mercantile, anecdotal terms. A woodcut of about 1527 by Hans Burgkmair shows a peddler's rise and ruin in six scenes beneath the heading "Wie der Arm Reich wirt und der Reich Arm" (figure 83). A fragment of the familiar sequence appears in the second banderole: "macht Furderung / Furderung macht Reich." Jörg Breu the Elder's woodcut from about 1530 fills in the blanks (G.352). The inscriptions running above twelve half-length figures explain how "poverty makes humility / humility makes improvement / improvement makes envy / envy makes discord / discord makes again poverty." *The Misuse of Prosperity* is actually the first in a line of several purely allegorical treatments of this theme (the most elegantly concise version being Poussin's *Dance to the Music of Time* of about 1639 in the Wallace Collection). Heinrich Aldegrever's fourteen engravings from 1549 (B.106–116) are clearly modeled after Cornelis's series, demonstrating that his relationship with German printmakers could indeed be reciprocal (figure 84a–b).

The next elaborate treatment is Maarten van Heemskerck's so-called *Circulus Vicissitudinis Rerum Humanarum*, or *Cycle of Human Vicissitudes* (H.128–135), nine engravings probably executed by Cornelis Cort and dated 1564 (figure 85). Surrounded by subsidiary allegorical figures, the triumphal chariots carry World, Opulence, Pride, Envy, War, Want, Humility, and Peace. Here the idea that each state gives birth to another is expressed by placing a miniature version of one at the feet of the next. The *Cycle* was based upon the *ommeganck*, or annual procession, held at Antwerp on the Feast of the Circumcision in 1561, as recorded in an extant copy of a printed program that contains descriptions of every float—including the conventional closing Last Judgment, also reproduced by van Heemskerck.[18]

The tradition for an alliance between artists and *rederijkers* is well documented. A high proportion of painters belonged to *kamers*, while in 1480 Antwerp's guild of Saint Luke even united with the chamber De Violieren to form a single organization. The various civic celebrations in which rhetoricians participated often involved triumphal arches, floats, and assorted bits of scenery that certainly required the talents of their artist-members. Thus it is only natural to find the two groups sharing a common body of subject matter. The appearance of *rederijker*-style characters, costumes, and sets in the oeuvre of van Heemskerck and Bruegel, among others, has long been noted.[19] We have already observed a similar connection in a number of Cornelis's works. And like the later *Cycle of Human Vicissitudes*, his

Misuse of Prosperity might also reflect some unrecorded procession or dramatic rendering put on by the *rederijkers* of Amsterdam.

The Misuse of Prosperity: Conclusion

In the text to *Sorgheloos* it was clearly explained that addiction to such carnal vices jeopardizes not only one's soul but also, and almost as significantly, one's substance. Gambling, gluttony, and lechery are wicked not simply in and of themselves but also because they lead to financial ruin and hence prevent one from becoming a man "of status." As was noted earlier, Netherlandish society's increasingly commercial orientation had much to do with the emergence of certain themes that reveal a range of responses to the subject of material and, particularly, monetary wealth. Those merchants and moneylenders denounced by Brant, Erasmus, and other contemporary moralists found their pictorial kin in the oppressive, paper-cluttered bankers' and tax collectors' offices represented by Quinten Metsys, Marinus van Reymerswaele, and Jan van Hemessen. But for every statement or image condemning greed, there are others that staunchly affirm the legitimacy of wealth and the need to manage it wisely. For every portrayal of the rescue of the tax collector Matthew from a life of avaricious materialism, there is an image of a Prodigal type sinfully squandering his inheritance—an inheritance that was often interpreted, as we have seen, quite literally. Erasmus expressed current humanist thought on the virtues of a financially golden mean when he balances criticism of the miser with criticism of the spendthrift in his *Encomium Moriae*: "One man hastens to put into circulation what money he has; his neighbor hoards his up through thick and thin."[20] Excess, in either direction, is wrong. One should be neither too tightfisted nor too free with one's money, while recognizing at the same time that all earthly possessions are ephemeral and essentially worthless.

Still, a healthy appreciation of material success is revealed in the program for the 1561 Antwerp *landjuweel* (*rederijker* theatrical festivals in which many chambers from all over the Netherlands were involved). The prologues offered by participating chambers were devoted to a praise of merchants and their contributions to the country's welfare and affluence. And on this same occasion the audience was told that "honest profit is good," and that "wealth is the soul and blood of mankind."[21] In 1564 Antwerp's Circumcision Day procession featured a cart illustrating all the benefits of commerce. Grouped around a cornucopia, three nymphs signifying wealth greeted personifications of Hospitality, Gaiety, and Joy. Seated upon a golden throne, the Common Weal bore on her knees her daughter, Riches, who held two full purses—one for indispensable needs, the other for honorable pleasures.[22]

If not quite so effusive, *The Misuse of Prosperity* reflects a comparable attitude. We are cautioned, of course, to live by God's word (lines 45, 121–24) and to consider the hereafter rather than dwell on earthly joy (lines 114–16). Lines 43 and 115 both refer to the parable of Dives and Lazarus (Luke 16:19–31), a subject repre-

sented by Cornelis, we recall, in a woodcut of 1541; lest we suffer the rich man's fate, we are reminded to be charitable (lines 34–36, 40–44). But, at the same time, Diligentia declares, ". . . it is only because of me that . . . people prosper / And procure thereby the means to live in their old age / So those . . . who chase my people away are fools" (lines 24–26). Gheluck promises that "if the industrious one does his best / . . . I will come to load him with great riches / Which is a delight to industrious minds" (lines 28, 32–33). And Aermoede warns, ". . . in fortunate times take care of your goods" (line 97). A similar orientation is suggested by the inscription from which the series has derived its title. What the cycle portrays, above all, is how man "sijn voerspoet misbruyckt." Much as was the case with *Sorgheloos* (and, implicitly, *The Flighty Youth*), the ideal is an industrious life of comfortable moderation.

Demon of Drink

The Misuse of Prosperity is distinguished from van Heemskerck's version and, indeed, from most examples of the sequence by virtue of its emphasis on carnal vice. Instead of the more common progression from wealth and pride directly to envy and discord, Cornelis's series lingers on a gaming Idleness, a guzzling Gluttony, and Unchastity—the same vices that brought down Sorgheloos and, less explicitly, the Flighty Youth, and that are practiced by the followers of Sinte Aelwaer. This same interest in sins of the flesh is illustrated in yet another woodcut, the so-called *Demon of Drink* (figure 21).[23] Striking a dignified, contrapposto pose that clearly parodies the heroic ideal of a figure like Cornelis's own *Marcus Mutius Scaevola* (figure 13), the *Demon* presents us not with a noble Roman profile but rather that of a pig. He holds a sword and tankard, wears a wine cask as protective armor, and has a purse at his side. He breathes out billows of smoke that carry toads and other foul creatures, and treads a bunch of grapes underfoot. Crowned with cards, dice, and vines, he may be Boschian in his fantastic and grotesque combination of parts but is typical of Cornelis in the direct and unmistakable nature of his moralizing message. He expresses in a single, concise form all of the traditional associations between drink, gaming, boorishness, contention, and prodigality.

Nabal, Ceres, and Bacchus

Gluttony is once again the subject in Cornelis's unusual image of Ceres, Bacchus, and the Old Testament villain Nabal (figure 18).[24] The horizontal format, shallow interior setting, and three figures all recall *Truth, Hate, and Fear*, which likewise placed the CÄT monogram in a small cartouche at the lower margin. In *Truth*, Jan Ewoutsz's device was set into a window; here his initials and compass appear as part of the decoration on a jug that has fallen to the floor, spilling its contents. The story of Nabal is told in chapter 25 of 1 Kings, where he is described as a wealthy

inhabitant of Maon during the exile of David. At the time of sheep-shearing, a customary period of hospitality, David sent ten of his men with the request that Nabal should entertain them in return for their protection of his flocks. Nabal refused and insulted the envoys, whereupon David prepared to attack him. Nabal's wife, Abigail, appeased David with gifts of bread, wine, and meat and returned home to find her husband drunk; ten days later, God struck him dead.

In the comparatively few contemporary portrayals of this character, he is invariably overweight and surrounded by food and drink, as, for example, in two scenes from van Heemskerck's engraving series on *The History of David and Nabal* of 1555 (figure 86a–b). In a series of the *Seven Deadly Sins* after Maarten de Vos, Gula's two exempla are Lot and his daughters, and a grossly fat Nabal who is seated behind a table in the right background. In Cornelis's image, he has a definite belly and a suggestively placed and shaped purse and is seated upon a sort of throne with goat's-head armrests. But instead of other characters from the biblical story, there are two classical deities. While a coarse-featured Bacchus grasps his hair, an equally inelegant, heavy-limbed Ceres uses her sickle to cut Nabal's throat. Embodying those vices that bring about the central character's downfall—namely, his overindulgence in food and drink—they clearly recall the teams of *sinneken* types encountered elsewhere in Cornelis's work and might, again, suggest the influence of *rederijker* theater. But while *spelen van sinne* often adapted material from both Scripture and classical mythology, only very rarely did they actually juxtapose the two, as is the case here. In using mythological deities rather than the normal paired personifications (like the Weelde and Ghemack of *Sorgheloos* or the Haet and Vreese of *Truth*), and in combining them with a figure from the Old Testament, Cornelis restates his familiar warning against intemperance in decidedly unfamiliar terms.

8 Moral Exemplars

Marcus Mutius Scaevola

If nearly all of the works surveyed so far focus on the representatives or conse-
quences of vice, Cornelis's early *Marcus Mutius Scaevola* offers us instead a moral
exemplar drawn from Roman legend (figure 13).[1] According to Livy (II:12–13) and
Plutarch (VI:17), when Etruscan forces were besieging the city, a young warrior
managed to penetrate enemy lines, intending to assassinate their leader, King Por-
sena. By mistake he killed the king's scribe and was taken prisoner. To prove how
cheaply he held his own life, he put his right hand into a fire. Deeply impressed by
such bravery, Porsena released Mutius, thereafter dubbed Scaevola, or "left-
handed," and quickly came to terms with the Romans. Mutius Scaevola appears in
several contemporary engraving series of characters from classical history and
myth. In a set of four from 1535 by Georg Pencz, for instance, the others are Marcus
Curtius, Titus Manlius, and Regulus (figure 87).[2] He was also the subject of several
independent paintings and prints but is generally shown, as in the Pencz, with Por-
sena, the slain scribe, and other accessory figures.[3]

 In Cornelis's woodcut, we see a sturdy young man in antique armor standing
before a landscape of classical buildings, some in ruin. Narrative detail has been
reduced to the essential burning brazier. With his left hand above it (an error re-
sulting from failure to allow for the reversal of the printed image), Mutius Scaevola
is about to be crowned with the laurel wreath of Victory (labeled FAMA). It is borne
by putti emerging from billows of smoke. Nearby are the words "Menich gheest"
(Great Spirit), while the socle below, on which he has rested his sword, bears three
alternating lines of Dutch and Latin:

> Die alle sign leet met leet wil wreken
> MANU BELLATORIA
> Sampsons cracht sal hem ghebreken
> NEC ERIT VICTORIA
> Soe leert u leet met lijden breken
> SIC VIVES IN GLORIA.
>
> (Whoever wants to avenge his suffering by inflicting suffering
> By means of a warlike hand

He shall lack Samson's strength
Nor will Victory be won
So learn to vanquish your suffering by enduring
Thus shall you live in Renown.)[4]

Cited as a model of patience by Valerius Maximus (III:3, 1), Mutius Scaevola also retained an association with the related virtue of constancy, whose personification was often said to have her hand similarly thrust into a pan of flaming coals.[5] Here, however, the message is more than that standard one of perseverance in adversity. The two alternating texts are unusual in their emphasis on the fact that Mutius Scaevola's victory came not as a result of his rash act of violence—not by "a *warlike* hand"—but rather as a result of the self-control and discipline he demonstrated thereafter—by the hand that was consumed by fire. Mutius succeeded not because of his murderous attack but because of the greater courage required for his subsequent gesture. Real strength resides not in force but rather in restraint, and we are likewise admonished to "vanquish our suffering" through endurance. Produced one year after the Anabaptists' attempted seizure of Amsterdam, with the subsequent executions and lingering political unrest, this Mutius Scaevola transforms its hero into an advertisement for nonviolence—a theme that will, as we have seen, recur in Cornelis's oeuvre.

The Wise Man and Wise Woman

Representing a virtually comprehensive catalogue of virtues—feminine, as well as masculine—is *The Wise Man and Wise Woman* (figure 89). Usually and justifiably attributed to Cornelis, *The Wise Man and Wise Woman* has clear affinities to *Sorgheloos*, with the same density of line and descriptive detail, and can likewise be dated in the early 1540s. Unsigned save for what seems to be a *figuursnijder*'s mark near the woman's feet, the woodcut survives in several impressions, one of which bears a lengthy text and a fragmentary address. Only the upper half of the first line remains, but it does seem to match Jan Ewoutsz's standard "Gheprent tot Aemstelredam," and we may reasonably assume that he was the publisher if not the cutter.[6] The woman's attributes and their explanations are virtually identical to those in a woodcut of about 1525 by Anton Woensam (B.1, figure 88), who probably also designed a pendant, now lost, that would have corresponded to Cornelis's man.[7] Like Woensam's figure, Cornelis's couple describe themselves in accompanying texts:

Come and look at me, I signify a Wise Man
The Wise Man says:

[1] I wear a helmet on my head
as all Wise Men should be doing
for it signifies discretion, I tell you clearly

and thus must he, who wants to start in good time, be
5 discreet in his actions, which he aims to accomplish
for a thoughtless chatterer never reached a high position

My beard signifies honor, and steadfastly at that
in all my actions I am merciful
avoiding all quarreling in sincere love for peace
10 grieving with him whose actions cause damage
I grieve with the grieving and rejoice with the happy
so that temptation may not attack and conquer me

I also happily bear a lion's heart
because it signifies a strong character
15 undaunted, courageous, but always with good cheer
to defend my life, my honor and my goodness
yes, better to shed my red blood than lose my honor
and so should every man act, who has it in his power

The gilt cross, I am telling you plainly,
20 that I wear on my breast, it teaches how and in what way
we may please God only through faith
for out of faith has arisen that sanctifying treasure
so that an exemplary life arises from us each day
through which everyone should banish all falsehood

25 The fleshly coat, pure and gracious
signifies that our reputation must be excellent
for without a good reputation all is put to shame
however distinguished someone appears
so show that your actions are hateful to no one
30 and don't be like those who are unwittingly blinded by folly

I will tell you the meaning of the silken belt
it teaches you discretion without any boasting
be sensible and wise in everything you undertake
noting what may come of it in the end
35 thus you will obtain praise and approval from everyone
while the thoughtless one will only incur dislike

The scales signify justice
which in a wise man exerts itself above all
which means that he does not seek to play sly tricks on another
40 anymore than he would wish that to happen to himself
this is the teaching of the blessed Christ
blessed be he who remains steadfast in it to the end

The meaning of the T-square is also from the scriptures
for it means moderation in this hard life
45 for all pious wise men praise sobriety
whether in food or in drink or in simple clothing
and it is the true proof of a Christian
so let everyone accept a lesson in moderation

The four-sided stone on which I am standing right now
50 signifies steadfastness at all times
be sincere and truthful in your speaking
do not depart from your good intentions for any advice
whatever you wish for or do understand me well
but in steadfastness you will escape from sins

55 The dog signifies, hear me speak,
that a wise man will always be serviceable
not willfully wild, not like the madman
but helpful to his neighbors, strong in love
this is the advice of a steadfast wise man
60 whoever accepts it cannot be defeated
for God will be with such a man in his might
he will please all people here

Everyone look at me because I am a wise woman
A wise woman says:

I, a wise woman, have vision as sharp as a falcon's
to keep all villainy away from me
65 I love the good and hate the depraved
who would be eager to bring me to shame
for like Susanna I would wish for death
before I cooperated in any way with a villain
yes, like Lucretia I would rather kill myself
70 than have anyone despise me in this world's meeting place

I have also always aimed very diligently
to hear God's word industriously
that is why I carry this key very resolutely
like Magdalen and Martha I prefer God's friends
75 and whatever I hear does not go to waste in me
but I fulfill it in accordance with God's grace
I strive diligently to visit the poor
so that I may satisfy them as much as I can

A golden padlock I wear on my mouth at all times
80 so that no villainous words shall escape from my mouth
but I say nothing without deliberation

and a wise woman should always be thus
in order to uphold her marital covenant
as Sarah was obedient to her husband Abraham
85 do not tell tales on others' actions, I say to you roundly
but carry yourself in modest virtue

To this mirror I turn myself fervently
to defend myself against all pride
let me devote myself to pious living
90 so that I may recognize my transience with equanimity
knowing that into the earth, after the end of life,
I must disappear, like a wretched carrion
the mirror shows me this as clearly as if written with a pen
therefore each wise woman should abandon pride

95 I also have a steadfast character, very solemnly
just as the turtledove does for sure
except for my husband I am averse to all men
yes, resisting all scandalous acts with strong character
neither through sweet words nor through treasure or goods
100 shall anyone get possession of my valiant body
yes, like Thisbe I would rather shed my red blood
than be another man's wife

Around my waist I have two snakes, understand the motive
this should be the behavior of a wise woman
105 who wants to defend herself against shame and impurity without wrangling
for snakes are evil to deal with as one can see
they move fast, they bite, they are bad in their behavior
just so a wise woman, understand me well,
shall never trust anyone's words
110 except her lawful husband's, that is my advice

I would gladly come to the aid of the poor
in order to acquire eternal life
therefore I carry in my hand a full measure
to give from it charitably to all those in need
115 for in all that is written I find no better way
to free myself from sins
than by giving alms, I tell you just so
for that way we become God's chosen beloved

I go on horse's feet as my companions do
120 to be very firmly respected
for deceit is everywhere in the world
therefore each wise woman should take my advice

on horse's feet you must go
or like Bathsheba you will quickly lie down in places of temptation
125 be also very careful on the paths
or you will be conquered by the attacks of the flesh

Nearly every one of these attributes can be related to a biblical metaphor, animal lore, or some other allegorical tradition that would have had fairly wide currency in Cornelis's day. The wise man's beard, a symbol of his honor (line 7), is similarly explained in Valeriano's *Hieroglyphica*, where it is said to represent force and virtue and the wisdom and perfection of the virile sex.[8] His courage and strong character (lines 14–15) are expressed by the heart of a lion, whose reputation as a brave and noble beast was already longstanding. The cross on his breast is an obvious symbol for the wise man's faith (lines 21–22). The "vleysachtighen rock" (fleshly coat) of line 25 probably refers to his mantle and brings to mind the description of a righteously wrathful Lord in Isaiah 59:17:

> He put on justice as a breastplate, and a helmet of salvation upon his head: he put on the garments of vengeance, and was *clad with zeal like a cloak* [italics mine].

The "armor of God" was a metaphor also employed by Paul, who urged the Ephesians (6:13–17) to take up the breastplate of justice, the shield of faith, the helmet of salvation, and the sword of the Spirit.[9] In the *Wise Man*'s text, the helmet is said to signify "discretion" (line 3) and, in fact, helmets are worn by the likes of Prudenza and Ragione in Ripa.[10] But it also forms part of what was clearly intended as a classical warrior's costume. From his head down to his ornate greaves, Cornelis's figure (and presumably its German model) also participates in that concept of the Christian soldier made famous by the *Enchiridion* of Erasmus and portrayed in Dürer's *Knight, Death, and the Devil*.[11] The wise man's belt is a recurring detail in Cornelis's work—a duplicate of that worn by the figure in his *Allegory of Christianity* (figure 41) and very similar to those worn by his personification of Patience in *Patience, Satan, and Sin*, by Ceres in *Nabal, Ceres, and Bacchus*, and by Eendracht in *The Misuse of Prosperity* (figures 16, 18, 25a). Here it signifies discretion, good sense, and wisdom (lines 32–33). Because they embraced the hips and loins, belts represented control over instincts and desires; Ripa gives them to Castità and Virginità.[12] The scales indicate, as usual, justice (line 37), while his T-square—an instrument of measure like the compass, clock, or plumb line—was often associated with moderation (line 44).[13] Like the truncated column of Patiencia in *The Misuse of Prosperity*, the wise man's four-sided stone also symbolized steadfastness (line 50). In Valeriano the square stone is said to represent stability and constancy, in contrast to the variability suggested by Fortune's sphere.[14] Finally, the wise man's readiness to help others (lines 56, 58) is indicated by his dog—an animal whose associations with contention and envy (as noted in connection with *Truth, Hate, and Fear*) were matched by its reputation for fidelity and friendship.

The wise woman can be particularly compared with Weelde as she appears in

profile in scene three of *Sorgheloos* (figure 37c). (Morally, of course, she could not differ more from Weelde—or, for that matter, from the aggressive Aelwaer and the meddlesome females of the *Fable of the Father, Son, and Ass*.) She refers, first, to her "vision as sharp as a falcon's" (line 63); its function, as in Woensam's explanation, is to protect her honor (line 64). Though the falcon is referred to only in terms of its keen sight, it was occasionally associated with sexual abstinence—an interpretation equally appropriate in this context. As Picinelli explains, the falcon refrains from actually consuming the prey it has been trained to catch, just like the pure youth who could indulge in licentious behavior but does not.[15]

A wise woman should also be slow to speak (lines 80–81) but quick to hear God's word (lines 71–72)—notions expressed by means of the padlock and key. A padlock, we recall, was the usual attribute of Secrecy and Silence. Among the emblems of Guillaume de la Perrière's 1539 *Théâtre des Bons Engins* is one that shows Venus standing upon a turtle, holding a finger to her lips, and grasping a key. She signifies, we are told, the woman who stays close to home, remains quiet, and carefully guards her household goods.[16] This was a standard image of the "virtuous wife"— though in Woensam and Cornelis's versions the key, shifted to her ear, functions instead as a natural adjunct to the closed-mouth conceit. The mirror—a common *vanitas* motif—here helps the woman to remember our end as "wretched carrion" (line 92) while keeping Christ's eternal and unchanging presence before her eyes. The turtledove at her bosom was a frequent attribute of Chastity (lines 96–102) because of the belief that these birds, once separated, never take another mate.[17] Like her husband, the wise woman wears a belt, though now those wicked desires that are under control have assumed the form of snakes, "evil to deal with" (line 106).[18] She is also charitable—a trait straightforwardly represented by the "full measure" (line 113) of bread and drink in her left hand. Horses, finally, were more often a symbol of ungovernable and irrational passion but could also, conversely, signify such positive qualities as magnanimity, courage, and perseverance.[19] In this context, the wise woman's hooves, a sign of her sure-footed respectability (lines 120, 123–26), might be compared to Camerarius's image of a horse climbing toward the summit of a hill despite the blast of harsh winds; so, he explains, does virtue maintain its course in the face of all setbacks (*Symbolorum et Emblematum ex Animalibus Quadrupedibus*, Nuremberg, 1595).[20]

Ruth Kelso and others have observed that the sixteenth century witnessed a surge of interest in relations between the sexes—an interest reflected in the ever-growing share of didactic writings devoted to the proper conduct of women and in the popularity of images featuring both exemplary and not-so-exemplary females (e.g., the good wife of Proverbs 31, Susannah, Lucretia, Salome, Potiphar's wife, and other biblical and classical heroines and villainesses).[21] While the causes underlying this increased concern are manifold, there is general agreement that the Reformation played a significant role, given its rejection of the Catholic view that the conjugal state—albeit ordained by God—was decidedly inferior to celibacy. Indeed, by doing away with clerical celibacy and often marrying, Reformers conferred upon the institution a new legitimacy. Erasmus and Luther both praised marriage as a noble

part of the divine plan, as an arrangement designed by God to help assure social order.[22] It was only natural that this reevaluation of matrimony should spark discourse on the qualities required for its successful practice. It was only natural, too, that most of the (male) authors should direct the bulk of their advice and admonitions to women. This new concern for marriage and the role of women within it has also been linked to the continuing emergence of an urban middle class, with its moral code stressing moderation and sobriety in all aspects of life—the same moral code we have already seen manifested in *Sorgheloos, The Flighty Youth, The Misuse of Prosperity, Demon of Drink,* and *Nabal, Ceres, and Bacchus.* The sexual and social stability represented by a chaste marriage and, particularly, a chaste wife was essential if fathers were to be assured that their carefully accumulated inheritances would pass on to their own offspring.[23]

Whether the elevated status of marriage helped improve the status of women remains a matter of controversy.[24] Indisputable, however, is the fact that standards of ideal behavior for men and women continued to differ considerably. Contemporary moralists stressed that marriage was a partnership, and that husband and wife should be accorded equal respect within it. At the same time, there was no question but that the husband should govern his household with a firm if gentle hand.[25] The most important qualities for a woman (and this applied alike to maidens, wives, and widows) were obedience, silence, humility, modesty, and especially chastity.[26] The Spanish-Dutch humanist Juan Luis Vives summarized such views on the two sexes in one passage from his highly influential *Institutio Foeminae Christianae* (ed. princeps Antwerp, 1523):

> For a man, various virtues are necessary, such as wisdom, eloquence, a good memory, a sense of justice, strength, charity and magnanimity. But for a woman, these male virtues do not apply; for her, only chastity is essential. . . .[27]

These varying expectations find a clear echo in Cornelis's *Wise Man and Wise Woman.* There is inevitably some overlapping of virtuous characteristics. Both, for example, are distinguished by their discretion (lines 3–5, 32, 79–81) and their faith or piety (lines 19–21, 71–72, 89). The man, however, also speaks of his courage (line 15) and justice (lines 37–38) in terms as suggestive of a very active relationship to the outside world as is his soldierly garb (see, for instance, lines 5, 7–8, 29, 33). Even his discretion is indirectly aimed at attaining "a high position" (line 6). Moreover, he makes no reference to a wife or to sexual continence. By contrast, his consort's discretion is, as noted above, the equivalent of silence; she counsels that a woman carry herself "in modest virtue," like the "obedient" Sarah (lines 84, 86). She refers several times to a husband (lines 84, 97, 110) and repeatedly alludes to chastity, citing such models as Susanna and Lucretia (lines 67–70, 97–102). Finally, it might be noted that Cornelis's print mirrors current attitudes toward male-female relationships even in its positioning of the two figures. As in the majority of double portraits of married couples of the sixteenth and seventeenth centuries, the wise man occupies the place of honor, on the (heraldic) right side, while the wise woman stands on the lesser side, the (heraldic) left.[28]

9 Images of Death and Faith

Allegory of Transitoriness

Cornelis's extant oeuvre includes three variations on the memento-mori theme. In the earliest, the so-called *Allegory of Transitoriness* of 1537, a bearded man and a child place their hands upon an hourglass bearing Jan Ewoutsz's initials and compass and the words "Des tijts cortheyt" (the shortness of time); the Latin equivalent, VELOCITAS TEMPORIS, is pointed out below (figure 14).[1] An animated skeleton completes the group, which thus recalls not only the standard division of life into Youth, Maturity, and Old Age but also the pairing of a putto with a skull or a skeletal figure of Death—a theme that had enjoyed particular popularity in northern art since the 1520s.[2] The *Allegory*'s scriptural inspiration was Ecclesiastes 11; again printed in both Dutch and Latin, verse 7 surrounds a sun at the upper left:

> The light is sweet, and it is delightful for the eyes to see the sun.

The upper right corner's shadowed sky clearly corresponds to verse 8:

> If a man live many years, and have rejoiced in them all, he must remember the darksome time, and the many days: which when they shall come, the things past shall be accused of vanity.

The same admonition is repeated in verses 9 and 10, which allude to childhood and youth as well:

> Rejoice, therefore, O young man, in thy youth, and let thy heart be in that which is good in the days of thy youth, and walk in the ways of thy heart, and in the sight of thy eyes: and know that for all these God will bring thee into judgment.

> Remove anger from thy heart, and put away evil from thy flesh. For youth and pleasure are vain.

The word TEMPUS appears above the heads of the mature man and the skeleton, whose bony finger directs our attention to the phrase NASCENDO MORIMUR (In being born, we die). Lifted from the *Astronomica* of Manilius (IV:16), the latter—like *Homo bulla, Hodie mihi cras tibi*, or *Quis evadet*—had become a common *vanitas* epigram. Finally, an open book resting on the ledge reads COGNITIO DEI ET NATURAE

RATIONALIS on one page; a Dutch translation, "Kennisse van God Ende Redelicke Natuer" (Knowledge of God and Rational Nature), appears on the next.

Though its full-fledged revival at the hands of Justus Lipsius and his circle was a phenomenon beginning in the last quarter of the sixteenth century, Stoicism would exert a pervasive if not always explicitly defined effect upon European thought throughout the entire Middle Ages and Renaissance.[3] Prior to the rediscovery of other Stoics by later humanists, the major source of understanding of this philosophy on the part of the Latin West was provided by Cicero and Seneca. If the former was upheld as a paragon of style, Seneca's popularity can be largely attributed to the terse, witty, and uniquely aphoristic quality of his writing. Besides the numerous printed editions of his works issued since the 1470s and culminating in Erasmus's magnificent *Opera Omnia* from 1529, there were countless anthologies of Senecan and pseudo-Senecan maxims assembled by various compilers. In an era that was so taken with proverbs and maxims, few ancient authors satisfied this hunger so completely. Stoicism had long been perceived, moreover, as having many points in common with Christianity—a notion further supported by the apocryphal correspondence between Seneca and Saint Paul. It was a philosophy of particular moral seriousness, with a strong emphasis on virtue, the problem of sin, and moral responsibility. It referred often to the gods and even God, extolling his wisdom and omnipotence and stressing the need for absolute obedience to his laws.

Rudolf Wittkower has suggested a connection between certain Stoical precepts and a number of memento-mori compositions created by the likes of Frans Floris, Hendrik Goltzius, and Maarten de Vos at a time when this philosophy had reached its greatest popularity in the Low Countries.[4] The focus of his observations is a painting by de Vos, characteristically featuring putti with various symbols of transience, mortality, and rebirth (figure 90). One child, seated beneath an apple tree and flanked by urns of flowers, blows bubbles, while the other lies asleep beside a skull, some sheaves of wheat, and an hourglass; toward the background is a scene of harvesting and of Christ rising from his tomb. Along with its specifically biblical elements, de Vos's picture comes quite close in spirit, notes Wittkower, to the Stoical view that death should be embraced as a necessary and inevitable part of the divine order. Seneca, especially, returned again and again to the theme that we must be ever aware of life's brevity and prepare for our end unceasingly, but with a tranquil mind. In Epistle XXIV, for instance, he declares that "the very day which we are now spending is shared between ourselves and death," yet it is "so little to be feared that through its good offices nothing is to be feared." In much the same way, there is no sense of horror or the macabre attached to this group of images. The putti present their *vanitas* symbols with a quiet and even confident air; rotting corpses and dread of judgment are replaced by a calm trust in the workings of an ultimately benevolent providence.

A very similar spirit distinguishes Cornelis's *Allegory*, whose inscription VELO-

CITAS TEMPORIS was lifted from a line in Seneca's Epistle XLIX: "Infinita est velocitas temporis, quae magis apparet respicientibus" (Infinitely swift is the flight of time, as those see more clearly who are looking backward). Of even greater interest, though, are the words that appear in the open book. Whether taken from some specific source as yet unknown to me, or coined for this occasion, they seem to enunciate, in a highly concentrated form, an unmistakably Neo-Stoical view of the interrelationship between God, the world, and man. For the Stoics, a single divine order pervaded all things; in man, the divine principle was identified with reason, which gave him access to the rational order of the universe and, in turn, to the existence and will of a rational God. By comprehending the general rationality of nature, man could discover the rational laws operative within himself and, by following them, perfect himself.

As the historian William Bouwsma has observed, this notion of a cosmos based on and accessible through reason is found throughout the writings of Renaissance thinkers, albeit in a fragmentary and unsystematic form and often side by side with entirely contradictory views.[5] Juan Luis Vives, for example, would state that the universe is governed "by the divine intelligence which commands and forbids according to reason." Calvin (whose first publication was a commentary on Seneca's *De Clementia*) argued, in his *Institutes*, that "this skillful ordering of the universe is for us a sort of mirror in which we can contemplate God." For the French moralist Pierre Charron, nature was "the equity and universal reason which lights in us, which contains and incubates in itself the seeds of all virtue, probity, justice."[6] Such sixteenth-century authors avoided the purely Stoical position that the Deity, the world, and reason were one, being careful to affirm instead the decidedly Christian view of a transcendental God. Our woodcut, too, maintains this same distinction in the phrases COGNITO DEI ET NATURAE RATIONALIS and "Kennisse van God Ende Redelicke Natuer": we must strive to know both God *and* rational Nature. It is by means of such knowledge, so the *Allegory* implies, that we may arrive at a calm acceptance of the swiftness of time, human mortality, and divine judgment—a calm acceptance that finds perfect expression in Cornelis's heroic half-figures.

The Ages of Man

The formula of three ages that was modified for Cornelis's *Allegory of Transitoriness* is but one of several employed since antiquity. The division of human life into four stages found a ready correspondence in, among other things, the seasons and the ages of the world; seven stages could be matched up with the planets, while twelve could be paired off with the months.[7] Northern artists generally preferred the higher numbers, which allowed for more in the way of anecdotal elaboration. And, in fact, when he returned to the ages again in a woodcut from the 1540s or early 1550s, Cornelis represented ten (figure 32). The *Allegory*'s monumental Ro-

manist forms and sense of Stoical rigor are replaced here with the relaxed style and homely detail more characteristic of his mature work.

While the other systems could vary as to how many years went into each stage, the ten ages were usually split up into decades, resulting in a neat if highly improbable hundred-year life span. In a bit of German doggerel that seems to have been repeated since at least the thirteenth century, each one was tersely characterized:

Zëhen jâr: ein kint	Ten years: a child
zweinzec jâr: ein jungelinc	twenty years: a youth
drîzec jâr: ein man	thirty years: a man
vierzec jâr: wol getân	forty years: well done
vünfzec jâr: stille stân	fifty years: come to a halt
sëhzec jâr: abe gân	sixty years: all gone
sibenzec jâr: ein grîse	seventy years: an old man
ahtzec jâr: ûz der wîse	eighty years: no more wisdom
niunzec jâr: der kinder spot	ninety years: children's mockery
hundert jâr: genâde got!	hundred years: God's mercy![8]

Other lines were chosen for the earliest extant representation of the ten ages, a 1464 engraving by the Netherlandish Master of the Banderoles (figure 91). But with only a few minor modifications, the familiar rhyme is printed along with the figures in an anonymous woodcut of 1482 from Augsburg.[9] A more sophisticated alternative to these simple lineup arrangements was the circular format. In a woodcut of about 1517 (G. 1061), Hans Schäufelein positioned his ages around a center that shows how we all must end.[10] Most often, however, the ten ages are ranged across a stepped, bridgelike structure that clearly conveys the notion of man's precarious passage through life.[11] In a woodcut dated 1540 and attributed to Jörg Breu the Younger, Death hovers above, while the Judgment Day unfolds below (figure 92). The ten ages each had their own quite consistent animal attributes, here tucked into small niches: children were like playful kids and adolescents like awkward calves; young men were recklessly strong like bulls, while mature men were noble and wise like lions. As they grew older, men became crafty like foxes, avaricious and greedy like wolves, contentious like dogs, indolent like cats, and finally foolish like asses.

There are two extant impressions of Cornelis's *Ages of Man*, both with the same texts and, unhappily, the same blank areas, obviously reserved for additional lines.[12] The first verses, at the lower left, concern a boy riding a hobbyhorse (the occupations of the ages were also fairly standardized) and accompanied by a kid:

1 The young boy shows
2 He's ten years old
3 Knows nothing yet
4 But foolishness,

5 As we can see, is
6 Caused by him

Next comes the twenty-year-old with a falcon and the usual calf. In his cartouche is a characterization that brings to mind the protagonists of *Sorgheloos* and *The Flighty Youth*:

7 A proud young man
8 Of twenty years
9 Is merry in his
10 Behavior
11 Not knowing
12 About saving

The thirty-year-old sits on his bull, grasping an unfurled banner that Cornelis may well have borrowed from the Breu. His text reads:

13 Good sense comes
14 In the course of time
15 So some are found
16 Who seek only good fun

Above the forty-year-old and his lion is a banderole bearing words from the old rhyme, "Vertich Jaer wel ghedaen" (Forty years, well done). The fifty-year-old, with his fox and a document, has at his feet the line "Vijftich Jaer stilghestaen" (Fifty years, come to a halt). The next figure has a banderole that reads "Sestich Jaer of ghegaen" (Sixty years, all gone). Referring to their current reputation for greed and rapaciousness (just like old men) and to their common characterization as "wolves," Cornelis has made his sixty-year-old a turbaned Turk.[13] The seventy-year-old's cartouche is empty, but he has his usual dog and rosary, while the eighty-year-old rests on an ass:

17 Look what I show
18 The eighty-year-old
19 He rides the ass
20 It saddens him
21 To live longer

The ninety-year-old dangles his feet over an open grave; his animal companion is a goose, whose frequent appearance at this point can perhaps be explained in terms of its proverbial associations with both longevity and death.[14] The closing verse reads:

22 The ninetieth year
23 One sees it clearly

83

²⁴ You're all old ware
²⁵ A living death

Flanking this assembly are two trees that further emphasize the contrast between youth and age. The left one is leafy and hung with musical instruments and soldiers' equipment and has two birds fluttering above its branches; the right one is bare except for an owl, crutches, medicine boxes, and spectacles. The centrally placed skeleton recalls Breu's print, as does the small-scale Last Judgment. Instead of setting it beneath the span of a bridge, however, Cornelis has used a triumphal arch—a structure with very different implications—suggesting not only the victory of Death and Time ("Die tijt," represented by a hand-held hourglass in the clouds above) but also, perhaps, the far greater victory of those righteous souls who are being chosen for a place in heaven. Cornelis's composition even manages to include something of the circular format, with all of its allusions to the endless cycles of life and Fortune. A draped coffin at the bottom center leads up to the distant eschatological vision while also providing a visual and conceptual link between the aged man at the right and the infant in a cradle, with a spinning top and porridge bowl, at the left.

It is not surprising to find that the Ages of Man was yet another allegorical theme taken up by the *rederijkers*. Antwerp's Feast of the Circumcision procession of 1562 made this the subject of several floats, more or less faithfully reproduced in a set of four anonymous engravings issued by Jacques de Weert.¹⁵ Cornelis's clever architectural solution might actually be considered in relation to the portable yet often quite elaborate outdoor stages on which *rederijker* performances took place—such as the one built for Antwerp's *landjuweel* of 1561 (figure 93). We should also recall the temporary triumphal arches erected on the occasion of ceremonial entries. The designs for those put up at Amsterdam in 1549 in Philip II's honor seem not to have survived, but Cornelis's structure can be compared to one of the five erected for the young prince's entry into Ghent the same year (figure 94).¹⁶ Finally, *The Ages* even bears a certain resemblance to the layout of some *rederijker* devices; that of the 's-Hertogenbosch chanber, from 1542, combines its figures and architecture in much the same way and even opens up, at the center, to reveal a narrative vignette—an arrangement not at all unlike our woodcut's (figure 95).¹⁷

Deathbeds of the Righteous and Unrighteous

We have already observed how *Sorgheloos* appropriated the Düreresque style of its various models. In his *Deathbeds of the Righteous and Unrighteous* (figure 33), Cornelis carefully reproduced an entire composition—another woodcut attributed to Jörg Breu the Younger (figure 96)—but replaced its weighty forms with his own brand of Dutch mannerism. Like *The Ages of Man*, *Deathbeds* is undated and lacks a publisher's address, but it bears Cornelis's monogram and can probably be placed in the later 1540s or early 1550s.¹⁸ Just as in Breu's image (generally dated c. 1540),

84

there are two figures, heirs of the *ars moriendi* tradition, stretched out on a single elongated bed—a motif derived from Christ's description of events leading up to the Last Judgment, as found in Luke 17:34: "... in that night there shall be two men in one bed; the one shall be taken and the other shall be left." At the left is the good soul, surrounded by Hope with her hands clasped in prayer, Liefde with her flaming heart, and Geloof (Faith) with a book; an angel holds a laurel wreath labeled "Gratie" (Grace) over his head. To the right, a devil emerges from cracks in the floor and grabs the wicked man, whose fiery fate is identified, in both prints, by Job 18:21: "... this [is] the place of him that knoweth not God." Though it is missing from the only extant impression, Cornelis also seems to have allowed room, in the puffs of smoke above the devil's head, for Breu's second inscription, from 1 Peter 5:8: "Be sober and watch: because your adversary the devil, as a roaring lion, goeth about seeking whom he may devour." Werelt (World) looks as if she is abandoning the damned soul; Doot (Death), with his skull-emblazoned standard, is the third member of this infernal trio. Beyond them, the sheep and goats are being separated, as Christ sits in judgment above. Cornelis has attempted to integrate the composition's upper and lower halves, so abruptly split in the Breu; he does away with the earlier print's cloud bank, extends the landscape farther back, and brings it up at the sides.

He has also added a windmill, from which an angel hoists one figure as a second stands in the doorway; on a hilltop to the far right, another angel lifts one man, while his companion seems to flee. Both these small scenes were doubtless inspired by the description of another event before the Judgment Day, in Matthew 24:40–41:[19]

> Then two shall be in the field: one shall be taken, and one shall be left. Two women shall be grinding at the mill: one shall be taken, and one shall be left out.

The fundamental issue underlying this period's varying reevaluations and rejections of the sacraments, pilgrimages, indulgences, and good works—in short, all those traditional, external means whereby man could obtain God's grace—was, of course, that of justification. The Catholic position held that each of these means played, if to different degrees, an essential role in salvation. The importance of works, particularly, was affirmed. In Matthew 25:31–46, Christ himself specified six acts of mercy in direct connection with the separation of the blessed from the damned. By the twelfth century a seventh, burying the dead, was added to feeding the hungry, giving drink to the thirsty, taking in strangers, clothing the naked, caring for the sick, and visiting prisoners.[20] The declaration of James 2:17—"So faith also, if it have not works, is dead in itself"—was unequivocal, and orthodox theologians reiterated this claim in statements such as that issued at the sixth session of the Council of Trent in 1547:

> If one saith, that the justice received is not preserved and also increased before God through good works; but that the said works are merely the fruits and signs

85

of Justification obtained, but not a cause of the increase thereof; let him be anathema.[21]

Such statements were in direct response to the Protestant understanding as initially articulated by Luther. He held that hope and charity would spring from faith but only the latter could save—an argument further supported by still other scriptural passages, notably Romans 3:28 ("For we account a man to be justified by faith, without the works of the law") and Ephesians 2:8–9 ("For by grace you are saved through faith, and that not of yourselves, for it is the gift of God; Not of works, that no man may glory"). If faith is present, good works are certainly desirable in the eyes of the Lord, but they cannot open one's way to heaven. Still other Reformers—particularly Calvin—would take a more extreme stance and deny their value entirely: "The best work that can be brought forward . . . is still always spotted and corrupted with some impurity of the flesh."[22] The effects of this controversy, as felt in the Netherlands, are clearly reflected in the topic of Ghent's often-cited 1539 *landjuweel*: "What is the dying man's greatest support?" Most of the participating chambers responded with dramas that stressed the importance of faith in God's mercy; the Church and its sacraments are hardly mentioned, while the role of good works is diminished or even ridiculed. (The plays were published as a collection that was promptly banned in 1540.)[23]

Matthew's link between the Last Judgment and the works of mercy had long been pictorially expressed in the tympana of medieval cathedrals and later in altarpieces, but the connection would obviously take on a special resonance during the sixteenth century. In 1569–1570, for example, Maarten de Vos and his assistants executed a series of paintings for the castle chapel of the Duke of Brunswick and Lüneburg at Celle. A Last Judgment was represented on the back of the pew in the chapel's south side; the six canonical works of mercy are on the railing in front of the pew. That the works were included, yet not directly connected to the Judgment, has been convincingly interpreted by Craig Harbison as a reflection of the duke's strong Lutheran convictions, which rejected works as a prerequisite for salvation (unlike Catholicism) but granted them a significant place in the lives of all true believers (unlike Calvinism).[24] In Jörg Breu's woodcut, the six works appear as roundels to either side of Christ and are thus accorded a prominent position that, at the very least, does nothing to deny their traditional, orthodox role—nor, it should be noted, is Cornelis's version at all different in this respect.[25]

Allegory of Christianity

Along with his *Wise Man and Wise Woman* and *Deathbeds*, the so-called *Allegory of Christianity* is Cornelis's third known copy (figure 41).[26] Based upon a Hans Sebald Beham print of about 1540 (B.128, figure 42), Cornelis's woodcut—probably done a few years thereafter—even appears to emulate its model's precisely crosshatched engraving style. Both images portray a triumphant figure; her wings are

labeled VICTORIA in the Beham, which also identifies the snake trodden underfoot as DIABOLUS. She bears Charity's traditional flaming heart and the cross of Faith; the label SPES is included in the Beham without being related to any particular object, while Cornelis's image seems to omit Hope entirely. The sun—Beham's LUMEN AETERNUM—refers to Christ, as does the cornerstone in the left foreground, on which Cornelis has placed his monogram. The rainbow is an allusion to God's covenant with man as established after the Flood (Genesis 9:12–17). Toward the right, the crumbling wall and distant ruins, both absent from Beham's image, were most likely intended as a reference to the outmoded old faith or heathenism.[27] The woman's headdress of stars, laurel, and vine leaves is identified as PRAEMIUM (Reward) in the Beham and doubtless alludes, like the wreath in Breu and Cornelis's *Deathbeds*, to the "crown of justice" or "crown of life" promised to the faithful in 2 Timothy 4:8, James 1:12, and the Apocalypse 2:10.

Along with his brother Barthel, Georg Pencz, and Hans Denck, Hans Sebald was, we recall, tried and convicted for heretical and anarchistic views in 1525. According to records of the court proceedings, the accused men expressed doubts regarding the authority of Scripture, the Real Presence in the Eucharist, the value of baptism, and the full divinity of Christ.[28] Such extreme opinions—apparently inspired in part by the apocalyptic, anarchistic teachings of Thomas Müntzer (1489–1525)— were as unacceptable to Nuremberg's Lutheran government as they would have been to Catholic ears. Whether Hans Sebald quickly tempered these left-wing views or out of practical necessity declined to express them in his art remains unclear. Whichever is the case, he not only went on to design woodcuts for a number of distinctly pro-Lutheran broadsheets and illustrations for several works by Luther himself but also produced a series of eminently orthodox illuminations for a prayer book commissioned by Cardinal Albrecht von Brandenburg.[29] His *Allegory*, at any rate, remains a doctrinally neutral, generically Christian statement, constructed out of traditional Christian symbols—symbols that are repeated, toward an equally nonpartisan end, in Cornelis's version.[30]

Loss, Redemption, and Current Doctrinal Issues

Allegory of the Prodigal Son: *Introduction*

Composed of six separate, unframed, and unsigned woodcuts that lack even a publisher's address, the *Allegory of the Prodigal Son* is generally attributed to Cornelis and is dated in the 1540s for what are, in fact, compelling stylistic reasons (figure 97a–f).[1] We find a number of features familiar from his other works: an emphasis upon contours without too much interior modeling (cf. the *Winged Pig*, figure 29, and *Arterial System of the Human Body*, figure 30); a simplified and rather unsophisticated system of shading by means of long, straight parallel strokes (cf. the woodcut version of *Concord, Peace, and Love*, figure 20); architecture that opens up, usually to one side, to reveal mountainous vistas and cotton-ball clouds (for the clouds, see especially *Concord, Peace, and Love*); long-limbed, somewhat awkwardly posed figures, mostly in the foreground (cf. *The Flighty Youth*, figure 24a–b); ovoid heads often without any indentation at the brow (cf. Diligentia and Gheluck in *The Misuse of Prosperity*, figure 25b); buttonlike eyes and open mouths (cf. *Nabal, Ceres, and Bacchus*, figure 18). His *Dives and Lazarus* of 1541 (figure 38) has a clearly related arrangement of characters and setting; its patterned tile floor can be compared to the *Prodigal Son*'s first and last scenes, while the woman at Dives's table bears an obvious resemblance to the last scene's Laeticia. In the second scene, Mundus's goat's-head chair reminds us of the throne in *Nabal, Ceres, and Bacchus*. Liefde in the woodcut version of *Concord, Peace, and Love* has a certain kinship with the Superstitio of scene three or the Desperatio of scene four. The same scene's Bellum is very similar to two of the rear-view noblemen in Cornelis's *Lords and Ladies of Holland* and *Lords of Brederode* (figures 8a, 9), while its swine are duplicates of those in the *Winged Pig*. Finally, the Prodigal himself is the same physical type as the protagonist of Cornelis's *Flighty Youth*, while his father recalls the old man in the *Fable of the Father, Son, and Ass* (figure 23a–b).

Long before its popularity as a subject for drama, the parable had been subjected to complex allegorical interpretations at the hands of patristic commentators—particularly Tertullian (*De Pudicitia*, 8:9), Saint Ambrose (*Expositiones in Lucam*, lib. VII), and Saint Jerome in his letter to Pope Damasus. According to nearly all these early authors, the Prodigal represented the heathens, his father was God, and his patrimony was the free will given to each man. Like the wayward boy, the heathens

were said to have left God to live in idolatry. The citizen who hires the Prodigal to tend pigs (Luke 15:15) was equated with Satan, while his farmhouse was the world. The youth's repentance and return home were seen as the heathens' conversion to the true religion; the robe, ring, and shoes he puts on (15:22) were, respectively, baptism, faith, and good teaching. The killing of a fatted calf stood for Christ's crucifixion, while the objecting older brother represented the Jews or, more specifically, the Pharisees. This entire analysis was meant to explain the relationship between Jews and Christians during the apostolic period.[2]

Many of these analogies would be repeated in the thirteenth-century *Bible moralisée* and remained viable long thereafter. In a collection of sermons published at Basel in 1495, for example, Johannes Meder offers Luke's story as a more universal allegory on the denial and acceptance of the Lord but still mentions the Jewish-Christian opposition, likens the calf to Christ, and gives the robe, ring, and shoes their old meaning.[3] The same exegetical tradition was also incorporated into several of the Prodigal Son plays cited earlier. The 1529 *Acolastus* by Gnapheus compared the son's departure to man's spiritual rebellion, while the father's pardon equals divine pity, and the Prodigal's reintegration equals man's salvation. And in *De Historie van den Verloren Sone*, the leave-taking is once again likened to a turning away from God, while the pigs, as in Ambrose and Augustine, are demonic spirits.

As we noted in connection with *Sorgheloos*, the Prodigal Son was but one of many scriptural subjects whose unprecedented popularity in sixteenth-century art and literature can be credited in part to that period's rediscovery of the Bible. The parable also had special relevance for an increasingly mercantile, commercially oriented society, with all of its concerns regarding extravagance, avarice, and other appropriate ills. At the same time, however, this story of a soul's loss and recovery was assigned a particular and important role within the context of current theological debate. From 1522 on, Luther delivered a series of sermons in which the Prodigal Son was employed as the illustration par excellence of his doctrine of justification by faith. He identified the older brother not with the Jews but with "papists and monks" and their legalistic emphasis on works and penitential satisfaction. The Prodigal no longer represents Christianized heathens but, instead, those who are saved through belief in divine mercy.[4] These same analogies would be repeated in a 1527 play by an ex-Franciscan, Burchard Waldis; his *Parabell vam Vorlorn Szohn* retains the traditional interpretations of the robe, ring, and shoes, and of the calf as Christ. Yet he expands upon the new elder brother/Catholic comparison and even includes one scene where the innkeeper hopes for Luther's success—for then the cloisters would be forced to close and send their inhabitants to the taverns.[5] Among Hans Sachs's many dramatic efforts is a Prodigal Son play dated 1556, in which the older brother refuses to forgive his errant sibling, claiming that salvation can be bought only with good works.[6] The other side proved equally eager to recruit him for their cause: in 1547 the Council of Trent's answer to solifidianism described the Son as a perfect penitent, who recognized and redressed his sins through love.[7] The orthodox position was also set forth in a play of 1537 by the German

dramatist Hans Salat. Here the Prodigal is corrupted by two devils who rejoice because Lutheranism will encourage everyone to lead loose lives, since there is no longer any need for good works, penance, or absolution.[8]

The Good Shepherd with Sinners

We might briefly interrupt our discussion of *The Prodigal Son* to mention another closely related theme that would prove equally appropriate as an illustration either of the Protestant belief in the Lord's unconditional mercy, or alternatively of the Catholic demand for penitence, depending upon one's religious orientation. Especially popular during the later sixteenth and seventeenth centuries, it showed such regenerate sinners as King David, Manasseh, Mary Magdalen, Peter, the Good Thief, or Zacchaeus in attitudes of supplication before him. Naturally enough, these groupings often included a Prodigal, whose story in Luke 15 was immediately preceded by those related parables of the lost drachma (verses 8–10) and lost sheep (verses 4–7)—and, in fact, it is usually Christ in his role as the Good Shepherd to whom the various sinners appeal. While there are some unquestionably reformist images of this subject, in 1540 Cornelis produced a doctrinally neutral *Good Shepherd with Sinners* (figure 15). It shows Christ with three men in an open, rolling landscape.[9] To the left, the Prodigal appears as a swineherd who proclaims, in a nearby banderole, "Father, I have sinned against heaven, and before thee" (Luke 15:18). The other two kneeling figures are David and the tax collector of Luke 18:9–14—the latter with a fragmentary inscription from verse 13: "O God, be merciful to me a sinner." The lower cartouche and a banderole beside the cross are empty in the only extant impression, but to the upper right are lines from Ezekiel 34:15–16: "I will feed my sheep . . . saith the Lord God. I will seek that which was lost; and that which was driven away, I will bring back again; . . . and I will strengthen that which was weak."[10]

The Prodigal Son: *Scenes One through Four*

Presumably worked out in collaboration with some learned adviser and clearly directed toward a well-educated audience, the theologically complex program of Cornelis's series on the Prodigal Son sets it apart from contemporary examples like Beham's (figure 48a–d) or van Heemskerck's four woodcuts from about 1548 (H.50–53), both of which more or less limit themselves to a straightforward presentation of the gospel account. The closest pictorial precedents for Cornelis's elaborately allegorical approach can be found not among prints or paintings but rather among tapestries, where the subject seems to have enjoyed considerable popularity. In a set of two panels woven in Brussels in about 1485 and probably based on a lost mystery play, we follow the Prodigal as he is prompted by Mundus, Dissipatio, and the Seven Sins to embark upon his reckless way. Turning his back on Castitas, Obediencia, and Temperancia, he is introduced to Luxuria and then Venus, along

90

with her retinue of Cecitas Mentis (Blindness of Mind), Affectio Seculi (Worldliness), and Inconstancia. His downfall is marked by the appearance of a man identified as Ira Dei (Anger of God) and a hag named Fames (Hunger) (figure 98). The left half of the second piece illustrates his return home under the influence of Contricio and the Virtues; the right half consists of a parallel sequence of scenes showing the Fall of Man, the advent of Christ, and the restoration of Adam to his original state of grace.[11] Cornelis's equally large cast of nonscriptural characters—all bearing attributes and Latin labels—acts out an equally complex narrative constructed from an assortment of exegetical traditions, apocalyptic allusions, theatrical conventions, and references to current doctrinal issues.

The opening scene (figure 97a) shows the protagonist collecting his inheritance in a grandiose hallway, as other members of the household look on. In the left background he then departs, accompanied by the first of many supporting figures, Conscientia, who bears the tablets of the Law. Johannes Meder's sermons sent him off with a rosary, while in Gnapheus's *Acolastus* he is given an equally anachronistic Bible, so it seems to have been customary to arm the youth somehow. But these safeguards are, of course, to no avail. By the second scene (figure 97b) he has arrived at the inevitable inn, where Conscientia lies trampled beneath a table. Standing behind Filius Prodigus is Vanitas with a pipe and soap bubble—one of the earliest translations of the phrase *Homo bulla* into pictorial terms.[12] Flanking the hapless youth is a wench named Caro (Flesh) and a Mundus is his less common masculine form—holding a scepter, wearing a world sphere as a headdress, and with a fool's cap draped over his shoulders.[13] Hovering above in a billow of infernal clouds is the seven-headed apocalyptic dragon, or Satan, here labeled "Spiritus Erronei, et Fanatici" (Spirit of Error and Frenzy)—probably in reference to the false spirits of 1 Timothy 4:1: "Now the Spirit manifestly saith, that in the last times some shall depart from the faith, giving heed to *spirits of error*, and doctrines of devils."

A similar warning appears in 1 John 4:

v.1 Dearly beloved, believe not every spirit, but try the spirits if they be of God: because many false prophets are gone out into this world.

v.6 We are of God. He that knoweth God, heareth us. He that is not of God, heareth us not. By this we know the spirit of truth, and the *spirit of error* [italics mine].

Caro, Mundus, and the satanic dragon together make up what were referred to as the Three Enemies of Man, a conceit employed since patristic times and one that enjoyed considerable artistic popularity. We have already encountered two examples in Cornelis's *Deathbeds* and its German progenitor, where the World and the Devil were teamed up with Death (who occasionally substituted for Flesh). Their presence in *The Prodigal Son*'s second scene actually helps account for what initially appears to be a rather motley gathering of accessory figures. In another passage from the First Epistle of John (2:16), three lusts are distinguished: lust of the flesh, lust of the eyes, and the "pride of life." According to the exegetical tradition, 91

these three lusts were what led men to accept the evil suggestions of the World, Flesh, and the Devil. Each was defined, moreover, in precise terms: lust of the flesh took the form of gluttony, lechery, and sloth; lust of the eyes was identified with the World and took the form of avarice and a desire for honor; the pride of life was identified with the Devil and took the form of ambition and vainglory, and often a sinful desire for knowledge and an adherence to spurious doctrines.[14]

In one typical dramatic adaptation of this formula, a fifteenth-century English play entitled *The Castle of Perseverence*, Mankind and the Virtues take refuge in a fortress; leading the assault against them are Flesh, assisted by Gluttony, Lust, and Sloth; World, assisted by Avarice; and the Devil, assisted by Pride, Anger, and Envy.[15] Similarly, in Cornelis's image, Caro is a seductive creature who embraces the Prodigal while handing him a goblet of wine at a table spread with food, drink, and a backgammon board. Mundus seems to have been given his standard subaltern, Avaritia, here an old woman who secretly hands the Prodigal's full purse to a man labeled Proprium Commodum (Self-Interest). Avaritia and Proprium Commodum were apparently inspired by the procuress and her thieving accomplice in Lucas van Leyden's *Tavern Scene* (figure 50). The satanic Spiritus has been provided with two equally suitable manifestations, Haeresis and Ratio. Haeresis holds a fox or wolf and carries a scorpion on her head, all typical attributes.[16] Ratio is dressed as a scholar and plays the bagpipes, the instrument of fools. Sitting on his cap is a frog, generally considered an impure and evil animal: frog spirits come from the mouths of the dragon, the beast, and the false prophet in Apocalypse 16:13. Their noisy calling was tied to empty and insubstantial talk; among the *Emblemata* of Joannes Sambucus (Antwerp, 1564), for example, is one showing a pond filled with frogs, silenced by lamplight—so, too, it is explained, the truth silences tiresome sophists.[17]

Cornelis's figure reflects what was, at the time, a widespread backlash against certain forms of intellect. Alongside Renaissance humanism's trust in man and his rational faculties, there ran a nonsectarian and European-wide strain of mysticism and spirituality that depreciated the powers of the mind.[18] In the current search for a more passionate and personal religious life, many preferred to attribute as much as possible to God, and correspondingly little to our own limited and faulty understanding. John Colet's characterization of human reason as a "dense gloom," a "blindness," full of "fickleness and incapacity," is typical.[19] For Luther, reason is a positive thing only insofar as it accords with Scripture; the moment it deviates, its impotence is manifest. "The more subtle and acute is reason, without knowledge of divine grace," he says in his commentary on the Epistle to the Galatians, "the more poisonous a beast, with many dragons' heads."[20] In one woodcut by an anonymous follower of Jacob Cornelisz van Oostsanen, a deer whose antlers represent the Old and New Testaments is threatened by demons armed with papal decretals, a rosary, and amulets. Approaching from the right is, once more, the apocalyptic

dragon, here specifically identified as Menschenleeringe (Human Doctrine); honoring it are two men labeled Philosophen (figure 99).[21]

In our *Prodigal Son*'s third scene (figure 97c), the now ragged and penniless youth is driven from the inn by Haeresis and an old hag named Paupertas, who brandishes a distaff stand. Directing him on toward his next destination is a woman labeled Superstitio—a term that generally referred to heresy or false religion (as in "the Mahometan superstition").[22] The rosary, hat, and staff identify her as a pilgrim, who thus personifies the protagonist's figurative journey away from God and toward wrong belief, just as in traditional exegeses of the parable. At the same time, however, it should be remembered that the pilgrimage was among those churchly institutions then under strong attack from many sides—including Erasmus, whose 1526 *Peregrinatio Religionis Ergo* was but one of many writings in which he heaped scorn upon the foolish credulity and greed inspired by this practice. The Prodigal appears again, kneeling at the Synagoga Sathanae (Synagogue of Satan), a phrase that occurs in Apocalypse 2:9 and 3:9, where it indicates the place of worship of false Jews. Sitting enthroned beneath a baldachino labeled Morbus (Disease) and beside a column inscribed Obstinatio is an exotically crowned figure.[23] Pointing toward some distant pigs, he corresponds to that man in the parable who hires the Prodigal and who was traditionally interpreted as the Devil.

According to Luke 15:16, the unhappy youth hungered after his pigs' husks, and in Cornelis's fourth scene (figure 97d) he actually eats from a trough labeled Fermentum Pharisaeorum—the leaven of the Pharisees cited in Matthew 16:6 and 11, Mark 8:15, and Luke 12:1. A similar association had already been made in the *Bible moralisée*, where the slops were identified as "carmina poetarum" and "dogmata phariseorum erroribus plena."[24] But this designation had particular implications during Cornelis's time. Like the charge of heresy, accusations of pharisaism—of a hypocritical and merely external show of religion—were leveled by both Catholics and Protestants against each other.[25] It was among the swine that the Prodigal's change of heart took place—as represented, for example, in Dürer's engraving of about 1496. In Cornelis's image, his state of mind is embodied in the figure labeled Desperatio, whose hair-pulling, dagger, and gnawing snake (Morsus Conscientiae, or Sting of Conscience) are all typical attributes.[26] To Desperatio's left is Morbus, no longer a part of Satan's throne, as in the previous print, but instead a figure with a urine flask, physician's staff, and medicine box. Fames is next, emaciated and ragged as usual. Bellum, too, has his customary armor, sword, and flaming torch. Like the Three Enemies of Man in the second scene, these characters constitute a distinct trio, corresponding to the choice of divine punishments offered to King David, another prototypical sinner, in 2 Samuel:12–13; for his offence of numbering the Israelites against God's wishes, he was obliged to accept either disease, famine, or war.[27] Still another threesome of sorts occupies the left foreground: Diabolus, Mors, and Infernus (Devil, Death, Hell), referring to the fate that awaits the Prodigal should he not mend his ways.

93

Finally, materializing from the smoke above is an image labeled Ultio Divina (Divine Punishment) and derived from a 1529 pamphlet published in commemoration of the death of Balthasar Hubmaier, leader of the Moravian Anabaptists until his execution in 1528 (figure 100). One of the very few pictorial documents clearly designed on the Anabaptists' behalf, its woodcut illustration by Hans Weiditz shows a world sphere bearing down upon a whip, which in turn entwines a scepter, crosier, and quill pen. The text explains this motif as a depiction of heavenly wrath brought down against haughty rulers, false shepherds, and scholars' seductive writings. Weiditz's woodcut also represents perhaps the first extant example of a symbol unknown throughout early Christian and mediaeval times: the tetragrammaton, or the four consonants of the ancient Hebrew name for God. One focus of the image debate of the sixteenth century was God the Father's proper portrayal. Among Reformers, opinions ranged from Luther's acceptance of the traditional white-bearded, patriarchal figure to Calvin's and the more radical sectarians' complete rejection of any such anthropomorphizing. The tetragrammaton was a solution that seems to have been initially promoted by iconoclastic Anabaptists. As the Hubmaier pamphlet explains, these sacred letters best suggest the Lord's mysterious, unfathomable nature.[28]

Patience, Satan, and Sin

Cornelis employed this solution himself: the first time in his *Patience, Satan, and Sin* from the early 1540s (figure 16), where Patientia stands upon a square stone, the symbol of her steadfastness (cf. *The Wise Man*) and at the same time, as it is clearly labeled, a symbol for Christ (cf. the *Allegory of Christianity*).[29] She has vanquished Mors, shown as a skull beneath her foot, but is still menaced by Satan, who pulls at a chain attached to her ankles—chains and shackles being among this virtue's more common attributes.[30] Grabbing at the hem of her skirt is a half-submerged old woman, unidentified in both surviving impressions. Given the presence of the Devil and Death, she probably personifies Sin, another character who was sometimes substituted for one of the usual Three Enemies. A very similar siege was represented in a series of woodcuts dated 1536 and printed at Antwerp by Willem Liefrinck (father of Hans Liefrinck, the publisher of most of Cornelis's princely portraits). Loosely based on the *Psychomachia* of Prudentius, this series consisted originally of seven images, three of which—Temperance versus Gluttony, Charity versus Avarice, and Concord versus Discord—have been lost. The remaining four show Faith fighting Incredulity, Chastity fighting Flesh, Humility fighting Pride, and the struggle of Patience. The participants themselves are represented as abstract personifications with essentially neutral attributes. All actual propagandizing is restricted to the accompanying texts, which dismiss the power of the Church and good works in favor of individual faith in Christ; it is Christ, not the pope, who is

94

the "optimus maximus," while the clergy are compared to the whore of the Apoc-
alypse.

Though ostensibly written by a certain "Lucas Volder," according to Karel Boon,
there is no such name in the Antwerp archival records; he prefers to see this as a
pseudonym for Willem de Volder, already familiar to us as Guglielmus Gnapheus,
author of *Acolastus*.[31] The images were designed by the Monogrammist AP, whose
Tavern Scene (H.9) was mentioned earlier. More apparent here are his stylistic ties
to Bernart van Orley (brought before the Catholic Inquisition in 1527 on the charge
of having attended a secret evangelical service).[32] In the scene that features Patience
(figure 102), she stands, again, upon a rock labeled Christus, protected by the shield
of Fides and the anvil of Tolerantia. Surrounding her are eight threatening figures,
including Diabolus as a horned beast, a male Mundus, and Ira mounted on a lion.
Patience reappears to the right, standing victorious over Ira; various misfortunes
that call for the practice of patience—imprisonment, infirmities, and the loss of a
house by fire—are illustrated beyond.

In Cornelis's *Patience*, her representatives are Saints Lawrence and John the Bap-
tist, whose martyrdoms take place on the banks of a stream that grows turbulent
toward the foreground. In the background of Maarten van Heemskerck's 1559
Triumph of Patience, a small ship is similarly threatened by stormy seas (H.120).[33]
The "deep waters" of Psalm 68:2–3 and 16, Psalm 87:17–18, and Psalm 123:4–5
had become a standard symbol of tribulation; in the *Hecatongraphie* of Gilles Cor-
rozet (Paris, 1543), for instance, a wading woman, bearing a globe on her shoulders,
represents "Esperance en adversité."[34] The Patiencia of Cornelis's *Misuse of Pros-
perity* had clasped her hands in prayer (figure 25f); now she crosses her arms upon
her breast, a pose that could suggest not only sloth (as with Cornelis's personifica-
tion of Vreese) but also forebearance.[35] Holding a crucifix, she gazes up toward the
source of her strength, the Deity, in his tetragram form, while an angel hovers
above her with the "crown of justice."

In discussing Cornelis's woodcut, K. G. Boon suggests that it shows an affinity
for Anabaptist thought—partly because the attitude and glance of Patience "suggè-
rent une [Anabaptist] soumission résignée à une puissance supérieure." Her cross,
he claims, indicates an identification with Christ's suffering, while the crowning
angel recalls a passage from Thomas à Kempis, whose *Imitatio* "n'avait pas échappé
à l'attention des Anabaptistes néerlandais." But none of these elements is uniquely
or unmistakably Anabaptist in its orientation—not even the tetragrammaton,
which also appeared as a generically pro-Reformation symbol (and which would
actually be used in decidedly Catholic works by the early seventeenth century).[36]

That Cornelis's *Patience* may have been understood as heterodox by at least
some of his contemporaries, however, is revealed by a reference to it (or to another
very similar print) in a 1543 trial for heresy in Louvain. One of the rare examples
of a specific known image cited in connection with such a prosecution, it was found
among the possessions of a sculptor and his wife. Although the exact reasons for

CHAPTER 10

the guilty verdict remain unclear, the couple was executed (he by beheading, she by being buried alive).[37] Still, it should be remembered that we have no evidence regarding the circumstances behind Cornelis's creation of the print nor of its reception in Amsterdam.

The Prodigal Son: *Scenes Five and Six*

In addition to its presence in *Patience, Satan, and Sin*, Cornelis used the tetragram a second time, in *The Prodigal Son*'s homecoming scene (figure 97e). Here God's Greek and Latin names are printed beneath the Hebrew, a not uncommon variation on the motif. Pointing up toward it is Poenitentia, who tramples the serpent Desperata Conscientia. For Catholics, the return to grace demanded not only contrition but also external satisfaction. Just as love for Christ was manifested by means of good works, so, too, was inner remorse also outwardly expressed, through confession to a priest and the performance of certain prescribed penitential acts: the recital of prayers, attendance at mass, fasting, and pilgrimages. Personifications of Penitence were traditionally provided, in fact, with such attributes as a rod, a scourge, a bared breast, or a grate.[38] Protestants held, however, that contrition alone was sufficient. Out of contrition grew all-important faith, which freed the soul from fear of retribution; external satisfaction was unnecessary because Christ had already achieved satisfaction on behalf of every man.[39]

How *The Prodigal Son*'s personification relates to these views is not entirely clear; instead of her normal punitive attributes, Poenitentia holds a compass, often employed in the sense of direction through God. Among the *Emblemata* of Sambucus, for example, is one that shows a man in prayer before the polestar, guided by a compass; in the same way, it is explained, we are guided by the power of Christ's word.[40] Poenitentia's characterization might have been similarly meant to emphasize inner movement over visible self-chastisement. Still, she plays a larger and clearly more active role than the Fides standing quietly to the right. Completing this trio is Spes with her traditional anchor. To the left, behind the welcoming Pater, are Veritas with an open book and Dilectio (Love) bearing the robe, ring, and shoes. This pair and another in the next scene refer to Bernard of Clairvaux's well-known parable of the Four Daughters of God, based on Psalm 84:11–12:

> Mercy and truth have met each other:
> justice and peace have kissed.
>
> Truth is sprung out of the earth: and justice
> hath looked down from heaven.

According to Bernard's exposition, man was originally vested with four virtues but lost them after the Fall. They argue about his punishment; Truth and Justice demand a harsh sentence, while Mercy and Peace plead for leniency. Not until

96

Christ's birth and sacrifice are all of them reconciled; only then can they "meet together" and "kiss," as in verse 11.[41]

In Cornelis's sixth scene (figure 97f), the protagonist is embraced by Dilectio's counterpart, Pax, while Veritas's counterpart, Iusticia, looks on. Also present are Laeticia (Joy) and a harp-playing Constantia. At a doorway to the left, Pater speaks with the elder brother, labeled Gens Iudaica (Jewish People), in reminiscence of patristic exegeses. Behind them is the calf, whose slaughter parallels a Crucifixion, with the Good Thief to the far right—another patristic interpretation. The final setting is identified along the upper margin as Ecclesia; a Dove of the Holy Ghost, traditionally associated with personifications of the Church, floats nearby. For Catholics, *Ecclesia* comprised not only a community of laymen but also an elaborate structure of ecclesiastical institutions designed to mediate between this community and God. Luther's solifidianism rendered such institutions unnecessary; if salvation depended exclusively upon a divine infusion of grace into the faithful soul, there was no need for a clergy exclusively empowered to administer sacraments and to perform other sanctifying rituals. For Lutherans, then, the Church was redefined in terms of a priesthood of all believers. The more radical sectarian groups provided still another definition; while the Catholic and Lutheran churches made room for all who called themselves Christians—including sinners as well as the righteous—Anabaptism and its offshoots conceived of the Church as an association whose membership was limited to the Lord's chosen few—an assembly of saints on earth, whose aim was to establish a kingdom of heaven on earth.

The general orientation of our *Prodigal Son*'s Ecclesia is actually suggested by two smaller scenes toward the rear. In one, an infant is being baptized—in opposition, of course, to Anabaptist doctrine. In the other, communion is being given to lay people who receive, significantly, the cup—in opposition to Catholic doctrine. Though communion in both kinds—*sub utraque forma*—had been the standard practice through the twelfth century, by the following century only the celebrating priest was permitted to drink from the chalice. In 1415 the Council of Constance officially sanctioned this change, more for practical and hygienic reasons than on any theological grounds. Among all the Protestant groups, Lutherans were most adamant in their reinstitution of the older, dual form, claiming that it represented apostolic practice as ordained by Jesus himself.[42]

The Last Supper

This debate over communion in two kinds brings us to an examination of Cornelis's *Last Supper*. The controversy was part and parcel of an overall reinterpretation of the nature and function of the Eucharist that found its original focus, we recall, in the Netherlands during the early sixteenth century. According to the orthodox view, the Mass was, above all, a true enactment of Christ's sacrifice. During the Last Supper, he had offered his body and blood to God the Father under the species

97

of bread and wine; by means of the miraculous change known as transubstantia-
tion, this same offering was repeated each time the priest would consecrate the host
and chalice. Reformers, as noted before, remained divided over the issue of Christ's
corporal presence. While Luther accepted it, others—like Cornelis Hoen, Carlstadt,
Oecolampadius, and Zwingli—claimed that the bread and wine merely symbolized
the body and blood. Luther and his sacramentist opponents were, however, unani-
mous in rejecting the central role of the priest as the agent of any sort of transfor-
mation. They viewed the eucharistic meal, moreover, not as one that was meant to
reproduce Christ's sacrifice but rather, above all, as a commemoration of Christ's
sacrifice. It was, before everything else, a meal of fellowship and a renewal of the
pledge of faith as first established between Christ and his disciples at the original
Supper.

 The biblical accounts of this event—in Matthew 26, Mark 14, Luke 22, and John
13—comprise several episodes: the eating of the pasch, Christ's announcement that
one of the apostles will betray him, their reaction to this statement, the exposure
of Judas, and Christ's institution of the sacrament with the words "This is my
body" and "This is my blood." Representations of this last moment alone, in which
the apostles sit calmly while Christ blesses the wine and bread, were rare through-
out the Middle Ages and Renaissance. The most notable fifteenth-century example
is, of course, Dirck Bouts's altarpiece, which was commissioned by Louvain's Con-
fraternity of the Blessed Sacrament. As a pictorial theme, the Last Supper was gen-
erally interpreted from the standpoint of its place within the Passion. The Betrayal
had long been understood as among the hardest of Christ's sufferings: most com-
mon, then, were those images that emphasized the disciples' agitated response to
his prediction. With the model established by Leonardo's version in Santa Maria
delle Grazie, sixteenth-century artists gave increasing attention to the portrayal of
a range of psychological states, from John's gentle sorrow to the amazement, anxi-
ety, and outrage of the others.[43]

 Carl Christensen's recent study on the relationship between art and the Refor-
mation in Germany includes an analysis of a number of Last Supper compositions
by Lutheranism's semi-official artists, the Cranachs, and notes the extent to which
they retain many standard motifs: references to the paschal meal are present in the
form of the lamb and various eating utensils; John weeps against Christ's breast;
and other apostles respond to his announcement of the Betrayal.[44] A definite depar-
ture from tradition is evident, though, in a work like Lucas the Younger's panel
from 1565 in Dessau, where the eleven faithful disciples are given the features of
different Reformers. On the one hand, this not uncommon practice of providing
contemporary figures with roles and attributes previously reserved for saints re-
flects the development of a distinct Protestant hagiography—a trend that had begun
during the 1520s with images of a haloed Luther, as in Baldung's well-known wood-
cut.[45] At the same time, the "canonization" of latter-day personalities served,
somewhat paradoxically, the distinctly Protestant aim of actualizing and hence

making more accessible the story of Salvation. Within the context of the Reformation's fundamental reinterpretation of the eucharistic rite per se, the active role of current church leaders in the Dessau panel and other Last Suppers may have had an even more precise intent: namely, to emphasize the foundation of a new, evangelical brotherhood through its full participation in the meal that was established by Christ as an expression of brotherhood.[46]

Cornelis Anthonisz's *Last Supper* (figure 31) is one of a handful of woodcuts that present the subject not as part of a Passion series but rather as a fully independent scene, designed on a large scale.[47] While Cornelis's image seems to acknowledge Dürer's woodcut *Last Supper* of 1523 in a detail like the shallow basin in the foreground, its most obvious models are not German at all.[48] Instead, the looser, more fluid line of Cornelis's mature style is applied toward the creation of a dignified, virile company that brings to mind not only Leonardo's composition as reproduced in engravings like Fra Antonio de Monza's of about 1500 but also Raimondi's *Last Supper* engraving after Raphael (figure 103). The setting is a narrow chamber with fluted pilasters; an opening at the center reveals one of Cornelis's vaguely exotic cityscapes. His conception of the Supper itself is somewhat unusual in its attempt to fuse the motif of Christ consecrating the bread and wine with that of Judas's identification. Christ gazes at Judas with one hand raised in a blessing gesture that seems, at the same time, to point toward the betrayer. The accompanying Latin inscription translates:

1 Whoever you are, fair viewer of this sacred table
Consider what this picture means to you
The meal of salvation is seen engraved in this picture
By the art of the famous man Cornelis Anthonisz

5 Here we see our most mild savior Jesus
As he founds the memorial of his strong friendship
While he happily celebrates the last supper
He institutes for us the feast of his body and blood

Happy is he who while he looks at this with his external eyes
10 Holds it fast inside with internal eyes, so that he may meditate on it
Christ gives himself as food to you, so that you can be
The food of your brother, lest evil sloth destroy you

He paid out his whole self for you, so then stand by him
In whatever way you are able, with all your strength and abilities
15 You will do nothing in vain, since he will pay back everything with interest
When this external, corporeal part of us has been laid aside

Thus the text refers to Christ's foundation of a "memorial of friendship" in line 6, yet also goes on to refer to the sacrificial import of the event in lines 11 and 12. Taken as a whole, the text is as generalizing and uncontroversial as the figures

99

above are idealized and temporally remote—and in this regard it is not, perhaps, without significance that Cornelis's name is proudly proclaimed, with an emphasis matched only by his identification in the *Map of Amsterdam*.[49]

The Prodigal Son: *Conclusion*

Turning our attention once again to the final scene of Cornelis's *Prodigal Son* (figure 97f), we might compare its careful inclusion of communion and baptism to a woodcut from about 1545 by Cranach the Younger (figure 104). To the right of the dividing column, Cranach presents a visual catalogue of Catholic practices. In the distance, pilgrims follow a procession around a church; a dying man is given a monastic cowl in the hopes of insuring his salvation; and a bishop consecrates a bell. In the center, an altar is being blessed with the assistance of a devil, while a solitary priest celebrates a private mass. In the foreground, a crowd of clergy attend a sermon, and the pope himself sells indulgences. To the left of the column there appears, in contrast, the "true religion of Christ"; Luther, inspired by the Holy Spirit, preaches to a crowd of laymen. Of the orthodox seven sacraments, Lutherans held that only two had a substantial scriptural basis. Both are shown here, where a baby is baptized and the faithful receive the host and the chalice—precisely, then, as in *The Prodigal Son*.[50]

This similarity aside, Cranach's *True and False Religion* and Cornelis's *Prodigal Son* are, nevertheless, very different in their approach and actually serve to illustrate some basic distinctions between Reformation-related art in Germany and in the Netherlands. It has already been suggested that German visual propaganda was largely Lutheran in its orientation. Unlike the essentially iconoclastic Zwinglians and more radical sects, the Lutherans accepted and indeed encouraged the development of an evangelical kind of ecclesiastical art and were quick to exploit the proselytizing possibilities of printed images.

As R. W. Scribner and others have noted, one of the most obvious features of Lutheran art, especially the printed variety, is its presentation of a simple polar contrast between the old and new views—a process involving the reduction of complex doctrinal issues to a number of discrete and easily identifiable symbols.[51] The contrast was especially embodied in persons; the pope, his clerics, and their congregations were placed in opposition to Christ, Luther, preachers, and evangelical communities. Such stereotypes are structurally linked; the type of sanctification of Reformers seen in the Dessau *Last Supper* had, as its natural complement, a corresponding demonization of the Catholic hierarchy. This could take the comparatively mild form of papal wolves (see chap. 5) but often went to more fiercely satirical lengths. Flatulence, excrement, bestial childbirth, and other such motifs were all employed in the service of anti-Catholic invective. In one broadsheet dating from the 1560s, for example, monks are portrayed as the product of Satan's defecation (figure 101).

100

Needless to say, not every German artist nor every German artist's work would assume a clearly definable position with regard to current religious matters. Just as a broad range of individual responses to these issues remained, there was an equally large number of images that could reflect ideas of religious reform without adopting any sort of party line, and without falling under the rubric of propaganda—pro-Lutheran, anti-Lutheran, or whatever. Moreover, the ambiguities inherent in the relationship between what we know of an artist's personal beliefs, his artistic output, the demands of the market, and other social factors were as operative here as elsewhere. It suffices to recall the case of the brothers Beham and Georg Pencz, whose trial records provide an unusually detailed picture of their rather radical views. Yet Pencz would later work as Nuremberg's official city painter; Barthel became court artist to the Catholic Dukes of Bavaria in Munich; Hans Sebald, as noted earlier, entered the service of Cardinal Albrecht von Brandenburg and also went on to design images for the Lutheran cause.

Bearing all this in mind, we are still left with the fact that in the Netherlands, up until the third quarter of the sixteenth century, even those images showing the clearest Reformation sympathies cannot begin to match the vehement tone of many of their German counterparts.[52] Such restraint was doubtless influenced in part by the imperial government's greater measure of success in suppressing any suggestions of heterodoxy by means of censorship and punishment. But at the same time, not until the widespread shift to Calvinism in the northern Netherlands in the 1570s was there a single, relatively unified institution that could present itself as an antipode to the Catholic Church. Sacramentism, while essentially native in origin, never developed into a distinct, organized body of believers. Anabaptism—also an import, like Calvinism—showed certain exclusivistic tendencies that, along with its iconoclastic views, probably tended to discourage the development of any educative propaganda, visual or otherwise. Familiar with the writings of Luther and other advocates of evangelical religion, the majority of reform-minded Netherlanders during the first half of the sixteenth century nevertheless retained an Erasmian distaste for fanaticism in matters of faith and turned more toward a course of religious and political extremism only with the iconoclastic riots of 1566.[53] Before this time, even in their printed images (where we would expect the strongest possible statements), there is little sanctification of identifiable Protestant leaders and correspondingly little of the ferocious demonization of their Catholic opponents. Nor did that type of bilateral, antithetical composition exemplified by Cranach's *True and False Religion* ever attain popularity.

Among the most forceful extant images is a drawing of about 1525 from the circle of Bernart van Orley, whose troubles with the Inquisition were mentioned earlier (figure 105). It shows, toward the upper left, a church building surrounded by such defenders of the faith as Athanasius, Pope Felix III, Ambrose, and Berenger of Tours. Below, clerics are shown trading in ecclesiastical offices. At the bottom is a 101

procession of abusers of power, including Cain, Nimrod, Semiramis, and Ahab, among others; they are headed toward a mouth of Hell, where pleasure-seekers have already arrived. At the center of the composition is Christ being delivered by Judas to the Principes Sacerdotum. Behind him is Lucifer, who holds a banner decorated with the papal tiara, a king's crown, bishops' miters, and cardinals' hats.[54] Similarly anticlerical sentiments are expressed in a number of drawings by Jan Swart. In his *Wise and Foolish Virgins*, for example, the latter are dressed as nuns, while in his *Parable of the Royal Wedding* the unworthy guest is portrayed as a monk.[55] Clerics and votive-sellers also litter the landscape of the *Ship of Sinte Reynuyt* (figure 57), first published in Amsterdam in 1525–1530 by Doen Pietersz (who, we recall, had issued several Bible editions based on Luther's). Equally pointed is that woodcut from the school of Jacob Cornelisz in which some of the "godless hunters" are beasts wearing cowls, and their weapons include amulets, a rosary, and decretals (figure 99). But however much such images may criticize the Church, its prelates, and practices, none of them suggests that any alternative institution should take its place. There are no portraits of Leo X, Clement VIII, Paul III, or Julius III as the Antichrist, nor any of Reformers invested with halos or other marks of holiness and authority.

In Amsterdam, as we recall, the Anabaptist disturbances of 1534–1535 brought about a much stronger official stance against any signs of heresy. Many citizens certainly retained Protestant sympathies but were obliged to be discreet in their expression. Anxious about the possibility of another uprising, from approximately 1538 on the city became far more stringent in enforcing censorship and imposing punishments of exile and execution.

So far as Cornelis Anthonisz's biography is concerned, there are considerable gaps. We can only note that he seems never to have moved from his birthplace and apparently remained in the good graces of its municipal government, which continued to provide him with cartographical commissions, as well as employing him in connection with the entry of Prince Philip. Yet so far as his extant oeuvre is concerned, it suggests a lack of interest in conventional religious imagery that is pronounced even within the context of the period's overall shift in subject matter, and even considering the greater thematic latitude generally permitted in prints. The Virgin Mary is entirely absent from his work; there are few saints and no mediaeval saints' legends; Christ appears not in his Infancy but rather as founder of the faith, teacher, shepherd, and judge.[56] And, as we saw, the tetragram in his *Patience* (figure 16) may have been interpreted as heterodox by the authorities in Louvain. Nevertheless, the *Deathbeds* (figure 33) would almost seem to make a positive pictorial statement regarding the role of good works in the matter of man's salvation, as does *The Wise Man and Wise Woman* (figure 89), whose prominent jug and loaf of bread are explained as representing the best means to win eternal life (lines 112, 115–18). But neither of these images is at all polemical, and the fact that they were taken over secondhand by Cornelis is a further mitigating factor.

By the same token, caution is also required in connection with *Sinte Aelwaer* (figure 28). It is certainly true that Protestant propagandists would utilize those old traditions of mock religious ceremonies, processions, and cult practices, since they could so easily be turned against a religion now seen as corrupt and obsolete.[57] The anti-Catholic thrust of a work such as Peter Flötner's *Procession of Clergy* is clear (G.825–826); accompanied by a text highly critical of the clergy and indulgences, it features fat friars and their concubines, vomiting, excrement, beer steins and sausages, codpieces, and a backgammon board. The play *Van nyeuvont, loosheit, ende praktike*, with its emphasis upon the business of promoting the cult of Deceit, likewise seems to take as its actual subject the many abuses associated with honoring saints. But the use of mock processions, prayers, and the like need not always imply rejection either of the forms themselves or of the beliefs underlying them. On the contrary, this sort of parody becomes most effective when there is real tension in its application of elevated form to debased content. The type of behavior being faulted seems all the more reprehensible when it takes on a literary or pictorial shape that could, by contrast, be perceived as truly praiseworthy and holy; unless one presumes a certain sincere respect for the original, the satire loses much of its force.[58] Thus even though *Aelwaer* includes a reference to the mercenary motives of her cult's three sponsors, its real target is not the honoring of saints but the "honoring" of contention and querulousness. (Similarly, in the *Ship of Sinte Reynuyt*, the mocking of pilgrimages, votive and indulgence sellers, and the prominent inclusion of the clergy are all apparently unorthodox elements. But again its primary goal is criticism of the sorts of ne'er-do-wells we have already encountered in *Sorgheloos* and *The Flighty Youth* and, for that matter, in *Aelwaer*'s text itself.)

Of the works by Cornelis examined thus far, it is the unsigned *Prodigal Son* that turns out to express the clearest reforming sentiments—particularly when its more ambiguous features are approached in the light of the unquestionably nontraditional communion of the last scene. As noted earlier, for example, the charge of heresy would be leveled against all participants in the conflict; but it now seems reasonable to view the figure of Haeresis as corresponding more to the claim that it was conventional Catholicism, with its deviations from the gospel, that was truly guilty of this crime. Haeresis's academic companion, Ratio, also takes on more precise connotations, suggesting, in particular, the current disaffection with Scholasticism. Luther, for example, decried its style of speculative, intellectualizing theology "which men regulate according to reason," and "which belongs to the Devil in hell."[59] Spiritus Erronei et Fanatici, Superstitio, Fermentum Pharisaeorum, and Synagoga Sathanae also assume a more specific thrust, while Gens Judaica brings to mind that standard identification of the older brother with the legalistic approach of "papists and monks." Even so, the series as a whole is far from stridently polemical in tone, nor does it declare any definite sectarian allegiance. If the final scene's sacraments conform to Lutheran practice, the fourth and fifth scenes' Ultio 103

Divina and the tetragrammaton are, we remember, both drawn from an Anabaptist broadsheet. Indeed, the coexistence of these elements in the same series points to a fact that has become increasingly clear to historians, namely, the wide diversity of doctrinal views and lack of strict doctrinal boundaries during the earlier stages of the Reformation (1520s–1550s), particularly in the Netherlands.[60]

"When it was highest . . ."

Apart from his unconventional representation of Nabal, Cornelis's oeuvre includes two images whose subject matter is drawn from the Old Testament. The first is an unsigned woodcut showing Moses and Aaron behind what were clearly meant to be the tablets of the law (figure 106). The only surviving impressions are late and were taken from a cut-down block; originally the tablets were surely complete and no doubt contained the text of the Ten Commandments.[1] Although there is nothing in the way of a publisher's address to lend further weight to the attribution, the half-length presentation, the imposing, monumental quality of the figures, and the carefully rendered facial features can be particularly compared to the early *Allegory of Transitoriness* (figure 14); it seems reasonable, then, to date this work in the late 1530s.

The other work is a narrative scene—a *Fall of the Tower of Babel*, dated 1547 in the lower left-hand corner and designed on what was still an unusually large scale for an etching (32.4 by 38.4 centimeters).[2] Genesis 11:1–9 tells how, after the Flood, the offspring of Noah settled on a plain in the land of Sennaar:

> And they said: Come, let us make a city and a tower, the top whereof may reach to heaven: and let us make our name famous before we be scattered abroad into all lands. And the Lord came down to see the city and the tower, which the children of Adam were building. And he said: Behold, it is one people, and all have one tongue: and they have begun to do this, neither will they leave off from their designs, till they accomplish them in deed. Come ye, therefore, let us go down, and there confound their tongue, that they may not understand one another's speech. And so the Lord scattered them from that place into all lands, and they ceased to build the city. And therefore the name thereof was called Babel, because there the language of the whole earth was confounded: and from thence the Lord scattered them abroad upon the face of all countries.

The story was repeated in more detail by the first-century A.D. author Flavius Josephus in his *Jewish Antiquities* (i:iv). It was his version that popularly established Nimrod (the "stout hunter" and founder of cities mentioned in Genesis 10:8–10) as the tower's instigator. Josephus describes Nimrod as a tyrant who swore to 105

avenge the death of his forefathers in the Deluge by constructing a tower so high that no waters could reach it, should God have a mind to drown the earth again. Nimrod's people set to this task with great eagerness, whereupon God, unwilling to annihilate them, instead "created discord . . . by making them speak different languages." So, explains Josephus, the place where they made the tower was called Babylon from the confusion of speech, "for the Hebrews call confusion 'Babel.' " He closes his account with a paraphrase of the story as recounted in Book III of the *Sibylline Oracles* from the second century B.C., where it is said that "the gods sent winds against it and overturned the tower."[3] This report of the tower's actual destruction is not included in Genesis 11 but obviously brings to mind the fall of Babel/Babylon as prophesied in Isaiah 13, 14, 21, 46, and 47 and in chapters 50–51 of Jeremias; in Jeremias 51:1 there is even mention of a similar means of destruction: "Thus saith the Lord: Behold I will raise up as it were a pestilential wind against Babylon."

Babylon's fall was also, of course, a central theme in the Apocalypse of John. In chapter 18, the city is beset by plagues, death, famine, and fire; kings, merchants, and shipmasters look on and weep; and a mighty angel casts down a millstone to signify its demise. The notion of the tower's collapse certainly remained a viable one. In Petrus Comestor's highly influential biblical commentary, the *Historia Scholastica*, it is said that God dispatched his angels to confound the Babylonians' tongues and then directed his winds to demolish their construction.[4]

But most representations of the story would show neither the fall nor even the confounding and dispersal of the people.[5] Rather, the focus is generally on the building process, with busy figures mixing mortar, laying bricks, and hauling pulleys. Images of the tower have been traced as far back as the sixth century; by the thirteenth century they were appearing with some regularity among manuscript illuminations, particularly in world chronicles, in Augustine's *De Civitate Dei*, and in the *Speculum Humanae Salvationis* (where its confusion of tongues was opposed to the Pentecost), as well as in Bibles. Neither Genesis nor Josephus provided much information regarding the precise shape of the tower; up until the sixteenth century it is portrayed, for the most part, as a slender, four-sided or polygonal structure, often tapering as it rises. It is usually assumed that the story in Genesis had been inspired by the great temple towers or ziggurats of Mesopotamia. Herodotus visited such a temple in Babylon itself in the mid-fifth century B.C. and described it as consisting of eight towers, one growing out of the other to form a single tall structure that was mounted by means of an exterior encircling ramp (1:180–81).[6] It is uncertain to what degree information regarding such architecture might have been transmitted to mediaeval artists by means of classical sources like Herodotus or by more recent travelers' reports. In any case, by the late fourteenth century we also begin to find examples in which the slender, sided tower is similarly equipped with a spiral ramp—as, for instance, in a miniature from the *Bedford Hours* of 1423–1430.[7] This scene is notable as well by virtue of the fact that, although construction

proceeds apace at the lower levels, divine retribution has already begun above; two hammer-wielding angels attack the tower, pieces of masonry drop off, and fights break out among the workmen, suggesting the conflict and chaos that will shortly overtake the others.

The Tower of Babel continued to appear among the illustrations in printed editions of the Bible, the *Speculum Humanae Salvationis*, and various world chronicles; in the *Nuremberg Chronicle* of 1493 it is still rather narrow and square. Not before the 1520s or 1530s was there a general shift toward a round type, such as in Hans Holbein the Younger's woodcut from the 1538 *Historiarum Veteris Testamenti Icones* (figure 107). Like most previous examples, Holbein's structure looks hardly capable of reaching heaven. The square, spiral-ramp tower from the *Grimani Breviary* of about 1500–1510 is perhaps the first to create an impression of enormous height (figure 108); later towers would become increasingly massive, while workers and surrounding buildings multiply in number but seem increasingly dwarfed.

It was in the Netherlands, of course, that the Tower of Babel would attain greatest popularity as a subject for independent paintings, though evidence regarding its early development in this respect remains fragmentary. The catalogue of Andrea Vendramin includes a Tower assigned to Lambert Lombard.[8] Marcantonio Michiel cites another, supposedly by Patinir, in the house of Cardinal Grimani in 1521; this work has been tentatively identified with a panel now in the Cà d'Oro, more recently attributed (though still improbably) to either Jan van Scorel or Jan Swart.[9] Whatever the authorship, it most likely predates Bruegel's enormously influential versions of the subject: the so-called *Large Tower* of 1563 in Vienna and the *Small Tower*, from about 1564–1568, in Rotterdam.

In the 1561 Antwerp *ommeganck* after which van Heemskerck modeled his *Cycle of Human Vicissitudes* series, the triumphal cart of Hooverdicheyt (Pride) was decorated with a portrayal of the Tower of Babel.[10] The tower was, indeed, the quintessential image of human arrogance and its ultimate consequences. Georgia Montanea's *Monumenta Emblematum Christianorum Virtutum* (ed. princeps Lyon, 1571) represents the tower assaulted by wind and fire from the skies, while men attack it with picks and a battering ram; the lemma reads "Quid superest" (What survives).[11] Petrus Iselburg's *Emblemata Politica* (ed. princeps Nuremberg, 1617) includes a Tower of Babel with the motto "Humana consilia vana" (Vain human plans).[12] Similar sentiments are suggested by the inscription printed on a banderole floating in the upper corner of Cornelis's etching (figure 26): "Alst op thoechste was / most het doen niet vallen" (When it was highest / must it not then fall?). To the upper right is another inscription borne upon a cloud—"Babelon / Genesis"—and the bat from Dürer's *Melencolia I*, now bearing the monogram CᴀT . Below, the tower cracks and collapses in great chunks, blasted by a divine wind that bears sword-wielding and trumpet-playing angels. To the left, a ship sinks in the harbor, while turbaned horsemen and foot soldiers escape across a 107

bridge. Trapped amid the buildings tumbling down all around them, the people of Babylon rush about in terror or lie crushed by pieces of masonry. Bent at the waist and with his shoulders twisted in a pose clearly inspired by the Torso Belvedere, Nimrod appears fallen in the foreground, a crown and scepter at his side; nearby is another, half-kneeling figure in a Dying Gaul attitude.

Both allusions to antique sculpture are very much in keeping with the scene as a whole. In addition to the piece of a denticulated cornice, the scattered Corinthian capitals, the fluted columns, and other classicizing forms, there is the tower itself. Stacked one atop the other, each of its seven levels is circular in plan and composed of an identical sequence of stories, all marked by sturdy pilasters. The first story has small round windows; the second has no openings; the third has arches; and the uppermost is pierced by narrow rectangular windows. Jagged cross sections reveal an infrastructure of additional heavy archways. As we have seen, Cornelis's architecture can serve a variety of functions apart from the purely formal. In some cases, it simply reinforces a sense of the exotic—of an "other" time and place, however vaguely defined. The *Fable of the Father, Son, and Ass*, for example, has a background that includes a contemporary thatched farmhouse and a townscape but also antique-style buildings, both ruinous and intact (figures 23a–b, 65). In other cases—the *Allegory of Christianity* (figure 41) and *The Ages of Man* (figure 32), for example—the architecture, far from being merely evocative, plays an important symbolic role. None of Cornelis's works—except for the one at hand—portrays buildings that can be specifically identified. But for reasons that will become increasingly clear, we can recognize in Cornelis's tower a deliberate reference to the Colosseum.

The name "Colosseum" was probably applied to the Flavian amphitheater soon after its construction in the first century, no doubt in response to its impressive size. A mediaeval belief held, however, that the name was derived from a huge statue of Phoebus mistakenly thought to have stood either inside or on top of the building, which was thus interpreted as a temple of the sun, complete with a roof. Not until the fifteenth century did humanists reestablish its original role as the site of gladiatorial games.[13] The Colosseum's marvelous character assured it a prominent place in virtually every guidebook since the twelfth-century *Mirabilia Urbis Romae*, as well as in countless maps and views. The *Nuremberg Chronicle*, for example, represents it clearly if not quite correctly as a round structure of four stories, all of which are arched. Northern artists who visited Italy during the sixteenth century were careful to include it in their study of Roman monuments. Jan Gossaert's pen and ink drawing from 1508, in the Berlin Kupferstichkabinett, is a characteristically overwrought portrayal, if fairly accurate as a record of the individual architectural components. Van Heemskerck sketched the Colosseum several times during his stay in the city from 1532 to 1536–1537 and later incorporated it into a number of paintings and designs for engravings. His 1552 *Bullfight in an Arena* and his view

108

of the Colosseum from the 1572 *Wonders of the World* engraving series both include large statues that demonstrate the old legend's longevity (even though they bear the attributes of Jupiter rather than Apollo).[14]

Another, less direct reminiscence of the Colosseum can perhaps be recognized in a drawing attributed to Jan van Scorel, no doubt produced after if not during his own Italian sojourn of the early 1520s. Set in a landscape punctuated by various classical structures, some apparently in a state of decay, the great circular building consists of four levels that decrease slightly in height and circumference as they rise; there are arched openings at the first story and a roof at the top.[15] Whether this was intended simply as an architectural fantasy or, in fact, as a Tower of Babel is not entirely clear; there is none of the active construction usually associated with this scene, nor any group of figures that might be identified as Nimrod and his retainers. In any event, an adaptation of the Colosseum for portrayals of the biblical tower seems natural enough; it was universally famous, fittingly enormous, and quite suited to the kind of stacking treatment found in Cornelis's and, later, Bruegel's versions. Moreover, unlike those monuments of the geographically more appropriate but less commonly visited Near East, it was quite accessible. Last but by no means least, it would have carried connotations entirely suited to the tower's standard role as an emblem of both *superbia* and *vanitas*.

As noted earlier, the cart of Pride in the Antwerp *ommeganck* of 1561 bore an image of the Tower of Babel. Yet when van Heemskerck re-created this procession in his engraving series of 1564, he gave *Superbia*, instead, a background of antique monuments, including a pyramid, obelisks, a large statue of a helmeted warrior, a column clearly modeled after Trajan's, a triumphal arch, and a fabulous, multi-tiered structure whose arches and Corinthian pilasters support an entire city (figure 109). For all the admiration and awe accorded such ancient monuments, there was also a long-standing, parallel tradition that perceived them concurrently as witnesses to the transitory nature of even the most impressive human achievements—indeed, the more imposing and ambitious the monuments, the more forceful this message. Whether as a result of divine punishment for our hubris, or as a result of the ravages of time, or, finally, as a result of man's own destructive impulses, every human work will ultimately end in ruin. Sebastián de Covarrubias would express a similar idea in his *Emblemas Morales* (Madrid, 1610), where the image of a setting sun, a galloping horse and rider, and a decaying arch is accompanied by the motto "Cuncta fluunt" (Everything vanishes); the epigram lists five of the Wonders of the World—the Colossus, the Pyramids, the Pharos, the Mausoleum, and the Temple of Diana—and explains that they, too, are transitory.[16]

There was, of course, no more renowned and visible illustration of the vicissitudes of Fortune than ancient Rome, whose monuments would inspire countless authors to reflect upon her eternal greatness while, at the same time, mourning her 109

inevitable decline.[17] Both themes are interwoven in the poem *De Roma* by Hildebert de Lavardin (1056–1133), bishop of Le Mans:

> Rome, without compare, though all but shattered;
> Your very ruins tell of greatness once enjoyed.
> Great age has tumbled your boasting,
> The palaces of Caesar and the temples of the gods
> alike lie smothering in the mud.
> Fallen, fallen the prize of all that effort
> At whose power the dread Araxes once trembled
> Whose prostration he laments today.[18]

But perhaps the lengthiest exploration of the contrast between Rome's past glory and present deterioration is to be found in Joachim du Bellay's series of sonnets from 1558, *Les Antiquitez de Rome*:

> Rome, living, was the ornament of the world,
> Dead, she is its tomb. . . .
>
> These old palaces, these old arches that you see,
> These old walls, which one calls Rome.
> See what pride, what ruin. . . .
>
> Only the Tiber, which flows toward the sea
> Remains of Rome. Oh earthly inconstancy![19]

Dating from the 1540s is a series of five *Trionfi* by Michael Coxcie, most likely preparatory drawings for tapestries. In the last design, Saturn/Time appears seated amid a collection of ruins, including a pedestal whose inscription seems to identify the site with Rome (figure 110).[20]

 If Rome, more than any other specific locale, typified the passing of all earthly glory, the Colosseum perhaps typified Rome more than any of her other landmarks—an identification that is reflected in the celebrated saying apparently devised by mediaeval pilgrims and recorded by the Pseudo-Bede:

> Quamdiu stabit coliseus, stabit et Roma;
> quando cadet Coliseus cadet et Roma;
> quando cadet Roma, cadet et mundus.
>
> (So long as the Colosseum stands, Rome stands;
> when the Colosseum falls, Rome will fall;
> when Rome falls, the world falls.)[21]

We are, then, hardly surprised to find it singled out from the city's other crumbling monuments as an image of *vanitas*: such might have been van Heemskerck's intention—at least in part—when he placed the Colosseum in his 1553 *Self Portrait*.[22] More explicit is the role of the Colosseum in an engraving from Jacobus à Bruck's

110

Emblemata Politica (Cologne, 1618), where it appears together with an old tree that splits the crown around its trunk. The accompanying motto reads "Sic conterit aetas" (Thus time destroys), while the epigram explains how all empires, regardless of their size and might, must eventually crack and fall, just like the oak.[23]

In addition to its fame, its relative accessibility, its suggestively enormous size, its easy adaptation to a many-leveled treatment, and its association with notions of human pride, ambition, and *vanitas*, there is yet another reason why the Colosseum might have been chosen as a model for the Tower of Babel, namely, the traditional connection between Babylon and Rome, as established by Scripture itself. In the Apocalypse, the great harlot of Babylon is "drunk with the blood of the saints and . . . martyrs" and rides a beast "whose seven heads are seven mountains" (17:6, 9)—clear references to Rome and her seven hills. Patristic writings continued to make this analogy, perhaps the most familiar being Augustine's characterization of pagan Rome, in his *De Civitate Dei*, as the "daughter of the former Babylon" and a "second Babylon in the west."[24]

Needless to say, its eventual emergence as the capital of a Christian empire also resulted in another, very different picture: that of a purified Rome, reborn from the ashes of her wicked heathen past. Beginning with Origen, Tertullian, Jerome, and Augustine, we encounter a version of universal history that remained commonplace even in Cornelis's day. Whether it was seen as the fourth of Daniel's Four Monarchies or the sixth of the Six Ages corresponding to the days of creation, the Roman Empire—founded by Augustus and subsequently purified and transformed by the Church—was the last of the world empires. It would continue, in its Christian form, until the very end of time. So long as Rome stood, the world would stand—and it is this idea that lies behind the proverbial ". . . quando cadet Roma, cadet et mundus."[25] With the Italian Renaissance, of course, the long-prevailing, essentially negative view of heathen culture was radically amended. Ancient Rome, far from being seen largely in terms of spiritual darkness, was instead upheld as an ideal. Her fallen glory might prompt thoughts of earthly transience; her architecture might appear in Quattrocento images of the Adoration of the Magi as a symbol of the passing of paganism.[26] But even if ancient Rome had not lived "under grace," still her art and philosophy inspired the highest esteem and emulation.

Not surprisingly, it was the Reformation that revived the early Christian image of a depraved and sinful Rome, of Rome as Babylon—though now, instead of ancient Rome, it was contemporary, papal Rome that would be perceived as such.[27] We noted, in connection with Cornelis's *Prodigal Son*, how charges of heresy and pharisaism were leveled by both Reformers and Catholics against each other, and the same holds true in this case. In Germany, Catholic apologists called Luther a *Babeltürmer*; in the Netherlands, the chronicler Marcus van Vaernewijck (1518–1569) likened the dissension caused by Calvinists, "Martinists," and Anabaptists to the chaos of Babel.[28] The metaphor was more often and more emphatically employed in Protestant writings, however. Rome and the papacy were repeatedly re- 111

ferred to as Babylon, while the pope himself was identified as both Nimrod and, as we saw earlier, the Antichrist. The proliferation of different orders, each with its own habits, practices, and doctrinal views, was compared to the confusion of tongues; in poems dated 1528, 1548, and 1558, for example, Hans Sachs relates the story of Genesis 11 and goes on to complain that "Carmelites and Bernardines, Carthusians and Augustinians" were still building onto the tower.[29] In a *spel van sinne* performed at Middelburg in 1539, a soul is rescued by Faith from "Babilon die groot," where Catholic devotions are practiced. And in a Dutch pamphlet entitled *Den val der Roomischer Kercken met al hare afgoderie*, there are explicit references to the Babel/Babylon of the Apocalypse.[30]

Moreover, the comparison between contemporary Rome and sinful Babylon was made not merely in a moralizing but also in a literally eschatological sense. As numerous historians have noted, the age of the Reformation also saw a widespread resurgence of interest in eschatology. Newly anxious about the matter of their salvation, men naturally gave increased attention to all those events leading up to the Last Judgment. From the late fifteenth century on, there had been a proliferation of popular writings that predicted the imminence of a great change. Many of the comets, meteors, strange heavenly lights, misbirths, and deformations of nature recorded in broadsheets and pamphlets of the day were interpreted as omens of such a change, which was sometimes understood as the end of the world or sometimes as the coming of a new epoch of the world's existence.

The evangelical movement as a whole was quick to adapt these apocalyptic convictions to its own needs. Anabaptists and other radical sectarians were not the only ones to hold millenarian views. Melanchthon, Luther, and others within the mainstream of the Reformation also expressed their opinion that the final days were at hand and would be signaled by the fall of the pope/Antichrist and the collapse of papal Rome/Babylon. It was by the dissemination of the true gospel that the papacy would be overthrown; Christ would then return to found a kingdom of true believers.[31] In the Cranach workshop's illustrations for the September 1522 edition of Luther's New Testament translation, such notions are given explicit pictorial form. In the woodcuts for Apocalypse 11, 16, and 17, the beast from the bottomless pit and the great harlot both wear papal tiaras. In the woodcut for chapter 14 (figure 111), Babylon itself is unmistakably shown as the city of Rome, now in a state of collapse and conflagration, with views of the Vatican Palace, the Belvedere, and the Castel S. Angelo derived from the right half of the panorama in the *Nuremberg Chronicle*. The New Jerusalem, on the other hand, seems to have been portrayed as a German town—indeed, the cityscape in Holbein's corresponding illustration for the Basel 1523 New Testament is actually a portrayal of Lucerne.[32]

That Cornelis's etching (figure 26) refers to the sin of pride and to pride's consequences is unquestionably clear from his inscription at the upper left corner. Yet 112 this message in and of itself cannot begin to account for what is a uniquely cata-

strophic presentation. In those relatively few images where the tower actually falls, it seems to be a gradual process—as, for example, in the *Bedford Hours* miniature. Cornelis's tower, on the other hand, virtually explodes. Moreover, when the demolition is equally drastic—as, for example, in two successive scenes from van Heemskerck's 1569 *Clades* series—it is still only the tower that collapses, while all the surrounding architecture remains intact (figure 112). But in Cornelis's print the destruction is universal, including all the outlying buildings and even a ship that sinks in the harbor. Finally, the angels descending on a blast of heavenly wind are armed with trumpets and swords, just as in portrayals of the Last Judgment and the Apocalypse. Thus there is an unusual degree of fusion here between the story of the Tower of Babel as presented in Genesis 11 and the destruction of Babylon as described, particularly, in the Revelations of St. John. This fusion might even be reflected in one additional, most puzzling detail; all extant impressions of the etching show two strokes—rather blurred but clearly added in the plate—that seemingly alter the inscription "Genesis 11" so as to read "Genesis 14." Since Genesis 14 bears no conceivable relationship to the scene below, we must conclude either that it was an erroneous emendation or an allusion to chapter 14 of the Apocalypse, where the fall of Babylon is first mentioned.[33]

Whatever the case, Cornelis's otherwise undeniably apocalyptic *Tower of Babel* cannot help but recall those illustrations from the 1522 New Testament and raises the question of whether his print might have had similarly partisan aims. Does it make the same pictorial connection between the fall of wicked Babylon and the fall of the Catholic church as we saw in the Cranach workshop woodcuts? The only image that can be cited in support of this possibility is the illustration for Apocalypse 14 in the Wittenberg 1534 edition of Luther's Bible (figure 113). Here the view of Rome includes a collapsing structure, presumably meant to be the Colosseum, in a version that seems to reflect the lingering belief in its original role as a roofed temple.[34] Pulled out of its topographical context, Cornelis's Colosseum-inspired tower would still have suggested Rome. But as an isolated monument, it is unlikely that the ancient arena would have made an appropriate or, more importantly, a readily comprehended symbol of *Catholic* Rome. Except for the 1534 illustration, every view of Babylon-as-Rome in Lutheran Bibles was careful to focus on modern (or modernized) buildings specifically linked with the papacy. Most consistently singled out is the Castel S. Angelo, which also turns up in other examples of Reformation propaganda—notably in images of the so-called Papal Ass, a monster allegedly fished from the Tiber in 1496. In one pamphlet from 1523 by Melanchthon and a second from 1545 by Luther—both translated into several languages and often reprinted—the monstrous ass, interpreted as an omen that the papacy's end had come, is shown standing before the Tor di nona (a papal prison) and the Castel S. Angelo (figure 114).[35]

There is thus every reason to interpret Cornelis's *Tower* as participating in the long-standing tradition of an essentially neutral, moralizing equation of apocalyptic 113

Babylon and Rome—however tempted we might be to understand his image as the Dutch equivalent of the Lutheran Bible illustrations. Instead, Cornelis's portrayal of a consistently "ancient Roman" Babylon is the natural outgrowth of a series of standard, nonpartisan literary and pictorial associations—associations that had long linked Rome, Roman ruins, the Tower of Babel, the city of Babylon, the sin of pride, the theme of *vanitas*, and the end of the world.[36]

12 Conclusion

What image of Cornelis Anthonisz has emerged from our examination of these more than twenty works? At the outset of this study, we cited Maarten van Heemskerck as another Dutch printmaker with a similar penchant for unabashed and elaborate allegorizing. Indeed, in one case—that of *The Misuse of Prosperity* and the *Cycle of Human Vicissitudes* (figures 25a–g, 109)—he and Cornelis even illustrated precisely the same allegorical sequence. Among the most diligently Italianate artists of his generation, van Heemskerck developed a vigorous, strongly plastic figural style to which he would remain faithful throughout his long career. This formal idiom was applied not only to his many scripturally inspired subjects but also to a notably large number of subjects of a decidedly humanistic nature. The latter were surely prompted, in part, by his extended stay in Rome from 1532 to 1536–1537, yet were no doubt reinforced by his documented friendships, once back in Haarlem, with a number of the leading artistic and intellectual lights of the day. Ilja Veldman has observed that this scholarly orientation would become, if anything, increasingly pronounced as time went on. Particularly after about 1560, when van Heemskerck seems to have established a close association with the famed philologist, historian, poet, and physician Hadrianus Junius (1511–1575), scenes from mythology and themes like the Four Seasons, the Four Temperaments, the Seven Planets, and the Triumphs of Petrarch appeared with increasing frequency among his designs for engravings.[1]

On the basis of Cornelis's two earliest dated woodcuts, we might be inclined to suppose that he would tread a similar path. For the *Marcus Mutius Scaevola* of 1536 (figure 13), he cast an impressively muscled, Gossaertesque figure in the role of a character from Roman legend—one whose demonstration of self-control gave him an honored place in the pantheon of Stoical exemplars.[2] And the *Allegory of Transitoriness* of 1537 (figure 14) offers an even more explicit expression of Stoical precepts, with its COGNITIO DEI ET NATURAE RATIONALIS and Senecan VELOCITAS TEMPORIS. Any expectation that these two works represent the first in a long line of images featuring comparably monumental, heavyset heroes and edifying classical exhortations is thoroughly foiled, however, by what follows. His *Good Shepherd with Sinners* of 1540 (figure 15), for example, employs a certain solid though clearly 115

more proletarian type also seen, as we recall, in such works as *Truth, Hate, and Fear* (figure 17), *Nabal, Ceres, and Bacchus* (figure 18), and *Patience, Satan, and Sin* (figure 16). But Cornelis's most consistent mode turns out to have been that Scorelesque brand of mannerism first encountered in *Concord, Peace, and Love* of 1539 (figure 20), with its more loosely rendered forms and lanky, slightly awkward, though still elegant figures. Repeated in *Dives and Lazarus* of 1541 (figure 38), *Fable of the Father, Son, and Ass* of 1544 (figure 23a–b), *The Misuse of Prosperity* of 1546 (figure 25a–g), *Tower of Babel* of 1547 (figure 26), and *Lords of Brederode* of 1550–1551 (figure 9), this approach is also particularly exemplified by such other, undated prints as *The Flighty Youth* (figure 24a–b), *The Ages of Man* (figure 32), *Deathbeds of the Righteous and Unrighteous* (figure 33), *The Last Supper* (figure 31), *Allegory of the Prodigal Son* (figure 97a–f), and *Arterial System of the Human Body* (figure 30).

At the same time, we found Cornelis very much aware of the work of German graphic artists, particularly in woodcut. *Sorgheloos* (figure 37a–f) based its narrative on a series of images devised by the Dutch painter Pieter Cornelisz Kunst but rendered its forms in a detailed, descriptive linear language most reminiscent of those designs by Jörg Breu the Younger, Hans Schäufelein, and Dürer that also served as sources for several individual motifs. In Cornelis's *Wise Man and Wise Woman* (figure 89), this language would be applied toward an iconographical model apparently provided by Anton Woensam. In *Sinte Aelwaer* (figure 28), it was Dürer, once more, who inspired the ass. The *Allegory of Christianity* (figure 41) was modeled after a work—in this case an engraving—by Hans Sebald Beham, while *Deathbeds* borrowed its composition from yet another woodcut by Breu. Elsewhere the debt is not quite so direct but still clearly detectable: his *Ages of Man* has several features that indicate some familiarity with a version of the subject again by Breu; his *Truth, Hate, and Fear* can be related to certain elements in the *Michelfeldt Tapestry* (figure 78).

If the emphatically Romanist style of the early *Marcus Mutius Scaevola* and *Allegory of Transitoriness* was short-lived, so, too, it seems, was Cornelis's involvement with subjects or sentiments of a self-consciously humanistic kind. Excluding the *Map of Amsterdam*'s obligatory Neptune (figure 3), his only mythological characters would be a Ceres and Bacchus whose unusual role in relation to the biblical Nabal actually sets them somewhat apart from conventional representations of classical deities. And while *The Tower of Babel*'s broken columns, capitals, and pediments and its paraphrases of the Colosseum, the Torso Belvedere, and the Dying Gaul type certainly constitute deliberate allusions to the art of antiquity, they function, again, in rather particular, specifically biblical terms.

Herring and pigs' feet; a cat in the cupboard and dog in the pot; disreputable taverns and a filthy scullery; an *oblieman* and a biting, beating Poverty; profligate youths just out of the egg; a mock saint complete with menagerie; gossiping 116 shrews, a belligerent mercenary, a camp follower, an obscenely gesturing peasant;

a wolfish Turk; Truth as a *huisvrouw*; and a barrel-bodied swine—features like these all exemplify the more colloquial inclinations of Cornelis's work. Through the frequent use of proverbs or figures of speech and of elements derived from folklore, popular customs, and rituals to help convey his explicitly moralizing messages, Cornelis participates in the same venerable tradition whose most renowned representative would be, of course, Pieter Bruegel.

Surely not without some bearing on the colloquial aspects of Cornelis's oeuvre is the matter of personal connections. So far as can be documented, his only direct, protracted association was with that unpretentious *figuursnijder* and publisher, Jan Ewoutsz. Just as there is no evidence of Cornelis's ever having visited Italy, neither is there anything in his biography to imply the sort of distinguished friendships enjoyed by certain other artists. *The Prodigal Son*'s complex interweaving of various exegetical threads does suggest a collaboration, in one instance, with a theologically learned adviser. Yet his identity remains a mystery—and we are unable to verify any ties with particular scholars or other prominent cultural figures, either beyond or even within the limits of Amsterdam.

In many respects, then, Cornelis can be said to conform to our expectations of an artist active, for the most part, in the comparatively modest medium of woodcut. His imagery may lack the insistent erudition of van Heemskerck's, and his accompanying texts may show a distinct preference for the vernacular (*Marcus Mutius Scaevola, Allegory of Transitoriness, The Last Supper,* and *The Prodigal Son* being the only works to employ Latin—and the first two even having translations). Yet his oeuvre was still clearly meant for an audience sophisticated enough to appreciate an often elaborate allegorical vocabulary and a comic sensibility that involves both parody and some very clever visual and verbal punning. As the texts to *Sinte Aelwaer* and *Sorgheloos* so explicitly indicate, this audience was doubtless found, above all, in that same literate (though not learned) urban middle class from which the *rederijkers* drew the bulk of their membership, and to which they directed their poetic and theatrical efforts.

What, then, did Cornelis have to say to his peers? In the first place, we observed his full-fledged participation in the general movement of that period away from such traditional religious subjects as scenes from the Infancy, the Passion, the life of the Virgin, and the lives of saints. Indeed, we even found him adopting such newly minted motifs of Protestant iconography as the tetragrammaton, the Ultio Divina, and communion in two kinds. In the *Allegory of the Prodigal Son,* we saw these and other elements combined to produce a demonstrably unorthodox statement—a statement that reflects, by the same token, the fundamentally moderate nature of evangelical thought in the Netherlands during the first half of the sixteenth century. Temperate in tone and, so far as we can tell, devoid of any clear-cut sectarian allegiances, Cornelis's *Prodigal Son* is also his only extant work that could be classified as propagandistic in intent.

In fact, of just as much importance as its contribution to the history of graphic 117

propaganda was the role of the Reformation in helping to turn the attention of contemporary artists (and their audience) toward religious narratives and individuals that might yield some broadly ethical rather than merely devotional message—hence Nabal's appearance as a model of unbridled appetite in *Nabal, Ceres, and Bacchus*; David, the tax collector, and the Prodigal's appearance as models of remorse and the powers of divine forgiveness in the *Good Shepherd*; Lawrence and John the Baptist's appearance as models of patience in *Patience, Satan, and Sin*; and Nimrod and his subjects' appearance as models of pride and the vanity of human ambition in *The Tower of Babel*.

On the whole, however, Cornelis would exhibit less interest in the sacred and scriptural than in basically secular characters offering eminently practical lessons on how best to live in this world. Illustrated and stated in different ways in such works as *Sorgheloos, The Flighty Youth, Sinte Aelwaer, Fable of the Father, Son, and Ass, Concord, Peace, and Love, Truth, Hate, and Fear, The Misuse of Prosperity, Demon of Drink*, and *The Wise Man and Wise Woman* is the pragmatically offered advice to live temperately, chastely, industriously, thriftily, discreetly, respectably, peaceably, and according to the dictates of conscience and common sense.

Appendix

Sorgheloos

1 Ick Sorgheloose stel my ter jacht fray ende lustisch
 Met Weelde mijn lief die ick beminne
 Ghemack mijn pagie is oock seer rustich
 Op welcke twee ick fondeer mijn hert ende sinne
5 Want duer haer beyder aenschouwen solaes ick vinne
 Dies my gheen molestacie mach so beswaren
 Als ick slechs haer beyder pays ghewinne
 Want druck ende verdriet doense van my verharen
 Ken achtet goet niet, al hebbent mijn ouders gaen sparen
10 Ick wilt verteeren met hoveeren drincken ende storten
 Want minnert het goet die daghen die corten

 Ghy jonghe ghesellen van cloecke statueren
 Slacht niet den sorgheloose maer leeft by maten
 Peynsende tleven sal hier niet langhe dueren
15 Ende die sorgheloose blijve by godt verwaten
 Ende si en comen oock niet tot mannen van staten
 Jae na een vruecht volghen wel duysentich suchten
 Maer met u goet doet de armen doch charitaten
 So sullen uut u wasschen die gherechte vruchten
20 Ende weelde en ghemack sullen daer door van u niet vluchten
 Maer uwer buchten sullen daer door vermeeren van stonden an
 Dus peynst doch een weynich op den ouden man

 Tsa laet ons nu storten ende poeyen
 Want int huys van Quistenburch sijn wy gheseeten
25 O Weelde mijn lief wilt u doch verfroyen
 Hier is ghenoech om drincken om eeten
 Ende Ghemack mijn pagie wilt doch alle druck vergheten
 Want in mijn boerse is noch so menich pont
 Ende tuwer beyder besten vaet mijn vermeeten
30 Want die liefde uwer beyden heeft mijn herte doorwont
 Tlijf is mijn ghesont stelt den buyck int ront
 Tot deser stont wilt trueren noch sorghen
 Faelgeert ons tgelt ick hebt ghestelt al op een borghen

 Alle jonghe ghesellen hoort mijn vertrecken
35 Bruyct doch maet in uwen jonghe leven fier

119

Want dusdanich leven is mede te ghecken
Men mach wel drincken wijn ende bier
Ende beminnen weelde in matelicker manier
Maer thuys van Quistenburch wilt niet in logeren
40 Want onmaet vergaet als men daghelicx aenschouwen hier
Ghemack moechdi oock wel begheren
Maer al winnende moecht ghijt te met verteren
So moechdi domineren na uwer willen
Want een weynich goets smijtmen haest door die billen

45 Tsa pijper speelt op die maeltijt is ghedaen
Wy moeten nu een wijl danschen ende reyen
Want goet loon suldy van my ontfaen
Weelde en ick Sorgheloos onder ons beyen
Sullen een voetken houwen om druck te verspreyen
50 Opdat Ghemack mijn pagie mach vruecht aenschouwen
Dus speelt op een speelken hier van den keyen
Al sou ick een penninck in mijn boerse niet houwen
Want ramp in die boerse volcht tgheluck van vrouwen
Dus laet ons danschen hoveren genuecht hanteren
55 Al sout gheluck in ongheluck hem noch verkeren

Ghy jonghe bloemen tsi knecht ofte maecht
Spieghelt vant leven van den sorgheloose hier
Ende denckt opt woort dat den schrift ghewaecht
Tvolck sat om eeten ende sijn opghestaen fier
60 Om te danschen te spelen Volcht haer in gheen manier
Maer weest dancbaer van sijn gave grootelick
Ghij moet wel eerlick maecken goet schier
Ende comen by malcanderen meniotelick
Ja danschen by maten niet al verquisten bloetelick
65 Dus onthout mijn leere ende reghel fijne
Tis beter ghespieghelt dan een spieghel te zijne

O wreede Fortuyne hoe valdi mijn dus fel
Dat alle mijn patrimonien daer is ghebleven
Thert lijt inwendich groot ghequel
70 Want Weelde mijn lief wil mijn begheven
Met Ghemack mijn pagie dier zijn int herte verheven
Want Pover ende Aermoede beghinnen my te locken
Voor goet wert my tquaet noch toe ghedreven
Omdat ick gheen payment weet meer te docken
75 Och mijn ghelt mijn pandt ende alle mijn schoene rocken
Heb ick verlooren in eender canschen

120 Wat noort waert, mocht ick met Weelde int wambosch danschen

Ghi jonghe gheesten bruyct doch mate soet
In uwen leven dat onlang is duerlick
80 Speelt doch so haest niet om nobelen of ducate goet
Merct op den sorgheloose hier ghestelt figuerlick
Ende wilt doch leyen een leven puerlick
Als christenmenschen behooren met herten vuerlick
Twoort hebt niet in den mont maer leeft schriftuerlick
85 Tquaet en dorfdi niet leeren maer tcomt wel tijelick
Aenvaert die echt met herten blijelick
Opdat daer gheen amye tuwe wert ontstolen
Want si weten drae watter in der herten is verholen

Och leyder wat staet mijn te beghinnen
90 Weelde ende Ghemack gaen mijn ontlopen
Desperacie bestrijt my heel van binnen
Want op die twee stont alle mijn hopen
Sy souden niet hooren al werde van mi gheroepen
Mijn duecht die ick ghedaen heb, is al vergheten
95 Dats omdat mijn boerse niet langher mach open
Want Pover bijt my ja ick worde van Armoede ghesmeeten
Och had ick wat ick sout wel eeten
Daer ick onlancx nyet en wiste wat my was lustende
Nu mach ick by die schorluyen int stro zijn rustende

100 Dat eynde van blijschap is droefheyt voorwaer
Als Salemon dat seer suyverlick uutleyt
Dus elck wil hem reguleren een paer
Om mate te ghebruycken ende sinen tijt bereyt
Opdat namaels tbeginsel niet en wert beschreyt
105 Met den sorgheloose als elck mach aenschouwen
Want therten der vrouwen hem so diverschelick niet
Sodatter weynich is in te betrouwen hier
Si vullen een caproen wel duer haer woorts ontrowen hier
Maer tende na volcht een swaer verdriet
110 Want het hert volcht dick die woorden niet

Och, hoe deerlick heb ick hier Armoede ghelaeyen
Ende Pover stoot my van achteren te met voort
Vrienden ende maghen gaen van my draeyen
Dus heb ickt met mijn quaet regement verdoort
115 Die hont ende die catte pijpen accoort
Die kat sit int scapra ende die hont lickt die pot hier
Ende Armoede cooct wat met sinnen verstoort
Met stro, ouwe stoelen ende clompen onderhouwen wy tfier
Want turf ende hout is ons te dier

121

120 Ja met stinckende spierinck ende een garstighen harinck quaet
Daer moet Sorgheloose als nu me worden versaet

Elck neemt in danck als nu ten tyen
Twert hier ghestelt duer der minnen fonck
Omdat een yeghelick leven sal meyen
125 Elck neemt in danck als nu ten tyen
Wy spreken niet op een eerlick verblyen
Met vrienden ende maghen te drincken eenen goeden dronck
Elck neemt in danck als nu ten tyen
Twert hier ghestelt duer der minnen fonck
130 Van een ghenaemt Jacob Jacobzoon Jonck

Sinte Aelwaer

1 Gheestelick waerlick comt al ghelijcke
Om te versoecken dese groote santinne
Een patroenerse van arm ende rijcke
Edel onedel Twaer tot uwer gewinne
5 Sinte Aelwaer heet sy verstaet wel den sinne
Dus brengt haer uut minne u offerhande
Want si heeft gheregteert van swerelts beghinne
Oost west suyt noorden in allen landen
Daerder twe vergadert zijn opent u verstanden
10 Daer is si int middel soot heeft ghebleken
Wilt haer verlichten U licht laet branden
Ende wilt haer dach daghelicx een kaers ontsteken
Opdat ghi by haer moecht worden gheleken
Twordt u gheraden ter goeder trouwen
15 Haer gracie en sal u niet ontbreken
Wiltse doch met ooghen aenschouwen
Waer dat ghi zijt voor ende na
Lof grote Santinne Aelwaria

Op een eezel is si gheseten
20 Die niet haest uut sinen treet en gaet
So ist oock mede so elck mach weeten
Met Alwaerts kinderen dit wel verstaet
Sy willen doch recht hebben tsi goet of quaet
Niemant en wilt verloren gheven
25 Sy en vraghender niet na wat hindert of baet
Al soyden si altijt onrustelick leven
Dese waerde grote santinne voorschreven

Onder den eenen arm heeft si een vercken
Ende in dander hant een kat op gheheven
30 Twelck is tot Aelwaers verstercken
Een vercken moet guorten in allen percken
Twelck alle onrust heeft te beduyen
Doort lollen der katten so mach men bemercken
Donvredelicheyt van daelwarighe luyden
35 Waer ick vaer noorden of suyden
Ick moet haer aenroepen vroech ende spa
Lof grote Santinne Aelwaria

Op Sinte Aelwaers hooft een voghelken sticht
Een aecxter gheheten die altijt schatert
40 So is een aelwarich mensch die nemmermeer swicht
Die zijn kinnbacken nemmermeer goet en snatert
Heeft hi recht onrecht zijn tonghe die clatert
Met luttel bescheyts ramp heb zijn kiesen
Dus moetet wel wesen een onghevallice pratert
45 Die altijd winnen wil ende niet verliesen
Onder duysent Walen ende Vriesen
Daer is Sinte Aelwaer wel bekent
Ick weetse die met Aelwaers horen so sterck bliesen
Dat si daer door int eynde werden gheschent
50 Maer Tamstelredame der stede present
Daer is Sinte Aelwaer hooch op gheresen
Haer figuere worter door liefde gheprent
Sy wort vanden menighen int herte ghepresen
Dunct u niet dat ick die waerheyt ra
55 Lof grote Santinne Aelwaria

Sinte Aelwaer begint tonsen huyse heel te bonnen
Sprack daer een man van vremde faetsoene
Alsmen hem des avents droncken thuys siet comen
Soe stoot hij teghen den drompel zijn schoene
60 Maer sanderendaechs smorgens vroech voorde noene
Dan hoortmen Sinte Aelwaer thooft op steken
Dan swijcht hi ende en is niet so coene
Dat hi niet een woort wederom en darft spreken
Al slumerende overdenct hi zijne ghebreken
65 Hoe dat hi sijn ghestelicke schult niet can betalen
Daerom moet si een gordijn preken
Mer tgeloof vandien is verde te halen
Sinte Aelwaers gheest sietmen oock dickmael dalen

123

Daer si met die canneken cloppen ende clincken
70 Tbier ende wijn en laten si oock niet verscalen
Totdat si van mijn heer van Valckesteyn singhen
Al dese religie van Sinte Aelwaers dinghen
Moet ick vercondighen waer ick sit of sta
Lof groote Santinne Aelwaria

75 Te Bordeus hout Sinte Aelwaer dick haer stacie
Daer die behulpelicke vroukens vander gilde wonen
Susterkens broerkens sentse oock haer gracie
Lollaertkens bagijnkens so si kan betonen
Dit volck en aelwaert niet om malcander te hoonen
80 Maer elck wilt liefste kint gheacht zijn
Si schickent so si mogen om hem selven te verscoonen
Op si so moghen vanden pater bedacht zijn
Sinte Aelwaer toont oock haer moghende cracht fijn
Op dobbelaers fluysers ende sanghers mede
85 Dat die hoofden staen en roken tmoet oock gesacht zijn
Verkeerders tictackers sijnt oock haer seden
Retorijckers muysikers claghen seer met reden
Organisten herpenisten alte konstenaers tsamen
Hoe dat si vergheten sijn in dorpen in steden
90 Van Sinte Aelwaers gracie twelck si haer namen
Maer al dese ander moeten haer tot dancbaerheyt ramen
Van Sinte Aelwaers gracie buyten haer sca
Lof groote Santinne Aelwaria

Den abt van Grimberghen met mijn heer van Kijfhoeck
95 Die sachmen verheffen ende canonizeeren
Met doctor Muylaert Hoet in gherijf cloeck
Sinte Aelwaria niet om vol te eeren
Oock ginghen si een costelick gilt ordineeren
Opdat die relequien nyet en soude verdwalen
100 Om een commers gulden is dit goet te ontbeeren
Daer moecht ghi dit ghilde wel mede betalen
Comt Noormans Denen Duytsen ende Walen
Dese gracie moechdi altsamen verwerven
Met sanck salmense eerlick te kercken halen
105 Al die ghene die in dit ghilde sullen sterven
Een eewighe memorije moecht ghi u selver erven
U kints kinderen die sullent ghenieten
Sinte Aelwaers gheest salder oock om sterven
124 Mit den dou haers gracijs sal sise beghieten

110 Haer te bewijsen laet u niet verdrieten
Godt weet dat ickse niet en versma
Lof grote Santinne Aelwaria

Prince

Prince nacijen des volcx zijn quaet om sommen
Ende by na onmoghelick als ment wel besiet
115 Ofter yemant waer vergheten te nomen
Advocaten procurues wi bidden u en wilts u belegen niet
Of wiet mach sijn Pieter of Griet
Van Sinte Aelwaers ghilde vaet dit bediet
So mochdi gheacht zijn als haer gerechte dienaren
120 Ghi en dorfter niet om te Roemen of te Colen varen
Haer milde gracije is u altoos by
Sy en wilse voor niemant ter werlt sparen
Hoe groot hoe machtich hoe rijcke dat hij sy
Dus wil ick gaen sluyten met herten bly
125 Sinte Aelwaers leggende seer soet om hooren
Want luttel yemant isser ter werelt vry
Van wat staten dat si sijn gheboren
Ofter yemant waer die haer gracie hadde verloren
Men soudese weer crijghen waert datmer om ba
130 Lof Grote Santinne Aelwaria

Fable of the Father, Son, and Ass

1 Die man moet sot zijn ofte heel verbaest
Dat hi den Jongen op den Ezel laet rijden
Want hy is out ende traech tscijnt heel gheraest
Dat hy den Jonghen niet en laet ghaen besijden
5 Hy soude den Ezel self bescrijden

Het kint moet hier gaen te voet
Den ouden heeft hem op den Ezel ghestrect
Tes teerkens van leeden arm jonghe bloet
Ick pyense dat den Ouden den luyaert stect
10 Het behoort van alle man te zijn beghect

Keyaert en heeft noyt sotter volck ghebroet
Sy laten den Esel bi hem ledich gaen
Ende si beyde gaen self te voet
Sy connen van moetheyt nauwelick staen
15 Tes ommer sotlick van hem ghedaen

125

Hoe sout wel gaen hoort mijn vermeeten
Dit volck is heel vol onghenaden
Sy zijn beyde te gaer op den Ezel gheseten
Dat arme beest is heel verladen
20 . . . te voet ginck wat mochtet schaden

Fable of the Father, Son, and Ass

(IMPRESSION IN THE BIBLIOTHÈQUE ROYALE ALBERT I, BRUSSELS)

Top inscription:

Niet Zonder Opspraeck / Hoe dat men't maeckt /
Men vint 'er die 't laeckt / Doet wel en volhart /
Tot Nijdigers smert.

Die hem stoot aen een Stroo / Is zelden vroo /
Beter benijt dan beklaegt / Als 't Godt behaeght.

1 De Vaer komt met zyn Soon gerijden
Met zijn Ezel by de straet
Hy moet van elck opspraeck lyden
Hoe hy 't maeckt 't is altijt quaet
5 Eerst laet hy zyn Soon op sitten
En den Ouden gaet daer by

Joffvrouw Klaps spreeckt tot Brigitte
Siet eens aen dees sotterny
Dat hy laet den Jongen Ryden
10 Sterck van leeden kloeck te voet
En de Ouden gaet besyden
Hy mach van Esels sijn gebroet

Om dees opspraeck te vermijden
En oock dese Joffvrouws praet
15 Zoon seyd Vaar 'k salt Beest beschrijden
'T is toch beter dat ghy gaet
Dit was weeran niet te deeghen
Hoort hy van Hans Haneveer

D' met syn Griet loopt by de wegen
20 Roept wie siet dees wreetheydt meer
Dat het Kleyne wicht moet lopen
En de Vaar belast het Beest
'K souw mijn Esel niet verkoopen
126 Sulcken onbeleef den geest

²⁵ Om 't gekal van dees te mijden
Spreeckt den Ouden goeden Vaer
Laet ons gaen Soon bey ter zyden
Datse swygen allegaer
Maer den krighsman met Zantippe
³⁰ Komen op de wegh gegaen

Die daer roept met ope lippen
Ziet dees Esel toch eens aen
Zy den Esel soo verschoonen
Die de last toch dragen moet
³⁵ Waerom eet den Esel Boonen
Als hy voor haer doet geen goet

Komt mijn Soon seyd weer den Vader
Laet ons bey nu sitten op
Eer dees luy toch worden quader
Want een krijghsman heeft een kop
⁴⁰ Ziet den Ouden weer eens vallen
Wt de gavel inden greep

Hoort den Rekel met Lijs kallen
Wiens Muyl klapt gelijck een sweep
Wie heeft oyt toch soo belaaden
⁴⁵ Een Beest kleyn en swack van leen
Wie ziet oyt soo sotte daden
Datse ryden met haer tween

Doen sprack den Ouden heel verslagen
Dat dit vollick zy gepaeyt
⁵⁰ Zoon laet ons den Esel dragen
Maer hier door ist heel bekayt
Ziet een Wysen out van dagen
Onderwyst dees na haer wensch

Niemant kan of sal behagen
⁵⁵ Hoe hy 't maeckt aen yder mensch
Dan den eenen sal 't gevallen
En den ander niet genoecht
I u wercken Godt voor allen
Dien behaeght naer hem u voeght

Besluyt

⁶⁰ Niement op aerde kan yder behagen
Hoe wys van zinnen, of konstigh van wercken

127

Den berisper heeft altijt zyn klaeuwen geslagen
Om u te begrijpen zal hy altijt bemercken
Dies wilt uwe zinnen op 't weldoen maer scherpen
65 Voldoende uwe wercken na Godes behagen

Translation:

Not without reproach / Whatever one does /
Someone will condemn it / Do well and endure /
The pain inflicted by the envious.

He who takes offense at a straw / Is seldom happy
Better envied than pitied / As it pleases God.

1 The father comes riding with his son
With his ass, along the roadway
He has to endure everyone's reproach
Whatever he does it is always wrong
5 First he let his son ride
And the father went alongside

Miss Gossip says to Brigitte
Look at this foolishness
He lets the boy ride
10 Strong of limb, sure-footed
And the father goes beside
He makes the ass his burden

To avoid this reproach
And this miss's talk
15 Son, says the father, I'll ride the animal
It is better that you walk
This was, again, not to be done
As he heard from Hans Cock-feather

Who with his Griet walked along the way
20 He calls, see this cruelty
That the little mite must walk
While the father burdens the beast
I wouldn't sell my ass
To such a simpleton

25 To avoid this babbling
The good father says
Son, let us both go beside

128

So that everyone will be quiet
But the soldier with Zantippe
30 Came along the way

He calls with open mouth
Look at this ass, then
They so honor the ass
Who should carry the load
35 Why does the ass eat beans
If he does nothing for them

Come, my son, says the father again
Let both of us ride
Before these people become angrier
Because a soldier has a head
40 See the father, once again, go
From bad to worse

Hear the rascal blather on with Lijs
Whose mouth cracks like a whip
Who would ever burden
45 A small and powerless beast
Who has seen such a foolish act
That both of them ride

Then the father speaks, very dejected
So that these people are content
50 Son, let us carry the ass
But this is all wrong
See a wiseman, out today
He will tell us his wish

No one can or should please
55 Whatever he does for every man
For if one is pleased
For another it's not enough
In your works, it is God above all
Whom you should please and comply with

Conclusion

60 No one on earth can please everybody
No matter how wise in mind, or artful in deeds
The rebuker always strikes with his claws
To attack you, he will always notice

129

So just sharpen your mind to good works
65 Carry out your deeds according to God's wish

The Misuse of Prosperity

1 Ick Eendracht heb macht wilter op letten
Steden te draeghen moelen stenen te versetten
Ia een onuerwinnelicheit bin ick voor alle vianden
Maer suchten weenen oeruralt haer die mijnre verpletten
5 Ende verliesen haren refugium met groten schanden
Alsoet wel ghebleken is in diuersche landen
Maer die mijn bemint ende neemt voor ooghen
Die moet discordia vast sluyten aen banden
Of anders vint hy hem int laetste bedroeghen

10 Ick Pax ofte Vrede werde ghegenereert
Door Eendracht mijn moeder hoech glelaudeert
Alle vruchten doe ic comen terperfectie dier zijn gesayt
Ist Poorter Buerman arm rijcke door mijn verfrayt
Ia die melancoliuse gheeste door mijn verfrayt
15 Want den telghe van Olijue tot die sulcke drayt
Diet Duyfken Noe bracht in voor leen tijen
Ken acht niet Mars schoelieren alsiense ontpayt
Maer alle vreesamighen wilt v met mijn verblijen

Als dan coem ic Diligencia ofte naersticheyt genaemt
20 Elck een behoeftich dier niet wil sijn beschaemt
Want den loyert can ick met dese swepe drijuen
Oock bin ick aen mijn voeten ghespoert alsoet betaemt
Om den slapighen den vaeck wt den ooghen te wrijuen
Want alleen door mijn die menschen beclijuen
25 Procurirende daer si in haer oude daeghen of mogen leuen
Dus sot sijnse die mijnre veriaeghen tsi mannen ofte wijuen
Want die naerstich laboriret Godt sal hem die cost gheuen

Als die Naerstighe zijn best is doende
Dan coem ick Gheluck die sulcke alsoe begoende
30 Dat het Fortuynen wiele geheel met hem sal drayen
Ia soe onuersiens hem beuellende eer hijt is vermoende
Ende met groote rijckdoemen hem coem belayen
Welcke die naerstighe sinnen is een verfrayen
Maer Gheluck is gheen erue ick ontloepse allencken
35 Die mijn vijnden niet waer nemen alse wayen
Ende haeren broeder in haeren geluck niet bedencken

Doert Gheluck heb ick Rijcdoem mijn fundacie
Ick stae in een welbehaeghen van allen nacie
Seer lustich is mijn habitatie in allen contreyen
40 Maer wee die door mijn zijn euen-mensche toent fallatie
Of hem opleggen de enige gramacie die sullen mijns beschryen
Of die tot het roepen der armen haer ooren niet en neygen
Sy sullen metten Rijcke man roepen maer niet worden verhoert
Dus verdwaest door mijn niet al ley ick v in veel vette weyen
45 Maer oefent v leuen altijt naet godtlicke woort

Wt Rijcdoem volch ick Ledicheyt voerwaer
Ick bin van veelen die poorte der Hellen een paer
Tis claer elck een bemint mijn noch grotelick
Dobbelen fluysen bueken den gaertkaerte in oepenbaer
50 Sulcx moeter dagelix ghespeelt zijn ick segt v bloetelick
Verkeeren tictacken tvrouwenspel annaert elc een meniotelick
Niet peysende datse door sulcx haren edelen tijt verquisten
Salt ydel woort voor Godt zijn een criminael doetelick
Och wee dan mijn schoelieren naet schrijuen der euangelisten

55 Ick Gulsicheyt coeme wt Ledicheyt ple(ij)nlick
Alst vercken inden drecke wroet onreynlick
Dies gelijcks mijn schoelieren sich hebben in al . . . heuen
Suypen vreeten spijen schijten vileijnlick
Wat is die Gulsighe anders haer leuen
60 Doer verlastinghe der natueren si desc Werlt begheuen
Tsijn moerderen haer selfs leuen vry sonder falen
Spiegelt v doch an haer al de door mijn gecomen zijn in sneuen
Ende tmeeste die ziele sorch ick moet ter hellen daelen

Ick Oncuysheyt seer lustich int anscouwen
65 Elck vleyschelick gesinde bemin(t) mijn sonder flouwen
Want siestimeren mi een suikerdose soet (int) ge(bruyc)ken
De borsse slachtick diemen nauwelic van mi soude connen houwen
Want ick weet die mijnen in mijn armkens te beluycken
Maer als ick het visken heb binnen der vuycken
70 Ende die doot wil genaecken ick segt v bloot
Soe ist eylaes niet wetende werwert si sullen duycken
Want die verdoemenisse heb ick in mijnen schoot

Ick Nijdicheyt fel in mijn opstel
Breng die menighe in soe grooten ghequel
75 Mit mijnen hangel die ick can gheraeken
Ick ben die doer des doots die poorte vander hel
Om die gherechtighen te vernieten moet ick dick waeken

131

Gheen soeticheyt heb ick in gheenderhande saecken
Dus elck wacht hem voer mijn ick segt v te voeren
80 Mijn hangel bijt bitterder dan fenijntsel der Draeken
Dus wee haer allen die ick coem verstoeren

Ick Oorloghe quaet seer boes van daet
Vol van verraet ben ick een gehel obstinaet
Alle wasselick saet weet ick te vernieten
85 Nijdicheyt is mijn fundacie nae den rechten graet
Ken ghebruyck gheen maet elck mach mijener verdrieten
Ic brant ic steel ic moort ic roof ia gae wallen muren ofschieten
Maer voergaende sonden zijn die oorsaken
Dat ick regieren aldoe ic mennich onnosel de traenen wt vlieten
90 Want ick ben meer instrumente van wraeken

Als Oorloghe is in sijnder slueren
Soe coem ick Armoede voor elcx eenen dueren
Soe wel dat niemant mijn gaeren mit oogen siet
Nochtans moet mijn veel dan logieren een weelde besueren
95 Want door Oorloghe is van Rijcdoem haest veruloegen yet
Al binnen som hoemoedich van herten waerlick si vermogen niet
Dus in tyen van Gelucke wilt v goede bewaeren
Soe troudi my Armoet niet van wien elck ongeloegen vliet
Want ick moet mijn coste van duere te duere vergaeren

100 Ick Patientia leef altijt op hoepen
Wel wetende dat niemant Gods handen can ontloepen
Och hoe gaet mi therte noepen tot het gemeen weluaren
O heer of ghi eens wilde verhoeren het crijten het roepen
Van v arme schaepkens ick saecht so ghaern
105 Want het herte is mijn door sulcks int beswaren
Maer wt gherechte charitate wil ickt lieflick sustineeren
Welwetende dat God die sijnen wel bewaren
Dus rust ick Patientia in goede mitgauen mijn begheeren

Doer Patientia comt die vertroestinge diet al doet vervruechden
110 Die oude grijse benaest veriuechden
Dus hoert mijn blijschap elck een te beminnen
Maer salich is hy die mijn gebruyckt tot duechden
Op datse hier nae die eewighe blijtschap ghewinnen
Maer die op werltse blijtschap stelt sinen sinnen
115 Als den Rijcken man die twert namaels bescreyt
Dus om die eewighe blijtschap wilt loepen en runnen
132 Die verstandighen is haest ghenoech gheseyt

Hout dese Conclusie in uwer memorie
Wie Christelick sterft verrijst in glorie
120 In doots mortorie comt hi de sonder Christo begint
Dus o mensche denct dat ghi zijt Godts eygen soborije
Van die Godtlicke orije gedesenteert mijn wel versint
Dus voecht v in als dat ghi v onderwint
Laet Christus altijt v beghin middel een ende zijn
125 Dus o Heere die bant der sonden van elck onbint
Ende laet ons hier nae by v als die bekende zijn

The Wise Man and Wise Woman

Comt en siet my an ick beduy een wijs man,
Den wijse man seyt.

1 Ick draech een helm op mijnen hoot
ghelijck alle wijse mannen behooren te doen
want het beduyt secreete ick segt v bloet
en sulcken moet hi weesen die tijtelick wil begoen
5 secreet in zijn handelinghe daer hi hem toe wil spoen
want een onbedacht clappert quam noyt tot staeten groot

Mijn baert beduyt eerbaerheyt en dat ghestadelick
in alle mijn handelinge ben ick ghenadelick
oprecht vreetsaem alle twist meynde
10 bedroeuende mit hem wiens handelinghe valt schadelick
met den bedroefden ben ic bedroeft ende met den blijen verbliende
op dat temptatie my niet wert verwinlick bestrijende

Ooc draech ick een leuwen hart verhuechgelick
want het beduyt een stercken moet
15 onversaecht bladich maer altijt ghenochlick
om te beschermen lijf / eer ende goet
ia lieuer dan eer te verliesen te storten mijn roede bloet
ende dit sal een ieder man doen diet hem is vermuechlick

Dat vergulden cruys ick segt v plat
20 dat ick op mijn borst draghe leert hoe ende wat
wi alleen doort gheloue god moghen behaghen
want wt den gheloue is ghereesen dat heylsaem schat
so dat een exempelaer leuen wt ons rijst alle daghen
doer welck een yghelick alle valsheyt ghehoort te veriagen

25 Den vleysachtighen rock suyuer en ient
beduyt dat ons gherucht moet sijn bouen matich
want sonder goet gherucht ist al gheschent

133

al toenden hem al een int weesen noch so prelatich
dus toent dat v werck niemant mach sijn haetich
30 niet slachtende den onweetenen int soetheyt verblente

Vanden siden gordel wil ick v tbeduytsel noemen
dat is si leert v secreete sonder yet te beromen
in al dat ghi beghint weest cloeck ende wijs
aenmerckende tende wat er v of mach comen
35 so suldi van allen behalen lof ende prijs
daer donbedachte of comen sal alleenafgrijs

Die schalen beduyen rechtuaerdicheyt
twelck in een wijs man bouen al wel vlijt
dats dat hi met een ander niet soect behendighe aerdicheit
40 [d]an hi wilde dat hem schiede tenigher tijt
[d]it is die leere van Christus ghebenedijt
[w]el hem die ten enden tot bleeft in goeden velhardicheit

Tbeduytsel vanden winckel haeck is ooc scriftuerlic
want tes maticheyt int leuen suerlick
45 [w]ant alle gotlick wijsen prijsen soberinghe
[ts]i in spijs dranck / ofte in cledinghe onduerlick
[e]nde het is van een Christen den rechten proberinghe
[d]us tot maticheyt laet elck nemen een leeringhe

Den viercanten steen daer ick op stae te desen stonden
50 [b]eduyt stantachticheyt vroech ende laet
[o]precht warachtich weest in v vermonden
[v]goet opsette nyet verlatende doer eenichgen raet
[d]at ghi ghebiet ofte doet my wel verstaet
[m]aer op stantachticheyt staet so wijckti die sonden

55 Die hont beduyt hoert mi callen
2 [da]t een wijs man sal sijn altijt dienstachtich
[ni]et willich wilt niet slachtich den malle
[end]e behulpicheyt sijns naesten weest in liefte crachtich
[di]t sijn de wencken van een wijs man stantachtich
60 [die] desen heeft darf nyet sijn verslaghen
[w]ant god sal met de sulcken weesen machtich
hy hier alle menschen sal behaghen

Elck my anschouwe want ick sij een wijse vrouwe,
Een wijse vrouwe seyt.

Ick een wijse vrouw heb scherp ghesicht als een vallick[e]
134 om alle vilonie van mijn teweeren

65 ick beminne den goeden ende hate den schalcke
 die vlitich soude sijn om mijn te onteren
 want met Susanna sou ick den doot lieuer begheren
 eer ick een vilenijne gaf ccnich consente
 ia Lucrecia mij selfs mortificeren
70 dat my enighe verachte int swerelt parlemente

 Oock heb ick mijn altijt ghestelt zeer diliente
 om godts woort vlijtich te horen
 daer om voer ick den slotel seer pertinente
 met magdalena en marta heb ick godts vrienden vercor[en]
75 ende het geen dat ic bin hoorlick blijft in mijn niet verloere[n]
 maer dat beleue ick na die godtlicke ghenaden
 om de armen te visiteeren gae ick mijn naerstich
 spoere[n]
 op dat ick so veel in mijn es haer mach versaden

 Een gouwen slot draech ic an mijnen mont vroech en spad[e]
80 om dat gheen vilonie sal vloeyen wt mijnen mont
 maer nyet sprekende dan goeden beraden
 ende dit behoort een wijse vrouwe te hebben talder ston[t]
 om wel te onderhouwen haer echtelick verbont
 als Sara Abraham haer man obedierich
85 gheen anders werck te beclappen ick segt v goet ront
 maer v selfs te draghen in duechde mannierich

 Tot desen spieghel keer ick mijn zeer vierich
 om alle houerdie van mijn te weeren
 naet gotlich leuen zij ick mijn bestierich
90 soe dat ick mijn selfs broosheyt ghelick can kennen
 weetende dat ick inder aerden naet leuens ennen
 moet verdwinnen als een prie verwatich
 dit toont my den spieghel soe claer als gescreuen met penne[n]
 daerom elcke wijse vrouwe wes houerdie verlatich

95 Oock draech ick een stadighen moet zeer prelatich
 ghelijck als een tortel duyf sekerlick doet
 behaluen mijnen echten man bin ick alle anderen hatich
 ia alle anstotinghe wederstaende met een stercken moet
 om schoonheyt van spreken om schat noch goet
100 en sal iemant ghenaken mijn fiere lijf
 ia als Tisbe liuer verghyeten mijn roede bloet
 dan ick soude weesen een anders mans wijf
 om mijn middel heb ic twee slangen verstaet dit motijf
 Soe behoort te doen een wijse vrouwe

135

105 die schant en schae van haer wil weeren sonder ghekijf
want slangen zijn quaet om handelen somen mach schouwe[n]
si schieten si biten si binnen quaet om houwen
soe mede een wijse vrouwe mijn wel verstaet
sal daer ghenen worden iemant yet soe betrouwen
110 an haer gheechte man dats mijnen raet

Die armen soude ick ghaerne comen te baet
om te verweruen dat eewich leuen
daer om draech ick in mijn hant een vollen maet
om den nootrustighen daer wt zeer minlick te gheuen
115 want ken vint niet beters in als gheschreuen
waer doer ic my bet van sonden can ontbinden
dan doer almissen ick segt v euen
want daer doer werden wy godts vercoren beminden

Op paerden voeten gae ick als den ghesinden
120 om dat ick in eeren zeer vast sal staen
want het bedroch is ouer alle werelts eynden
waer om elck wijse vrouwe onder hout mijn raen
op paerden voeten soe moet ghi gaen
oft met Barsabea suldi haest de becoringhe plaetse vlijen
125 ende oock weest voorsichtich wel op de paen
of ghi wert verwonnen doert vleyschelick bestrijen

The Ages of Man

1 Tkechtken siet
2 Van jaren thien
3 Weet noch niet
4 Maer sotheydt
5 Sietmen door hem
6 gheschien

7 Een iongelinc fier
8 van twintich iaren
9 Is vroelijck van
10 maenier
11 Nyet weetende
12 van spaeren

13 Het verstant dat compt
14 Almitter tijt
15 So datment sompt
16 Die soecken niet dan iolijt

136

17 Siet wat ick stel
18 Die 80 Jaren heeft
19 Bereyt den Esel
20 Hem verdriet dat
21 hy langer leeft

22 Tneghentichste Jaer
23 Men merckent bloodt
24 Is al ouer ouwe waer
25 En al leuende doot

The Last Supper

1 Quisquis ades sacrae spectator candide mensae
2 Respice quid referat ista tabella tibi
3 Coena salutaris graphice hic exculpta Videtur
4 Arte Viri clari Cornelij Antonij

5 Hic servatorem Videas mitissimum Jesum
6 Fortis amicitiae condere mnemosynon
7 Ultima dum celebrat laetus convivia, nobis
8 Corporis hic epulum et sanguinis instituit

9 Foelix qui haec oculis dum externis aspicit, intus
10 Internis oculis, quod meditetur, habet
11 Dat tibi se Christus escam, tu fratris ut esca
12 Esse queas, mala ne te otis conficiant

13 Impendit tibi se totum, tu proximo adesto
14 Qua tu cunque queas, Viribus, Ingenio
15 Nil frustra facies cum foenere cuncta rependet
16 Hoc Ubi depositum est corporis ex uvium.

Notes

CHAPTER 1, Introduction

1. For a brief survey of the early history of the woodcut in the Netherlands, see Washington D.C., National Gallery of Art, *The Prints of Lucas van Leyden and His Contemporaries*, cat. by E. Jacobowtiz and S. Stepanek, 1983, 30–34.

2. Kurt Steinbart, *Das Holzschnittwerk des Jakob Cornelisz von Amsterdam*, Burg bei Magdeburg, 1937, 11–23.

3. Washington, D.C., *Lucas van Leyden*, 102–3.

4. Steinbart, *Holzschnittwerk, Jakob Cornelisz*, 80–107, 112–25.

5. Washington, D.C., *Lucas van Leyden*, 138–41, 147–50, 154–55, 228–33.

6. Nicolaas Beets, "Aanwinsten van zestiende-eeuwsche houtsneden in het Rijksprenten-kabinet te Amsterdam," *Het Boek*, XXI, 1932–1933, 177–208; "Cornelis Anthonisz: De His-torie-stukken," *Oud-Holland*, LVI, 1939, 160–84; "Cornelis Anthonisz: De Portretten," *Oud-Holland*, LVI, 1939, 199–221.

7. G. J. Hoogewerff, *De Noord-Nederlandsche Schilderkunst*, The Hague, 1936–1947, III, 480–512. His most plausible attribution is a half-length *Portrait of Reynout III van Brede-rode* (p. 492, fig. 264), which is also given to Cornelis in Pieter J. J. van Thiel et al., *All the Paintings of the Rijksmuseum*, Amsterdam and Maarssen, 1976, 85, no. A1619. Something that might be cited in favor of Cornelis's authorship is his woodcut series of the *Lords of Brederode*, quite possibly a commissioned publication, which therefore suggests some asso-ciation between the artist and the nobleman. The one other work deserving special mention is the group portrait of the *A-Company of the Kloveniersdoelen*, which continues to be given to Cornelis in more recent literature: see Van Thiel, *Paintings of the Rijksmuseum*, 85, no. C409; and Albert Blankert, *Amsterdams Historisch Museum: Schilderijen daterend van voor 1800*, Amsterdam, 1975–1979, 13; given this work's poor condition and considerable overpainting, however, its attribution is questionable.

8. Over the years about ten drawings, of widely varying styles, have been unconvincingly connected with Cornelis. See Paul Wescher, "Beiträge zu Cornelis Teunissen von Amster-dam. Zeichnungen und Holzschnitte," *Oud-Holland*, XLV, 1928, 33–39; and Otto Benesch, *Beschreibender Katalog der Handzeichnungen in der graphischen Sammlung Albertina. Bd. II: Die Zeichnungen der niederländischen Schulen des XV. und XVI. Jahrhunderts*, Vienna, 1928, 11. Beets's attribution to Cornelis of a pair of pen and ink and wash drawings of the execution of Amsterdam Anabaptists in 1535 is particularly tantalizing ("Aanwinsten," 177, note 4; "Historie-stukken," 181, note 2). More likely, though, is their identification by Mar-ijn Schapelhouman as early seventeenth-century copies after two of Barend Dircksz's lost paintings of the Anabaptists' uprising and its aftermath, in *Oude tekeningen in het bezit van de Gemeentamusea van Amsterdam waaronder de collectie Fodor. Deel 2: Tekeningen van Noord- en Zuidnederlandse kunstenaars geboren voor 1600*, Amsterdam, 1979, 15–18.

9. Hedwig Nijhoff-Selldorff and M. D. Henkel, *Nederlandsche houtsneden 1500–1550*, ed. Wouter Nijhoff, The Hague, 1933–1939.

10. Amsterdam, Rijksmuseum, *Vorstenportretten uit de eerste helft van de 16de eeuw:*

Houtsneden als propaganda, cat. by D. de Hoop Scheffer and A. J. Klant-Vlielander Hein, 1972.

11. F. J. Dubiez, *Cornelis Anthoniszoon van Amsterdam: zijn leven en werken*, Amsterdam, 1969. His earlier publications include "Cornelis Anthoniszoon: De betekenis van de Amsterdamse schilder, houtsnijder, en cartograaf Cornelis Anthoniszoon voor de culturele geschiedenis van onze stad," *Ons Amsterdam*, XI, 1959, 354–66, and "Nogmaals Cornelis Anthoniszoon," *Ons Amsterdam*, XII, 1960, 143–45.

12. This assessment is noted by Ilja M. Veldman, *Maarten van Heemskerck and Dutch Humanism in the Sixteenth Century*, Amsterdam, 1977, 7. See also Veldman's catalogue for the exhibition *Leerrijke reeksen van Maarten van Heemskerck*, Haarlem, Frans Halsmuseum, 1986, in which she deals with many of the same prints.

CHAPTER 2, Historical Background

1. The most useful accounts of the history of Amsterdam are those by Jan Wagenaar, *Amsterdam, in zijne opkomst, aanwas, geschiedenissen, voorregten, koophandel, gebouwen, . . .*, Amsterdam, 1760; H. Brugmans, *Opkomst en bloei van Amsterdam*, Amsterdam, 1944; and R. B. Evenhuis, *Ook dat was Amsterdam*, Amsterdam, 1965. Much of the information found in these works is summarized in Renée Kistenmaker and Roelof van Gelder, *Amsterdam: The Golden Age, 1275–1795*, New York, 1982, which also contains numerous illustrations. Not entirely reliable but quite entertaining is Geoffrey Cotterell, *Amsterdam: The Life of a City*, Boston, 1972.

2. Violet Barbour, *Capitalism in Amsterdam in the 17th Century*, Ann Arbor, 1963, 13–27, 60.

3. Lengthy biographies of these three men are to be found in J.F.M. Sterck, "Onder Amsterdamsche humanisten," *Het Boek*, VI, 1917, 4–18, 89–107, 165–79, 283–96; IX, 1920, 161–74; XIV, 1925, 49–61. See also Albertus J. Kölker, *Alardus Aemstelredamus en Cornelius Crocus: Twee Amsterdamse priester-humanisten*, Nijmegen and Utrecht, n.d.; B. de Graaf, "Alardus Amstelredamus (1491–1544)," *Folium: Librorum Vitae Deditum*, IV, 1954, 29–118; and Evenhuis, *Amsterdam*, 34–37.

4. George H. Williams, *The Radical Reformation*, Philadelphia, 1962, 344. For an excellent survey of the history of the Reformation in the Netherlands, with a focus on the later sixteenth century, see Utrecht, *Rijksmuseum Het Catharijneconvent, Ketters en papen onder Filips II*, cat. by S. Groenveld, C. Augustijn, R. P. Zijp et al., 1986.

5. Cornelius Krahn, *Dutch Anabaptism: Origin, Spread, Life, and Thought (1450–1600)*, The Hague, 1968, 72; Wagenaar, *Amsterdam*, 234; Brugmans, *Opkomst*, 56.

6. C. P. Burger, "De Boek- en prentdruk te Amsterdam," *Het Boek*, XIV, 1925, 235; F. J. Dubiez, *Op de grens van humanisme en hervorming: De betekenis van de boekdrukkunst te Amsterdam in een bewogen tijd*, The Hague, 1962, 228; Sterck, "Amsterdamsche humanisten," 106–7; Evenhuis, *Amsterdam*, 32. This is not to say that such infractions were always overlooked; in 1527, for example, the Amsterdam publisher Jan Severszoon de Croepel was fined and sentenced to live at St. Olaf's Gate on bread and beer for two months for the printing and possession of heretical books (Wagenaar, *Amsterdam*, 235; Dubiez, *Op de grens*, 234).

7. Krahn, *Anabaptism*, 57.

8. Williams, *Radical Reformation*, 30–33; Krahn, *Anabaptism*, 48–50.

139

9. Williams, *Radical Reformation*, 34; Krahn, *Anabaptism*, 50–52.

10. For an analysis of this aspect of Erasmus's thought, see B. Hall, "Erasmus: Biblical Scholar and Reformer," in *Erasmus*, ed. T. A. Dorey, London, 1970, 81–114. Two helpful introductions to his life and work are Margaret Mann Phillips, *Erasmus and the Northern Renaissance*, New York, 1950, and Roland H. Bainton, *Erasmus of Christendom*, New York, 1969.

11. Williams, *Radical Reformation*, 34–35.

12. Williams, *Radical Reformation*, 35–37; Krahn, *Anabaptism*, 50, 59.

13. Evenhuis, *Amsterdam*, 13–14. Jacob Cornelisz van Oostsanen represented the miracle in a woodcut of 1518 that would later be used as an illustration in Alardus's *Ritus* (Steinbart, *Holzschnittwerk, Jacob Cornelisz*, 74–77). The Host-bearing angels that appear at the upper right of the *Kloveniersdoelen* group portrait (see chap. 1, note 7) were also surely meant as a reference to this famous object of devotion. See also J.F.M. Sterck, *De Heilige Stede in de geschiedenis van Amsterdam*, Hilversum, 1938.

14. Krahn, *Anabaptism*, 60–61; Evenhuis, *Amsterdam*, 18.

15. Williams, *Radical Reformation*, 345; Krahn, *Anabaptism*, 47, 58. For a summary of the state of scholarship on this movement, see James M. Stayer, "The Anabaptists," in *Reformation Europe: A Guide to Research*, ed. Steven Ozment, St. Louis, 1982, 135–59. Stayer observes that one of the most significant recent developments in Anabaptist studies has been the demonstration that its adherents were by no means drawn exclusively from the poorer classes, as was long assumed.

16. Williams, *Radical Reformation*, 356–59; Krahn, *Anabaptism*, 145–55. For a more comprehensive account of the history of Anabaptism in Amsterdam itself, see Greta Grosheide, *Bijdrage tot de geschiedenis der Anabaptisten in Amsterdam*, Hilversum, 1938, and Albert Mellink, *Amsterdam en de Wederdopers*, Nijmegen, 1978.

17. Wagenaar, *Amsterdam*, 246–51.

18. For a full description of the festivities, see Juan Cristoval Calvete de Estrella, *El Felicissimo Viaje d'el Muy Alto y Muy Poderoso Principe Don Phelippe*, Antwerp, 1552, 285–89 (reprinted by the Societad Española de Bibliofilos, Madrid, 1930).

19. Brugmans, *Opkomst*, 60–65; Evenhuis, *Amsterdam*, 46–47. On the initial reception of Calvinism in the Netherlands, see Phyllis Mack Crew, *Calvinist Preaching and Iconoclasm in the Netherlands, 1544–1569*, Cambridge, 1978.

20. Max J. Friedländer, *Early Netherlandish Painting*, Leyden and Brussels, 1967–1976, XII, 54; Gert von der Osten and Horst Vey, *Painting and Sculpture in Germany and the Netherlands, 1500 to 1600*, Baltimore, 1969, 164.

21. J. G. van Gelder, "De Noordnederlandse schilderkunst in de zestiende eeuw (II)," *Kunstgeschiedenis der Nederlanden*, 3rd ed., ed. H. E. van Gelder and J. Duverger, Utrecht, 1954–1956, I, 469. The high altar of Amsterdam's Oude Kerk was executed by van Scorel. The shutters to this altarpiece were done some years later by Maarten van Heemskerck, who also painted two organ wings and designed a tapestry series for the ambulatory of the same church (see Rainald Grosshans, *Maerten van Heemskerck: Die Gemälde*, Berlin, 1980, 252, and B.J.M. de Bont, "De Oude of S. Nicolaaskerk te Amsterdam, hare kapellen, altaren, en fundatiën," *Bijdragen tot de Geschiedenis van het Bisdom Haarlem*, XXIV, 1899, 29).

22. Friedländer, *Early Netherlandish Painting*, XIII, 70.

23. I. H. van Eeghen, "Jacob Cornelisz, Cornelis Anthonisz en hun familierelaties," *Nederlands Kunsthistorisch Jaarboek*, 37, 1986, 95–132.

24. Van Eeghen, "Jacob Cornelisz," 111–12.

25. E. W. Moes and C. P. Burger, *De Amsterdamsche boekdrukkers en uitgevers in de zestiende eeuw*, Amsterdam and The Hague, 1900–1915, I, 189; van Eeghan, "Jacob Cornelisz," 113.

26. "De Braspenningsmaaltijd," *Openbaar Kunstbezit*, XII, 1968, 6a–b. However staid this scene may appear to our eyes, its festive nature is also indicated by the presence of flutes in the hands of one man seated at the table's far right corner and by a music sheet in the hands of another figure beside him. This sheet is inscribed with the descant part of a popular song by the late fifteenth-century Franco-Flemish composer Antoine Busnois: "In mijnen sin heb ick vercoren een meijsken" (In my thoughts I have chosen a maiden). See Pieter Fischer, *Music in Paintings of the Low Countries in the 16th and 17th Centuries*, Amsterdam, 1975, 39.

27. Hoogewerff, *Schilderkunst*, 483; Dubiez, *Cornelis Anthoniszoon*, 52; and Houbraken, *De Groote Schouburgh der Nederlandsche Konstschilders en Schilderessen*, 2nd ed., The Hague, 1753, I, 22–23.

28. Blankert, *Historisch Museum: Schilderijen*, 12.

29. Van Eeghen, "Jacob Cornelisz," 113. Sterck has presented an elaborate and, ultimately, unconvincing argument to the effect that the crossbowmen's costumes were meant to mock Franciscan habits (J.F.M. Sterck, "Aanteekeningen over 16e eeuwische Amsterdamsche portretten," *Oud-Holland*, XLIII, 1926, 257–60; and *Van Rederijkerskamer tot muiderkring*, Amsterdam, 1928, 50–53).

30. Cornelis was certainly not the first to employ this scheme. For earlier examples, see Amsterdam, Rijksmuseum, *Kunst voor de beeldenstorm*, cat. by B. Dubbe, W. H. Vroom, M. Faries, J. P. Filedt Kok et al., 1986, cat. no. 75, and G. Kauffmann et al., *Die Kunst des 16. Jahrhunderts* (Propyläen Kunstgeschichte, 8), Berlin, 1970, 198, fig. 79a.

31. Van Eeghen, "Jacob Cornelis," 114. Blankert, *Historisch Museum: Schilderijen*, 9–10, with full bibliography. This is, in fact, the only work actually cited in Houbraken's brief passage on Cornelis (*Groote Schouburgh*, 23). We might note at this point that van Mander fails to mention him at all.

32. Van Eeghen, "Jacob Cornelisz," 128.

33. (H.47) Moes and Burger, *Amsterdamsche boekdrukkers*, 193–94; Amsterdam, Historisch Museum and Art Gallery of Ontario, *Opkomst en bloei van het Noordnederlandse stadsgezicht in de 17de eeuw*, Richard Wattenmaker et al., 1977, 69; Juergen Schulz, "Jacopo de' Barbari's View of Venice: Map Making, City Views, and Moralized Geography before the Year 1500," *Art Bulletin*, LX, 1978, 472. Dubiez, *Cornelis Anthoniszoon*, 32, lists five different editions of the woodcut view. An example of the earliest edition was formerly in a Bamberg private collection but is now known only from written descriptions: apparently the Bamberg example included the words "Daniël 5, Mene, Tekel, Phares" and an image of a writing hand at the upper right. Beets, "Historie-stukken," 162, and van Eeghen, "Jacob Cornelisz," 113, both interpret this feature (which is absent from subsequent editions) as, respectively, a reference to the Anabaptists' uprising of 1535 and a veiled criticism of the city government.

34. Moes and Burger, *Amsterdamsche boekdrukkers*, 192.

35. Van Eeghen, "Jacob Cornelisz," 128.

36. Over the years, several such publications have been linked with Cornelis, although the most recent scholarship seems to agree that all but the *Caerte van Oostland* (H.48) and the 141

Onderwijsinge (H.63–73) are by some other hand. The only extant example of the *Caerte van Oostland* is a later edition from about 1560, now in the Biblioteca Augusta, Wolffenbüttel. The one extant copy of the *Onderwijsinge*, also a later edition, is in the Harvard University Library. On these two works, see Johannes Knudsen, *Het Leeskaartboek van Wisbuy*, intro. by C. P. Burger, Copenhagen, 1920; C. P. Burger, "Boek- en prentdruk," 236; Johannes Keuning, "Cornelis Anthonisz," *Imago Mundi*, VII, 1950, 51–65, and "XVIth-Century Cartography in the Netherlands," *Imago Mundi*, IX, 1952, 35–63; Dubiez, "Cornelis Anthoniszoon," 362–63, *Op de grens*, 163–64, and *Cornelis Anthoniszoon*, 16–26, 96, 98–99; Eleanor A. Saunders, "The Development of Marine Representations in Sixteenth-Century Northern Graphic Art," M.A. thesis, University of North Carolina, Chapel Hill, 1971, 32. Van Eeghen suggests that Cornelis may have been taught cartography by Willem Hendricxz Crook, Amsterdam's city overseer ("Jacob Cornelisz," 115).

37. Van Eeghen, "Jacob Cornelisz," 128; M. de Roever and B. Bakker, "Woelige tijden: Amsterdam in de eeuw van de beeldenstorm," *De Bataafsche Leeuw*, Amsterdam, 1986, 22, 36–37. My thanks to Jan Piet Filedt Kok for bringing this publication to my attention.

38. Dubiez, *Cornelis Anthoniszoon*, 35–36, 98. I was informed as to the details of this commission in a letter, dated January 16, 1984, from Ida Kemperman-Wilke of the Gemeentearchief, Weesp.

39. See, for example, Hoogewerff, *Schilderkunst*, 490, and Dubiez, *Cornelis Anthoniszoon*, 44. Documents regarding our Cornelis often refer to him as "Thoniszoon."

40. Van Eeghen, "Jacob Cornelisz," 119. Dr. van Eeghen actually found records for four other Cornelis Anthoniszoons resident in Amsterdam during the sixteenth century. It was certainly one of these men, and not our artist, as is frequently stated, who occupied a number of public offices in the city (Moes and Burger, *Amsterdamsche boekdrukkers*, 187–88; Dubiez, *Cornelis Anthoniszoon*, 11).

41. Van Eeghen, "Jacob Cornelisz," 114.

42. Van Eeghen, "Jacob Cornelisz," 112. On the *City of Algiers* (H.43, N.94–95) and *Siege of Terwaen* (H.44, N.216–219), see Nijhoff, *Nederlandsche Houtsneden*, 16–17, 50–51. Each survives in only one impression (*Algiers* with hand-coloring) in the Rijksprentenkabinet, Amsterdam.

43. Van Eeghen, "Jacob Cornelisz," 112.

44. Steinbart, *Holzschnittwerk, Jacob Cornelisz*, 64–72.

45. (H.55, N.130–135) Nijhoff, *Nederlandsche Houtsneden*, 26. There is one surviving impression, in the Albertina.

46. (H.50, N.206–213) Nijhoff, *Nederlandsche Houtsneden*, 48–49; Amsterdam, *Vorstenportretten*, 32–33. The extant examples include one in the Albertina, one in the Rijksprentenkabinet, and a third in the Amsterdam Universiteitsbibliotheek. The latter, with hand-coloring, is from a later edition published by the son of Jan Ewoutsz, Harmen Jansz Muller.

47. On the various sources for Cornelis's single-sheet portraits, and on the many uncertainties regarding their production, see Amsterdam, *Vorstenportretten*, 35–64.

48. Friedländer, *Early Netherlandish Painting*, XII, 76. It has also been suggested that the Lost Oude Kerk altar finds its reflection in two other, more elaborate Crucifixion compositions, again workshop pieces. See Utrecht, Centraal Museum, *Jan van Scorel*, 1955, cat. by A. C. Esmeijer and S. Levie, cat. no. 29.

49. See Washington, D.C., *Lucas van Leyden*, 260–61, 283–84, 296–97, 314–15, and Amsterdam, *Kunst voor de beeldenstorm*, cat. nos. 39, 60. Another woodcut with an equally

broad landscape has recently been associated with van Scorel himself; see Molly Faries, "A Woodcut of the *Flood* Re-attributed to Jan van Scorel," *Oud-Holland*, XCVII, 1983, 5–12.

50. See Sune Schéle, *Cornelis Bos: A Study of the Origins of the Netherland Grotesque*, Stockholm, 1965.

51. Impressions of *Charles V* (H.3) can be found in the British Museum; the Kunsthalle, Hamburg; the Staatliche Graphische Sammlung, Munich; the Kupferstichkabinett, Staatliche Museen Preussischer Kulturbesitz, Berlin-Dahlem; the Bibliothèque Royale Albert I, Brussels; the Bibliothèque Nationale, Paris; and the Nationalbibliothek, Vienna.

52. (H.46, N.119–120) There are two extant impressions of the *Arterial System*: one, in the British Museum, has Cornelis's monogram but no publisher's address; the other, in the Rijksprentenkabinet, has no monogram but carries the address of Sylvester van Parijs and is hand-colored. According to Julius Meyer et al., *Allgemeines Künstler-Lexikon*, Leipzig, 1872–1885, II, 100, the woodcut was originally accompanied by a separate sheet explaining each of the lettered arteries. For a transcription of the two different texts printed in the small tablet that hangs from the tree, see Dubiez, *Cornelis Anthoniszoon*, 106.

53. On the history of the broadsheet, see Karl Schottenloher, *Flugblatt und Zeitung: ein Wegweiser durch das gedruckte Tagesschrifttum*, Berlin 1922; Hellmutt Rosenfeld, *Das deutsche Bildgedicht: seine antiken Vorbilder und seine Entwicklung bis zur Gegenwart*, Leipzig, 1935, and "Der mittelalterliche Bilderbogen," *Zeitschrift für Deutsches Altertum und Deutsche Literatur*, LXXXV, 1954–1955, 66–75; Adolf Spamer, "Bilderbogen," *Reallexikon zur deutschen Kunstgeschichte*, ed. Otto Schmidt, Stuttgart, 1937-, II, 549–61; Hermann Wäscher, *Das deutsche illustrierte Flugblatt*, Dresden, 1955; William Coupe, *The German Illustrated Broadsheet in the Seventeenth Century*, Baden-Baden, 1966–1967; P. J. de Jong, "Laatmiddeleeuwse rijmprenten; begripsomschrijving en stand van het onderzoek," *Spektator; Tijdschrift voor Neerlandistiek*, IV, 1974–1975, 269–74; and Bruno Weber, *Wunderzeichen und Winkeldrucker, 1543–1586. Einblattdrucke aus der Sammlung Wickiana in der Zentralbibliothek Zurich*, Zurich, 1972. The best source for reproductions of sixteenth-century German broadsheets is certainly Max Geisberg, *The German Single-Leaf Woodcut: 1500–1550*, ed. and rev. by Walter Strauss, New York, 1974, and Walter Strauss, *The German Single-Leaf Woodcut: 1550–1600*, New York, 1975. Nijhoff, *Nederlandsche Houtsneden*, is less satisfactory in terms of consistently reproducing the texts as well as the images.

54. A survey of the literature indicates that at least during the first half of the sixteenth century the output of the more sensational type of broadsheet (that is, the type dealing with monsters, murderers, and similar topics) was actually rather limited in the Netherlands. This would seem to offer an intriguing parallel to the restraint exhibited by Dutch artists of the same period in their pro-Reformation graphic images (see chap. 10).

55. Carl C. Christensen, "Reformation and Art," in Ozment, *Reformation Europe*, 253. See also the additional bibliography cited in Linda and Peter Parshall, *Art and the Reformation*, Boston, 1986, 99–102, 113–19, 122–33, 140–42.

56. Coupe, *German Illustrated Broadsheet*, 13, 20.

57. See Paul Heitz, *Die Flugblätter des Sebastian Brant*, Strassburg, 1905.

58. See Heinrich Röttinger, *Die Bilderbogen des Hans Sachs*, Strassburg, 1927, and Nuremberg, Stadtgeschichtliche Museen, *Die Welt des Hans Sachs*, cat. by K. H. Schreyl et al., 1976.

59. Moes and Burger, *Amsterdamsche boekdrukkers*, 148–78; Burger, "Boek-en prentdruk," 235; N. de Roever, "Amsterdamsche boekdrukkers en boekverkoopers uit de zes-

tiende eeuw," *Oud-Holland*, II, 1884, 176–78; Dubiez, *Op de grens*, 198–203. Among Ewoutsz's very few publications of works by artists other than Cornelis is a woodcut of a *Lion Hunt* (N.302–304): see Nijhoff, *Nederlandsche Houtsneden*, 75–76, and K. G. Boon, "Scorel en de antieke kunst," *Oud-Holland*, LXIX, 1954, 51–53 (as after Jan van Scorel); J. Bruyn, "Twee anonyme navolgers van Jan van Scorel," *Oud-Holland*, LXX, 1955, 229–32 (as after a follower of Jan van Scorel); and Amsterdam, *Kunst voor de beeldenstorm*, cat. no. 118 (as after Jan van Scorel).

60. There is one copy in the Universiteitsbibliotheek, Amsterdam.

61. (H.62) Also cited by Dubiez, *Cornelis Anthoniszoon*, 47, 103, who reads the date as 1535. This reproduction indicates that the block was in a very worn condition and, hence, that it had been frequently printed.

62. According to Nijhoff, *Nederlandsche Houtsneden*, 24.

CHAPTER 3, Outcasts

1. On sixteenth-century economic developments and their reflection in current art and literature, see, for example, Georges Marlier, *Érasme et la peinture flamande de son temps*, Damme, 1954, 217–301, and, more recently, Lawrence Silver, "Power and Pelf: A New-Found *Old man* by Massys," *Simiolus*, IX, 1977, 81–91; Grace Vlam, "The Calling of Saint Matthew in Sixteenth-Century Flemish Painting," *Art Bulletin*, LIX, 1977, 561–70; Margaret Sullivan, "Peter Bruegel the Elder's *Two Monkeys*: A New Interpretation," *Art Bulletin*, LXIII, 1981, 122–23; Walter Gibson, "Artists and *Rederijkers* in the Age of Bruegel," *Art Bulletin*, LXIII, 1981, 443–44; and Keith Moxey, "The Criticism of Avarice in Sixteenth-Century Netherlandish Painting," Stockholm, Nationalmuseum, *Netherlandish Mannerism*, Nationalmuseum Skriftserie N.S.4, 1985, 21–34.

2. (H.29–34, N.70–75) There are two sets of all six woodcuts in the Rijksprentenkabinet: one with text, framework, and hand-coloring, and another without text, framework, or coloring. There are also complete sets, but again lacking the text and framework, in the Albertina and the Teylers Stichting, Haarlem. The Berlin Kupferstichkabinett has H.29, 33, 34; the Prentenkabinet, Museum Boymans-van Beuningen, Rotterdam, has H.32 and 33; and the British Museum has H.33—again, all without the text and surrounding framework. (Several of the blocks were reprinted in the eighteenth century with entirely different texts concerning the siege of Prague and other current events: see F. Muller, *De Nederlandsche geschiedenis in platen*, Amsterdam, 1863–1870, II, 127, 157–58; Moes and Burger, *Amsterdamsche boekdrukkers*, 152–53; M. D. Henkel, "Overzicht der litteratuur betreffende Nederlandsche kunst," *Oud-Holland*, L, 1933, 236.) Together with its architectural surround, each woodcut measures approximately 37.8 x 29 cm.

3. The same monogram was apparently placed on Ewoutsz's gravestone. See De Roever, "Amsterdamsche boekdrukkers," 177–79, and Moes and Burger, *Amsterdamsche boekdrukkers*, 175. A second, different monogram appears on the blade of *Gemack*'s halberd in scene five:

(In much the same way, two of the halberd blades in the *Lords and Ladies of Holland* bear the monogram C℥T) Although its positive identification still eludes me, I might note that

a very similar mark has been associated with Harmen Muller, the son of Jan Ewoutsz, in G. K. Nagler, *Die Monogrammisten*, Munich and Leipzig, 1857–1879, IV, 456, no. 1456:

Harmen (c. 1540–1617) could obviously not have been involved in the production of *Sorgheloos*. It is conceivable, however, that this second monogram represents a variant used by Jan Ewoutsz, the "M" shape perhaps being explained by the fact that, according to some sources, he, too, made use of the surname Muller (Moes and Burger, *Amsterdamsche boekdrukkers*, 148).

4. Nijhoff, *Nederlandsche Houtsneden*, 13–14, lists *Sorgheloos* among the works by unknown masters. The attribution to Cornelis has found general acceptance, however, and no other artist has ever been suggested.

5. (H.11) This work survives in one late impression, in the Rijksprentenkabinet.

6. (H.26, 14, N. 242, 198) Steinbart, *Holzschnittwerk, Jakob Cornelisz*, 67, notes the similarity of Weelde's pose to those of Gertrude and Margaret in Jacob's *Lords and Ladies of Holland*.

7. Julius Held, *Dürer's Wirkung auf die Niederländische Kunst seiner Zeit*, The Hague, 1931, 54–55.

8. Geisberg, *Single-Leaf Woodcut: 1500–1550*, I, 372, and III, 1019, 1026, 1030. Several of these borrowings are noted in Henkel, "Overzicht," 237, and Nijhoff, *Nederlandsche Houtsneden*, 95.

9. *Lockere Gesellschaft: Zur Ikonographie des Verlorenen Sohnes und von Wirtshausszenen in der niederländischen Malerei*, Berlin, 1970, 37–42.

10. On the history of the theme of the Prodigal Son in art, see Willibald Witwitzsky, "Das Gleichnis vom Verlorenen Sohn in der bildenden Kunst bis Rembrandt," diss. Univ. Heidelberg, 1930; Ewald Vetter, *Der Verlorene Sohn*, Düsseldorf, 1955; and K. Kallensee, *Die Liebe des Vaters. Das Gleichnis vom Verlorenen Sohn in der christlichen Dichtung und bildenden Kunst*, Berlin, 1960.

11. Renger, *Lockere Gesellschaft*, 23.

12. Geisberg, *Single-Leaf Woodcut: 1500–1550*, 201, 321.

13. See Renger, *Lockere Gesellschaft*, 120–32 and figs. 81, 82.

14. Friedländer, *Early Netherlandish Painting*, X, pl. 108–11. See also Rik Vos, *Lucas van Leyden*, Bentveld and Maarssen, 1978, 104–11. For a possible political interpretation of one of these panels, see Washington, D.C., International Exhibitions Foundation, *Old Master Paintings from the Collection of Baron Thyssen-Bornemisza*, cat. by Allen Rosenbaum, 1979, 113–15.

15. Friedländer, *Early Netherlandish Painting*, XII, pl. 126–27, and Renger, *Lockere Gesellschaft*, 96–119 and figs. 63–70. See also Dietrich Schubert, *Die Gemälde des Braunschweiger Monogrammisten*, Cologne, 1970.

16. Renger, *Lockere Gesellschaft*, 74–75, 106–7.

17. Sebastian Brant, *The Ship of Fools*, trans. with intro. and commentary by Edwin Zeydel, New York, 1944, 97–98.

18. Gerrit Kalff, *Het Lied in de middeleeuwen*, Leiden, 1884; D. T. Enklaar, *Varende Luyden. Studiën over de middeleeuwsche groepen van onmaatschappelijken in de Nederlanden*, Assen, 1937, and *Uit Uilenspiegel's kring*, Assen, 1940.

19. *Veelderhande geneuchlijcke dichten, tafelspelen ende referenynen*, new ed. Leiden, 1899 (reprinted 1971).

20. *Een Schoon Liedekensboeck. in den welcken ghy in. vinden sult. veelderhande liedekens. oude ende nyeuwe om droefheyt ende melancolie te verdryven*, ed. W. G. Hellinga, The Hague, 1941, 120–22, 207.

21. Herman Pleij, *Het gilde van de Blauwe Schuit: Literatuur, volksfeest en burgermoraal in de late middeleeuwen*, Amsterdam, 1979, 237–44.

22. The "autobiographical" interpretation actually found one of its first opponents in J. van Mierlo: see the section on "De Poëzie der onmaatschappelijken" in his *De Letterkunde van de middeleeuwen*, vol. II of *Geschiedenis van de letterkunde de Nederlanden*, Brussels, 1940, 257–61. Pleij's views were first presented in a three-part article, "Materiaal voor een interpretatie van het gedicht over de Blauwe Schuit (1413?)," *Spektator; Tijdschrift voor Neerlandistiek*, I, 1971–1972, 311–25; II, 1972–1973, 196–224; III, 1973–1974, 680–721. His book, *Het gilde van de Blauwe Schuit*, is a revised and expanded treatment of the same topic. For a concise presentation of the critical history of "vagabond verse," see Hermina Joldersma, "Het Antwerps Liedboek: A Critical Edition," diss. Princeton Univ., 1983, XCIX–CVII.

23. Still the most informative introduction is J. J. Mak, *De Rederijkers*, Amsterdam, 1944.

24. For a discussion of the dramatic output of these two chambers, see Else Ellerbroek-Fortuin, *Amsterdamse rederijkersspelen in de zestiende eeuw*, Groningen, 1937.

25. Pleij, *Blauwe Schuit*, 7–13, 97–108.

26. On the history of the Latin school play, see P. Bahlmann, *Die lateinischen Dramen von Wimphelings Stylpho bis zur Mitte des sechzehnten Jahrhunderts: 1480–1550*, Münster, 1893, and W. Criezenach, *Geschichte des neuen Dramas: Renaissance und Reformation*, Halle, 1901, II, 1–168.

27. H. Holstein, *Das Drama vom Verlornen Sohn. Ein Beitrag zur Geschichte des Dramas*, Geestmünde, 1880, 3–9; Franz Spengler, *Der Verlorene Sohn in Drama des XVI Jahrhunderts*, Innsbruck, 1888, 17–28; J.F.M. Kat, *Der Verloren Zoon als letterkundig motief*, Bussum, 1953, 43–45. For an English translation of *Acolastus*, see G. Gnapheus, *Acolastus. A Latin Play of the Sixteenth Century*. Latin text with English translation by W.E.D. Atkinson, London and Ontario, 1964.

28. Holstein, *Das Drama vom Verlornen Sohn*, 3–9; Spengler, *Verlorene Sohn*, 37–50; Kat, *Verloren Zoon*, 41–42.

29. Holstein, *Das Drama vom Verlornen Sohn*, 44–49; Spengler, *Verlorene Sohn*, 104–40; Kat, *Verloren Zoon*, 49.

30. Spengler, *Verlorene Sohn*, 165–68; Kat, *Verloren Zoon*, 60–68; *De Historie van den Verloren Sone*, ed. G. J. Boekenoogen, Leiden, 1908.

31. See W.M.H. Hummelen, *De sinnekens in het rederijkersdrama*, Groningen, 1958.

32. Kat, *Verloren Zoon*, 61. In another play the setting is the "taveerne Int duyster Verstandt" (Tavern of Dim Understanding): see H. A. Enno van Gelder, "Erasmus, schilders, en rederijkers," *Tijdschrift voor Geschiedenis*, LXXI, 1958, 307.

33. Renger, *Lockere Gesellschaft*, 25.

34. On Jacob Jacobz's other works, see Ellerbroek-Fortuin, *Amsterdamse rederijkersspelen*, 124–26, 130–32, 181–211, 174–75.

35. Raimond van Marle, *Iconographie de l'art profane au Moyen-Age et à la Renaissance*, The Hague, 1932, II, 105; Renger, *Lockere Gesellschaft*, 45–46.

36. Brant, *Ship of Fools*, 246–47.

37. P. J. de Jong, "Sorgheloos, een zestiende eeuwse rijmprentenreeks; tekst en commentaar," *Spektator; Tijdschrift voor Neelandistiek*, VII, 1977–1978, 108. De Jong's article and Renger's discussion (*Lockere Gesellschaft*, 42–65) together render *Sorgheloos* the most thoroughly examined of all of Cornelis's moralizing prints. The series is also reproduced, along with an inexact translation of portions of the text, in David Kunzle, *The Early Comic Strip; Narrative Strips and Picture Stories in the European Broadsheet from c. 1450 to 1825*, Berkeley, 1973, 262–64. See, in addition, J. Bolte, "Bilderbogen des 16. Jahrhunderts," *Tijdschrift voor Nederlandsche Taal- en Letterkunde*, XIV, 1895, 122–26, and this author's cat. no. 151 in Amsterdam, *Kunst voor de beeldenstorm*.

38. Renger, *Lockere Gesellschaft*, 42–43.

39. All of these occurrences are noted by De Jong, "Sorgheloos," 107.

40. Walter Gibson, "Some Flemish Popular Prints from Hieronymus Cock and His Contemporaries," *Art Bulletin*, LX, 1978, 673–77.

41. On the connotations of the term *ghemack*, see Renger, *Lockere Gesellschaft*, 46. My own conviction as to the parallels between *Sorgheloos*'s paired personifications and the dramatic convention of *sinnekens* was subsequently reinforced by De Jong ("Sorgheloos," 112). See also Gibson, "Artists and *Rederijkers*," 435.

42. Cf. Exodus 32:6. On the history of attitudes toward dancing and its representation in art, see Carl Stridbeck, *Bruegelstudien; Untersuchungen zu den ikonologischen Problemen bei Pieter Bruegel d.Ä.*, Stockholm, 1956, 218–21, and H. P. Clive, "The Calvinists and the Question of Dancing in the 16th Century," *Bibliothèque d'Humanisme et Renaissance*, XXIII, 1961, 296–323.

43. Brant, *Ship of Fools*, 205.

44. For an introduction to the character of the fool, see E. Tietze-Conrat, *Dwarfs and Jesters in Art*, London, 1957.

45. For the various contemporary connotations of the terms *pover* and *aermoede*, see Renger, *Lockere Gesellschaft*, 50. On the personification of poverty in general, see Liselotte Stauch, "Armut," *Reallexikon zur deutschen Kunstgeschichte*, 1113–16, and Gerhard Hertel, *Die Allegorie von Reichtum und Armut; ein Aristophanisches Motiv und seine Abwandlungen in der abendländischen Literatur*, Nurembert, 1969.

46. A. J. Bernet Kempers, "De Oblieman; Metamorfosen van een koekjesverkoper," *Volkskunde*, LXXIV, 1973, 1–43, and "De speler met de ronde bus," *Oud-Holland*, LXXXVII, 1973, 240–42. Both articles convincingly refute the interpretation of this type as proposed by Konrad Renger in "Versuch einer neuen Deutung von Hieronymus Boschs Rotterdamer Tondo," *Oud-Holland*, LXXXIV, 67–76 (see also *Lockere Gesellschaft*, 26–34, 51–54): Renger would argue that Bosch's wayfarer and Cornelis's Lichte fortune both represent essentially the same standard folk character; Bernet Kempers demonstrates that they are instead quite distinct. Over the years the Rotterdam panel has been the subject of as many varying analyses as any of Bosch's works: for the most recent attempt, together with a fairly comprehensive listing of earlier efforts, see Virginia Tuttle, "Bosch's Image of Poverty," *Art Bulletin*, LXIII, 1981, 88–95.

47. K. Moxey has noted that elaborately slit-patterned clothing, fashionable among the German aristocracy and haute bourgeoisie from about 1510 to 1520, was later taken up by mercenaries. The slit-pattern clothing worn by Sorgheloos, Ghemack, the Flighty Youth, the serving-boy in *Dives and Lazarus*, the Prodigal Son, and many Prodigal Son types in other

147

contemporary images was doubtless meant to convey an impression of foppishness and dandyism. On mercenaries (and the representation of peasants), see Moxey, "The Social Function of Secular Woodcuts in Sixteenth Century Nuremberg," in *New Perspectives on the Art of Renaissance Nuremberg. Five Essays*, ed., J. C. Smith, Austin, 1985, 63–81. For a differing view on the origin and spread of slit clothing, see Amsterdams Historisch Museum, *De smaak van de elite. Amsterdam in de eeuw van de beeldenstorm*, eds. R. Kistemaker and M. Jonker, 1986, 68–76.

48. B.H.D. Hermesdorf, *De herberg in de Nederlanden: een blik in de beschavingsgeschiedenis*, Assen, 1957, 237, 265; Renger, *Lockere Gesellschaft*, 59.

49. Renger, *Lockere Gesellschaft*, 21.

50. Kat, *Verloren Zoon*, 29.

51. Renger, *Lockere Gesellschaft*, 58. The same biting and beating motifs appear again in one scene from a Prodigal Son series engraved by J. Gelle after A. Braun: see Renger, fig. 35.

52. Renger, *Lockere Gesellschaft*, 50.

53. Renger, *Lockere Gesellschaft*, 61–63. Renger observes the lack of any corresponding pictorial tradition for the poor kitchen, adding that Bruegel's version (published as an engraving in 1563, along with the antithetical *Rich Kitchen*—H.154, 159) is really the first of its kind and that no real models have been identified. We might note, however, that there are actually several distinct parallels between *Sorgheloos*'s sixth scene and Bruegel's *Poor Kitchen*—parallels that would probably have been even more apparent in the original drawing (now lost) because of its reversed composition. There is the same prominent hearth, complete with a smoking fire and cauldron being stirred by a figure either kneeling, or sitting, in profile. In both there is a circular table, an undernourished dog, and an empty pot being inspected nearby (by a boy, in the Bruegel).

Also demonstrating certain similarities to *Sorgheloos*'s last scene is Bruegel's 1558 drawing for the *Alchemist*, another variation on the theme of foolishly incurred want (L. Münz, *Bruegel: The Drawings*, London, 1961, 227). We can compare its general disposition of figures, smoking fireplace, empty cupboard (occupied by children rather than a cat), bellows, and view of the now indigent family through a large opening at the left rear. It is certainly not unreasonable to suggest that both these works may reflect some knowledge of Cornelis's image. (And, in fact, I recently encountered this very suggestion, though only with regard to the *Alchemist*, in Matthias Winner, "Zu Bruegel's 'Alchimist,' " *Pieter Bruegel und seine Welt*, eds. O. von Simson and M. Winner, Berlin, 1975, 197).

54. Hertel, *Reichtum und Armut*, 99–101.

55. *Woordenboek der Nederlandsche Taal*, eds. M. de Vries, L. A. te Winkel, et al., The Hague and Leiden, 1882–, XVII, 110–11.

56. *Veelderhande geneuchlijcke dichten*, 79.

57. *Woordenboek der Nederlandsche Taal*, VII, pt. I, 1792; L. Brand Philip, "The *Peddler* by Hieronymus Bosch, a Study in Detection," *Nederlands Kunsthistorisch Jaarboek*, IX, 1958, 34, note 66.

58. *Woordenboek der Nederlandsche Taal*, XIV, 2774–75; D. Bax, *Hieronymus Bosch: His Picture-Writing Deciphered*, trans. M. A. Bax-Botha, Rotterdam, 1979, 217–19. See also C. P. Burger, "De haring in de geschiedenis en in de literatuur," *Het Boek*, X, 1921, 145ff.

59. Bax, *Bosch*, 230–33. A trotter also appears tucked into the jacket of the wayfarer in Bosch's Rotterdam tondo; see the literature referred to above, note 112, for several different interpretations of its possible significance in this context.

60. Bax, *Bosch*, 223–25.

61. De Jong, "Sorgheloos," 112.

62. (H.27, N.411–414) The Rijksprentenkabinet has the only complete impression, with hand-coloring, text, and Jan Ewoutsz's address (see Nijhoff, *Nederlandsche Houtsneden*, 171–72, and Bolte, "Bilderbogen," 128–29); it also has one example each of the first and fourth sheets, without coloring or text. The Museum Boymans-van Beuningen has the second, third, and fourth sheets, again minus coloring and text, while the British Museum has a textless, uncolored fourth sheet. Fully assembled, *The Flighty Yough* measures approximately 115.5 x 37 cm.

63. The field with eyes and wood with ears was, for that matter, represented by Bosch himself in a drawing (see C. de Tolnay, *Hieronymus Bosch*, Baden-Baden, 1966, 388). See Otto Moll, *Sprichwörter-bibliographie*, Frankfurt a.M., 1958, for a listing of early proverb collections and secondary sources. For a sample of proverb broadsheets (mostly later sixteenth- and seventeenth-century), see L. Lebeer, "De Blauwe Huyck," *Gentsche Bijdragen tot de Kunstgeschiedenis*, VI, 1939–1940, 161–229. As David Kunzle notes ("Bruegel's Proverb-Painting and the World Upside Down," *Art Bulletin*, LIX, 1977, 199, note 5), the assessment of proverb illustration, as a phenomenon that also has bearing on much comic and genre painting of the period, has barely begun.

64. C. Tuinman, *De Oorsprong en uitlegging van dagelijks gebruikte Nederduitsche spreekwoorden*, Middelburg, 1726, I, 88; P. J. Harrebomé, *Spreekwoordenboek der Nederlandsche taal of verzameling van Nederlandsche spreekwoorden en spreekwoordelijke uitdrukkingen*, Utrecht, 1858–1870, I, 115, 149; *Woordenboek der Nederlandsche Taal*, III, pt. 2, 3135.

65. Harrebomé *Spreekwoordenboek*, I, 148–49, 177; *Woordenboek der Nederlandsche Taal*, III, pt. 2, 3140, pt. 3, 3971.

66. Renger, *Lockere Gesellschaft*, 125–27.

67. Bax, *Bosch*, 191–94; Lilian Randall, "A Mediaeval Slander," *Art Bulletin*, XLII, 1960, 28–30.

68. Harrebomé, *Spreekwoordenboek*, II, 390–91; *Woordenboek der Nederlandsche Taal*, XXI, 1814.

69. *Woordenboek der Nederlandsche Taal*, XXI, pt. 2, 2813; XVIII, 1230; XXI, 1922–23, 1940–41. The conceit of a foolhardy youth whose immoderate flight leads to his downfall obviously suggests the story of Icarus—a story that would, in fact, be used by emblematists to illustrate the dangers of intemperance (see A. Henkel and A. Schöne, *Emblemata. Handbuch zur Sinnbildkunst des XVI. und XVII. Jahrhunderts*, Stuttgart, 1967, 1617). It is certainly possible that *The Flighty Youth*'s imagery was constructed from a selection of current avian proverbs and figures of speech, but with specific reference to the Ovidian character. At the same time, there is nothing in either Cornelis's representation or in the accompanying text to make such a reference explcit.

70. On feathers, wings, owls, and folly, see Gerta Calmann, "The Picture of Nobody: an Iconographical Study," *Journal of the Warburg and Courtauld Institutes*, XXIII, 1960, 60-104. On the owl, see also Heinrich Schwarz and Volker Plagemann, "Eule," *Reallexikon zur deutschen Kunstgeschichte*, VI, 267–322, and Bax, *Bosch*, 208–13.

71. On lameness in particular, see S. Sas, *Der Hinkende als Symbol*, Zurich, 1964.

72. On the emblematic history of this motif, see K. Giehlow, "Die Hieroglyphenkunde des 149

Humanismus in der Allegorie der Renaissance," *Jahrbuch der Kunsthistorischen Sammlungen des Allerhöchsten Kaiserhauses*, XXXII, 1915, 155–56, and Stauch, "Armut," 1115.

73. Renger, *Lockere Gesellschaft*, 58.

74. For further information regarding van de Venne and his many variations on the theme of poverty, see L. J. Bol, "Een Middelburgse Bruegel-groep," *Oud-Holland*, LXXIII, 1958, 59–79, 128–47.

75. See, for example, Hans Sebald Beham's engraving of *Infortunium* (B.140). The rather illogical progression from the ragged state of our protagonist in his fourth appearance to his decidedly more presentable fifth appearance has caused at least one commentator to wonder whether *The Flighty Youth* was indeed conceived at one time as a unit (Kunzle, *Early Comic Strip*, 451). Lending further weight to this query is the rather abrupt entrance of a shaded sky. It is possible that the block including the last two figures was not designed at the same time as the other three blocks. The surviving evidence does not permit any definite answers.

76. De Jong, "Sorgheloos," 111–12, has also made this observation.

Chapter 4, Troublemakers

1. Pleij, *Blauwe Schuit*, 15–62.

2. A. Gittée, "Scherzhaft gebildete und angewendete Eigennamen im Niederländischen," *Zeitschrift des Vereins für Volkskunde*, III, 1893, 419–31; J. W. Muller, "Nog iets over Sint-Brandaris," *Tijdschrift voor Nederlandsche Taal- en Letterkunde*, XVIII, 1899, 193–99; J. Schrijnen, *Essays en studiën in vergelijkende godsdienstgeschiedenis, mythologie, en folklore*, Venloo, n.d., 68.

3. Enklaar, *Varende Luyden*, 37–135; Pieter van Moerkerken, *De Satire in de Nederlandsche kunst der Middeleeuwen*, Amsterdam, 1904, 105–7; Pieter Schröder, *Parodieën in de Nederlandsche letterkunde*, Haarlem, 1932, 50–53.

4. (H.39, N.121) There are five extant impressions. The Rijksprentenkabinet has the only example with hand-coloring, text, and Jan Ewoutsz's address (see Nijhoff, *Nederlandsche Houtsneden*, 24, and Bolte, "Bilderbogen," 129–33); it also has an uncolored example, without text or address. The Bibliothèque Nationale, the British Museum, and the Ashmolean Museum, Oxford, each have one uncolored, textless example. Complete with text, *Sinte Aelwaer* measures approximately 37 x 28.5 cm. See this author's cat. no. 155 in Amsterdam, *Kunst voor de beeldenstorm*.

5. *Van nyeuvont, loosheit, ende practike: hoe sij vrou Lorste verheffen*, ed. and intro. by E. Neurdenburg, Utrecht, 1910. For another representation of Vrou Lorts, see M. E. Kronenberg, "Bij de afbeelding van Vrou Lors," *Het Boek*, XXXV, 1961, 28–30.

6. Enklaar, *Varende Luyden*, 63–64.

7. See Enklaar, *Uilenspiegel's kring*, 49–65; C. P. Burger, "Nederlandsche houtsneden 1500–1550; Het schip van Sinte Reynuut," *Het Boek*, XX, 1931, 209–21; Rotterdam, Museum Boymans-van Beuningen, *Erasmus en zijn tijd*, cat. by J. Besse, N. van der Blom, et al., 1969, cat. no. 155; Washington, D.C., *Lucas van Leyden*, 262; and Amsterdam, *Kunst voor de beeldenstorm*, cat. no. 40.

8. Although the resemblance does not seem to be particularly strong, it has been suggested that this figure was actually meant to portray Erasmus. See Beets, "Aanwinsten," 181–85, and Amsterdam, *Kunst voor de beeldenstorm*, cat. no. 40.

9. *Woordenboek der Nederlandsche Taal*, I, 28–29.

10. Enklaar, *Varende Luyden*, 127–28, 133–34.

11. On this literary convention and its variations, see Ruth Mohl, *The Three Estates in Medieval and Renaissance Literature*, New York, 1933; W. Heinemann, "Zur Ständedidaxe in der deutschen Literatur des 13–15 Jahrhunderts," *Beiträge zur Geschichte der Deutschen Sprache und Literatur*, LXXXVIII, 1966, 1–90, LXXXIX, 1967, 290–403, XCII, 1970, 388–437; and Keith Moxey, "*The Ship of Fools* and the Idea of Folly in Sixteenth-Century Netherlandish Literature," in *The Early Illustrated Book: Essays in Honor of J. Lessing Rosenwald*, Washington, D.C., 1982.

12. Neurdenburg, *Van nyeuvont*, 26–40.

13. P. de Jong, "Sinte Aelwaer, een parodiërende rijmprent," *Spektator; Tijdschrift voor Neerlandistiek*, V, 1975–1976, 128. It should be noted, at this point, that De Jong describes *Aelwaer* as representing not only an ass, pig, cat, and magpie but also a rat, on the saint's left shoulder; it is, he suggests, a reference both to slander and to death (p. 134). Clearly, however, the "rat" is nothing more than a bit of drapery.

14. Wilhelm Fraenger, *Hans Weiditz und Sebastian Brant*, Leipzig, 1930, 115. See also *Deutsches Wörterbuch*, Jacob and Wilhelm Grimm, et al., Leipzig, 1854–1965, III, 1146. On the ass as an image of ignorance, error, laziness, and obstinacy, see V. Plagemann and M. Denzler, "Esel," *Reallexikon zur deutschen Kunstgeschichte*, V, 1484–1528. Dame Folly herself rides an ass in a fifteenth-century engraving discussed by H. W. Janson, *Apes and Ape Lore in the Middle Ages and the Renaissance*, London, 1952, 204–5. On the ride on an ass as a form of punishment actually meted out to various criminals, and especially to adulteresses and scolds, see Plagemann, "Eselsritt," *Reallexikon*, V, 1529–36.

15. Brant, *Ship of Fools*, 142–43, 212–15. See also Friedrich Winkler, *Dürer und die Illustrationen zum Narrenschiff*, Berlin, 1951, 37.

16. Fraenger, *Hans Weiditz*, 115–16. Attribution of the Petrarch woodcuts is still a matter of some dispute. See Francesco Petrarcha, *De Remediis Utriusque Fortunae*, trans. and with a commentary by Rudolf Schottlaender, Munich, 1975, 308.

17. Campbell Dodgson, *Catalogue of Early German and Flemish Woodcuts Preserved in the Department of Prints and Drawings in the British Museum*, London, 1903/1911, I, 496–97; Heinrich Röttinger, *Erhard Schön und Niklas Stör, der Pseudo-Schön*, Strassburg, 1925, 132. On the character Seltenfried, see Grimm, *Deutsches Wörterbuch*, X, 546.

18. Franz Brietzmann, *Die böse Frau in der deutschen Literatur des Mittelalters*, Berlin, 1912, 158–61; Aleide Roessingh, *De Vrouw bij de dietsche moralisten*, Groningen, 1914, 74–83; Katharine Rogers, *The Troublesome Helpmate: A History of Misogyny in Literature*, Seattle and London, 1966, 93–94.

19. Jan Grauls, *Volkstaal en voksleven in het werk van Pieter Bruegel*, Antwerp and Amsterdam, 1957, 6–76. See also W. S. Gibson, "Dulle Griet and Sexist Politics in the Sixteenth Century," in *Bruegel und seine Welt*, 9–15.

20. *Woordenboek der Nederlandsche Taal*, XVIII, 584; Grimm, *Deutsches Wörterbuch*, VIII, 1847. See also S. Braunfels, "Schwein," in *Lexikon der christlichen Ikonographie*, E. Kirschbaum et al., Freiburg, 1968–1976, IV, 134–36.

21. Bax, *Bosch*, 228; Grimm, *Deutsches Worterbuch*, V, 288–89; H. Bächtold-Stäubli, *Handwörterbuch des deutschen Aberglaubens*, Berlin and Leipzig, 1936–1937, VIII, 527–36.

22. Brant's chapter "Of Bad Women" also refers to their magpie tongues and to Ovid's account of the magpie's origin: "Pierus had a brood of young / Their tongues were smeared with venom dire / They burned ablaze and stung like fire" (*Ship of Fools*, 213). Talkative

people are likened to magpies in several Dutch expressions (*Woordenboek der Neder-landsche Taal*, III, pt. 3, 4053–54). On the possible role of this bird in Bosch's Rotterdam tondo and in Bruegel's *Magpie on the Gallows*, see D. Bax, "Bezwaren tegen L. Brand Philips interpretatie van Jeroen Bosch' Marskramer, Goochelaar, Keijsnijder en voorgrond van Hooi-wagenpaneel," *Nederlands Kunsthistorisch Jaarboek*, XIII, 1962, 5–7.

23. De Jong, "Sinte Aelwaer," 132.

24. *Middelnederlandsche Woordenboek*, E. Verwijs, J. Verdam, et al., The Hague, 1885–1952, IV, 1538–39, VIII, 1724.

25. De Jong, "Sinte Aelwaer," 132.

26. *Middelnederlandsche Woordenboek*, IV, 746; Enklaar, *Varende Luyden*, 127–28.

27. *Middelnederlandsche Woordenboek*, II, 200.

28. De Jong, "Sinte Aelwaer," 128; Pleij, *Blauwe Schuit*, 113.

29. De Jong notes, in fact, that all three of the characters in lines 94–96 are named again in one piece from the *Veelderhande geneuchlijcke dichten* ("Sinte Aelwaer," 135, note 4).

30. K. Gödeke, "Asinus vulgi," *Orient und Occident*, I, 1862, 531–60; Julius Tittman, *Schauspiele aus dem sechzehnten Jahrhundert*, Leipzig, 1868, I, 203–8; Philippe de Vig-neulles, *Les Cent Nouvelles Nouvelles*, intro. by C. Livingston, Geneva, 1962, 384.

31. For a discussion of the late antique origins of fable illustration, see Adolph Gold-schmidt, *An Early Manuscript of the Aesop Fables of Avianus and Related Manuscripts*, Princeton, 1947.

32. For Netherlandish editions, see John Landwehr, *Fable Books Printed in the Low Coun-tries: A Concise Bibliography until 1800*, Nieuwkoop, 1963.

33. According to Christian Küster, the only other illustrations of our fable are those ap-pearing in two editions from Spain and two published in Italy in the later sixteenth century ("Illustrierte Aesop-Ausgaben des 15. und 16. Jahrhunderts," diss. Univ. Hamburg, 1970).

34. Pencz also provided woodcut illustrations for Sachs's versions of the fables of the shep-herd and hunter and the rabbits and frogs; see *Welt, Hans Sachs*, 88, cat. no. 83; 89, cat. no. 84; and 92, cat. no. 88.

35. Hans Sachs, *Werke*, eds. A. von Keller and E. Goetze, Stuttgart, 1870–1908, IV, 300–3; Gödeke, "Asinus," 547–49; *Welt, Hans Sachs*, 75, cat. no. 76.

36. Apparently forming part of the same series is a sixth woodcut that represents a herald in conversation with an old man (see *The Illustrated Bartsch*, ed. W. Strauss, New York, 1978–, XI; *Burgkmair, Schäufelein, Cranach*, ed. Tilman Falk, 288, B.104). Campbell Dodg-son has noted that two additional woodcuts, now lost, are recorded in copies after Schäufel-ein's suite; one showed the ass being carried, while the other showed the old man together with a pope and an emperor (*German and Flemish Woodcuts, British Museum*, II, 54). Dodg-son is mistaken in identifying the eight scenes as illustrating Sachs's account; they do, how-ever, show a distinct if unexplained relationship to a play by the Augsburg *Meistersinger* Sebastian Wild, first published in 1566 (Gödeke, "Asinus," 551; Tittman, *Schauspiele*, 208).

37. Washington, D.C., International Exhibitions Foundation, *Titian and the Venetian Woodcut*, intro. and cat. by David Rosand and Michelangelo Muraro, 1976, 11.

38. *Venetian Woodcut*, 37–54.

39. *Venetian Woodcut*, 70–91.

40. On the woodcut as wall hanging, see Horst Appuhn and Christian v. Heusinger, *Rie-senholzschnitte und Papiertapeten der Renaissance*, Unterschniedheim, 1976.

41. Friedländer, *Early Netherlandish Painting*, II, pl. 80; W. Martin, *Jan Steen*, Amsterdam, 1954, fig. 60.

42. Friedländer, *Early Netherlandish Painting*, XII, pl. 126, no 235.

43. Geisberg, *Single-Leaf Woodcut 1500–1550*, I, 338–62.

44. A width or height of over 50 cm. was my most basic requirement in classifying a woodcut as monumental. Images that *could* stand alone as "nonmonumental" but that seemed basically to have been intended as parts of a monumental, pasted-together composite were counted as parts of such a composite (for example, Nijhoff, pl. 25–29 or Geisberg, II, 461–67). All other images—including those belonging to series that show no clear evidence of ever having been meant to be joined by means of a framework or otherwise—were counted among the nonmonumental woodcuts. I must confess to being puzzled by Appuhn's totals. He states that he considers as monumental (1) all works composed from several blocks, and (2) all works printed from one block, whose larger dimension exceeds 50 cm. Using these guidelines, he comes up with seventy monumental woodcuts from Geisberg's *Single-Leaf Woodcut 1500–1550*; those in Strauss's *German Single-Leaf Woodcut 1550–1600*, those in Nijhoff, and those from Italy add up, he claims, to another seventy (*Riesenholzschnitte*, 35). Our criteria would seem to be more or less the same, yet a careful tabulation on my part yielded not only a larger proportion of Netherlandish examples but also a somewhat greater total of monumental woodcuts from Germany as well.

45. Nijhoff, *Nederlandsche Houtsneden*, 7.

46. On the *Nine Heroes*, see Washington, D.C., *Lucas van Leyden*, 156–57.

47. Washington, D.C., *Lucas van Leyden*, 164–83, 214.

48. (B.5, H.45, N.90–93) Nijhoff, *Nederlandsche Houtsneden*, 16, notes only the uncolored Albertina and the colored Rijksprentenkabinet impressions and reproduces the former; Bolte, "Bilderbogen," 126–27, provides a transcription of the verses on the latter. Neither seems to have been aware of the example in Brussels (whose text I have included, along with a translation, in the Appendix). There is a fourth, fragmentary example, of the second and third blocks only, in the Berlin Kupferstichkabinett. When complete, the work measures about 30.5 x 148 cm. See also this author's cat. no. 153 in Amsterdam, *Kunst voor de beeldenstorm*.

49. Like *Sinte Aelwaer*'s Abt van Grimberghen, Heer van Kijfhoeck, and Doctor Muylaert, Keyaert was apparently a standard comic appellation. The world *kei* not only meant a smooth stone but also had the connotation of fool (*Middelnederlandsch Woordenboek*, III, 1273)—thus the motif of the stone of folly and the theme of an operation for its removal (see J. van Gils, "Het snijden van den kei," *Nederlandsch Tijdschrift voor Geneeskunde*, 1940, LXXXIV, 1310ff.).

50. *Woordenboek der Nederlandsch Taal*, V, 2051.

51. Variations on this type of headgear can be found, for instance, in the *Nuremberg Chronicle* (folios xxv, xxxvii, lv, xcvi verso), in Hans Sebald Beham's engraving of *Christ in the House of Simon* (B.25), or in van Heemskerck's painting of the same theme (Grosshans, *Van Heemskerck*, fig. 127).

52. See Washington, D.C., *Lucas van Leyden*, 264–65, and Amsterdam, *Kunst voor de beeldenstorm*, cat. no. 41. On the history of the mercenary and his public image, see Charles Oman, *A History of the Art of War in the Sixteenth Century*, New York, 1937, 74ff.; Fritz Redlich, "The German Military Enterpriser and His Work Force"; *Viertaljahrschrift für Sozial- und Wirtschaftsgeschichte*, XLVII-XLVIII, 1964–1965; J. R. Hale, "Sixteenth-Century Ex-

planations of War and Violence," *Past and Present*, LI, 1971, 9–10; and Moxey, "Social Function," *New Perspectives*.

53. Jane S. Fishman, *Boerenverdriet: Violence between Peasants and Soldiers in Early Modern Netherlands Art*, Ann Arbor, 1982, 43–44.

54. E. de Jong, "Erotica in Vogelperspectief: De dubbelzinnigheid van een reeks 17de eeuwse genrevoorstellingen," *Simiolus*, III, 1968–1969, 22–52; Ardis Grosjean, "Toward an Interpretation of Pieter Aertsen's Profane Iconography," *Konsthistorisk Tidskrift*, XLIII, 1974, 124–26. On the motif of the hand tucked inside the shirt and its additional associations with the sin of sloth, see Susan Koslow, "Frans Hals's *Fisherboys*: Exemplars of Idleness," *Art Bulletin*, LVII, 1975, 418–32.

55. On this portrayal of the peasant in sixteenth-century art and literature, see Fishman, *Boerenverdriet*, 43–44; R. W. Scribner, "Images of the Peasant 1514–1525," *Journal of Peasant Studies*, III, 1975, 29–48; Hessel Miedema, "Realism and the Comic Mode: The Peasant," *Simiolus*, IX, 1977, 205–19; Keith Moxey, "Sebald Beham's Church Anniversary Holidays: Festive Peasants as Instruments of Repressive Humor," *Simiolus*, XII, 1981–1982, 107–30; Moxey, "Social Function," 63–68; and especially the excellent discussion provided by Paul Vandenbroek in "Verbeeck's Peasant Weddings: a Study of Iconography and Social Function," *Simiolus*, XIV, 1984, 79–124.

56. In Cornelis's day, perhaps no group was more consistently characterized as naturally aggressive and violent than, of course, the Turks: see John Bohnstedt, *The Infidel Scourge of God: The Turkish Menace as Seen by German Pamphleteers of the Reformation Era* (Transactions of the American Philosophical Society, N.S., LVIII, pt. 9), Philadelphia, 1968, and Paul Coles, *The Ottoman Impact on Europe*, London, 1968, 145–49. This perception is, indeed, unmistakably reflected in the wolfish sixty-year-old of his *Ages of Man* (fig. 32). But as I suggested above, I do not believe that the *Fable*'s second couple was meant to be specifically recognized as such, and hence as representatives of yet another distinctly belligerent "class." Even within the context of western artists' often fanciful and inaccurate portrayal of the Ottomans, Cornelis's figures remain too ambiguous—with some "Jewish" as well as "Turkish" touches—to have been intended as anything other than "Orientals," of the same ilk as the decidedly benign "Wysen," who appears at the end of the frieze.

Chapter 5, Upstarts

1. (H.41, N.352) There are two extant examples, both in the Rijksprentenkabinet; one is an eighteenth-century impression, accompanied by a text concerning the disastrous speculations of 1719–1720. See Nijhoff, *Nederlandsche Houtsneden*, 114–15, and Maurits de Meyer, *De Volks-en kinderprent in de Nederlanden van de 15e tot de 20e eeuw*, Antwerp and Amsterdam, 1962, 31, 381, and fig. 113. Cornelis's image measures 27 x 23.5 cm.

2. Brant, *Ship of Fools*, 238–41. On the term Grobian and on Grobian texts as a distinct literary genre satirizing uncouth behavior (especially at table), see Vandenbroeck, "Verbeeck's Peasant Weddings," 109–14.

3. Attribution of the *De Officiis* woodcuts is closely bound up with questions as to the hand involved in the illustrations for the 1532 *De Remediis Utriusque Fortunae*. In fact, the *Fool Crowning a Sow* was one of a number of woodcuts from the Cicero that would later be reused for the Petrarch: see note 16, chap. 4, and Richard Muther, *Die deutsche Bücherillustration der Gothik und Frührenaissance 1460–1530*, Munich and Leipzig, 1884, 138–41.

4. Howard Patch, *The Goddess Fortuna in Mediaeval Literature*, Cambridge, 1927, 48, note 2.

5. Desiderius Erasmus, *The Praise of Folly*, trans., intro., and commentary by Hoyt Hudson, Princeton, 1941, 103.

6. On all five emblems, see Henkel and Schöne, *Emblemata*, 511, 515, 536, 546, 547.

7. Jean Cousin, *Le Livre de Fortune*, ed. Ludovic Lalanne, Paris and London, 1883, 21, and pl. XXXIX, XL.

8. Roemer Visscher, *Sinnepoppen*, intro. and commentary by L. Brummel, The Hague, 1949, 175. Clearly inspired by Visscher's pig is the one that appears, with the same message, in Daniel Meissner and Eberhard Kieser's *Thesaurus Philopoliticus; oder, Politisches Schatz-kästlein*, facsimile of Frankfurt, 1627–1631 eds., Unterchneidheim, 1972-, II, 14, 40.

9. On the world sphere, see Percy Schramm, *Sphaira, Globus, Reichsapfel; Wanderung und Waldlung eines Herrschaftszeichens von Caesar bis zu Elisabeth II*, Stuttgart, 1958; on Fortuna's wheel, globe, and wings, see Patch, *Goddess Fortuna*, 45–46, 147–77; and Samuel Chew, *The Pilgrimage of Life*, New Haven and London, 1962, 35–69.

10. David Kunzle, "Bruegel's Proverb Painting," 198, and "World Upside Down: The Iconography of a European Broadsheet Type," in *The Reversible World; Symbolic Inversion in Art and Society*, ed. Barbara Babcock, Ithaca, 1978, 59–60.

11. *Welt, Hans Sachs*, 159.

12. R. W. Scribner, *For the Sake of Simple Folk: Popular Propaganda for the German Reformation*, Cambridge, 1981, 166–68.

13. Lewis Carroll, *Alice's Adventures in Wonderland*, in *The Complete Works*, intro. by Alexander Woollcott, New York, 1976, 98. The possibility of winged pigs is also mentioned in *Through the Looking Glass* (*Complete Works*, 86).

14. As Kunzle and others have observed, whether or not the hierarchical inversions of the world upside down were seen as desirable could vary—depending on the particular image, the particular viewer, and his particular historic moment ("Bruegel's Proverb Painting," 198; "World Upside Down," 82; see also Peter Burke, *Popular Culture in Early Modern Europe*, New York, 1978, 189). In the papal-wolves woodcut, the reversal is unmistakably positive; the heroes and villains are, moreover, clearly distinguished and labeled. Likewise, the *Winged Pig*'s implied reversal is presented as an unmistakably negative occurence. But exactly who are the swinish men to which the work refers? Because this must remain an open question, its sociopolitical stance is an essentially ambiguous one.

CHAPTER 6, Virtues in Exile

1. The etching of *Concord, Peace, and Love* (H.2) exists in one impression, in the Albertina, and measures 11.4 x 24.6 cm.; there is one late impression of the woodcut version (H.37, N.353), measuring 24.4 x 36.7 cm., in the Rijksprentenkabinet. Examples of *Truth, Hate, and Fear* (H.36, N.101) can be found in the Rijksprentenkabinet and in the British Museum; it measures 17.1 x 36.2 cm. See Nijhoff, *Nederlandsche Houtsneden*, 18, 115.

2. *Middelnederlandsch Woordenboek*, II, 1102–3.

3. On these various sleepers and types of sleep, see Gizella Firestone, "The Sleeping Christ-Child in Italian Renaissance Representations of the Madonna," *Marsyas*, II, 1942, 43–62; Lieselotte Möller, "Schlaf und Tod: Überlegungen zu zwei Liegefiguren des 17. Jahrhuderts," *Festschrift für Erich Meyer*, Hamburg, 1959, 237–48; Millard Meiss, "Sleep in Venice. An-

cient Myths and Renaissance Proclivities," *Proceedings of the American Philosophical Society*, cx, 1966, 348–82; Madlyn Kahr, "Vermeer's Girl Asleep: A Moral Emblem," *Metropolitan Museum Journal*, vi, 1972, 115–32; and Benedict Nicolson, *Hendrick Terbrugghen*, London, 1958, 102–3.

4. "Credit" would later prove to be among the most popular of all deceased personifications, in prints designed to be hung in shops and alehouses as warnings to customers. See R. Saulnier and H. Van der Zee, "La mort de Crédit: image populaire, ses sources politiques et économiques," *Dawna Sztuka*, ii, 1939, 195–217.

5. Gustav Pauli, *Barthel Beham: Ein kritisches Verzeichnis seiner Kupferstiche*, Strassburg, 1911, 33–34. For a further consideration of this work, see Herbert Zschelletzschky, *Die "Drei Gottlosen Maler" von Nürnberg*, Leipzig, 1975, 11–14, 67–77.

6. *Welt, Hans Sachs*, 152.

7. Röttinger, *Bilderbogen, Hans Sachs*, 64.

8. See Desiderius Erasmus, *The Complaint of Peace*, trans. and intro. by W. Hirtin, New York, 1946. See also Robert Adams, *The Better Part of Valor: More, Erasmus, Colet, and Vives on Humanism, War, and Peace, 1496–1535*, Seattle, 1962, 88–121, and Jean-Claude Margolin, *Guerre et Paix dans la Pensée d'Érasme*, Paris, 1973.

9. On Everaert's play, see H. E. van Gelder, "Satiren der XVIde eeuwsche kleine burgerij," *Oud-Holland*, xxix, 1911, 208; on Thonisz's, see Ellerbroek-Fortuin, *Amsterdamse rederijkersspelen*, 164–69.

10. W.M.H. Hummelen, *Repertorium van het rederijkersdrama, 1500–ca. 1620*, Assen, 1968, 355–56.

11. Remarkably close to *Concord, Peace, and Love* is the relief on a late fourteenth-century French wooden love chest. Inscribed along its right side is the phrase "Honor is dead." To the left, a woman lies in a garden while an old man behind her says, "Speak softly, Honor sleeps." She responds, "I am not dead, nor asleep, but none among you cares about me." Two men, one in armor, stand nearby. See Heinrich Kohlhaussen, *Minnekästchen im Mittelalter*, Berlin, 1928, no. 4770, pl. 34. Clearly, the precise conceit employed by our print had been established more than a century earlier. However, this is the only other example known to me. I would like to thank Keith Moxey for bringing this work to my attention.

12. Fritz Saxl, "Veritas Filia Temporis," *Philosophy and History. Essays Presented to Ernst Cassirer*, Oxford, 1936, 197–222.

13. Calmann, "The Picture of Nobody," 65; W. Deonna, "Le Silence, gardien du secret," *Zeitschrift für Schweizerische Archaeologie und Kunstgeschichte*, xii, 1951, 28–41.

14. Dodgson, *German and Flemish Woodcuts, British Museum*, i, 341–42; Scribner, *Simple Folk*, 140–42.

15. Koslow, "Hals's *Fisherboys*."

16. See S. Braunfels, "Schnecke," *Lexikon der christlichen Ikonographie*, iv, 98–99, and Lilian Randall, "The Snail in Gothic Marginal Warfare," *Speculum*, xxxvii, 1962, 360–61.

17. Ripa, for one, characterizes Odio Capitale as an old man armed with a sword and shield, and lists a dog as one of the attributes of Invidia (*Iconologia*, reprint of the Rome, 1603 ed., intro. by Erna Mandowsky, Hildesheim, 1970, 242, 366); see also P. Gerlach, "Hund," *Lexikon der christlichen Ikonographie*, ii, 334–36. We have already encountered the dog's association with anger in the illustration to the *Narrenschiff*'s chapters, "Of Bad Women" and "Of Ready Anger"; in the latter, Brant refers specifically to the angry man who "snarls about him like a dog" (*Ship of Fools*, 142). In the anonymous woodcut *Frow Selten-*

frid and in Schön's adaptation thereof, the dog is identified as Hederlin—that is, the spirit of Quarrelsomeness (Fraenger, *Hans Weiditz*, 116). On the notion of Hate himself as the offspring of Truth, see Saxl, "Veritas," 198–99.

18. Donald Gordon, " 'Veritas Filia Temporis.' Hadrianus Junius and Geoffrey Whitney," *Journal of the Warburg and Courtauld Institutes*, III, 1939–1940, 228–40.

19. *Iconologia*, 104–6.

20. On the etymology of the prefix *zwie-* and its gradual supplantation, in most cases, by *zwei-*, see Grimm, *Deutsches Wörterbuch*, xv, no. 10, 1126–27.

21. *Welt, Hans Sachs*, 169.

22. H.J.E. Endepols, *Het Decoratief en de opvoering van het middelnederlandsche drama volgens de middelnederlandsche toneelstukken*, Amsterdam, 1903, 86.

23. George Clutton, "Two Early Representations of Lutheranism in France," *Journal of the Warburg and Courtauld Institutes*, I, 1938, 287–89.

24. For other examples of the half-shod mercenary, see Werner Weisbach, " 'Ein Fuss beschuht, der andere nackt.' Bemerkungen zu einigen Handzeichnungen des Urs Graf," *Zeitschrift für Schweizerische Archaeologie und Kunstgeschichte*, IV, 1942, 108–22. The same notion is very likely suggested by the shoeless, stockingless leg of one of the otherwise well-dressed figures in Lucas van Leyden's *Four Soldiers in a Wood* (B.141).

25. See J. G. van Gelder and J. Borms, *Brueghel's zeven deugden en zeven hoofdzonden*, Amsterdam, 1939, 18; J.G.F. Gils, *Een andere kijk op Bruegel den oude*, The Hague, 1940–1942, II, 79; and Stridbeck, *Bruegelstudien*, 95–96. There are many other cases in which differently shod feet have less to do with conveying a clear sense of contrast than with a character's overall raggedness. This is probably true, for example, of the crullerman and the Prodigal in the Pieter Cornelisz Kunst series (figs. 47e and 47i), and of Pover in scenes five and six of *Sorgheloos*: here the wearing of only one shoe would seem to be part and parcel of the figures' generally tattered appearance. The boot and slipper worn by the protagonist of Bosch's Rotterdam tondo can most probably be understood in the same light, although, not surprisingly, some other, more elaborate interpretations have also been offered.

26. Sachs, *Werke*, III, 311–19; Georg Stuhlfauth, "Neue Beiträge zum Schrifttum des Hans Sachs und insbesondere zum Holzschnittwerk Hans Sachsischer Einzeldrucke," *Zeitschrift für Bücherfreunde*, XI, 1919–1920, 196; Heinrich Röttinger, *Erhard Schön und Niklas Stör, der Pseudo-Schön*, Strassburg, 1925, 89; Röttinger, *Bilderbogen, Hans Sachs*, 70.

27. Bolte, "Bilderbogen," 134–49, discusses this work along with the other Pieter Warnersz publications that were influenced by German models. See also Nijhoff, *Nederlandsche Houtsneden*, 27, 45–46, 51, 73, 78–79, 87; Amsterdam, Rijksmuseum, *Centsprenten: Nederlandse volks- en kinderprenten*, intro. and cat. by C. F. van Veen, 1976, 91–94, 98; Beets, "Aanwinsten," 203–8; and H. A. Krans, "Peter Warnersen drukker en uitgever te Kampen," *Het Boek*, XXIV, 1936–1937, 147–86; and Amsterdam, *Kunst voor de beeldenstorm*, cat. nos. 254–58. Several of Warnersz's woodcuts have actually been attributed to Cornelis by both Beets and Krans. Two of them—the *Rich Man and Death* and the *Wheel of Life* (Nijhoff 45–46, 73)—do, in fact, show a clear resemblance to his prints. It should be noted, though, that the former bears the monogram AI, and that the latter is dated 1558, five years after Cornelis's death. In any case, the stylistic ties do not seem to me to be strong enough to indicate Cornelis's direct involvement. More likely, as Nijhoff suggests, these woodcuts are the work of some unknown follower.

28. Ellerbroek-Fortuin, *Amsterdamse rederijkersspelen*, 124; Sterck, *Rederijkerskamer tot muiderkring*, 41–47.

29. Sachs, *Werke*, XXII, 439–45.

CHAPTER 7, Carnal Weakness

1. (H.19–25, N.123–129) Impressions of the figure Oerloghe are present in the Rijksprentenkabinet and the British Museum; the Metropolitan Museum of Art, New York, has Eendracht, Rycdom, Leecheyt, Gulsicheyt, Oncusheit, and Oerloghe; the Munich Graphische Sammlung has the figure of Eendracht. The Museum of Fine Arts, Boston, has Diligentia and Rycdom; the Statens Museum for Kunst, Copenhagen, has the figure of Oncusheit; the Hessisches Landesmuseum, Darmstadt, has all fourteen figures, but without text. Nijhoff published the only complete example, with framework and text (*Nederlandsche Houtsneden*, 25–26); formerly in the university library at Göttingen, it was lost during World War II. Fully assembled, the *Misuse* would measure approximately 36.5 x 196 cm. Perhaps the clearest precedent for setting single personifications within an elaborate frame that joins to form a continuous woodcut frieze is found in Burgkmair's series of *Virtues* and *Vices* from about 1510 (G.476–489).

2. G. P. Valeriano Bolzani, *Hieroglyphica*, reprint of the Lyon, 1602, ed., New York, 1976, 526. See also Guy de Tervarent, *Attributs et symboles dans l'art profane, 1450–1600*, Geneva, 1958–1959 and 1964, Suppl. and Index vol., 437. For the usual attributes of Concord/Peace, see Ripa, *Iconologia*, 81, 375–77, and L. von Wilckens, "Eintracht," *Reallexikon zur deutschen Kunstgeschichte*, IV, 1031–39.

3. Tervarent, *Attributs et symboles*, I, 157, 195.

4. Cf. the description of Ricchezza in Ripa, *Iconologia*, 434.

5. On Luxuria in general, see Ellen Kosmer, "The 'noyous humoure of lecherie,' " *Art Bulletin*, LVII, 1975, 1–8. On the bear as an image of the flesh and its lusts, see L. Stauch, "Bär," *Reallexikon zur deutschen Kunstgeschichte*, I, 1446–47, and J.J.M. Timmers, *Symboliek en iconographie der christelijke kunst*, Roermond, 1947, 758–59.

6. *Iconologia*, 449. See also Amsterdam, Rijksmuseum, *Tot Lering en Vermaak. Betekenissen van Hollandse genrevoorstellingen uit de zeventiende eeuw*, intro. by E. de Jongh, 1976, 59–61.

7. L. Stauch, "Angel, Angler," *Reallexikon zur deutschen Kunstgeschichte*, I, 694–98; B. Ott, "Fischer, Fischfang," *Lexikon der christlichen Ikonographie*, II, 40–42; John Knipping, *Iconography of the Counter Reformation in the Netherlands*, Nieuwkoop, 1974, II, 358–59.

8. Ripa, *Iconologia*, 175, 245. Filippo Picinelli, *Mundus Symbolicus*, reprint of the Cologne, 1694, ed., New York, 1976, II, 152.

9. Cf. the description of Guerra in Ripa, *Iconologia*, 199.

10. Chew, *Pilgrimage of Life*, 119–21. On the beaten heart, see also Knipping, *Iconography of the Counter Reformation*, I, 104. On the column (and stone) as symbols of Patiencia's fortitude, see W. S. Heckscher, "Shakespeare in His Relationship to the Visual Arts," in *Art and Literature: Studies in Relationship*, ed. E. Verheyen, Durham, 1985, 397–418.

11. A harp is played by Allegrezza d'amore in Ripa, *Iconologia*, 11.

12. Niccolò Machiavelli, *Discourses*, trans., with intro. and notes by Leslie Walker, New Haven, 1950, II, 7–8.

13. Francesco da Buti, *Commento sopra la Divina Commedia di Dante Allighieri*, Pisa, 1858, I, 214–15; Patch, *Goddess Fortuna*, 171–72.

14. Adolf Katzenellenbogen, *Allegories of the Virtues and Vices in Mediaeval Art*, London, 1939, 70–72.

15. Walter Gibson, "Hieronymus Bosch and the Mirror of Man: the Authorship and Iconography of the *Tabletop of the Seven Deadly Sins*," *Oud-Holland*, LXXXVII, 1973, 210–13.

16. George Puttenham, *The Arte of English Poesie*, in *English Reprints*, ed. E. Arber, London, 1869, IX, pt. 2, 217.

17. Machiavelli, *Discourses*, I, 94–95. For the appearance of this theme in the work of other writers, see Richard Simpson, *The School of Shakespeare*, London, 1878, II, 87–88; Erwin Panofsky, "Et in Arcadia Ego. On the Conception of Transience in Poussin and Watteau," *Philosophy and History. Essays Presented to Ernst Cassirer*, 241–42; Samuel Chew, *The Virtues Reconciled: An Iconographic Study*, Toronto, 1947, 125–28; and Sheila Williams and J. Jacquot, "Ommegangs anversois du temps de Bruegel et de van Heemskerck," *Les Fêtes de la Renaissance: Fêtes et cérémonies au temps de Charles Quint*, ed. J. Jacquot, Paris, 1975, II, 363, 386–88.

18. Van Heemskerck's series and its source are discussed at length in Williams and Jacquot, "Ommegangs anversois," 362–68, and in Veldman, *Van Heemskerck*, 133–41. There is nothing to suggest that he referred specifically to Cornelis's *Misuse*. Other representations of the cycle include one illustration from Cousin's *Livre de Fortune* (pl. CXIX), a suite of engravings after Maarten de Vos (H.159–166), a series of drawings in an early seventeenth-century English commonplace-book (Chew, *Virtues Reconciled*, 127–28); and the frontispiece from a 1642 Dutch edition of Francis Bacon's *History of Henry VII* (Gottfried Kirchner, *Fortuna in Dichtung und Emblematik des Barock*, Stuttgart, 1970, fig. 13).

19. For the most recent examination of this relationship, together with a useful bibliography, see Gibson, "Artists and *Rederijkers*."

20. *The Praise of Folly*, 69.

21. Gibson, "Artists and *Rederijkers*," 443.

22. Williams and Jacquot, "Ommegangs anversois," 383.

23. (H.40, N.355) The only extant impression is a later one, to judge from the wormholes and other losses in the block; it is in the Rijksprentenkabinet. As is noted in Nijhoff, *Nederlandsche Houtsneden*, 117–18, this example bears an inscription in German: "Ein voller Mensch ist gar ein Schwein / Was kan dafür der edle Wein." The woodcut measures approximately 26.2 x 19.1 cm.

24. (H.28) Unrecorded in any of the literature prior to the recently published Holstein vol. XXX (1986), this work is also known from a single impression, taken from a block that shows considerable signs of wear. Housed in the British Museum, it measures approximately 24.3 x 28.2 cm.

CHAPTER 8, Moral Exemplars

1. (B.2, H.42, N.76–77) This work survives in four impressions: in the Rijksprentenkabinet, the Bibliothèque Nationale, the Berlin Kupferstichkabinett, and the British Museum. Nijhoff names only the latter and adds that there are other examples that lack Jan Ewoutsz's address, though without specifying their locations (*Nederlandsche Houtsneden*, 14). The im-

age measures approximately 54.3 x 37.3 cm. See also this author's cat. no. 149 in Amsterdam, *Kunst voor de beeldenstorm*.

2. B.74–77.

3. The representation that comes closest to Cornelis's (and that may well have been known to him) is Aldegrever's engraving of 1530 (B.69). Despite the presence of Porsena and a seated female figure, its heroic nude, rounded archway, and view of "classical" buildings are clearly comparable elements.

4. I would like to thank Professor William S. Heckscher for his advice on this translation and for his suggestion that the Dutch and Latin could be read as a single, continuous text. They can also stand independent of each other as two separate but complementary inscriptions.

5. See, for example, Ripa, *Iconologia*, 86.

6. (H.38, N.122) The impression with text and hand-coloring can be found in the Rijksprentenkabinet, which also has another, without text. There are two more textless examples in the Fondation Custodia, Institut Néerlandais, Paris, and in the British Museum. Quite possibly identical with the latter is the example cited by Nijhoff as being in an Edinburgh private collection. Nijhoff notes, too, that the block was reprinted in the eighteenth century with entirely different verses regarding the Austrian war of succession (*Nederlandsche Houtsneden*, 25). Together with its original letterpress, the work measures approximately 28 x 40 cm. As was the case with *Sorgheloos*, an attribution to Cornelis is generally accepted in the literature.

7. However, Ilja Veldman supposes that the male figure was Cornelis's own invention, in "Lessons for Ladies: a Selection of Sixteenth- and Seventeenth-Century Dutch Prints," *Simiolus* 16, 2/3, 1986, 114.

8. *Hieroglyphica*, 328–29. See also H. Wentzel, "Bart, Barttracht," *Reallexikon zur deutschen Kunstgeschichte*, I, 1477–78, and Timmers, *Symboliek en Iconographie*, 87.

9. Cf. Wisdom 5:18–21, and I Thessalonians 5:8.

10. *Iconologia*, 417, 426.

11. On this subject, see Andreas Wang, *Der Miles Christianus im 16. und 17. Jahrhundert und seine mittelalterliche Tradition*, Berne, Frankfurt, 1975.

12. *Iconologia*, 66, 506.

13. See Timmers, *Symboliek en iconographie*, 538–40.

14. *Hieroglyphica*, 415–16. See also Ripa's personifications of Costanza and Stabilità, *Iconologia*, 86, 472, and Heckscher, "Shakespeare," in *Art and Literature*, ed. E. Verheyen, 397–418.

15. *Mundus Symbolicus*, I, 295.

16. Henkel and Schöne, *Emblemata*, 1750; cf. also the variation by Hadrianus Junius, col. 1543. On the history of this emblem, see Heckscher, "Aphrodite as a Nun," in *Art and Literature*, 97–109.

17. See, for example, Ripa's Castità and Castità Matrimoniale, *Iconologia*, 66–67.

18. A serpentine belt is also worn by Bruegel's personification of Temperance (Stridbeck, *Brugelstudien*, 163).

19. See J. Traeger, "Pferd," *Lexikon der christlichen Ikonographie*, III, 411–15, and Picinelli, *Mundus Symbolicus*, 379–86.

20. Henkel and Schöne, *Emblemata*, 497. I have been unable to discover the meaning of the acronym that appears, as in Woensam's woodcut, on the hem of her skirt.

21. Ruth Kelso, *Doctrine for the Lady of the Renaissance*, Urbana, 1956, 9–10. See also Nijmegen, Museum Commanderie van Sint-Jan, *Tussen heks en heilige: Het vrouwbeeld op de drempel van de moderne tijd, 15de/16de eeuw*, cat. by Petty Bange, Grietje Dresen et al., 1985, 12, 19, 24–25, and Veldman, "Ladies," 114.

22. On this subject, see especially Steven Ozment, *When Fathers Ruled: Family Life in Reformation Europe*, Cambridge, Mass., 1983, 1–49; *Tussen heks*, 20, 26.

23. *Tussen heks*, 12, 17, 41–44, 55; Veldman, "Ladies," 120.

24. Joyce Irwin, "Society and the Sexes," in *Reformation Europe*, ed. S. Ozment, 344–46.

25. Ozment, *Fathers*, 50–54.

26. Kelso, *Doctrine*, 44, 108.

27. This passage is quoted by Veldman, "Ladies," 119.

28. This tradition is discussed in Haarlem, Frans Halsmuseum, *Portretten van Echt en trouw: Huwelijk en gezin in de Nederlandse kunst van de 17de eeuw*, cat. by E. de Jongh, 1986, 36.

CHAPTER 9, Images of Death and Faith

1. (B.4, H.26, N.118) There are six extant impressions: in the Rijksprentenkabinet, the Fondation Custodia, the Bibliothèque Nationale, the Ashmolean, the Museum Boysmans-van Beuningen, and the Kunsthalle, Hamburg. Nijhoff mentions only the latter but claims that there are additional examples without Ewoutsz's mark (*Nederlandsche Houtsneden*, 24). The work measures approximately 44.7 x 32.8 cm. For a Pieter Pourbus portrait based on Cornelis's woodcut, see this author's cat. no. 150 in Amsterdam, *Kunst voor de beeldenstorm*.

2. The most informative study of this theme is still H. W. Janson's "Putto with the Death's Head," *Art Bulletin*, XIX, 1937, 423–49.

3. See John Calvin, *Commentary on Seneca's De Clementia*, trans., intro., and notes by F. L. Battles and A. Hugo, Leiden, 1969, 36–51, and William Bouwsma, "The Two Faces of Humanism: Stoicism and Augustinianism in Renaissance Thought," *Itinerarium Italicum; Festschrift Paul O. Kristeller*, ed. H. Oberman and T. Brady, Leiden, 1975, 3–60. On Lipsius and his influence, see Léontine Zanta, *La Renaissance du Stoicisme au XVIᵉ siècle*, Paris, 1914, and Jason Saunders, *Justus Lipsius: The Philosophy of Renaissance Stoicism*, New York, 1955. A recent study on this subject is Gerard Verbeke, *The Presence of Stoicism in Medieval Thought*, Washington, D.C., 1983.

4. "Death and Resurrection in a Picture by Marten de Vos," *Miscellanea Leo van Puyvelde*, Brussels, 1949, 117–23.

5. "Stoicism and Augustinianism."

6. "Stoicism and Augustinianism," 18.

7. See Van Marle, *Iconographie de l'art profane*, II, 153–63; Chew, *Pilgrimage of Life*, 144–73; J. Poeschke, "Leben, Menschliches," *Lexikon der christlichen Ikonographie*, III, 38–39; Timmers, *Symboliek en iconographie*, 684–87; Anton Englert, "Die menschlichen Altersstufen in Wort und Bild," *Zeitschrift des Vereins für Volkskunde*, XVII, 1907, 16–42; Hans von der Gabelentz, *Die Lebensalter und das menschliche Leben in Tiergestalt*, Berlin, 1938; Kleef, Städtisches Museum Haus Koekkoek, *Die Lebenstreppe. Bilder der menschlichen Lebensalter*, 1983–84; J. A. Burrow, *The Ages of Man. A Study in Medieval Writing and*

Thought, Oxford, 1986; and Elizabeth Sears, *The Ages of Man. Medieval Interpretations of the Life Cycle*, Princeton, 1986.

8. Gabelentz, *Lebensalter*, 11. For several variations on this formula, see J. Zacher and E. Matthias, "Die zehn Altersstufen des Menschen," *Zeitschrift für Deutsche Philologie*, XXIII, 1891, 385–412, and A. Jeitteles and H. Lewy, "Zum Spruch von den 10 Altersstufen des Menschen," *Zeitschrift für Deutsche Philologie*, XXIV, 1892, 161–65.

9. For a transcription of these lines, see Gabelentz, *Lebensalter*, 13–14.

10. In one of the woodcuts published by Pieter Warnersz (see note 27, chap. 6), representatives of the four ages stand upon a wheel that has been laid flat on the ground.

11. For the motif of the bridge and the ages of man in a German woodcut of 1488, see Gibson, "Bosch and the Mirror of Man," 223ff. and fig. 15.

12. (H.35, n.214–215) Nijhoff cites only the example in the Rijksprentenkabinet and asks if there are others that may be textually complete (*Nederlandsche Houtsneden*, 49–50); the Albertina's impression is, however, identical in this respect. The work measures approximately 48.6 x 35.9 cm. See also this author's cat. no. 156 in Amsterdam, *Kunst voor de beeldenstorm*.

13. Englert mentions a German engraving, dated 1616, in which the sixty-year-old is characterized as a Jewish miser ("Altersstufen," 26). On the current image of the Turk, see the literature cited above, note 56, chap. 4. On his description as, specifically, a wolf, see Peter Burke, *Popular Culture*, 167.

14. Gabelentz, *Lebensalter*, 26; Zacher and Matthias, "Altersstufen," 410–11; Chew, *Pilgrimage of Life*, 172. In the far less frequent theme of the ages of women, their animal attributes are exclusively birds. From the seventeenth century on, it is somewhat more common to find examples that feature men and women together, as couples, representing the different ages.

15. William and Jacquot, "Ommegangs anversois," 374–75.

16. See Marcel Lageirse, "La Joyeuse entrée du Prince Philippe à Gand en 1549," in Williams and Jacquot, *Les Fêtes de la Renaissance*, 297–306.

17. The similarity between *rederijker* stages and the architecture often incorporated into their devices has been noted by Veldman, *Van Heemskerk*, 130–31.

18. (H.16, N.97–98) There is one extant impression, taken from a worm-eaten block, in the British Museum. The work measures approximately 41.5 x 37.3 cm. As Nijhoff notes, the much larger German woodcut (98 x 66 cm.) has been assigned in the past to both Holbein and Vogtherr (*Nederlandsche Houtsneden*, 17). For its more convincing attribution to Breu, see Heinrich Röttinger, "Breu-Studien," *Jahrbuch der Kunsthistorischen Sammlungen des Allerhöchsten Kaiserhauses*, XXVIII, 1909, 85. For arguments in support of the priority of Breu's print, see Dodgson, *German and Flemish Woodcuts, British Museum*, II, 436–37. Gibson assumes that Cornelis's composition came first and detects a relationship to *rejerijker* theater, especially in the character Werelt; she flees from the damned soul, he says, much as various personifications turn away from the dying protagonist in the play *Elckerlijk* ("Artists and *Rederijkers*," 435). But the parallels are not particularly striking; as will be seen, Werelt (World, not Luxury as per Gibson) is simply one member of a standard, universally known trio, placed here in opposition to the good soul's trio of Faith, Hope, and Charity.

19. I would like to thank Walter Gibson for bringing this passage to my attention.

162 20. See O. Schmitt, 'Barmherzigkeit," *Reallexikon zur deutschen Kunstgeschichte*, I,

1457–68, and C. Schweicher, "Werke der Barmherzigkeit," *Lexikon der christlichen Ikonographie*, I, 245–51.

21. J. Waterworth, *The Canons and Decrees of the Sacred and Oecumenical Council of Trent*, London, 1868, 47.

22. John Calvin, *Institutes of the Christian Religion*, ed. J. McNeill, trans. by F. L. Battles, Philadelphia, 1960, II, 776.

23. See Leendert van Dis, *Reformatorische rederijkersspelen uit de eerste helft van de zestiende eeuw*, Haarlem, 1937.

24. Craig Harbison, *The Last Judgment in Sixteenth Century Northern Europe: A Study in the Relation between Art and the Reformation*, New York, 1976, 125–26.

25. Harbison detects, in the Breu, a certain pictorial and ideological conflict between "the personal qualities of individual men on earth, and the more existential criteria of works upon both of which Christ seems to rely." He suggests that even though Breu continued to serve important Catholic bishops, "the growing Reformation cause must have helped him to express what he felt was the significance of the Last Judgment for the individual as well as for the Church" (*Last Judgment*, 113).

26. (B.3, H.17, N.354) There are four extant examples: in the Rijksprentenkabinet, the Bibliothèque Nationale, the Ashmolean, and the Albertina. As Nijhoff notes, several authors have repeated the claim that one impression was inscribed "Diligentia" in the small cartouche at the lower edge (*Nederlandsche Houtsneden*, 116); most likely, however, this reflects some confusion with the winged Diligentia from *The Misuse of Prosperity*. The *Allegory* measures approximately 24.5 x 16.8 cm.

27. On the sun, cornerstone, rainbow, and ruins, see H. Laag, "Sonne," S. Braunfels, "Stein," S. Pressouyre, "Ruine," and eds., "Regenbogen," *Lexikon der christlichen Ikonographie*, III, 521–22, 573–74; IV, 175–78, 210–12.

28. Zschelletzschky, "*Drei Gottlosen Maler*," 31–50.

29. On Beham's propagandizing broadsheets, see Scribner, *For the Sake of Simple Folk*, 30–32, 51–53, 161–63. On his prayer-book illustrations, see A. Biermann, "Die Miniaturenhandschriften des Kardinals Albrecht von Brandenburg (1514–1545)," *Aachener Kunstblätter*, XLVI, 1975, 232–39.

30. Both Beham and Cornelis's *Allegory* are discussed by E. de Jongh in his review of the Dubiez monograph, "Een mislukte monografie," in *Vrij Nederland*, 15 Nov. 1969, 9.

CHAPTER 10, Loss, Redemption, and Current Doctrinal Issues

1. (H.5–10, N.187–92) I am aware of only one complete set, in the Rijksprentenkabinet. (A later impression of the first scene is reproduced in Strauss, *German Single-Leaf Woodcut 1550–1600*, II, 810: hand-colored, with an ornamental border, German labels, and a German text, it is included among the publications of the Leipzig printmaker Nickel Nerlich.) Each of the six woodcuts measures approximately 27 x 21 cm., with some slight variations in block size. Nijhoff assigns the series to Cornelis and offers several points of contact with autograph works (*Nederlandsche Houtsneden*, 41–42). As is the case with *Sorgheloos*, no other attributions have ever been suggested. See also this author's cat. no. 152 in Amsterdam, *Kunst voor de beeldenstorm*, and two articles by Barbara Haeger, "The Prodigal Son in Sixteenth- and Seventeenth-Century Netherlandish Art: Depictions of the Parable and the Evolution of a Catholic Image," *Simiolus*, 16, 2/3, 1986, 128–38; and "Cornelis Anthonisz's 163

Representation of the Parable of the Prodigal Son: a Protestant Interpretation of the Biblical Text," *Nederlands Kunsthistorisch Jaarboek*, 37, 1986, 133–50. Our views differ with regard to many aspects of the series and its sources.

2. On patristic interpretations of the parable, see Renger, *Lockere Gesellschaft*, 66–69; Kat, *Verloren Zoon*, 17–18; Vetter, *Der Verlorene Sohn*, ix–x; and Philippe Verdier, "The Tapestry of the Prodigal Son," *Journal of the Walters Art Gallery*, xviii, 1955, 24–25.

3. Vetter, *Der Verlorene Sohn*, xxii–xxv.

4. Kat, *Verloren Zoon*, 37–38.

5. Kat, *Verloren Zoon*, 39–40; Vetter, *Der Verlorene Sohn*, xxix; Holstein, *Das Drama vom Verlornen Sohn*, 10–15; Spengler, *Verlorene Sohn*, 4–9.

6. Holstein, *Das Drama vom Verlornen Sohn*, 29; Spengler, *Verlorene Sohn*, 16–17.

7. Ewald Vetter, "Der verlorene Sohn und die Sünder im Jahrhundert des Konzils von Trient," *Spanische Forschungen der Görresgesellschaft: Gesammelte Aufsätze zur Kulturgeschichte Spaniens*, xv, 1960, 176–77.

8. Kat, *Verloren Zoon*, 40; Spengler, *Verlorene Sohn*, 12; Vetter, "Verlorene Sohn und die Sünder," 176.

9. On images of the Good Shepherd with sinners, see Vetter, "Verlorene Sohn und die Sünder," 190–218, and Anton Legner, *Der Gute Hirte*, Düsseldorf, 1959, 33–43. In a woodcut by Holbein the Younger, David, Manasseh, and a "public sinner" appear, to the left, before a forgiving God; to the right, the pope and his clerics sell indulgences in what is meant to illustrate the difference between true and false forgiveness—a clearly Protestant adaptation of the theme of famous penitents (see Rotterdam, *Erasmus en zijn tijd*, cat. no. 446).

10. (H.14, N.356) This sole surviving impression is a late one, taken from a worn and worm-eaten block; we should bear in mind the possibility that its inscriptions might differ from those in the original printing. Housed in the Ashmolean, it measures about 26.4 x 23 cm. Nijhoff (*Nederlandsche Houtsneden*, 118) suggests that Cornelis's three penitents were meant as representatives of three different "orders." David, from the Old Testament, would have stood for the Jews; the Prodigal, from the New Testament, would have stood for the Christians. The tax collector, who was commonly equated with the pagan nations, would have stood for heathendom; he is, in fact, wearing a turban. See also Vlam, "The Calling of Saint Matthew," 563, and Haeger, "The Prodigal Son," 133–38.

11. Verdier, "Prodigal Son." For other Prodigal Son tapestries, see Jules Guiffrey, *Les Tapisseries du XIIe à la fin du XVIe siècle*, Paris, n.d., 74–76, and "Late Gothic Tapestry Acquired for Institute," *Bulletin of the Minneapolis Institute of Arts*, xxvii, 1938, 26–30.

12. Stechow was inclined to place the invention of this motif in the later sixteenth century and cites its appearance in a painting of 1574 by Cornelis Ketel as perhaps the first ("Homo Bulla," *Art Bulletin*, xx, 1938, 227–28). A bubble-blowing child had been shown more than thirty years earlier, however, in a painting by Georg Pencz from 1541—about the same time as Cornelis's representation (Amsterdam, *Tot Lering en Vermaak*, 47).

13. On the male Mundus, see G. Gsodam, "Fürst der Welt, Frau Welt," *Lexikon der christlichen Ikonographie*, iv, 496–98; Knipping, *Iconography of the Counter-Reformation*, i, 42; and V. C. Habicht, "Der Fürst der Welt in der Malerei um 1520," *Repertorium für Kunstwissenschaft*, xlix, 1928, 155–58. Citing Boccaccio and Valeriano as sources, Ripa characterizes Mondo either as a man with a sphere balanced on his head or as Pan, whose name, he notes, signifies the universe (*Iconologia*, 330–32).

14. Chew, *Pilgrimage of Life*, 70–78; Donald Howard, *The Three Temptations: Medieval Man in Search of the World*, Princeton, 1966, 43–65.

15. Chew, *Pilgrimage of Life*, 71.

16. On the fox and wolf as symbols of heresy, see P. Gerlach, "Fuchs," and S. Braunfels, "Wolf," *Lexikon der christlichen Ikonographie*, II, 64; IV, 537, 539. On the scorpion, see Marcel Bulard, *Le Scorpion, symbole du peuple juif dans l'art religieux des xiv^e, xv^e xvi^e siècles*, Paris, 1935, II, 57–58, 63.

17. Brant describes the bagpipes as a "dunces' instrument" (*Ship of Fools*, 187); see also Stridbeck, *Bruegelstudien*, 112, 116, 219. In Picinelli, frogs are the symbol of sin, the devil, boastfulness, heresy, and preachers who take excessive pride in their sermons (*Mundus Symbolicus*, 464–66); see also Jeffrey Hamburger, "Bosch's *Conjuror*: an Attack on Magic and Sacramental Heresy," *Simiolus*, XIV, 1984, 8–12.

18. See Beard, *Reformation*, 147–83; and Eugene Rice, *The Renaissance Idea of Wisdom*, Cambridge, 1958, 124–30.

19. Rice, *Idea of Wisdom*, 125–26.

20. Beard, *Reformation*, 156.

21. For a full description and discussion of the print, see Nijhoff, *Nederlandsche Houtsneden*, 64–65, and K. G. Boon, "Divers aspects de l'iconographie de la Pré-Réforme aux Pays-Bas," *Gazette des Beaux-Arts*, 104, 1984, 210–16.

22. Burke, *Popular Culture*, 241.

23. His headdress is actually four-tiered. In shape and structure it departs too much from a papal tiara to have been intended as one, despite Haeger, "Cornelis Anthonisz's Representation," 136.

24. Vetter, *Der Verlorene Sohn*, xv.

25. On these mutual accusations, see Knipping, *Iconography of the Counter-Reformation*, II, 371; Vlam, "Calling of Saint Matthew," 563; C. Stridbeck, "*Combat between Carnival and Lent* by Pieter Bruegel the Elder," *Journal of the Warburg and Courtauld Institutes*, XIX, 1956, 103, 106; Pontien Polman, *L'Elément historique dans la controverse religieuse du xvi^e siècle*, Gembloux, 1932, 99–100; and Ewald Plass, *What Luther Says: An Anthology*, St. Louis, 1959, II, 631–48.

26. For the hair-pulling, see M. Barasch, *Gestures of Despair in Medieval and Renaissance Art*, New York, 1976; for the dagger and the gnawing serpents, see Ripa's descriptions of Affanno, Conscienza, and Disperatione (*Iconologia*, 7–8, 83, 106).

27. For later representations of David's three punishments, see Knipping, *Iconography of the Counter-Reformation*, II, 318–19.

28. Adolf Krücke, "Der Protestantismus und die bildliche Darstellung Gottes," *Zeitschrift für Kunstwissenschaft*, XIII, 1959, 76–77.

29. (H.18, N.354 bis) There are two extant, late impressions, both in the Rijksprentenkabinet. In one, the word "Christus" is printed; in the other, it was inscribed by hand. The work measures approximately 21.3 x 26.5 cm. Nijhoff notes an *Allegory of Patience* by Gilles Mostaert, done in pen and ink and dated 1555 (*Nederlandsche Houtsneden*, 116–17); several of its features suggest that Mostaert may have known our woodcut. Probably a free copy after Cornelis's *Patience* is an anonymous Flemish painting from about 1550, now in Wellesley (see C. Shell and John McAndrew, *Catalogue of European and American Sculpture and Paintings at Wellesley College*, Wellesley, 1964, 58–60.

30. Chew, *Pilgrimage of Life*, 119.

31. Karel Boon, "Patientia dans les gravures de la Réforme aux Pays-Bas," *Revue de l'Art,* LVI, 1982, 10–12. See also Nijhoff, *Nederlandsche Houtsneden,* 74, 159–64.

32. See. N. Beets, "Een godsdienstige allegorie door Barent van Orley," *Oud-Holland,* XLIX, 1932, 129–30, and Marlier, *Érasme,* 195–96.

33. This is the first in a seven-print series; for a detailed examination of the suite, see Veldman, *Van Heemskerck,* 62–70.

34. Henkel and Schöne, *Emblemata,* 1543.

35. Koslow, "Fisherboys," 421, note 24.

36. Boon, "Patientia," 13–15. See also Knipping, *Iconography of the Counter-Reformation,* II, 244; and W. Kemp, "Name Gottes," *Lexikon der christlichen Ikonographie,* III, 310–11.

37. Peter W. Parshall, "Kunst en reformatie in de Noordelijke Nederlanden—enkele gezichtspunten," *Bulletin van het Rijksmuseum,* 35, 1987, 171. For a report on the trial, see Willem Bax, *Het Protestantisme in het bisdom Luik en vooral te Maastricht: 1505–1557,* The Hague, 1937, 193–95.

38. See, for example, Ripa's description of Penitentia (*Iconologia,* 387–89).

39. For the distinctions between orthodox and reformed views regarding penitence, see P. McKeever, "Sacrament of Penance," *New Catholic Encyclopedia,* ed. W. McDonald et al., New York, 1967–, XI, 73–83.

40. Henkel and Schöne, *Emblemata,* 1471.

41. On Bernard's parable and its appearance in art and literature, see Hope Traver, *The Four Daughters of God,* Philadelphia, 1907, and Chew, *Virtues Reconciled.*

42. On the history of communion *sub utraque forma,* see J. Megivern, "Communion under both species," *New Catholic Encyclopedia,* IV, 44–46; Polman, *L'Elément historique,* 435–40; and Hermann Sasse, *This is My Body: Luther's Contention for the Real Presence in the Sacrament of the Altar,* Minneapolis, 1959, 89–99, 167.

43. On the evolution of the Last Supper as a pictorial theme, see especially Gertrud Schiller, *Iconography of Christian Art,* trans. Janet Seligman, Greenwich, 1971–, II, 24–41, and H. Aurenhammer, *Lexikon der christlichen Ikonographie,* Vienna, 1959–, I, 11–15.

44. Carl Christensen, *Art and the Reformation in Germany,* Athens and Detroit, 1979, 136–54. See also Oskar Thulin, "Reformatorische und frühprotestantische Abendmahlsdarstellungen," *Kunst und Kirche,* XVI, 1939, 30–37, and Hermann Oertel, "Das protestantische Abendmahlsbild im niederdeutschen Raum und seine Vorbilder," *Niederdeutsche Beiträge zur Kunstgeschichte,* XIII, 1974, 223–70.

45. On this and other Protestant images of Luther, see Scribner, *For the Sake of Simple Folk,* 14–36.

46. Schiller, *Iconography,* 41.

47. Heinrich Vogtherr the Elder's *Last Supper* from about 1526 measures 50 x 66 cm. (Geisberg, *Single-Leaf Woodcut 1500–1550,* IV, 1373); Hans Schäufelein's from about 1530–1535, measures 79 x 111 cm. (Strauss, *Illustrated Bartsch,* XI, 202–3, B.26). Together with its text, Cornelis's woodcut (B.1, H.12, N.99–100) measures about 36 x 54.5 cm. It survives in more impressions than any of his other works (save for the *Map of Amsterdam*), with one example in each of the following collections: the Rijksprentenkabinet; the British Museum; the Bibliothèque Nationale; the Berlin Kupferstichkabinett; the Graphische Sammlung, Stuttgart; the Kunstsammlungen, Veste Coburg; and the Statens Museum for Kunst, Copenhagen. I am also aware of another impression, which is in trade. To the best of my knowledge, all of the preceding were printed with the (possibly later) tone block. As Nijhoff notes

(*Nederlandsche Houtsneden*, 18), there are also impressions pulled from the line block only; one is in the Museum Boymans-van Beuningen, another in the Albertina, a third in the New York Public Library, a fourth in Hamburg, and a fifth is in London. See also this author's cat. no. 154 in Amsterdam, *Kunst voor de beeldenstorm*.

48. According to Panofsky's oft-repeated reading, Dürer's omission of a "sacrificial" paschal lamb from the 1523 woodcut refers to Luther's rejection of the Catholic sacrificial Mass; the prominent chalice is a corresponding reference to Luther's interpretation of the eucharistic rite as, instead, a testament and sacrament representing the promise of redemption (*The Life and Art of Albrecht Dürer*, Princeton, 1955, 221–23). Dürer's sympathy for the Lutheran cause in general has been amply documented, and there is additional evidence to suggest that he held unorthodox views specifically with regard to the Lord's Supper (Gottfried Seebass, "Dürer's Stellung in der reformatorischen Bewegung," *Albrecht Dürers Umwelt: Festschrift zum 500. Geburtstag A. Dürers am 21 Mai 1971*, eds. G. Hirschmann and F. Schnelbögl, Nuremberg, 1971, 124).

Whether such views are mirrored in the absence of the lamb and emphasis on the chalice is, however, doubtful. As noted above, the paschal lamb was present in many of the explicitly Lutheran versions that came out of the Cranach studio; by the same token, it was often missing from later examples of the Last Supper produced within decidedly Catholic circles (see, for example, Oertel, "Protestantische Abendmahlsbild," fig. 20a). Panofsky's claim that the shallow vessel on the floor in Dürer's woodcut was meant as a serving dish that "defiantly proclaims" the lamb's absence seems most improbable. It is, instead, the basin for the Washing of the Feet and can be compared with many virtually identical basins in other Last Suppers (see, for example, the Schäufelein woodcut cited in note 47). Regarding the chalice, there is no evidence that it was, then or ever, particularly associated with the "merely sacramental" as opposed to the sacrificial; if anything, it came to be featured, together with the Host, in images produced within the context of the Counter-Reformation's cult of a mystical, transubstantiated Eucharist (see Schiller, *Iconography*, 27, and Knipping, *Iconography of the Counter-Reformation*, 300–1). In Protestant iconography, any special emphasis upon the chalice was generally a reference to the claim that laymen should be allowed to partake of the wine (see, for example, Christensen, *Art and the Reformation*, 139–40). More likely, then, is Panofsky's additional suggestion that Dürer may have stressed it with this issue in mind.

49. Did the predominance of eucharistic concerns among the early Netherlandish Reformers and their Catholic opponents have any distinct artistic repercussions? One of the more successful images of its day was Pieter Coecke van Aelst's lost *Last Supper*, known from more than forty copies, many of which seem to have issued from his own Antwerp workshop during the late 1520s and early 1530s (Georges Marlier, *La Renaissance flamande: Pierre Coeck d'Alost*, Brussels, 1966, 97–99). The function of the original is uncertain; the small size of most of the replicas suggests that they were meant for private settings, though the first dated copy is large enough to indicate the main panel of an altarpiece (Wolfgang Krönig, "Das Abendmahlsbild des Pieter Coecke," *Miscellanea Prof. Dr. D. Roggen*, Antwerp, 1957, 174). It seems reasonable to suppose that the extraordinary popularity of Coecke's composition reflects, at least in part, a strong degree of interest in its subject at the very moment when Sacramentism was at a height in the Netherlands. For other possible pictorial responses to the eucharistic issue, see Lawrence Silver, "The *Sin of Moses*: Comments on the Early Reformation in a Late Painting by Lucas van Leyden," *Art Bulletin*, LV, 1973, 401–9, 167

and Craig Harbison, "Some Artistic Anticipations of Theological Thought," *Art Quarterly*, N.S. II, 1979, 67–75.

50. Several authors have recognized the significance of Cornelis's two sacraments: see Nijhoff, *Nederlandsche Houtsneden*, 42; Kat, *Verloren Zoon*, 72; and Van Gelder, "Erasmus, schilders, en rederijkers," 239.

51. Scribner, *For the Sake of Simple Folk*, 242.

52. This distinction between German and Netherlandish propaganda has also been observed by Boon, "Patientia," 8, and Christian Tümpel, "Die Reformation und die Kunst der Niederlande," Hamburg, Kunsthalle, *Luther und die Folgen für die Kunst*, ed. Werner Hofmann, Munich, 1983, 309.

53. For reflections of this extremism in Calvinist graphic propaganda, see R. P. Zijp, "De iconografie van de reformatie in de Nederlanden, een begripsbepaling," *Bulletin van het Rijksmuseum*, 35, 1987, 176–92.

54. See Beets, "Een godsdienstige allegorie"; Karel Boon, *Catalogue of the Dutch and Flemish Drawings in the Rijksmuseum*, II: *Netherlandish Drawings of the Fifteenth and Sixteenth Centuries*, The Hague, 1978, 133–34; Boon, "Divers aspects," pt. 2, *Gazette des Beaux-Arts*, 105, 1985, 1–7; and *Ketters en papen*, cat. no. 140, for an engraving of this composition.

55. Tümpel, "Reformation," 313.

56. However, a painting of the Madonna and Child with Cornelis's mark is mentioned in an inventory of 1625. See Van Eeghen, "Jacob Cornelisz," 127. There is also a *Man of Sorrows*, if we tentatively accept a small undescribed woodcut known to me in only one impression, in the Rijksmuseum (figure 115); his large dark eyes, anxious brows, and rather soft, splayed fingers have already been seen in *Nabal, Ceres, and Bacchus*. And the personification Vreese from *Truth, Hate, and Fear* seems almost the same figure in profile.

A very doubtful attribution is the *Ecce Homo* (N.96) originally published by Jan Ewoutsz but otherwise unsigned (Nijhoff, *Nederlandsche Houtsneden*, 17). Its landscape background shows a relationship to that of the first scene in *Sorgheloos*; its monumental, muscular, half-length form of Christ recalls the *Allegory of Transitoriness*. Quite unlike Cornelis, however, are the stiffly and almost schematically rendered anatomical and facial features. We can also safely reject the very clumsy and disjointed *Crucifixion* (H.13) of 1537, whose style actually has very little to do with Cornelis's.

The only other attribution that should be mentioned is a fragmentary woodcut in the Rijksprentenkabinet (one sheet out of a possible original six) representing the seven sins, together with an armored man labeled Blood, a ladder labeled Haughtiness, a demonic Satan, and three spear-wielding skeletons (N.316, H.15; figure 116). Arrayed before an enormous hell-mouth, they appear on the verge of recoiling from some now unknown enemy—perhaps the Christian Knight or a corresponding seven virtues. Obviously in keeping with Cornelis is the allegorical nature of the subject matter. Several figures can also be compared with those in autograph works: the costume and facial type of Oncusheyt recall Patientia in *Patience, Satan, and Sin*; the round-featured, snub-nosed Hoverdicheyt recalls Ceres in *Nabal, Ceres, and Bacchus*; the pinched expressions and "broken" noses of both Gulsicheyt and Ghiericheyt recall Saint Aelwaer.

At the same time, however, other elements seem quite uncharacteristic of Cornelis, notably, the dense crowding and overlapping of figures and the massive, blocky architecture directly behind them. A further complication is the relationship of this work to another

framentary woodcut (two sheets out of a possible original eight), assigned to the school of Bernart van Orley (figure 117). It represents the sins, along with World, Flesh, Blood, and devils, again in retreat before some onslaught from the left (N.314–315). If, as Boon claims, van Orley's woodcut preceded and inspired Cornelis's ("Divers aspects," 9), then it seems that Cornelis introduced features that would actually be atypical of his work. In the van Orley, the figures are more widely spaced than densely packed, and the backdrop is a rock-strewn landscape rather than a massive, weighty wall. In the final analysis, any suppositions as to precedence, possible models, meaning, and even authorship must be limited by our only partial knowledge of a once much larger work. On both woodcuts, see Boon, "Divers aspects," 8–10.

57. See Scribner, *For the Sake of Simple Folk*, 62–74, 95–99.

58. Burke, *Popular Culture*, 122–23; Coupe, *German Illustrated Broadsheet*, 214–15.

59. Beard, *Reformation*, 156.

60. See H. A. Enno van Gelder, *The Two Reformations of the Sixteenth Century*, The Hague, 1961; Zijp, "De iconographie van de reformatie"; and Utrecht, *Ketters en papen*, 26–28, 34–37, 41–46.

Chapter 11, "When it was highest ..."

1. (H.4, N.350) There is one impression in the Berlin Kupferstichkabinett and another in the Rijksprentenkabinet. For the latter, the block had evidently been cut down even more, along the lower edge; it was printed, together with a text, by an eighteenth-century publisher. The example in Berlin measures about 26.5 x 36.3 cm. See Nijhoff, *Nederlandsche Houtsneden*, 112–13. For a very similar anonymous German woodcut from about 1530–1540, see *Old Master and Modern Prints*, David Tunick, Inc., cat. no. 12, New York, 1984, pl. 56.

2. (H.1) I know of eight extant impressions: in the Rijksprentenkabinet; the British Museum; the Bibliothèque Royale Albert I, Brussels; the Ambrass Collection, Vienna; the Berlin Kupferstichkabinett; the Graphische Sammlung, Stuttgart; the Kunstsammlungen, Veste Coburg; and the Herzog Anton Ulrich Museum. One notable precedent for the *Tower*, in terms of its medium, size, and biblical subject matter, is a *Deluge*, dated 1544, by the Antwerp printmaker Dirk Vellert. A turbulent, multifigured composition measuring 28.1 x 30.2 cm., it could very well have been known to Cornelis (see Washington, D.C., *Lucas van Leyden*, 324–25).

3. Josephus, IV: *Jewish Antiquities*, trans. H. Thackeray (Loeb Classical Library), London, 1930, 52–57.

4. Petrus Comestor, *Historia Scholastica*, Cologne, 1479, 16r., v.

5. On the history of the Tower of Babel as a pictorial theme, see A. Mann, "Babylonischer Turm," *Lexikon der christlichen Ikonographie*, I, 236–38; R. Fritz, "Turmbau zu Babel," *Reallexikon zur deutschen Kunstgeschichte*, I, 1315–21; and especially Helmut Minkowski, *Aus dem Nebel der Vergangenheit steigt der Turm zu Babel*, Berlin, 1960.

6. Herodotus, trans. A. D. Godley (Loeb Classical Library), London, 1926, 225–27.

7. See Mann, "Babylonischer Turm," 238; Fritz, "Turmbau," 1319; and Wolfgang Born, "Spiral Towers in Europe and their Oriental Prototypes," *Gazette des Beaux-Arts*, XXIV, 1943, 234–37.

8. Tancred Borenius, *The Picture Gallery of Andrea Vendramin*, London, 1923, 25.

9. Minkowski, *Turm zu Babel*, 48, 68; Born, "Spiral Towers," 238; Sandra Moschini Marconi, *Gallerie dell'Accademia di Venezia: Opere d'Arte del Secolo XVI*, Rome, 1962, 284. We might also note an anonymous, single-sheet Dutch woodcut (c. 1530) that more or less retains the Tower type established by Holbein (see Nijhoff, *Nederlandsche Houtsneden*, 77–78).

10. Williams and Jacquot, "Ommegangs anversois," 364.

11. Henkel and Schöne, *Emblemata*, 1845.

12. Henkel and Schöne, *Emblemata*, 1846.

13. See E. Rodocanachi, *Les Monuments de Rome après la Chute de l'Empire*, Paris, 1914, 164; Howard Canter, "The Venerable Bede and the Colosseum," *Transactions and Proceedings of the American Philological Association*, LXI, 1930, 158–60; Gerard Brett, "The Seven Wonders of the World in the Renaissance," *Art Quarterly*, XII, 1949, 350–51; and Michela di Macco, *Il Colosseo: Funzione Simbolica, Storica, Urbana*, Rome, 1971, 53.

14. Brett, "Seven Wonders," 346, 351; Grosshans, *Van Heemskerck*, 203–8.

15. Paris, Institut Néerlandais, *L'Époque de Lucas de Leyde et Pierre Bruegel: Dessins des anciens Pays-Bas, collection Frits Lugt*, cat. by K. Boon, C. van Hasselt et al., Paris, 1981, 184.

16. Henkel and Schöne, *Emblemata*, 99.

17. See Wilhelm S. Heckscher, "Die Romruinen: Die geistigen Voraussetzungen ihrer Wertung im Mittelalter und in der Renaisance," diss. Univ. Hamburg, 1936; Ingrid Daemmrich, "The Ruins Motif as Artistic Device in French Literature," *Journal of Aesthetics and Art Criticism*, XXX, 1972, 449–57; and Rose Macaulay, *Pleasure of Ruins*, London, 1953, esp. 165–80.

18. Richard Krautheimer, *Rome: Profile of a City, 312–1308*, Princeton, 1980, 200.

19. Joachim du Bellay, *Oeuvres Poétiques, II: Sonnets*, ed. Henri Chamard, Paris, 1910, 5–6. See also Daemmrich, "Ruins Motif," 450–51.

20. See Nicole Dacos, *Les Peintres belges à Rome au XVIe siècle*, Brussels, 1964, I, 28–29. On the other drawings in this series, see Teréz Gerszi, *Netherlandish Drawings in the Budapest Museum: Sixteenth-Century Drawings*, Amsterdam, 1971, I, 37–38. In Herman Posthumus's *Landscape with Roman Ruins* of 1536, Time's destructive power is evoked by a Latin inscription that translates: "Greedy time and jealous old age destroy all." See Amsterdam, *Kunst voor de beeldenstorm*, cat. no. 107.

21. See Canter, "The Venerable Bede," 151, 161.

22. Grosshans, *Van Heemskerck*, 207–8. See also Eleanor Saunders, "Old Testament Subjects in the Prints of Maarten van Heemskerck: 'Als een claere spiegele der tegenwoordige tijden,'" diss. Yale Univ., 1978, 224–25, 275–76; Amsterdam, *Kunst voor de beeldenstorm*, cat. no. 148; J. Bruyn, "Oude en nieuwe elementen in de 16de-eeuwse voorstellingswereld," *Bulletin van het Rijksmuseum*, 35, 1987, 138–63; Bruyn discusses at some length the use of antique ruins in sixteenth-century northern art, 143–51.

23. Henkel and Schöne, *Emblemata*, 226.

24. Saint Augustine, *The City of God Against the Pagans*, V, trans. E. M. Sanford and W. M. Green (Loeb Classical Library), Cambridge, 1965, 95, 371, 439, 461.

25. On Rome as the seat of the last world empire, see Heckscher, "Romruinen," 9; Krautheimer, *Rome*, 42, 144; and Walther Rehm, *Der Untergang Roms im abendländischen Denken*, Leipzig, 1930, 19–32.

26. See Fritz Saxl, "The Classical Inscription in Renaissance Art and Politics," *Journal of*

the Warburg and Courtauld Institutes, IV, 1940–1941, 28; Hans-Peter Müller, "Die Ruine in der deutschen und niederländischen Malerei des 15. und 16. Jahrhunderts," diss. Univ. Heidelberg, 1949, 63–67; and Rab Hatfield, *Botticelli's Uffizi Adoration: A Study in Pictorial Context*, Princeton, 1976, 56–65.

27. G. Bandmann, "Rom, Roma," *Lexikon der christlichen Ikonographie*, III, 560.

28. Arno Borst, *Der Turmbau von Babel: Geschichte der Meinungen über Ursprung und Vielfalt der Sprachen und Völker*, Stuttgart, 1957–1963, III, pt. 1, 1062. On Van Vaernewijck, see Roger Marijnissen and Max Seidel, *Bruegel*, Brussels, 1969, 94.

29. Sachs, *Werke*, VI, 198–99.

30. On the *spel van sinne*, see Van Gelder, "Erasmus, schilders, en rederijkers," 222; on the pamphlet, see Saunders, "Old Testament Subjects," 242–43.

31. Rehm, *Untergang Roms*, 77–79; Scribner, *For the Sake of Simple Folk*," 115–17, 123–27, 146–49; Norman Cohn, *The Pursuit of the Millennium: Revolutionary Millenarians and Mystical Anarchists of the Middle Ages*, New York, 1970, 243.

32. On the 1522 New Testament, see P. Schmidt, *Die Illustration der Lutherbibel 1522–1700*, Basel, 1962, 93–112, and Scribner, *For the Sake of Simple Folk*, 169–70. For Holbein's image of the New Jerusalem in the 1523 edition, see Schmidt, 127, fig. 71.

33. I would like to thank Sarah Weiner for having so generously shared her knowledge of the Tower of Babel theme and, specifically, for having suggested this possible explanation of the "Genesis 14" inscription.

34. On the 1534 Wittenberg Bible, see Schmidt, *Lutherbibel*, 179–216.

35. Scribner, *For the Sake of Simple Folk*, 129–32.

36. For an interpretation that does view Cornelis's tower as a reference to papal Rome, see cat. no. 157, Amsterdam, *Kunst voor de beeldenstorm*. At this point we might mention, once again, Bruegel's two surviving versions of the Tower of Babel. Spawning a host of imitations by Netherlandish painters during the latter half of the sixteenth century and nearly as many analyses by art historians in the twentieth, they remain, like so much of his work, iconographically problematic. That the subject had special significance for Bruegel is suggested by his use of it on even a third occasion, in a lost miniature on ivory.

For several scholars, the Vienna and Rotterdam panels represent generalized statements on *vanitas* and pride: see, for example, G. Glück, *Pieter Bruegel the Elder*, Paris, 1936, 27; F. Grossmann, *Bruegel: The Paintings*, London, 1966, 195; and Stridbeck, *Bruegelstudien*, 247. To other authors, they represent more topical statements regarding a particular manifestation of pride. Rising out of Flemish landscapes that include bustling harbors and, in the Vienna version, an obviously contemporary city, the towers, according to this understanding, are allusions to Spain's tyrannical control over the Netherlands in political, commercial, and religious terms. Here the role of a modern Nimrod (whose regal figure actually appears only in the Vienna panel) is assigned to Philip II. His harsh rule would have been seen as similarly hubristic; his imposition of Catholic orthodoxy and foreign suzerainty would have been perceived as similarly unnatural and doomed to failure. Bruegel's adaptation of a round, arched structure reminiscent of Rome's Colosseum would have underlined the reference to arrogant imperial power, though now its setting is north of the Alps.

It has also been suggested that Bruegel's Towers were intended as references to his country's current state of religious divisiveness and general societal unrest and confusion. On these interpretations, see T. Foote, *The World of Bruegel*, New York, 1968, 96; W. S. Gibson, *Bruegel*, London, 1977, 97; J. C. Klamt, "Anmerkungen zu Pieter Bruegels Babel-Darstellun-

gen," *Pieter Bruegel und seine Welt*, 43–49; and S. Mansbach, "Pieter Bruegel's Towers of Babel," *Zeitschrift für Kunstgeschichte*, XLV, 1982, 46–49. Another, ultimately unjustifiable interpretation sees one or both of the Towers as images of the ideal state and human achievement: see Mansbach, 49–56; Z. Waźbiński, " 'La Construction de la Tour de Babel' par Bruegel le Vieux," *Bulletin du Musée National de Varsovie*, V, 1964, 112–21; G. Menzel, *Pieter Bruegel der Ältere*, Leipzig, 1966, 61.

Chapter 12, Conclusion

1. Veldman, *Van Heemskerck*, 92–98.
2. See, for example, Seneca, Epistle XCVIII:12, or *De Providentia* III:4, and Zanta, *Renaissance du Stoicisme*, 117.

Select Bibliography

Amsterdam, Historisch Museum. *De Smaak van de elite. Amsterdam in de eeuw van de beeldenstorm.* Ed. by R. Kistemaker and M. Jonker, 1986.

Amsterdam, Historisch Museum and Art Gallery of Ontario. *Opkomst en bloei van het Noordnederlandse stadsgezicht in de 17de eeuw.* Richard Wattenmaker et al., 1977.

Amsterdam, Rijksmuseum. *Centsprenten: Nederlandse volks en kinderprenten.* Intro. and cat. by C. F. van Veen, 1976.

———. *Tot Lering en Vermaak. Betekenissen van Hollandse genrevoorstellingen uit de zeventiende eeuw.* Intro. by E. de Jongh, 1976.

———. *Vorstenportretten uit de eerste helft van de 16de eeuw: Houtsneden als propaganda.* Cat. by D. de Hoop Scheffer and A. J. Klant-Vliedlander Hein, 1972.

———. *Kunst voor de beeldenstorm.* Cat. by B. Dubbe, W. H. Vroom, M. Faries, J. P. Filedt Kok et al., 1986.

Appuhn, Horst and Christian Heusinger. *Riesenholzschnitte und Papiertapeten der Renaissance.* Unterschneidheim, 1976.

Bahlmann, P. *Die lateinischen Dramen von Wimphelings Stylpho bis zur Mitte des sechzehnten Jahrhunderts: 1480–1550.* Münster, 1893.

Bainton, Roland. *Erasmus of Christendom.* New York, 1969.

Barbour, Violet. *Capitalism in Amsterdam in the 17th Century.* Ann Arbor, 1963.

Bax, D. *Hieronymus Bosch: His Picture-Writing Deciphered.* Trans. by M. A. Bax-Botha. Rotterdam, 1979.

Beard, Charles. *The Reformation of the Sixteenth Century.* London, 1883.

Beets, Nicolaas. "Aanwinsten van zestiende-eeuwsche houtsneden in het Rijksprentenkabinet te Amsterdam," *Heet Boek,* XXI, 1932–1933, 177–208.

———. "Een godsdienstige allegorie door Barent van Orley," *Oud-Holland,* XLIX, 1932, 129–37.

———. "Cornelis Anthonisz: De Historie-stukken," *Oud-Holland,* LVI, 1939, 160–84.

———. "Cornelis Anthonisz: De Portretten," *Oud-Holland,* LVI, 1939, 199–221.

Bernet Kempers, A. J. "De Oblieman; Metamorfosen van een koekjesverkoper," *Volkskunde,* LXXIV, 1973, 1–43.

———. "De speler met de ronde bus," *Oud-Holland,* LXXXVII, 1973, 240–42.

Blankert, Albert. *Amsterdams Historisch Museum: Schilderijen daterend van voor 1800.* Amsterdam, 1975–1979.

Bolte, J. "Bilderbogen des 16. Jahrhunderts," *Tijdschrift voor Nederlandsche Taal- en Letterkunde,* XIV, 1895, 119–53.

Boon, Karel. "Scorel en de antieke kunst," *Oud-Holland,* LXIX, 1954, 51–53.

———. *Catalogue of the Dutch and Flemish Drawings in the Rijksmuseum, II: Netherlandish Drawings of the Fifteenth and Sixteenth Centuries.* The Hague, 1978.

———. "Patientia dans les gravures de la Réforme aux Pays-Bas," *Revue de l'Art,* LVI, 1982, 7–24.

Boon, Karel. "Divers aspects de l'iconographie de la Pré-Réforme aux Pays-Bas," *Gazette des Beaux-Arts*, 104, 1984, 207–16, and 105, 1985, 1–14.

Bouwsma, William. "The Two Faces of Humanism: Stoicism and Augustinianism in Renaissance Thought," *Itinerarium Italicum: Festschrift Paul O. Kristeller.* Ed. by H. Oberman and T. Brady. Leiden, 1975.

Brant, Sebastian. *The Ship of Fools.* Trans. with intro. and commentary by Edwin Zeydel. New York, 1944.

Brett, Gerard. "The Seven Wonders of the World in the Renaissance," *Art Quarterly*, xii, 1949, 339–58.

Brietzmann, Franz. *Die böse Frau in der deutschen Literatur des Mittelalters.* Berlin, 1912.

Brugmans, H. *Opkomst en Bloei van Amsterdam.* Amsterdam, 1944.

Bruyn, J. "Twee anonyme navolgers van Jan van Scorel," *Oud-Holland*, lxx, 1955, 223–32.

———. "Oude en nieuwe elementen in de 16de-eeuwse voorstellingswereld," *Bulletin van het Rijksmuseum*, 35, 1987, 138–63.

Burger, C. P. "De Boek- en prentdruk te Amsterdam," *Het Boek*, xiv, 1925, 231–38.

Burger, C. P. "Nederlandsche houtsneden 1500–1550; Het schip van Sinte Reynuyt," *Het Boek*, xx, 1931, 209–21.

Burke, Peter. *Popular Culture in Early Modern Europe.* New York, 1978.

Calmann, Gerta, "The Picture of Nobody; an Iconographical Study," *Journal of the Warburg and Courtauld Institutes*, xxiii, 1960, 60–104.

Calvete de Estrella, Juan Cristoval. *El Felicissimo Viaje d'el Muy Alto y Muy Poderoso Principe Don Phelippe.* Antwerp, 1552 (reprinted by the Societad Española de Bibliofilos, Madrid, 1930).

Calvin, John. *Commentary on Seneca's De Clementia.* Trans., intro., and notes by F. L. Battles and A. Hugo. Leiden, 1969.

Canter, Howard. "The Venerable Bede and the Colosseum," *Transactions and Proceedings of the American Philological Association*, lxi, 1930, 150–64.

Chew, Samuel. *The Virtues Reconciled: An Iconographic Study.* Toronto, 1947.

———. *The Pilgrimage of Life.* New Haven and London, 1962.

Christensen, Carl. *Art and the Reformation in Germany.* Athens and Detroit, 1979.

Clutton, George. "Two Early Representations of Lutheranism in France," *Journal of the Warburg and Courtauld Institutes*, i, 1938, 287–91.

Coupe, William. *The German Illustrated Broadsheet in the Seventeenth Century.* Baden-Baden, 1966–1967.

Creizenach, W. *Geschichte des neuen Dramas: Renaissance und Reformation.* Halle, 1901.

Crew, Phyllis Mack. *Calvinist Preaching and Iconoclasm in the Netherlands, 1544–1569.* Cambridge, 1978.

Dacos, Nicole. *Les peintres belges à Rome au xvie siècle.* Brussels, 1964.

Daemmrich, Ingrid. "The Ruins Motif as Artistic Device in French Literature," *Journal of Aesthetics and Art Criticism*, xxx–xxxi, 1972, 449–57, 31–41.

Deutsches Wörterbuch. Jacob and Wilhelm Grimm et al. Leipzig, 1854–1965.

Van Dis, Leendert. *Reformatorische rederijkersspelen uit de eerste helft van de zestiende eeuw.* Haarlem, 1937.

Dodgson, Campbell. *Catalogue of Early German and Flemish Woodcuts Preserved in the Department of Prints and Drawings in the British Museum.* London, 1903/1911.

Dubiez, F. J. "Cornelis Anthoniszoon: De betekenis van de Amsterdamse schilder, hout-

snijder, en cartograaf Cornelis Anthoniszoon voor de culturele geschiedenis van onze stad," *Ons Amsterdam*, XI, 1959, 354–66.

———. "Nogmaals Cornelis Anthoniszoon," *Ons Amsterdam*, XII, 1960, 143–45.

———. *Op de grens van humanisme en hervorming: De betekenis van de boekdrukkunst te Amsterdam in een bewogen tijd*. The Hague, 1962.

———. *Cornelis Anthoniszoon van Amsterdam: zijn leven en werken*. Amsterdam, 1969.

Van Eeghen, I. H. "Jacob Cornelisz, Cornelis Anthonisz en hun familierelaties," *Nederlands Kunsthistorisch Jaarboek*, 37, 1986, 95–132.

Ellerbroek-Fortuin, Else. *Amsterdamse rederijkersspelen in de zestiende eeuw*. Groningen, 1937.

Endepols, H.J.E. *Het Decoratief en de opvoering van het middelnederlandsche drama volgens de middelnederlandsche toneelstukken*. Amsterdam, 1903.

Englert, Anton. "Die menschlichen Altersstufen in Wort und Bild," *Zeitschrift des Vereins für Volkskunde*, XVII, 1907, 16–42.

Enklaar, D. T. *Varende Luyden. Studiën over de middeleeuwsche groepen van onmaatschappelijken in de Nederlanden*. Assen, 1940.

———. *Uit Uilenspiegel's kring*. Assen, 1940.

Erasmus, Desiderius. *The Praise of Folly*. Trans., intro., and commentary by Hoyt Hudson. Princeton, 1941.

Evenhuis, R. B. *Ook dat was Amsterdam*. Amsterdam, 1965.

Faries, Molly. "A Woodcut of the *Flood* Re-attributed to Jan van Scorel," *Oud-Holland*, XCVII, 1983, 5–12.

Fischer, Pieter. *Music in Paintings of the Low Countries in the 16th and 17th Centuries*. Amsterdam, 1975.

Fishman, Jane. *Boerenverdriet: Violence between Peasants and Soldiers in Early Modern Netherlands Art*. Ann Arbor, 1982.

Fraenger, Wilhelm. *Hans Weiditz und Sebastian Brant*. Leipzig, 1930.

Friedländer, Max J. *Early Netherlandish Painting*. Leyden and Brussels, 1967–1976.

Von der Gabelentz, Hans. *Die Lebensalter und das menschliche Leben in Tiergestalt*. Berlin, 1938.

Geisberg, Max. *The German Single-Leaf Woodcut: 1500–1550*. Ed. and rev. by Walter Strauss. New York, 1974.

Van Gelder, H. A. Enno. "Erasmus, schilders, en rederijkers; de religieuze crisis der 16e eeuw weerspiegeld in toneel-en schilderkunst," *Tijdschrift voor Geschiedenis*, LXXI, 1958, 1–15, 206–42, 289–331 (also published in book form, Groningen, 1959).

———. *The Two Reformations in the 16th Century*. The Hague, 1961.

Van Gelder, J. G. "De Noordnederlandse schilderkunst in de zestiende eeuw (II)," *Kunstgeschiedenis der Nederlanden*, 3rd ed. Ed. by H. E. van Gelder and J. Duverger. Utrecht, 1954–1956, I.

Gibson, Walter. "Hieronymus Bosch and the Mirror of Man: the Authorship and Iconography of the *Tabletop of the Seven Deadly Sins*," *Oud-Holland*, LXXXVII, 1973, 205–26.

———. "Some Flemish Popular Prints from Hieronymus Cock and His Contemporaries," *Art Bulletin*, LX, 1978, 673–81.

———. "Artists and *Rederijkers* in the Age of Bruegel," *Art Bulletin*, LXIII, 1981, 426–46.

Gittée, A. "Scherzhaft gebildete und angewendete Eigennamen im Niederländischen," *Zeitschrift des Vereins für Volkskunde*, III, 1893, 419–31.

175

Gödeke, K. "Asinus vulgi," *Orient und Occident*, I, 1862, 531–60.

Gordon, Donald. " 'Veritas Filia Temporis.' Hadrianus Junius and Geoffrey Whitney," *Journal of the Warburg and Courtauld Institutes*, III, 1939–1940, 228–40.

De Graaf, B. "Alardus Amstelredamus (1491–1544)," *Folium: Librorum Vitae Deditum*, IV, 1954, 29–118.

Grauls, Jan. *Volkstaal en volksleven in het werk van Pieter Bruegel*. Antwerp and Amsterdam, 1957.

Grimm, Jacob and Wilhelm, et al. *Deutsches Wörterbuch*. Leipzig, 1854–1965.

Grosheide, Greta. *Bijdrage tot de geschiedenis der Anabaptisten in Amsterdam*. Hilversum, 1938.

Grosjean, Ardis. "Toward an Interpretation of Pieter Aersten's Profane Iconography," *Konsthistorisk Tidskrift*, XLIII, 1974, 121–43.

Grosshans, Rainald. *Maerten van Heemskerck: Die Gemalde*. Berlin, 1980.

Haarlem, Frans Halsmuseum. *Leerrijke reeksen van Maarten van Heemskerck*. Cat. by Ilja Veldman, 1986.

Haeger, Barbara. "Cornelis Anthonisz's Representation of the Parable of the Prodigal Son: A Protestant Interpretation of the Biblical Text," *Nederlands Kunsthistorisch Jaarboek*, 37, 1986, 133–50.

———. "The Prodigal Son in Sixteenth- and Seventeenth-Century Netherlandish Art: Depictions of the Parable and the Evolution of a Catholic Image," *Simiolus*, 16, 2/3, 1986, 128–38.

Hall, B. "Erasmus: Biblical Scholar and Reformer," *Erasmus*, Ed. by T. A. Dorsey. London, 1970, 81–114.

Hamburg, Kunsthalle. *Luther und die Folgen für die Kunst*. Ed. by Werner Hofmann. Munich, 1983.

Harbison, Craig. *The Last Judgment in Sixteenth Century Northern Europe: A Study in the Relation between Art and the Reformation*. New York, 1976.

Harrebomé, P. J. *Spreekwoordenboek de Nederlandsche taal of verzameling van Nederlandsche spreekwoorden en spreekwoordelijke uitdrukkingen*. Utrecht, 1858–1870.

Heckscher, Wilhelm S. "Die Romruinen: Die geistigen Voraussetzungen ihrer Wertung im Mittelalter und in der Renaissance." Diss. Univ. Hamburg, 1936.

Heinemann, W. "Zur Ständedidaxe in der deutschen Literatur des 13–15 Jahrhunderts," *Beiträge zur Geschichte der Deutschen Sprache und Literatur*, LXXXVIII, 1966, 1–90, LXXXIX, 1967, 290–403, XCII, 1970, 388–437.

Held, Julius. *Dürers Wirkung auf die Niederländsche Kunst seiner Zeit*. The Hague, 1931.

Henkel, A. and A. Schöne. *Emblemata. Handbuch zur Sinnbildkunst des XVI. und XVII. Jahrhunderts*. Stuttgart, 1967.

Henkel, M.D. "Overzicht der litteratuur betreffende Nederlandsche kunst," *Oud-Holland*, L, 1933, 231–39.

Hermesdorf, B. H. D. *De herberg in de Nederlanden; een blik in de beschavingsgeschiedenis*. Assen, 1957.

De Historie van den Verloren Sone. Ed. by G. J. Boekenoogen. Leiden, 1908.

Hollstein, F.W.H. *Dutch and Flemish Etchings, Engravings, and Woodcuts, ca. 1450–1700*, vol. XXX. Compiled by Ger Luijten. Amsterdam, 1986.

Holstein, H. *Das Drama vom Verlornen Sohn. Ein Beitrag zur Geschichte des Dramas*. Geestemünde, 1880.

Hoogewerff, G. J. *De Noord-Nederlandsche Schilderkunst*. The Hague, 1936–1947.

Houbraken, Arnold. *De Groote Schouburgh der Nederlandsche Konstschilders en Schilder-essen*, 2nd ed. The Hague, 1753.

Howard, Donald. *The Three Temptations: Medieval Man in Search of the World*. Princeton, 1966.

Hummelen, W.M.H. *De sinnekens in het rederijkersdrama*. Groningen, 1958.

———. *Repertorium van het rederijkersdrama, 1500–ca. 1620*. Assen, 1968.

Janson, H. W. "Putto with the Death's Head," *Art Bulletin*, XIX, 1937, 423–49.

Joldersma, Hermina. " 'Het Antwerps Liedboek': A Critical Edition." Diss. Princeton Univ., 1983.

De Jong, E. "Erotica in Vogelperspectief: De dubbelzinnigheid van een reeks 17de eeuwse genrevoorstellingen," *Simiolus*, III, 1968–1969, 22–74.

De Jong, P. J. "Laatmiddeleeuwse rijmprenten; begripsomschrijving en stand van het onder-zoek," *Spektator; Tijdschrift voor Neerlandistiek*, IV, 1974–1975, 269–74.

———. "Sinte Aelwaer, een parodiërender rijmprent," *Spektator; Tijdschrift voor Neerland-istiek*, V, 1975–1976, 128–41.

———. "Sorgehloos, een zestiende eeuwse rijmprentenreeks; tekst en commentaar," *Spek-tator; Tijdschrift voor Neerlandistiek*, VII, 1977–1978, 104–20.

Kalff, Gerrit. *Het Lied in de middeleeuwen*. Leiden, 1884.

Kat, J.F.M. *Der Verloren zoon als letterkundig motief*. Bussum, 1953.

Katzenellenbogen, Adolf. *Allegories of the Virtues and Vices in Medieval Art*. London, 1939.

Kelso, Ruth. *Doctrine for the Lady of the Renaissance*. Urbana, 1956.

Keuning, Johannes. "Cornelis Anthonisz," *Imago Mundi*, VII, 1950, 51–65.

———. "XVIth-Century Cartography in the Netherlands," *Imago Mundi*, IX, 1952, 35–63.

Knipping, John. *Iconography of the Counter Reformation in the Netherlands*. Nieuwkoop, 1974.

Knudsen, Johannes. *Het Leeskaartboek van Wisbuy*. Intro. by C. P. Burger. Copenhagen, 1920.

Kölker, Albertus. *Alardus Aemstelredamus en Cornelius Crocus: Twee Amsterdamse prie-ster-humanisten*. Nijmegen and Utrecht, n.d.

Krahn, Cornelius. *Dutch Anabaptism: Origin, Spread, Life, and Thought (1450–1600)*. The Hague, 1968.

Krans, H. A., "Peter Warnersen drukker en uitgever te Kampen," *Het Boek*, XXIV, 1936–1937, 147–86.

Krautheimer, Richard. *Rome: Profile of a City, 312–1308*. Princeton, 1980.

Krücke, Adolf. "Der Protestantismus und die bildliche Darstellung Gottes," *Zeitschrift für Kunstwissenschaft*, XIII, 1959, 59–90.

Kunzle, David. *The Early Comic Strip; Narrative Strips and Picture Stories in the European Broadsheet from c. 1450 to 1825*. Berkeley, 1973.

———. "Bruegel's Proverb Painting and the World Upside Down," *Art Bulletin*, LIX, 1977, 197–202.

———. "World Upside Down: The Iconography of a European Broadsheet Type," *The Re-versible World; Symbolic Inversion in Art and Society*. Ed. by Barbara Babcock. Ithaca, 1978.

Lebeer, L. "De Blauwe Huyck," *Gentsche Bijdragen tot de Kunstgeschiedenis*, VI, 1939–1940, 161–229.

Legner, Anton. *Der Gute Hirte*. Düsseldorf, 1959.

Lexikon der christlichen Ikonographie. E. Kirschbaum et al. Freiburg, 1968–1976.

Di Macco, Michela. *Il Colosseo: Funzione Simbolica, Storica, Urbana*. Rome, 1971.

Mak, J. J. *De Rederijkers*. Amsterdam, 1944.

Van Marle, Raimond. *Iconographie de l'art profane au Moyen-Age et à la Renaissance*. The Hague, 1932.

Marlier, Georges. *Érasme et la peinture flamande de son temps*. Damme, 1954.

Meiss, Millard. "Sleep in Venice. Ancient Myths and Renaissance Proclivities," *Proceedings of the American Philosophical Society*, CX, 1966, 348–82.

De Meyer, Maurits, et al. *De Volks- en kinderprent in de Nederlanden van de 15e tot de 20e eeuw*. Antwerp and Amsterdam, 1962.

Middelnederlandsch Woordenboek. E. Verwijs, J. Verdam, et al. The Hague, 1885–1952.

Miedema, Hessel. "Realism and the Comic Mode: The Peasant," *Simiolus*, IX, 1977, 205–19.

Minkowski, Helmut. *Aus dem Nebel der Vergangenheit steigt der Turm zu Babel*. Berlin, 1960.

Van Moerkerken, Pieter. *De Satire in de Nederlandsche kunst der Middeleeuwen*. Amsterdam, 1904.

Moes, E. W. and C. P. Burger. *De Amsterdamsche boekdrukkers en uitgevers in de zestiende eeuw*. Amsterdam and The Hague, 1900–1915.

Mohl, Ruth. *The Three Estates in Medieval and Renaissance Literature*. New York, 1933.

Moll, Otto. *Sprichwörter-bibliographie*. Frankfurt, a.M., 1958.

Moxey, Keith. "Sebald Beham's Church Anniversary Holidays: Festive Peasants as Instruments of Repressive Humor," *Simiolus*, XII, 1981–1982, 107–30.

———. "The *Ship of Fools* and the Idea of Folly in Sixteenth-Century Netherlandish Literature," in *The Early Illustrated Book: Essays in Honor of J. Lessing Rosenwald*. Washington, D.C., 1980.

Müller, Hans-Pieter. "Die Ruine in der deutschen und niederländischen Malerei des 15. und 16. Jahrhunderts," Diss. Univ. Heidelberg, 1949.

Muller, F. *De Nederlandsche geschiedenis in platen*. Amsterdam, 1863–1870.

Muller, J. W. "Nog iets over Sint-Brandaris," *Tijdschrift voor Nederlandsche Taal- en Letterkunde*, XVIII, 1899, 193–99.

Muther, Richard. *Die deutsche Bücherillustration der Gothik und Frührenaissance 1460–1530*. Munich and Leipzig, 1884.

New Catholic Encyclopedia. Ed. by W. McDonald et al. New York, 1967–.

Nijhoff-Selldorff, Hedwig and M. D. Henkel. *Nederlandsche Houtsneden 1500–1550*. Ed. by Wouter Nijhoff. The Hague, 1933–1939.

Nijmegen, Museum Commanderie van Sint-Jan. *Tussen heks en heilige: Het vrouwbeeld op de drempel van de moderne tijd, 15de/16de eeuw*. Cat. by Petty Bange, Grietje Dresen et al., 1985.

Nuremberg, Stadtgeschichtliche Museen. Die Welt des Hans Sachs. Cat. by K. H. Schreyl et al., 1976.

Van nyeuvont, loosheit, ende practike: hoe sij vrou Lortse verheffen. Ed. and intro. by E. Neurdenburg. Utrecht, 1910.

Oertel, Hermann. "Das protestantische Abendmahlsbild im niederdeutschen Raum und seine Vorbilder," *Niederdeutsche Beiträge zur Kunstgeschichte*, XIII, 1974, 223–70.

Von der Osten, Gert, and Horst Vey. *Painting and Sculpture in Germany and the Nether-lands, 1500 to 1600.* Baltimore, 1969.

Ozment, Steven, ed. *Reformation Europe: A Guide to Research.* St. Louis, 1982.

———. *When Fathers Ruled: Family Life in Reformation Europe.* Cambridge, Mass., 1983.

Parshall, Peter. "Kunst en reformatie in de Noordelijke Nederlanden—enkele gezichtspunten," *Bulletin van het Rijksmuseum,* 35, 1987, 164–75.

Patch, Howard. *The Goddess Fortuna in Mediaeval Literature.* Cambridge, England, 1927.

Phillips, Margaret M. *Erasmus and the Northern Renaissance.* New York, 1950.

Picinelli, Filippo. *Mundus Symbolicus.* Reprint of the Cologne, 1694 ed. New York, 1976.

Pieter Bruegel und seine Welt. Ed. by O. von Simson and M. Winner. Berlin, 1975.

Plass, Ewald. *What Luther Says: An Anthology.* St. Louis, 1959.

Pleij, Herman. "Material voor een interpretatie van het gedicht over de Blauwe Schuit (1413?)," *Spektator; Tijdschrift voor Neerlandistiek,* I, 1917–1972, 311–25; II, 1972–1973, 196–224; III, 1973–1974, 680–721.

———. *Het gilde van de Blauwe Schuit: Literatuur, volksfeest, en burgermoraal in de late middeleeuwen.* Amsterdam, 1979.

Polman, Pontien. *L'Elément historique dans la controverse religieuse de xvie siècle.* Gembloux, 1932.

Reallexikon zur deutschen Kunstgeschichte. Ed. by Otto Schmitt. Stuttgart, 1937–.

Redlich, Fritz. "The German Military Enterpriser and His Work Force," *Vierteljahrschrift für Sozial- und Wirtschaftsgeschichte,* XLVII–XLVIII, 1964–1965.

Rehm, Walther. *Der Untergang Roms im abendländischen Denken.* Leipzig, 1930.

Renger, Konrad. "Versuch einer neuen Deutung von Hieronymus Boschs Rotterdamer Tondo," *Oud-Holland,* LXXIV, 1969, 67–76.

———. *Lockere Gesellschaft: Zur Ikonographie des Verlorenen Sohnes und von Wirtshauss-zenen in der niederländischen Malerei.* Berlin, 1970.

Rice, Eugene. *The Renaissance Idea of Wisdom.* Cambridge, 1958.

Ripa, Cesare. *Iconologia.* Reprint of the Rome, 1603 ed. Intro. by Erna Mandowsky. Hildesheim, 1970.

Rodocanachi, E. *Les Monuments de Rome après la chute de l'Empire.* Paris, 1914.

Roessingh, Aleide. *De Vrouw bij de dietsche moralisten.* Groningen, 1914.

Röttinger, Heinrich. *Die Bilderbogen des Hans Sachs.* Strassburg, 1927.

De Roever, N. "Amsterdamsche boekdrukkers en boekverkoopers uit de zestiende eeuw," *Oud-Holland,* II, 1884, 68–79, 170–205.

Rogers, Katharine. *The Troublesome Helpmate: A History of Misogyny in Literature.* Seattle and London, 1966.

Rosenfeld, Hellmutt. *Das deutsche Bildgedicht: Seine antiken Vorbilder und seine Entwick-lung bis zur Gegenwart.* Leipzig, 1935.

———. "Der mittelalterliche Bilderbogen," *Zeitschrift für Deutsches Altertum und Deutsche Literatur,* LXXXV, 1954–1955, 66–75.

Rotterdam, Museum Boymans-van Beuningen. *Erasmus en zijn tijd.* Cat. by J. Besse, N. van der Blom, et al., 1969.

Sachs, Hans. *Werke.* Ed. by A. von Keller and E. Goetze. Stuttgart, 1870–1908.

Saunders, Eleanor. "Old Testament Subjects in the Prints of Maarten van Heemskerck: 'Als een claere spiegele der tegenwoordige tijden.' " Diss. Yale Univ., 1978.

179

Saxl, Fritz. "Veritas Filia Temporis," *Philosophy and History. Essays Presented to Ernst Cassirer*. Oxford, 1936, 197–222.

Schapelhouman, Marijn. *Oude tekeningen in het bezit van de Gemeentemusea van Amsterdam waaronder de collectie Fodor. Deel 2: Tekeningen van Noord- en Zuidnederlandse kunstenaars geboren voor 1600*. Amsterdam, 1979.

Schéle, Sune. *Cornelis Bos: A Study of the Origins of the Netherland Grotesque*. Stockholm, 1965.

Schiller, Gertrud. *Iconography of Christian Art*. Trans. by Janet Seligman. Greenwich, 1971–.

Schmidt, P. *Die Illustration der Lutherbibel 1522–1700*. Basel, 1962.

Een Schoon Liedekensboeck. in den weckcken ghy in. vinden sult. veelderhande liedekens. oude ende nyeuwe om droefheyt ende melancolie te verdryven. Ed. by W. G. Hellinga. The Hague, 1941.

Schottenloher, Karl. *Flugblatt und Zeitung: ein Wegweiser durch das gedruckte Tagesschrifttum*. Berlin, 1922.

Schrijnen, J. *Essays en studiën in vergelijkende godsdienstgeschiedenis, mythologie, en folklore*. Venloo, n.d.

Schröder, Pieter. *Parodieën in de Nederlandsche letterkunde*. Haarlem, 1932.

Schribner, R. W. "Images of the Peasant 1514–1525," *Journal of Peasant Studies*, III, 1975, 29–48.

———. *For the Sake of Simple Folk: Popular Propaganda for the German Reformation*. Cambridge, England, 1981.

Silver, Lawrence. "*The Sin of Moses*: Comments on the Early Reformation in a Late Painting by Lucas van Leyden," *Art Bulletin*, LV, 1973, 401–9.

Spengler, Franz. *Der verlorene Sohn im Drama des XVI Jahrhunderts*. Innsbruck, 1888.

Steinbart, Kurt. *Das Holzschnittwerk des Jakob Cornelisz van Amsterdam*. Burg bei Magdeburg, 1937.

Sterck, J.F.M. "Onder Amsterdamsche humanisten," *Het Boek*, VI, 1917, 4–18, 89–107, 165–79, 283–96; IX, 1920, 161–74; XIV, 1925, 49–61.

———. "Aanteekeningen over 16ᵉ eeuwsche Amsterdamsche portretten," *Oud-Holland*, XLII, 1926, 249–66.

———. *Van Rederijkerskamer tot muiderkring*. Amsterdam, 1928.

———. *De Heilige Stede in de geschiedenis van Amsterdam*. Hilversum, 1938.

Strauss, Walter. *The German Single-Leaf Woodcut: 1550–1600*. New York, 1975.

Stockholm, Nationalmuseum. *Netherlandish Mannerism*. National Skriftserie, N.S.4, 1985.

Stridbeck, Carl. *Bruegelstudien; Untersuchungen zu den ikonologischen Problemen bei Pieter Bruegel d.Ä*. Stockholm, 1956.

Taverne, E.R.M. "De Braspenningsmaaltijd," *Openbaar Kunstbezit*, XII, 1968, 6a–b.

Tervarent, Guy de. *Attributs et symboles dans l'art profane, 1450–1600*. Geneva, 1958–1959 and 1964.

Van Thiel, Pieter J. J., et al. *All the Paintings of the Rijksmuseum*. Amsterdam and Maarsden, 1976.

Thulin, Oskar. "Reformatorische und frühprotestantische Abendmahlsdarstellungen," *Kunst und Kirche*, XVI, 1939, 30–37.

Timmers, J.J.M. *Symboliek en iconographie der christlijke kunst*. Roermond, 1947.

Tittman, Julius. *Schauspiele aus dem sechzehnten Jahrhundert*. Leipzig, 1868.

Traver, Hope. *The Four Daughters of God*. Philadelphia, 1907.

Tuinman, C. *De Oorsprong en uitlegging van dagelijks gebruikte Nederduitsche spreek-woorden.* Middelburg, 1726.

Utrecht, Rijksmuseum Het Catharijneconvent. *Ketters en papen onder Filips II.* Cat. by S. Groenveld, S. Augustijn, R. P. Zijp, et al., 1986.

Valeriano Bolzani, G. P. *Hieroglyphica.* Reprint of the Lyon, 1602 ed. New York, 1976.

Vandenbroek, Paul. "Verbeeck's Peasant Weddings: A Study of Iconography and Social Function," *Simiolus,* XIV, 1984, 79–124.

Veelderhande geneuchlijcke dichten, tafelspelen ende refereynen. New ed. Leiden, 1899 (reprinted 1971).

Veldman, Ilja M. *Maarten van Heemskerck and Dutch Humanism in the Sixteenth Century.* Amsterdam, 1977.

———. "Lessons for Ladies: a Selection of Sixteenth- and Seventeenth-Century Dutch Prints," *Simiolus,* 16, 2/3, 1986, 113–27.

Verdier, Philippe. "The Tapestry of the Prodigal Son," *Journal of the Walters Art Gallery,* XVIII, 1955, 9–58.

Verheyen, E., ed. *Art and Literature: Studies in Relationship.* Durham, 1985.

Vetter, Ewald. *Der Verlorene Sohn.* Düsseldorf, 1955.

———. "Der verlorene Sohn und die Sünder im Jahrhundert des Konzils von Trient," *Spanische Forschungen der Görresgesellschaft: Gesammelte Aufsätze zur Kulturgeschichte Spaniens,* XV, 1960, 175–218.

Vlam, Grace. "The Calling of Saint Matthew in Sixteenth-Century Flemish Painting," *Art Bulletin,* LIX, 1977, 561–70.

Wäscher, Hermann. *Das deutsche illustrierte Flugbatt.* Dresden, 1955.

Wagenaar, Jan. *Amsterdam, in zijne opkomst, aanwas, geschiedenissen, voorregten, koophandel, gebouwen. . . .* Amsterdam, 1760.

Washington, D.C., International Exhibitions Foundation. *Titian and the Venetian Woodcut.* Intro. and cat. by David Rosand and Michelangelo Muraro, 1976.

Washington, D.C., National Gallery of Art. *The Prints of Lucas van Leyden and His Contemporaries,* cat. by E. Jacobowitz and S. Stepanek, 1983.

Wescher, Paul. "Beiträge zu Cornelis Teunissen von Amsterdam. Zeichnungen und Holzschnitte," *Oud-Holland,* XLV, 1928, 33–39.

Williams, George H. *The Radical Reformation.* Philadelphia, 1962.

Williams, Sheila and Jean Jacquot. "Ommegangs anversois du temps de Bruegel et de van Heemskerck," *Les Fêtes de la Renaissance: Fêtes et cérémonies au temps de Charles Quint.* Ed. by J. Jacquot, Paris, 1975.

Winkler, Friedrich. *Dürer und die Ilustrationen zum Narrenschiff.* Berlin, 1951.

Wittkower, Rudolf. "Death and Resurrection in a Picture by Marten De Vos," *Miscellanea Leo van Puyvelde.* Brussels, 1949, 117–23.

Witwitzsky, Willibald. "Das Gleichnis vom Verlorenen Sohn in der bildenden Kunst bis Rembrandt," Diss. Univ. Heidelberg, 1930.

Woordenboek der Nederlandsche Taal. Ed. by M. de Vries, L. A. te Winkel, et al. The Hague and Leiden, 1882–.

Zanta, Léontine. *La Renaissance du Stoicisme au xvi^e siècle.* Paris, 1914.

Zijp, R. P. "De iconografie van de reformatie in de Nederlanden, een begripsbepaling," *Bulletin van het Rijksmuseum,* 35, 1987, 176–92.

Zschelletzschky, Herbert. *Die "Drei Gottlosen Maler" von Nürnberg.* Leipzig, 1975.

Index

Illustrations

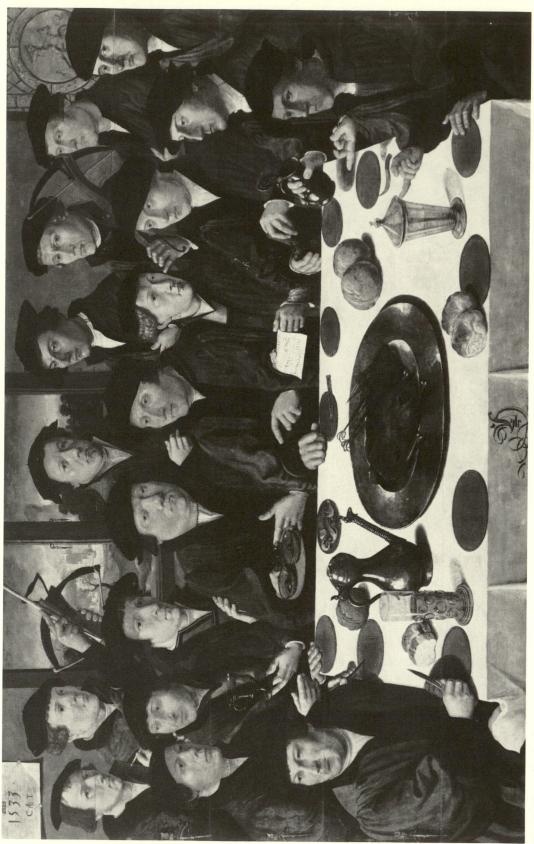

Fɪɢ. 1. Cornelis Anthonisz, *De Braspenningsmaaltijd*, panel.

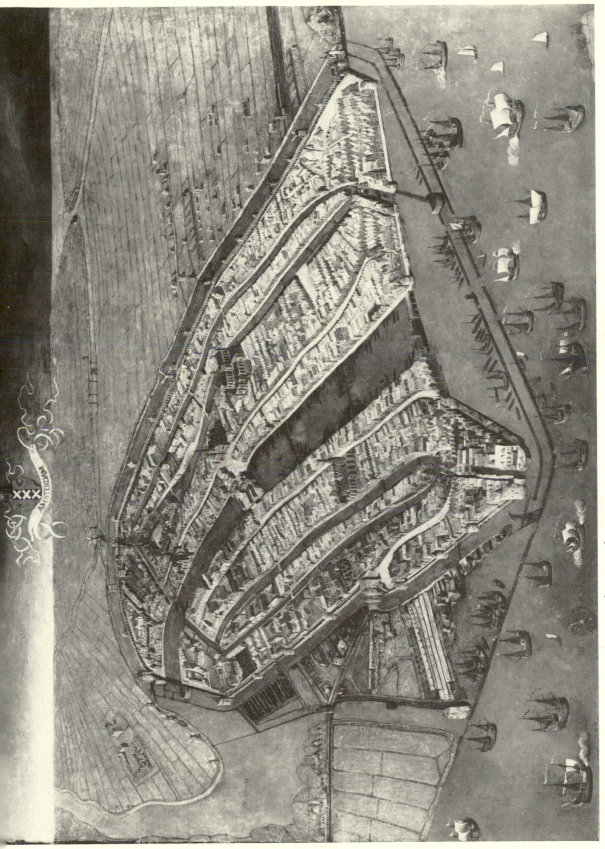

FIG. 2. Cornelis Anthonisz, *Map of Amsterdam*, panel.

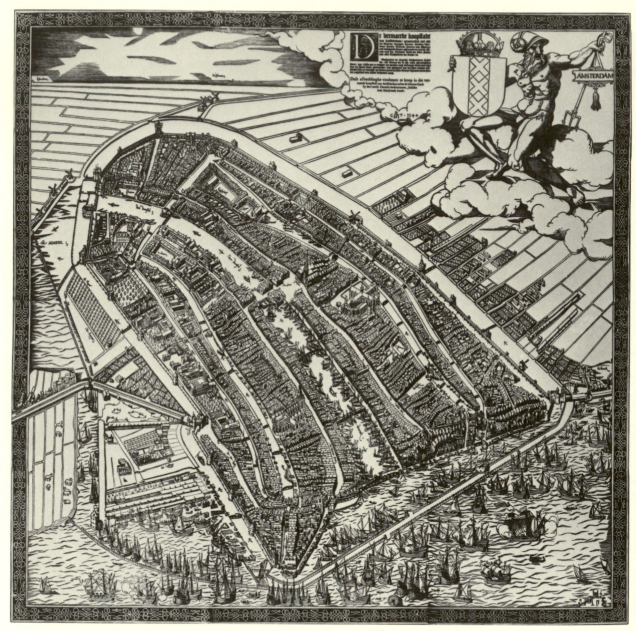

FIG. 3. Cornelis Anthonisz, *Map of Amsterdam*, woodcut.

Opposite page:
FIG. 4. (*top*) Cornelis Anthonisz, *Caerte van Oostland*, woodcut.
FIG. 5. (*bottom*) Cornelis Anthonisz, title page from *Onderwijsinge van der Zee*, woodcut.

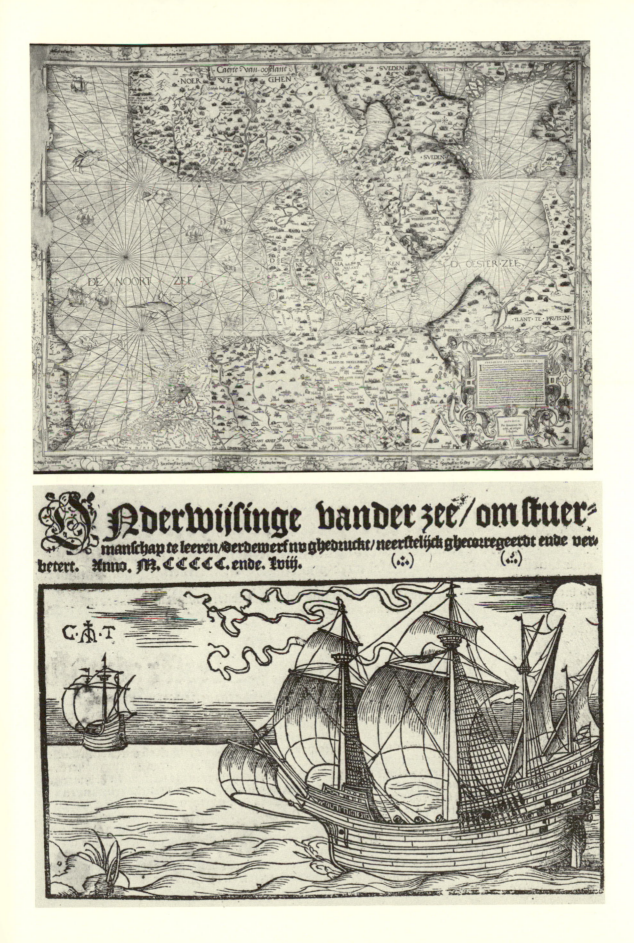

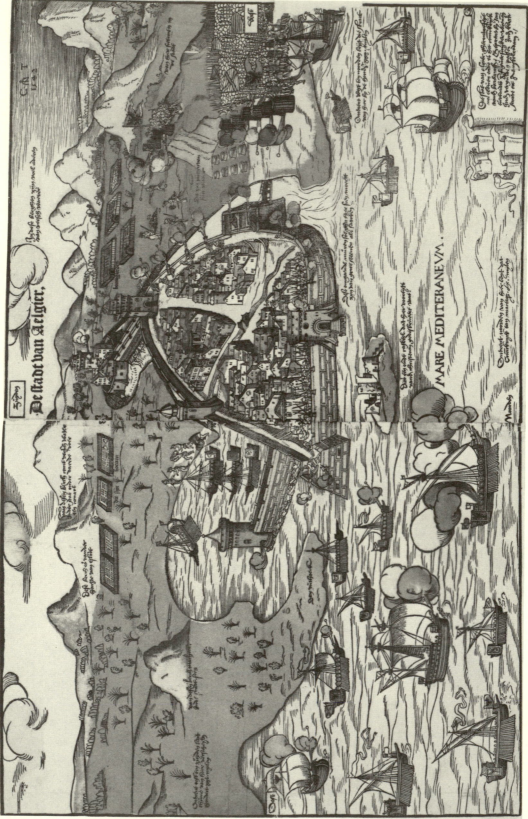

Fig. 6. Cornelis Anthonisz, *City of Algiers*, woodcut.

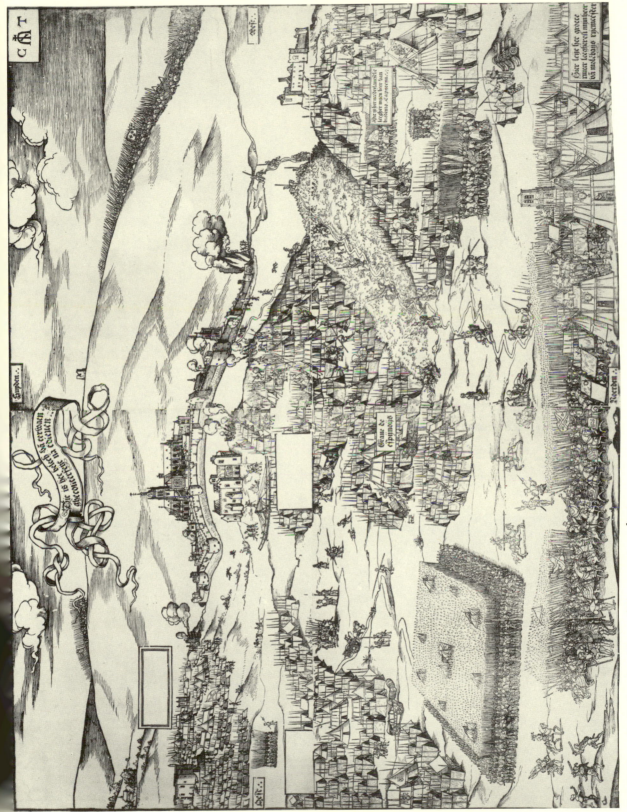

Fig. 7. Cornelis Anthonisz, *Siege of Terwaen*, woodcut.

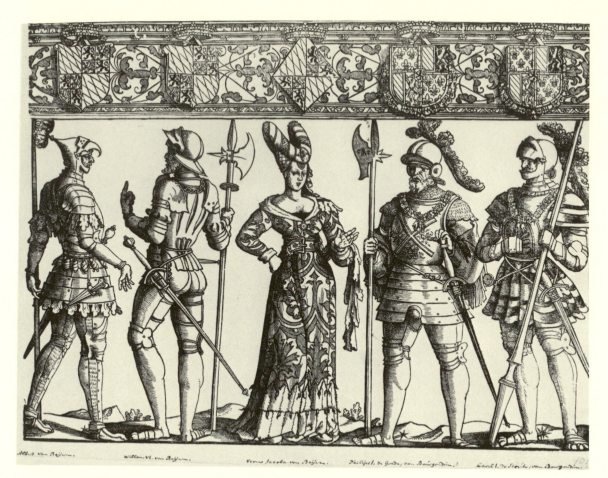

FIG. 8a. Cornelis Anthonisz, *Lords and Ladies of Holland*, woodcut.

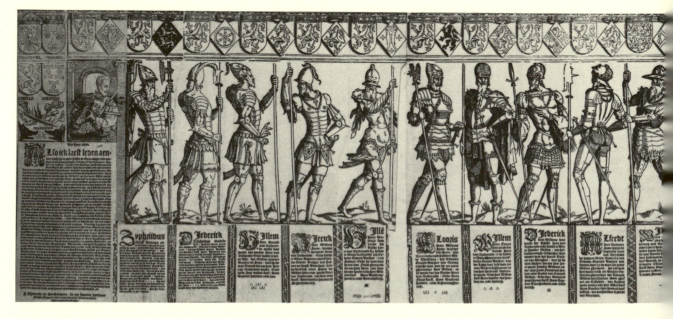

FIG. 9. Cornelis Anthonisz, *Lords of Brederode*, woodcut.

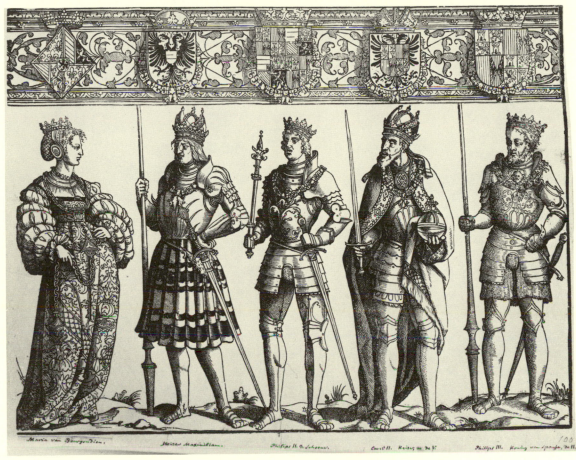

FIG. 8b. Cornelis Anthonisz, *Lords and Ladies of Holland*, woodcut.

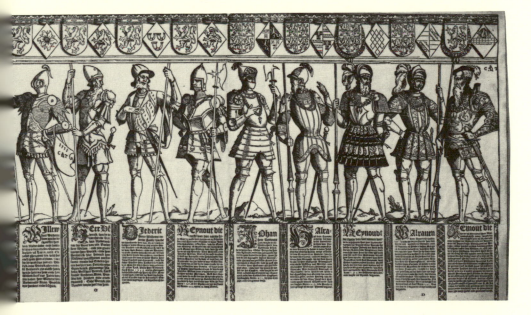

FIG. 10. Jacob Cornelisz van Oostsanen, one sheet from *Lords and Ladies of Holland*, woodcut.

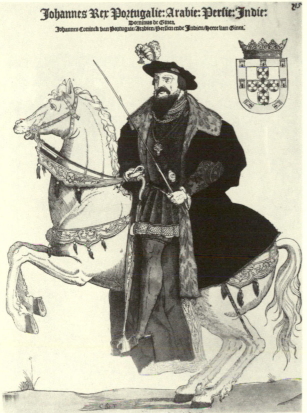

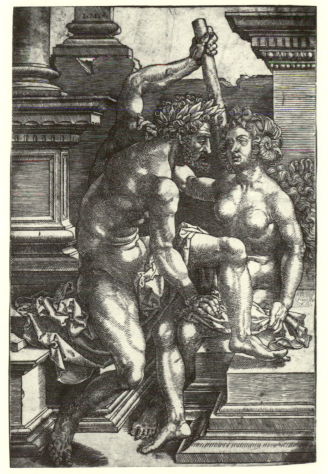

FIG. 11. Cornelis Anthonisz, *Johannes III of Portugal*, woodcut.

FIG. 12. Jan Gossaert, *Hercules and Deianeira*, woodcut.

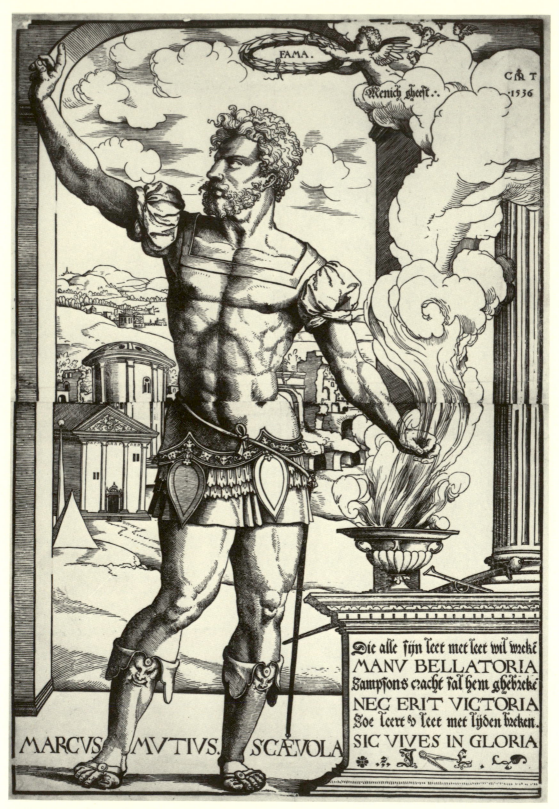

FIG. 13. Cornelis Anthonisz, *Marcus Mutius Scaevola*, woodcut.

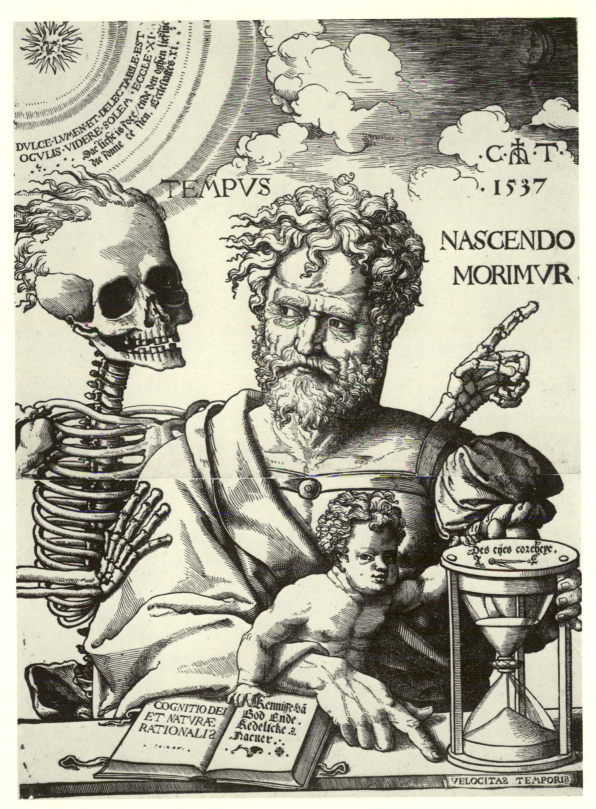

Fig. 14. Cornelis Anthonisz, *Allegory of Transitoriness,* woodcut.

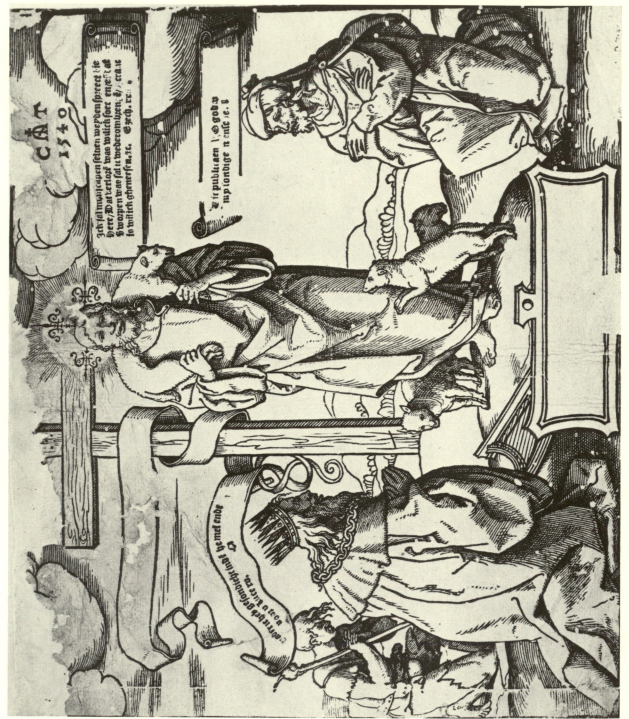

FIG. 15. Cornelis Anthonisz, *The Good Shepherd with Sinners*, woodcut.

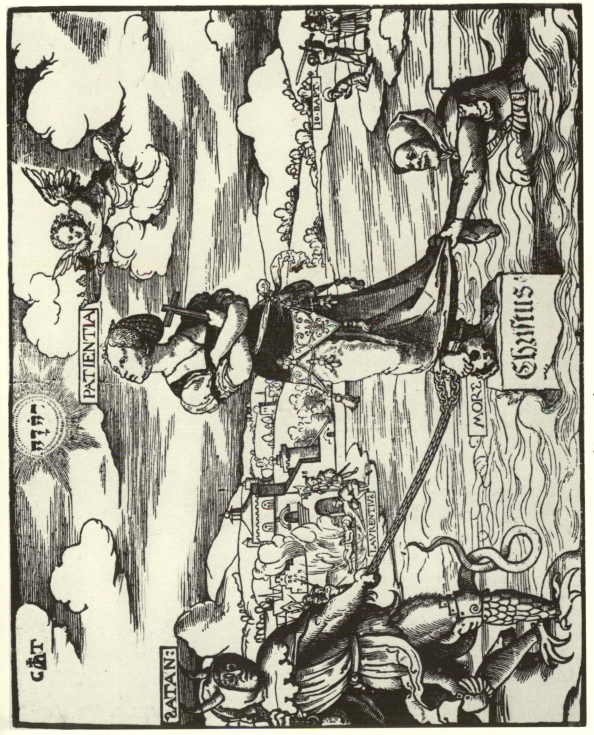

Fig. 16. Cornelis Anthonisz, *Patience, Satan, and Sin*, woodcut.

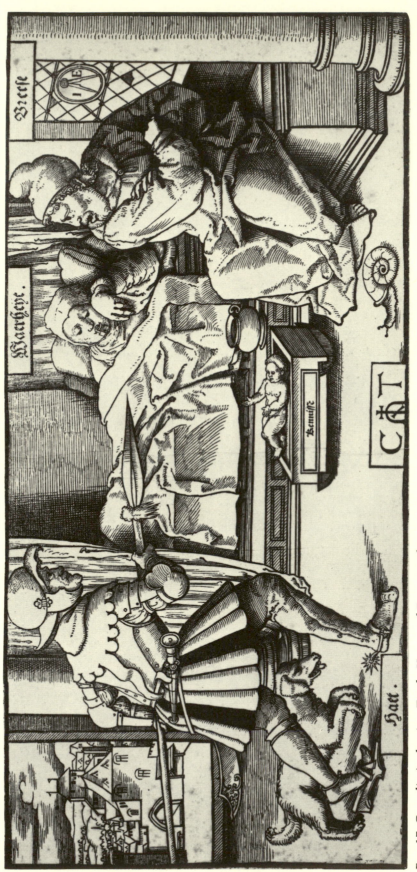

Fig. 17. Cornelis Anthonisz, *Truth, Hate, and Fear*, woodcut.

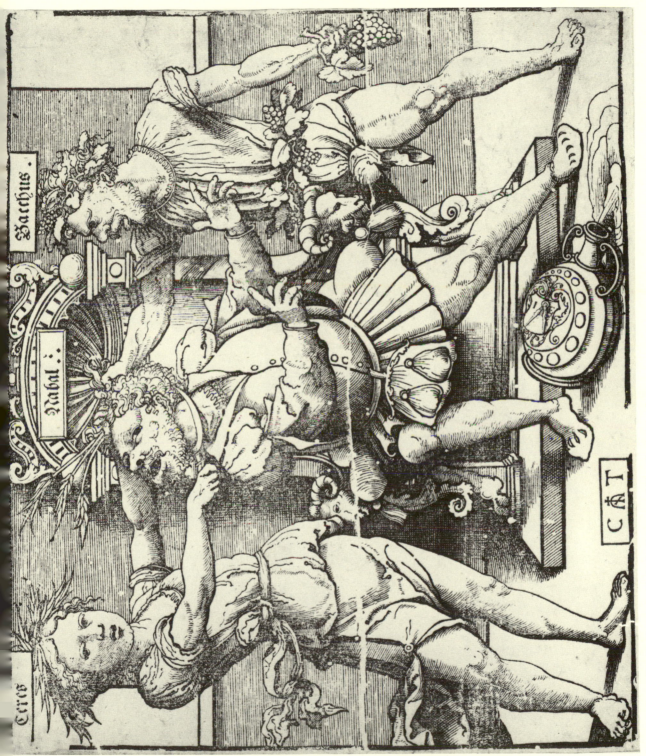

FIG. 18. Cornelis Anthonisz, *Nabal, Ceres, and Bacchus*, woodcut.

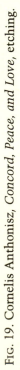

Fig. 19. Cornelis Anthonisz, *Concord, Peace, and Love*, etching.

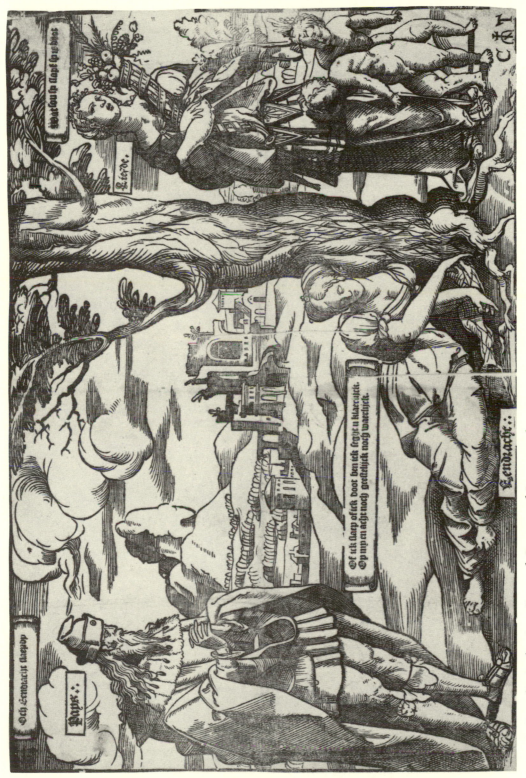

Fig. 20. Cornelis Anthonisz, Concord, *Peace, and Love, woodcut.*

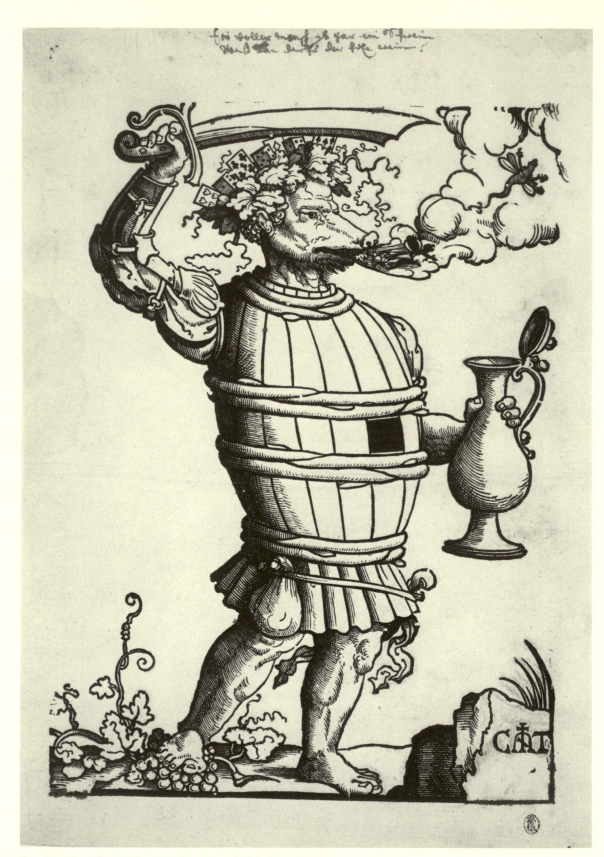

FIG. 21. Cornelis Anthonisz, *Demon of Drink*, woodcut.

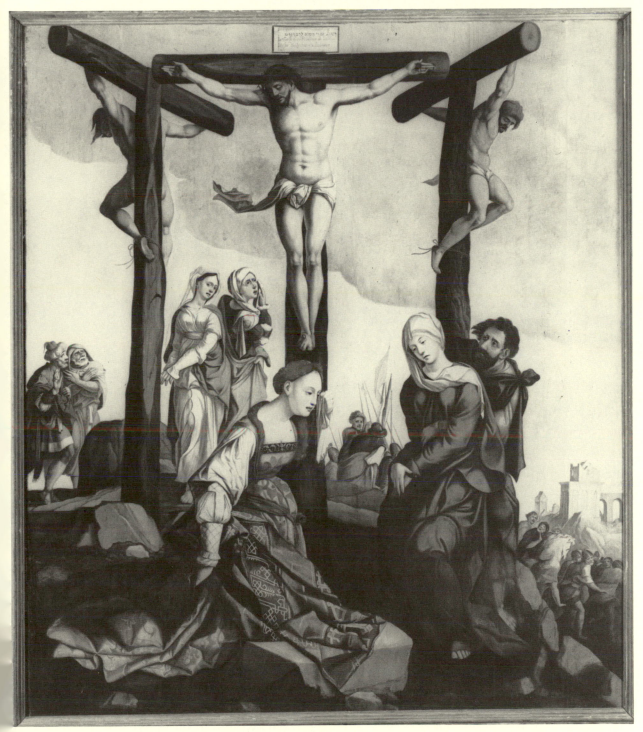

FIG. 22. School of Jan van Scorel, *Crucifixion*, panel.

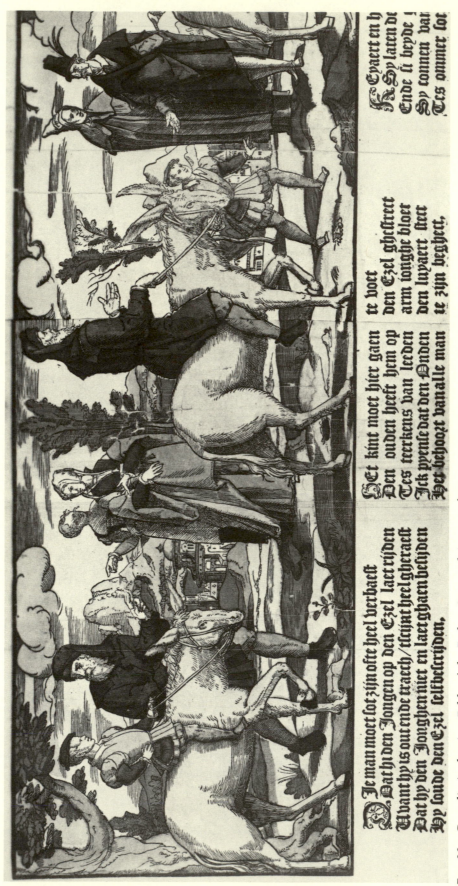

Fig. 23a. Cornelis Anthonisz, *Fable of the Father, Son, and Ass*, woodcut.

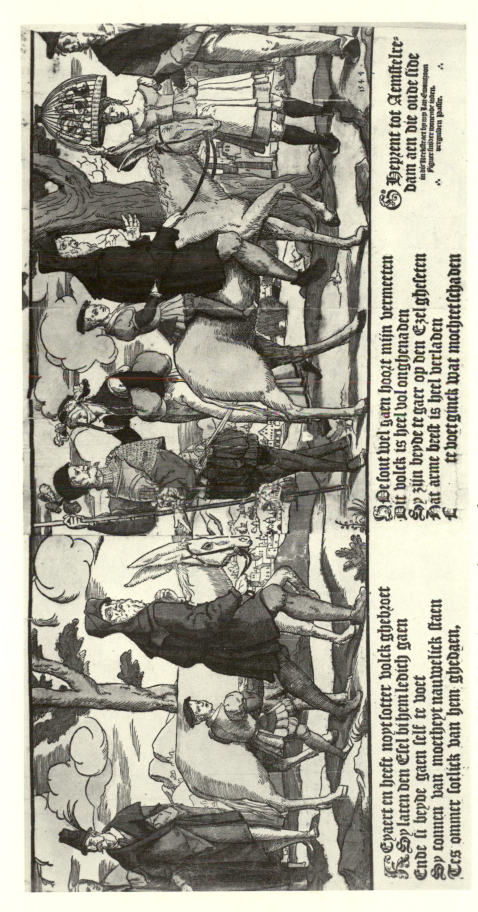

FIG. 23b. Cornelis Anthonisz, *Fable of the Father, Son, and Ass*, woodcut.

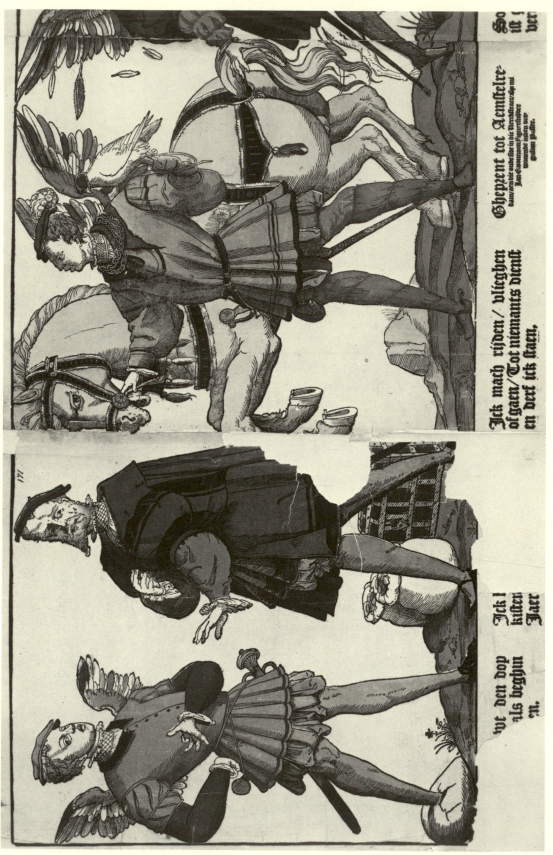

Fig. 24a. Cornelis Anthonisz, *The Flighty Youth*, woodcut.

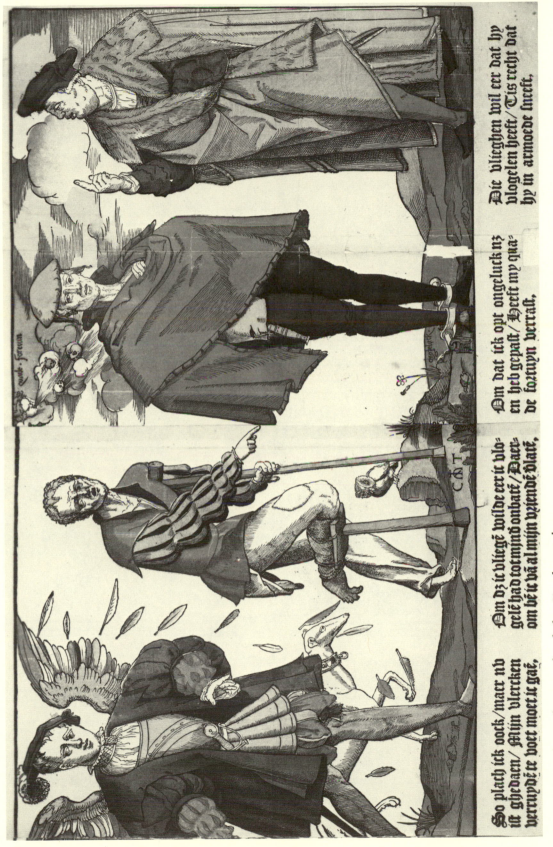

Fig. 24b. Cornelis Anthonisz, *The Flighty Youth*, woodcut.

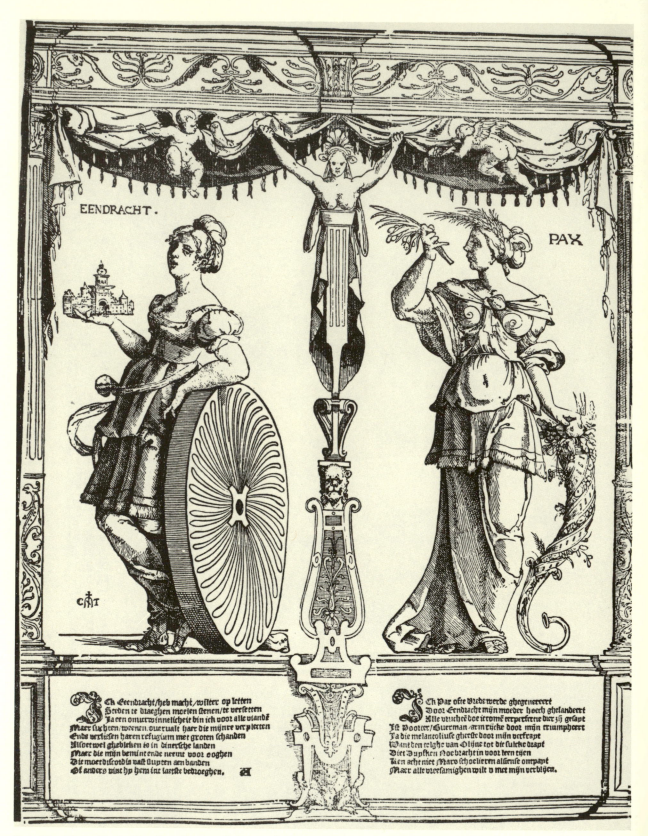

FIG. 25a. Cornelis Anthonisz, *Concord, Peace,* from *The Misuse of Prosperity,* woodcut.

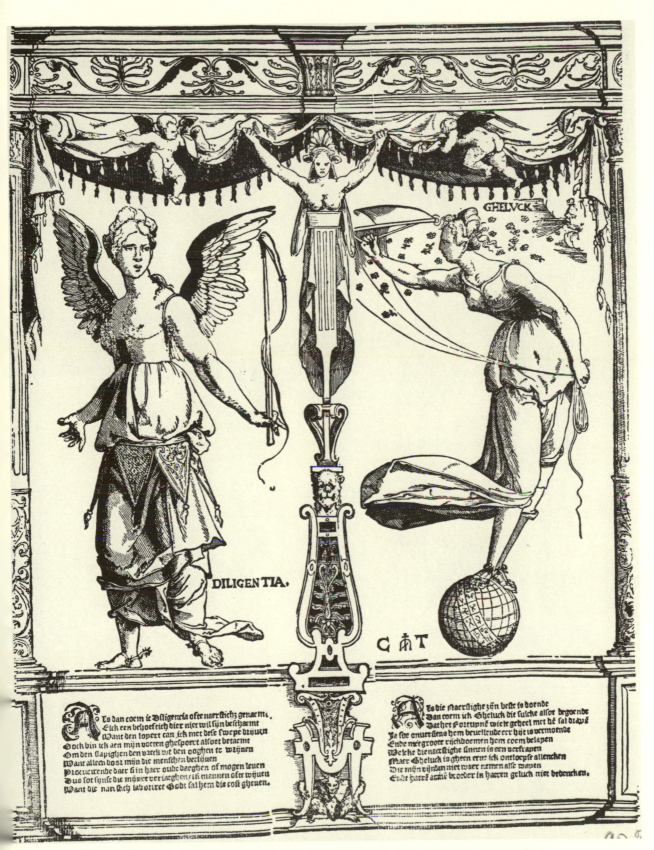

GHELVCK

DILIGENTIA.

C ♇ T

FIG. 25b. Cornelis Anthonisz, *Diligence, Good Fortune,* from *The Misuse of Prosperity,* woodcut.

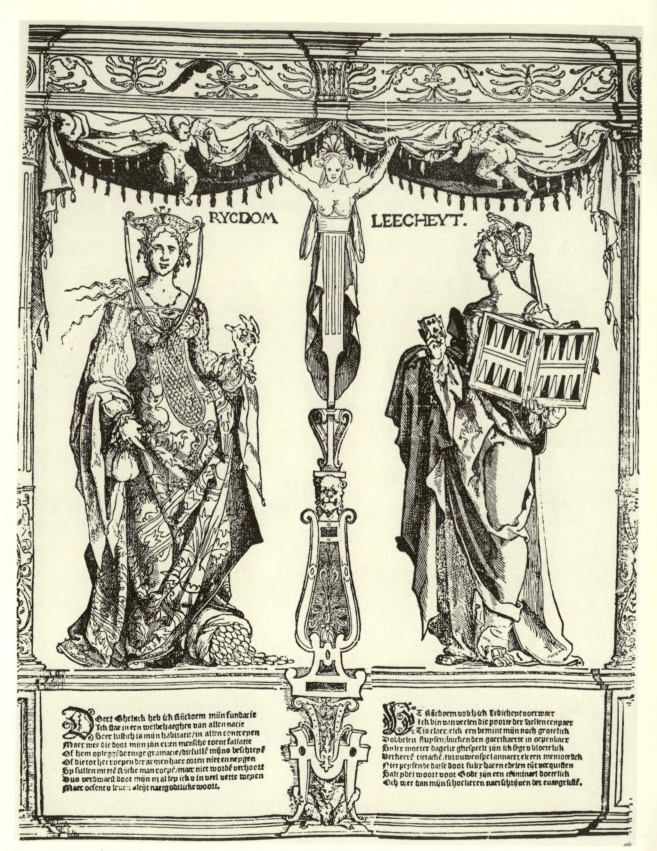

FIG. 25c. Cornelis Anthonisz, *Riches, Idleness,* from *The Misuse of Prosperity,* woodcut.

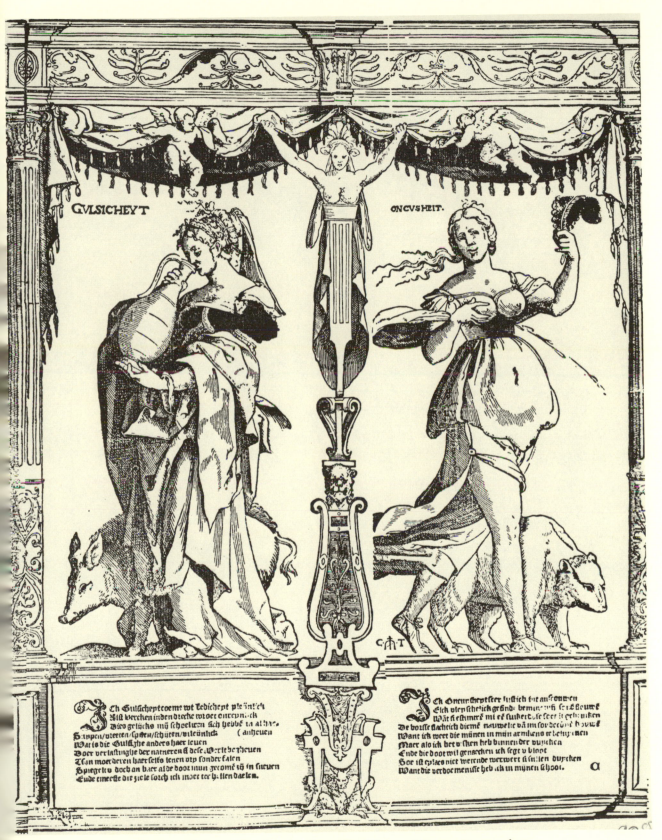

Fig. 25d. Cornelis Anthonisz, *Gluttony, Unchastity*, from *The Misuse of Prosperity*, woodcut.

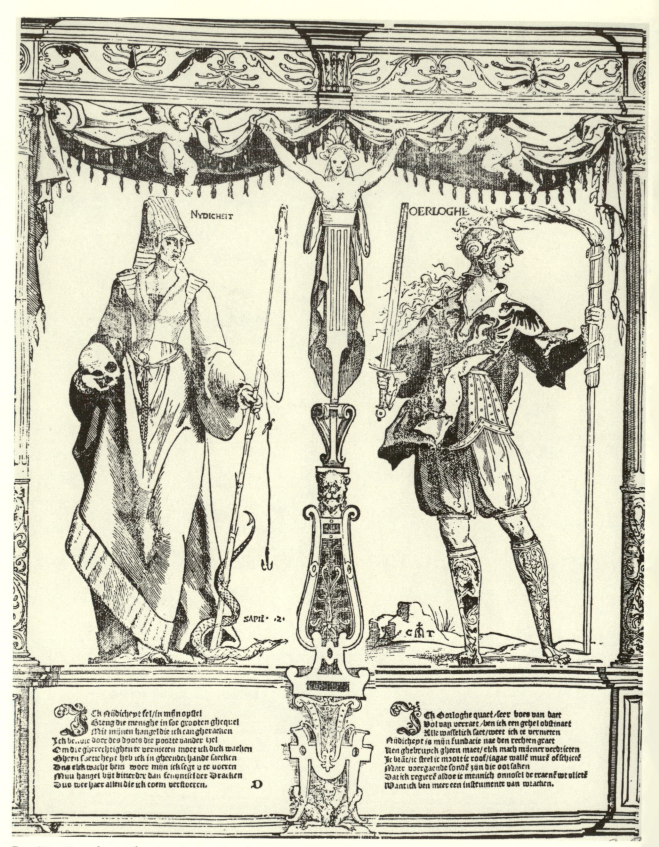

FIG. 25e. Cornelis Anthonisz, *Envy, War,* from *The Misuse of Prosperity,* woodcut.

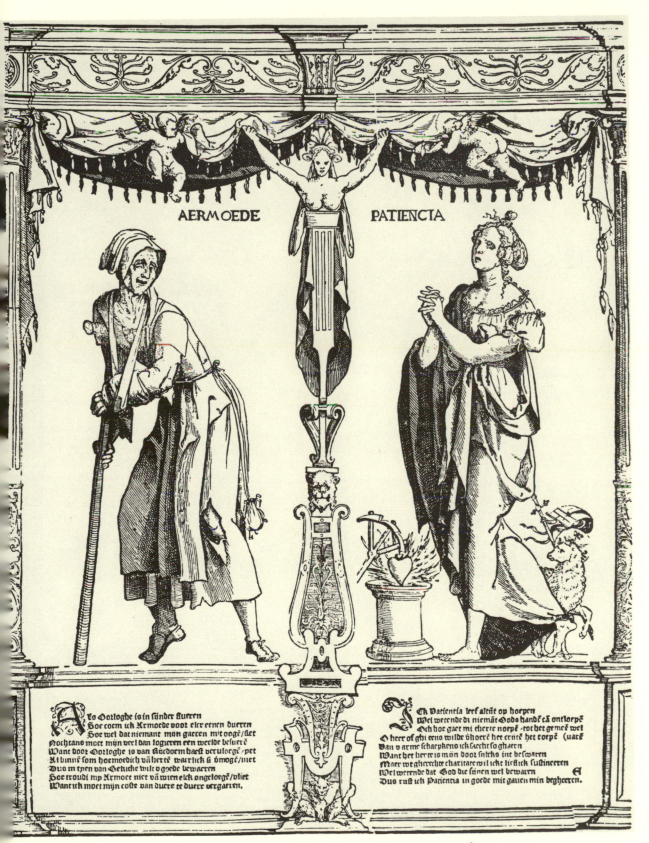

AERMOEDE PATIENCIA

Als Oorloghe so in sander queren
Hoe coem ick Armoede voor elck eenen dueren
Hoe wel dat niemant mijn gaeren mit ooghé/siet
Nochtans moet mijn veel van logieren een werlde besueré
Want door Oorloghe is van Kuedoem haest verulorgé/pet
Al binné som hoemordich váher té waerlick si ónogé/met
Dus in tyen van Gheluche wilt v goede bewaeren
Hoe troudi my Armoe niet vä wien elck ongeloregé/vliet
Want ick moet mijn coste van duere te duere vergaeren.

Ick Patientia leef altät op hoepen
Wel weerende di niemät Gods handé eä ontloepé
Och hoe gaet mi therre noepé/tot het gemeé wel
O heer of ghi eno wilde vhoeré het ernté het torpé (uaré
Van v arme schaepkeno ick saecht so ghaern
Want het herte is mijn door sulcho int beswaren
Maer wt gherechte charitate wil icke lieflick sustineeren
Wel weerende dat God die sinen wel bewaern
Dus rust ick Patientia in goede mit gauen mijn begheeren.

G. 25f. Cornelis Anthonisz, *Poverty, Patience,* from *The Misuse of Prosperity,* woodcut.

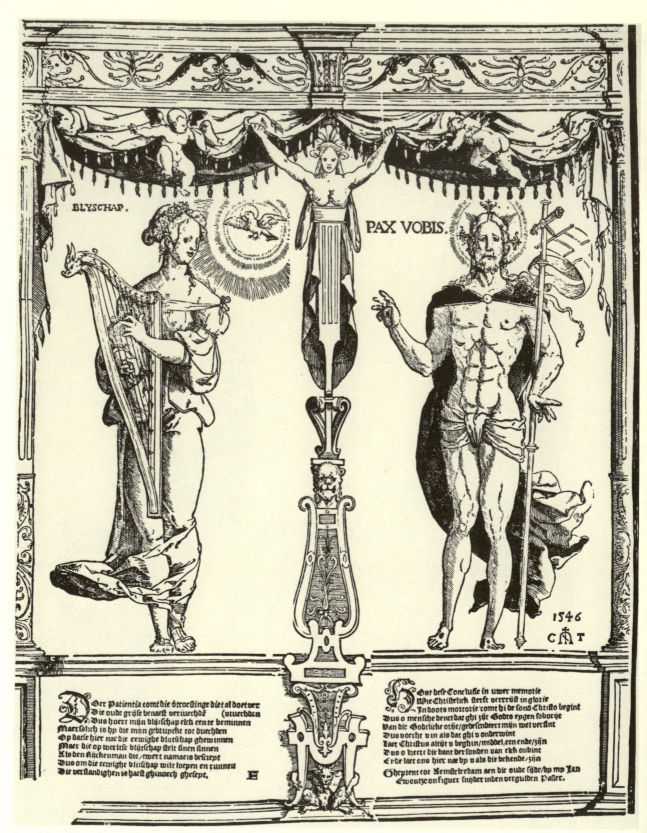

FIG. 25g. Cornelis Anthonisz, *Joy, Christ*, from *The Misuse of Prosperity*, woodcut.

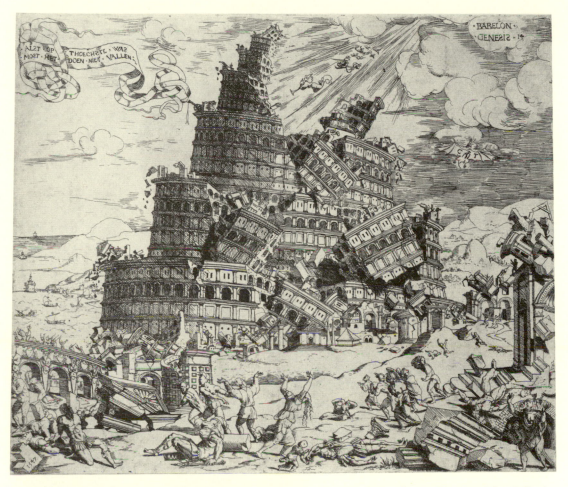

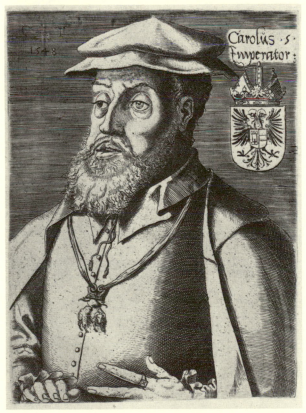

FIG. 26. Cornelis Anthonisz, *The Fall of the Tower of Babel*, etching.

FIG. 27. Cornelis Anthonisz, *Charles V*, etching and engraving.

**Elck dient sinte aelwaer met grooter begheert
die van veel menschen wordt gheeert.**

Prince.

FIG. 28. Cornelis Anthonisz, *Sinte Aelwaer*, woodcut.

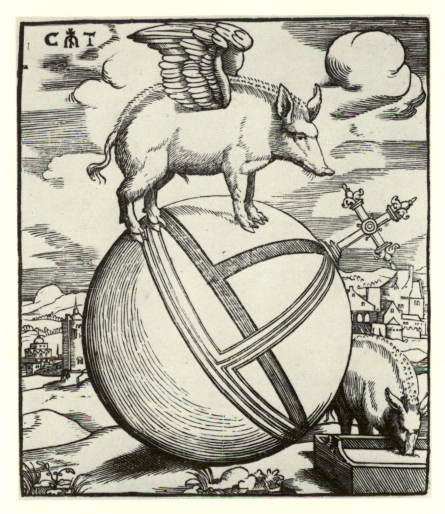

FIG. 29. Cornelis Anthonisz, *Winged Pig*, woodcut.

FIG. 30. Cornelis Anthonisz, *Arterial System of the Human Body*, woodcut.

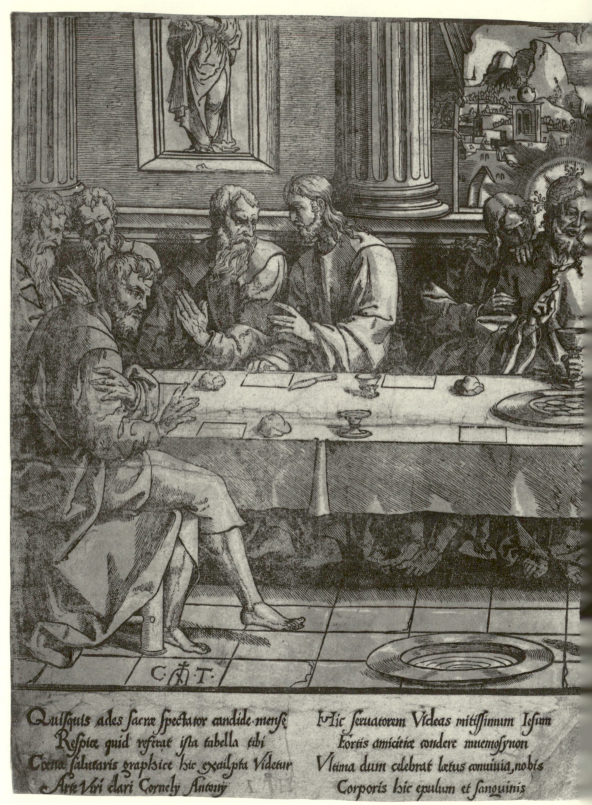

Quiſquis ades ſacræ ſpectator candide menſę
Reſpice quid referat iſta tabella tibi
Cœna ſalutaris graphice hic excülpta Videtur
Arte Viri clari Cornely Antonÿ

Hic ſeruatorem Videas mitiſsimum Ieſum
Fortis amicitiæ condere mnemoſynon
Vltima dum celebrat lætus conuiuia, nobis
Corporis hic epulum et ſanguinis

FIG. 31. Cornelis Anthonisz, *The Last Supper*, woodcut.

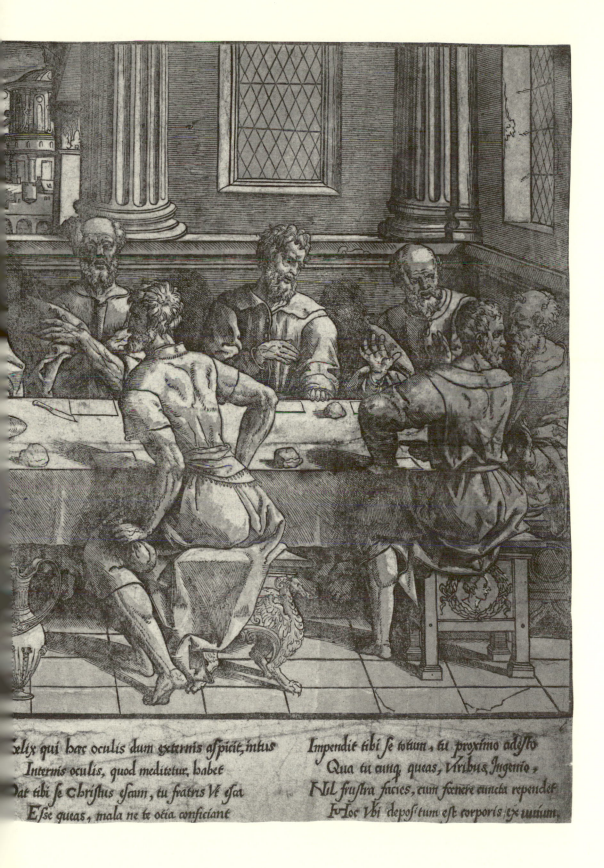

…elix qui hæc oculis dum externis aspicit, intus Impendit tibi se totum, tu proximo adesto
 Internis oculis, quod meditetur, habet Qua tu cunq, queas, Uribus, Ingenio,
…at tibi se Christus escam, tu fratris ut esca Nil frustra facies, cum fœnere cuncta rependet
 Esse queas, mala ne te otia conficiant Fu Ioc Ubi depositum est corporis, ex tuuium.

FIG. 32. Cornelis Anthonisz, *The Ages of Man*, woodcut.

FIG. 33. Cornelis Anthonisz, *Deathbeds of the Righteous and Unrighteous*, woodcut.

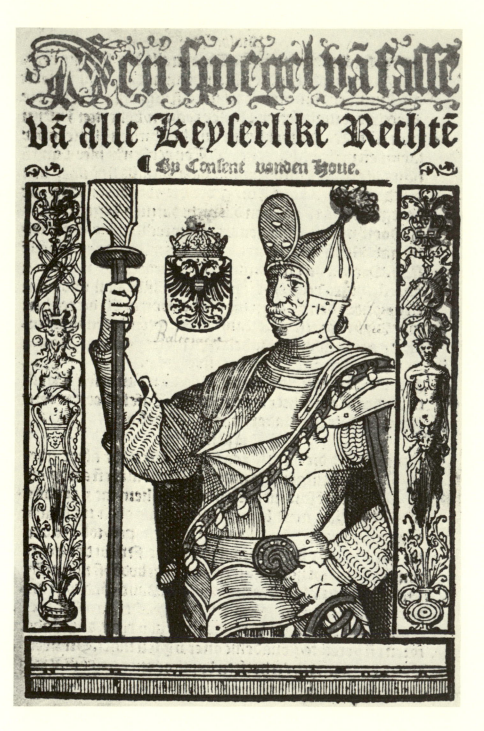

FIG. 34. Cornelis Anthonisz(?), title page from Eyke von Repgow, *Den spiegel van sassen van alle Keyserlike Rechten* (Amsterdam, 1550), woodcut.

FIG. 35. Cornelis Anthonisz, *Saint Olaf*, reproduction of a woodcut.

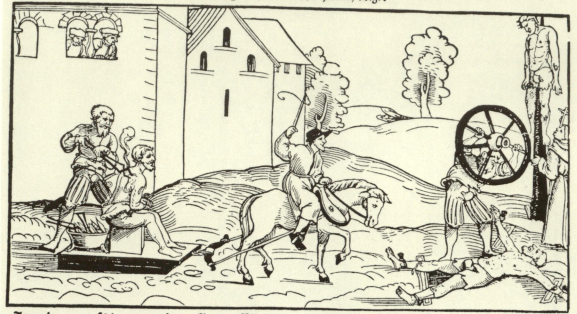

Anno XXXIIII/am freytag noch Sonntag Iudica/hat Hans Reichart
Glaser von Dietfurt/Burger allhie zů Regenspurg/an peynlicher frag/Nachmals
auch gütlich bekendt/Wie hernach volgt.

Item kurtz verschiner zeyt / sey der Hans Glaser/ willes gewest/ Herren Vlrichen Widman/ein priester alhie/vom leben zum tod zůpringē/vnd nachmals dem selben auffzeraymē/Darumb das der Hans Glaser sich eines abents nach Vesper zeyt zů gemeltē priester in sein behausung gethan/vnd zuuor ein geladen zündtpüchslein vnd ein lang protmesser/mit yhm genommen/mit dem priester inn das bier gezecht/biß es gantz spat vnd tunckel worden/het der Hans Glaser zu dem priester gesagt/er wolte nun heim ziehen/als wer der priester vor yhm/dem Glaser /zů der stuben her aus/vnd der Glaser yhm nach gangen/yn den priester vrplitz/also hinderwertlich/mit dem püchslein geschossen/das er hernider gefallen/vnd der Glaser als bald das brodtmesser gezuckt/vnd yhm/dem priester/sein gürgel damit abgeschniten/den priester von dem fleyg/hienein in ein kemmerlein gezogē der als bald tod gewest/also het der Hans Glaser/des priesters schlüssel genomen/ein Trühen auffgespert/vnd daraus genomen/bey fünffundreyssig gulden/an gold vnd müng.

Hans Glaser hat weyter bekandt.

Item am Freytag vor dem heyligen palmtag/nechstuerschinē/hab der Hans Glaser sein zündt püchslein geladen/vnd das selb sampt dem vorangezeygten brotmesser zů yhm genomen/yhm fürgesetzt Herrn Sebastian Gyrstner/Cörhern zů Sant Johans allhie/zůermörden/vnd yhm als dann auff zů raumen rc. Vnd als gemelter Herr Sebastian/seligen an bestimptem freytag zů kirchen gewest / hat der Hans Glaser an seiner behausung angeleüt/yhm sein Köchin auff gethon/vnd yhn gefragt was er wolte/er zů der Köchin gesagt/sie solte yhrem herren seyn Betbüchlein inn die kirchen schicken Also het die Köchin inn der stuben nach dem Betbüchlein gsůcht/aber das recht nit finden kinnen/da wer gemelte Köchin/vnd Hans Glaser/zů der stuben heraus gangen/da er sey hinderwertlich/mit dem püchslein geschossen/das sie als bald gestorbē/der Glaser yhr mit dem protmesser behend die gürgel abgeschniten/das sie als bald gestorben/also hat der Glaser der Köchin ein Creüg auff den rucke in den blossen leib geschniten vñ es darvmb gethan/das man nit brüsen oder sehen solt/das es ein schuß gewest were. In solchem hette das hündtlin im haus fast gepollen/dasse ibig het er zů yhm gelockt/vnd zu todt geschlagen/darnach inn das heymlich gemacht gewoffen/vnd als bald sein zündtpüchslein wider geladen.

Item nach solchem/wer Herr Sebastian seliger/von kirchen kommen/die haustpür auffgespert/da wer der Glaser im hoff gestanden / vnd gegen Herr Sebastian gangen/hat Herr Sebastian zů yhm gesagt/Mayster Hans was thůt yhr da / er antwurt/Ich biñ da kommen / vnd wil euch den gulden bezalen/den yhr mir gelyhen habt/het Herr Sebastian gesagt/so geht mit mir auffher/also wer Herr Sebastian seliger/vñ der Glaser mit einander die steygen hin auff/Herr Sebastian vor/vnd der Glaser hinder ym gangen/vnd als Herr Sebastian / noch ein staffel oder zwo hinauff gehabt/hett der Glaser /yhn mit dem püchslein/inn den ruck geschossen/das er auff die seyten ernider gefallen/vnd zu yhm gesagt du Pößwicht wiltu mich dann da ermörden/also weren sie beyde miteinander die stiegen herab gefallē/der Glaser sein brodtmesser gezuckt/vñ Herrn Sebastian sein gurgel damit abgeschniten / vnd sich nachmals dauon gemacht.

Item der Hans Glaser / sey vor dem das er Herren Sebastian seligen vnd sein Köchin ermördet hab/ Vngeuerlich inn zehen tagen sybē mal/mit seynem geladen zündtpüchslein vnd brotmesser/aus seiner behausung gangen/für Herrn Sebastians haus/vnd im willen gehabt/gemelten Herren Sebastian/zuermörden/aber alles inn yhm selbs gedacht/was wiltu thun/than es nit/vnd also vnderlassen bleyben/biß es doch zu letst leyder also volbracht hab.

Hans Glaser hat weyter bekandt.

Item bey dem Barfusser Gozhaus/allhie won ein alte Fraw in einem häuslein/het er hören sagenn/die selb Fraw solt vil gelts habenn/ Darumb sie er eins mals hinaben/vñ die selben Frawen gesůcht/aber nit anheyms gefunden/nachmals vber etlich tag/hat der Glaser sein zeündtpüchslein geladen/vnd widerumb hinab zu der alten Frawen behausung gangen/vnd des willens zewest/gegen yhr vorgemelter massen/auch zů handeln/aber er hette sye abermals nit anheyms gefunden.

Item der Glaser/hete yego vngeuerlich/vier wochen nach Wiehenechten nechstuerschinen/nechtlicher weyl sein zündtpüchslein geladen/vnnd an der behausung hinder dem heyligen Creüg/im pach Herren Hansen Gebhart zugehörig/angeleüt/vnd sich versehen/man solt yhm auffgethan/vnnd wo er gemelten Hansen anheyms gefunden /so wolte er vorgelauter massen/gegen jm auch gehandelt/vnd ihnen wie die andern ermöt haben.

Item im nechstuergangen Winter/eins tags nach vesper zeyt / hette er Hans Glaser sein zündtpüchslein geladen/vnd were gangen/für den Augspurger hoff/darinn Herr Vlrich Förl wone/Alda het er angeleut/het yhm der melter Herr Vlrich auffgethan/der Glaser des willens gewest/ gegen yhm Herren Vlrichen auch vorgelauter massen zů handlen/vnnd zůermörden / yedoch so were ein rew inn yhn gefallen/das er im gedacht/Ich Gott was wille da thun/vnd als Herr Vlrich /yhn den Glaser gefragt/was er wolt/het er sich des erdacht vnd gesagt/Lieber Herr Vlrich/mir seindt yegt zwen gulden gleser kommen / Ich bit euch yhr wellen de mir ein gulden leyhen/den will ich euch inn vierzehen tagen widergeben/vnd also nichtes gegen Herren Vlrichen / fürgenomen/sonder von yhm widerumb abgangen.

Steffan Hamer Briessmaler zů Nürnberg.

Benanter Hans Glaser seliger/ist alhie noch vrteyl vnd Recht rc. Durch den Nachrichter/vor den helisern/darinn er die drey mörd verpracht hat/nach auffgang des Rechtens mit glüenden zangen gezwickt/geradprecht/ Vnnd nachmals mit endung seins tods gespizt worden.

Fig. 36. Erhard Schön, *Execution of a Murderer at Regensburg*, woodcut.

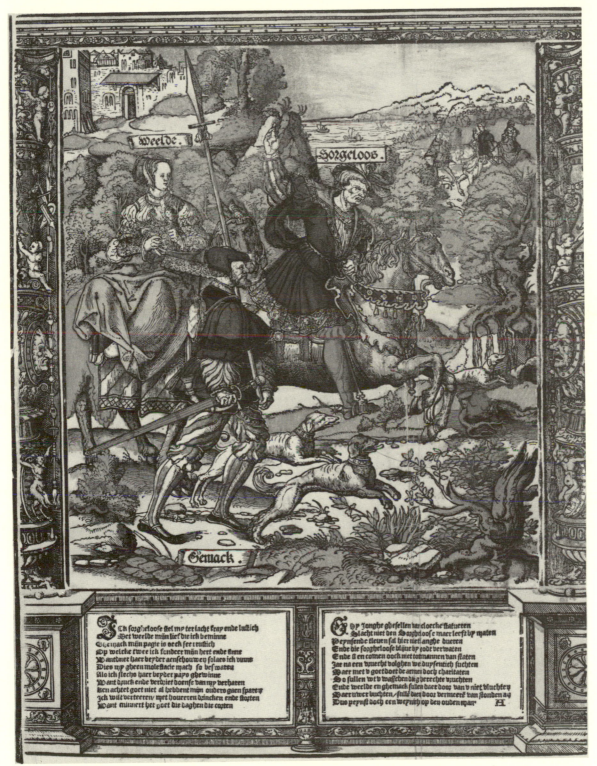

FIG. 37a. Cornelis Anthonisz, *Sorgheloos Sets out on the Hunt*, from *Sorgheloos*, woodcut.

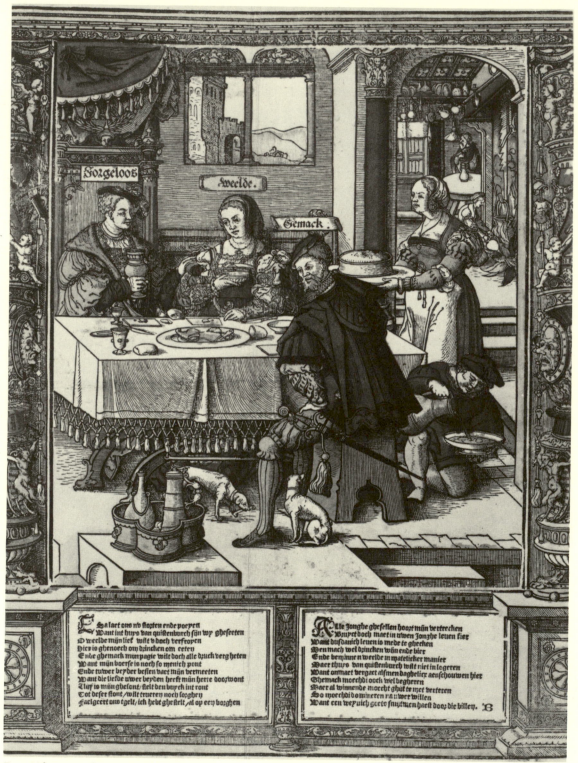

FIG. 37b. Cornelis Anthonisz, *Sorgheloos at the Inn*, from *Sorgheloos*, woodcut.

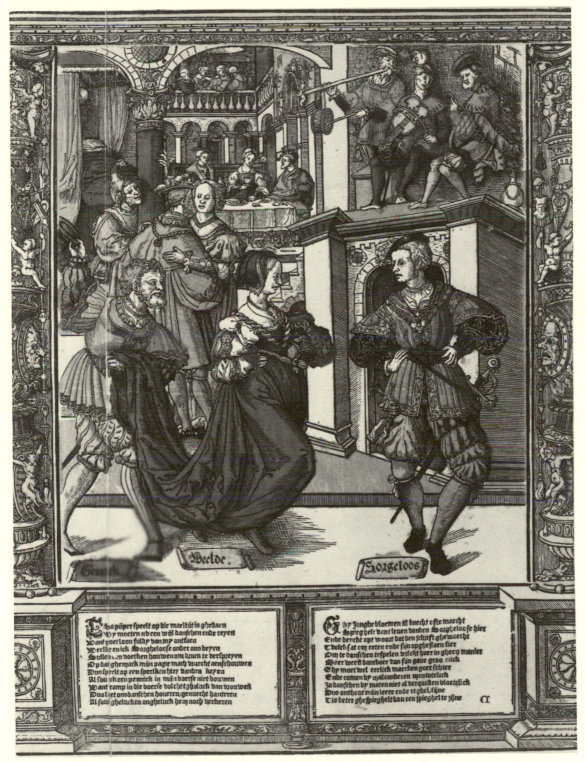

FIG. 37c. Cornelis Anthonisz, *Sorgheloos Dancing*, from *Sorgheloos*, woodcut.

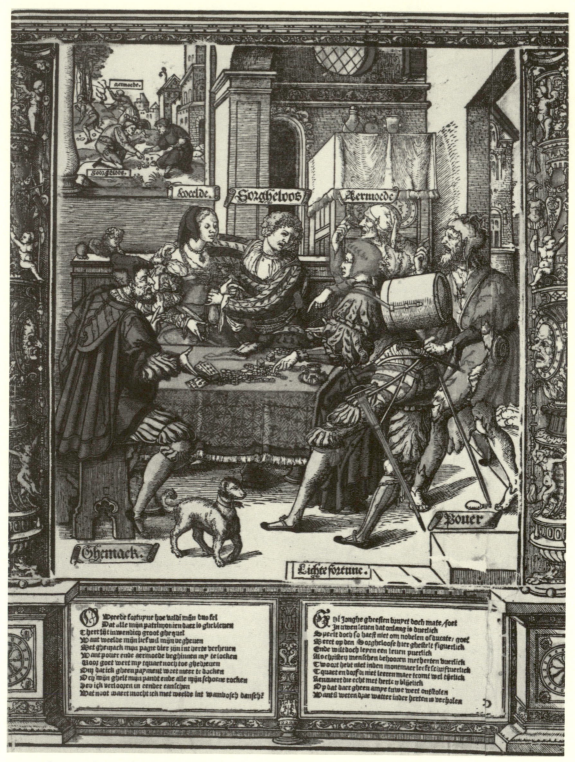

Fig. 37d. Cornelis Anthonisz, *Sorgheloos Gambling*, from *Sorgheloos*, woodcut.

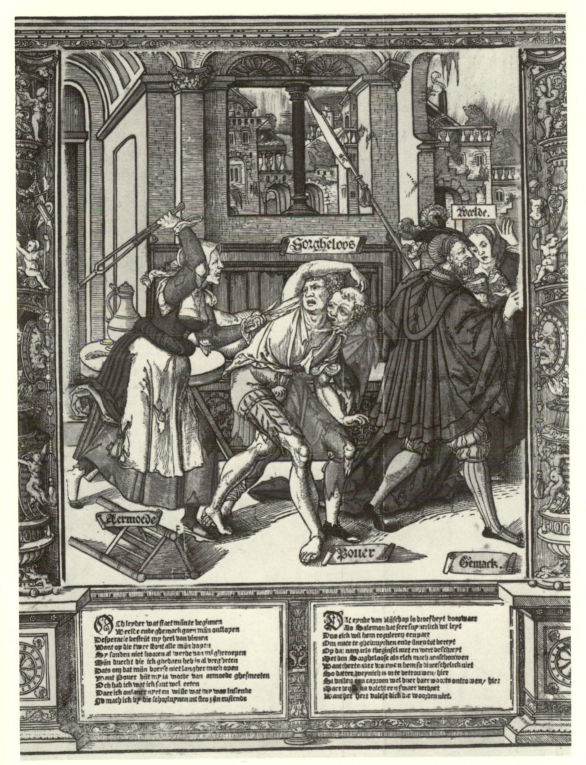

FIG. 37e. Cornelis Anthonisz, *Sorgheloos Expelled from the Inn*, from *Sorgheloos*, woodcut.

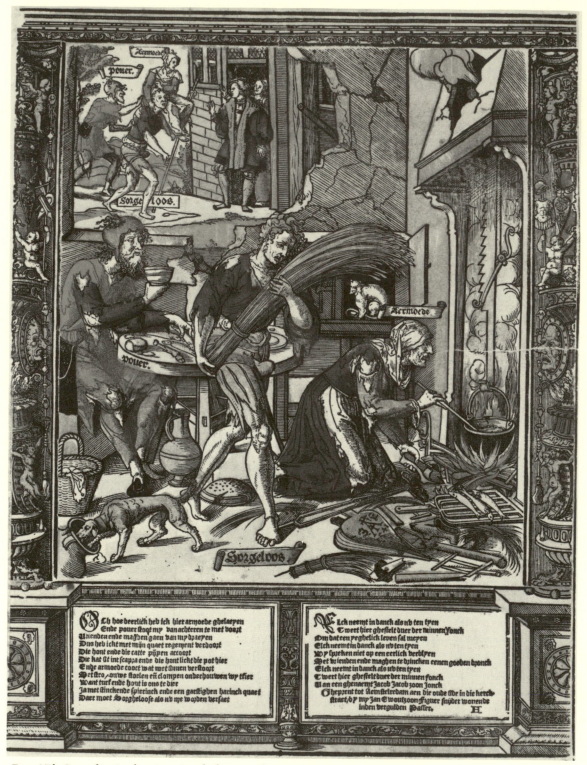

FIG. 37f. Cornelis Anthonisz, *Sorgheloos in the Poor Kitchen*, from *Sorgheloos*, woodcut.

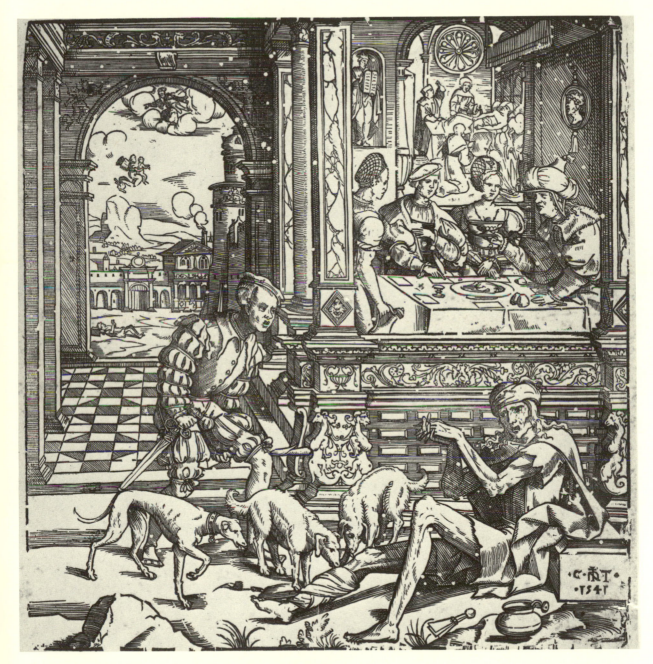

FIG. 38. Cornelis Anthonisz, *Dives and Lazarus*, woodcut.

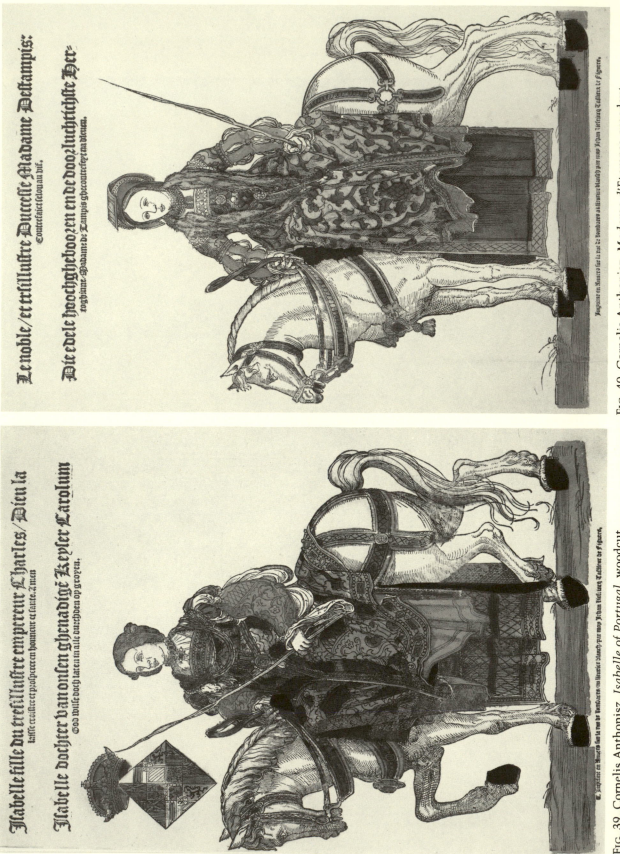

Fig. 39. Cornelis Anthonisz, *Isabelle of Portugal*, woodcut.

Fig. 40. Cornelis Anthonisz, *Madame d'Etampes*, woodcut.

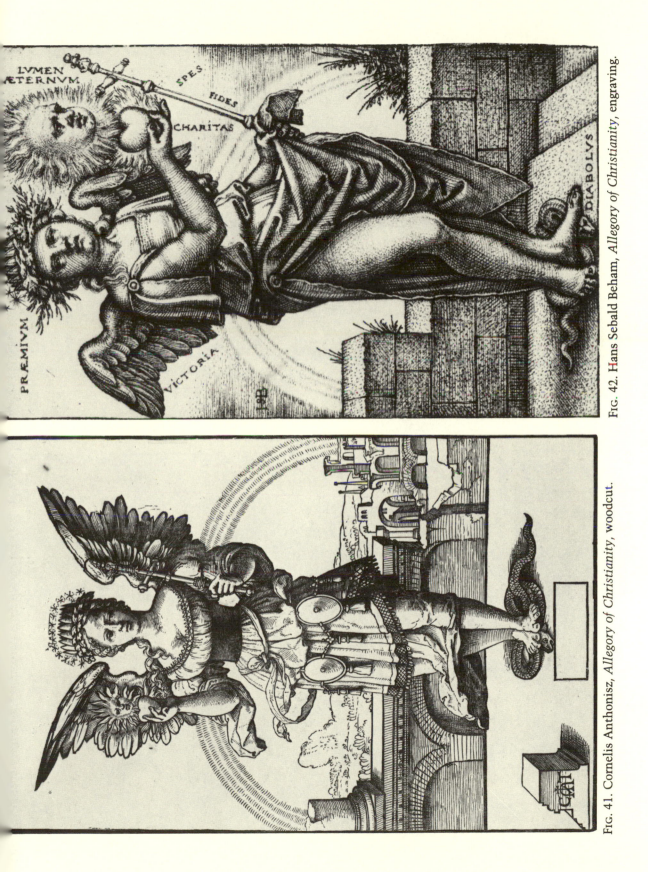

FIG. 42. Hans Sebald Beham, *Allegory of Christianity*, engraving.

FIG. 41. Cornelis Anthonisz, *Allegory of Christianity*, woodcut.

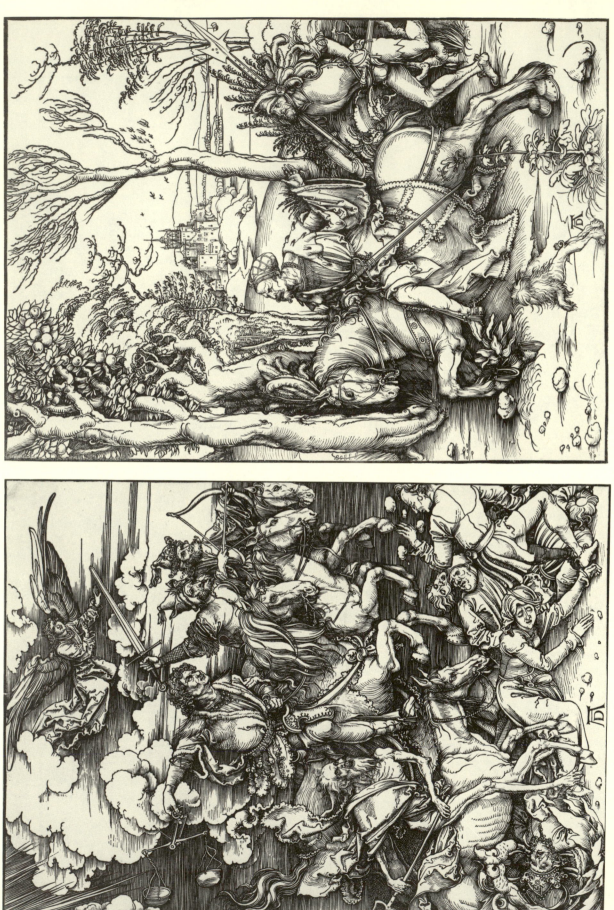

FIG. 44. Albrecht Dürer, *Knight and Landsknecht*, woodcut.

FIG. 43. Albrecht Dürer. *The Four Horsemen*, from the *Apocalypse*, woodcut.

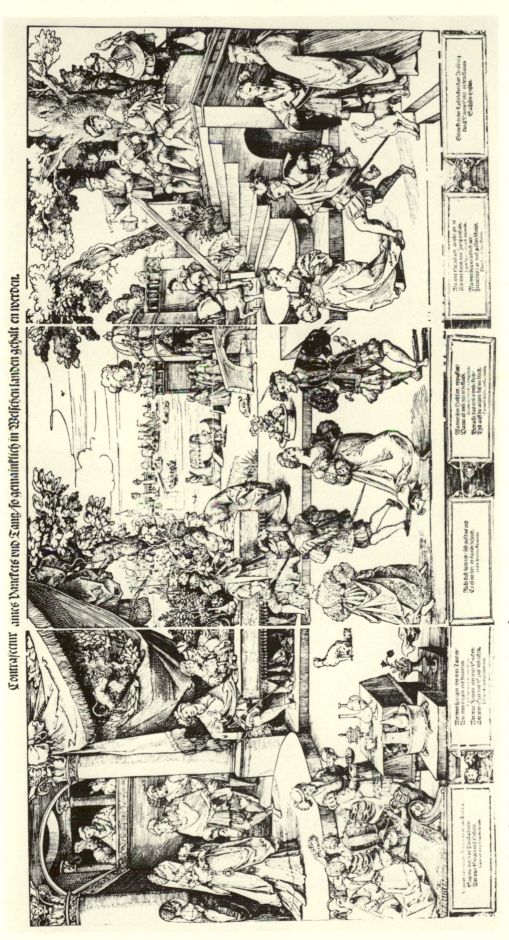

FIG. 45. Jörg Breu the Younger, *Venetian Banquet*, woodcut.

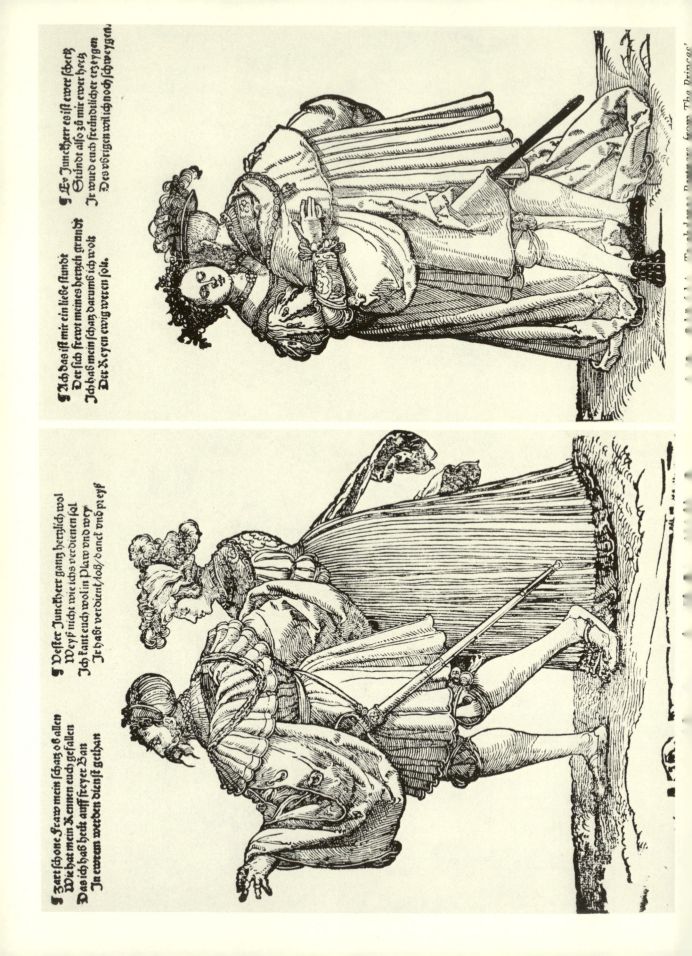

¶ Zart schone Fraw mein schatz ob allen
Wie hat mein Kennen euch gefallen
Das ich baß heit auff freyer Ban
In ewrem werden dienst gethan

¶ Dester Junckherr gantz hertzlich wol
Weyß nicht wie ichs verdienen sol
Ich kan euch wol in Platz vnd wey
Ja hab verdient loß/danck vnd preyß

¶ Ich das ist mir ein liebe stund
Der sich frewt meines hertzen grundt
Ich baß mein schatz darumb ich wol
Der Reyen ewig weren sol.

¶ Ey Junckherr es ist ewer scherz
Stündt also zu mir ewer hertz
Jr würd euch freundtlicher erzeygen
Des vbrigen wil ich noch schweygen.

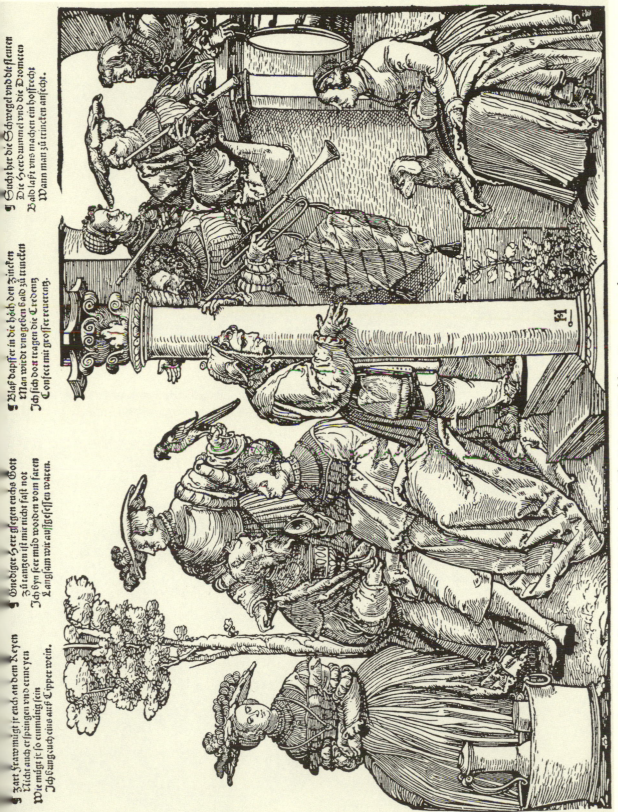

FIG. 46c. Hans Schäufelein, *Audience and Musicians*, from *The Princes' Wedding Dance*, woodcut.

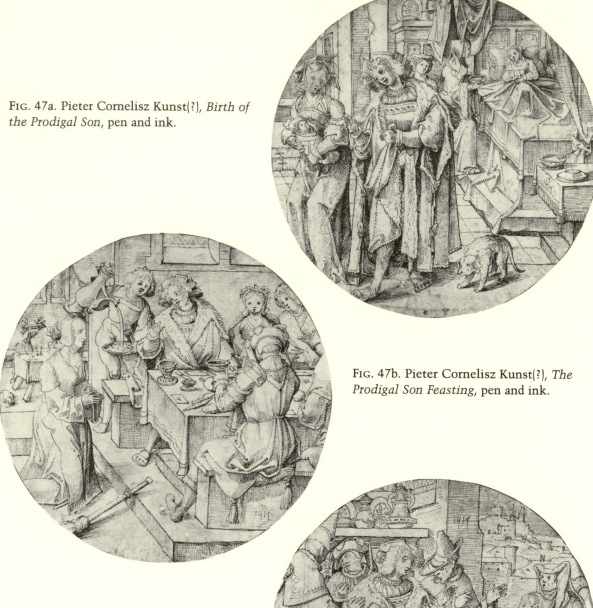

FIG. 47a. Pieter Cornelisz Kunst(?), *Birth of the Prodigal Son*, pen and ink.

FIG. 47b. Pieter Cornelisz Kunst(?), *The Prodigal Son Feasting*, pen and ink.

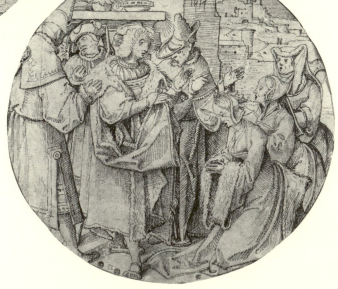

FIG. 47c. Pieter Cornelisz Kunst(?), *The Prodigal Son in Wealth*, pen and ink.

Fig. 47d. Anonymous Netherlandish, *The Prodigal Son Dancing*, glass painting.

Fig. 47e. Anonymous Netherlandish, *The Prodigal Son Gambling*, tempera on linen.

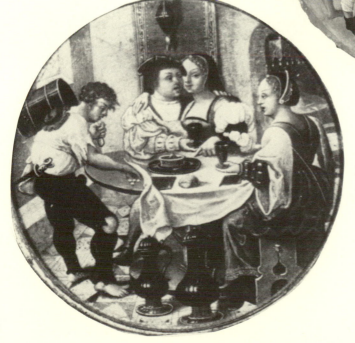

Fig. 47f. Anonymous Netherlandish, *The Prodigal Son Gambling*, tempera on panel.

Fig. 47g. Anonymous Netherlandish, *The Prodigal Son Expelled from the Inn*, tempera on linen.

Fig. 47h. Anonymous Netherlandish, *The Prodigal Son Turned Away from a Rich Man's Door*, tempera on linen.

Fig. 47i. Anonymous Netherlandish, *The Prodigal Son in a Poor Kitchen*, tempera on linen.

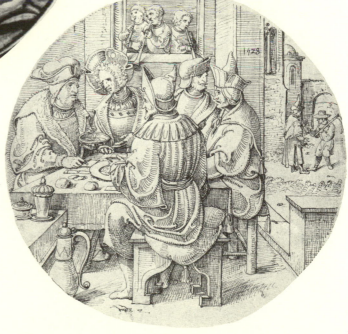

FIG. 47j. Anonymous Netherlandish, *The Prodigal Son Wandering*, tempera on panel.

FIG. 47k. Anonymous Netherlandish, *The Prodigal Son Greeted by His Father*, tempera on panel.

FIG. 47l. Anonymous Netherlandish, *The Prodigal Son's Homecoming*, pen and ink.

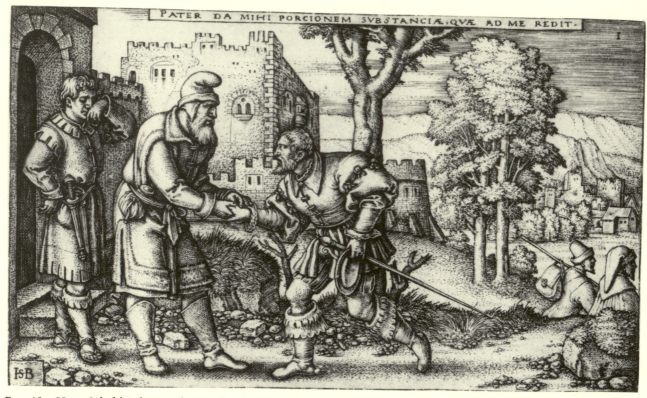

FIG. 48a. Hans Sebald Beham, *The Prodigal Son Receiving His Patrimony*, from *The Prodigal Son*, engraving.

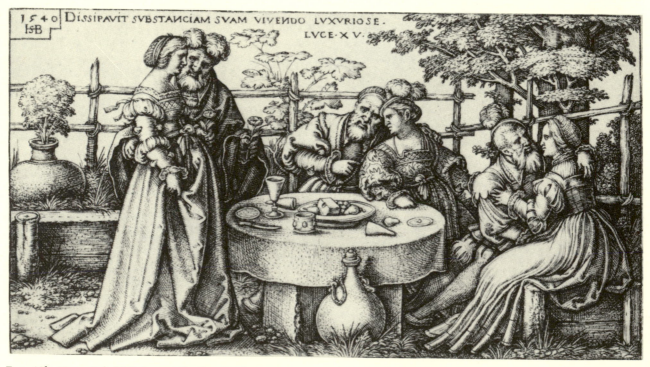

FIG. 48b. Hans Sebald Beham, *The Prodigal Son Feasting*, from *The Prodigal Son*, engraving.

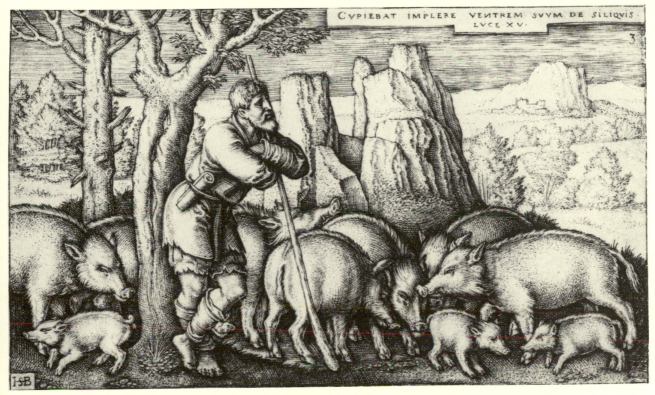

CVPIEBAT IMPLERE VENTREM SVVM DE SILIQVIS.
LVCE XV.

FIG. 48c. Hans Sebald Beham, *The Prodigal Son Tending Pigs*, from *The Prodigal Son*, engraving.

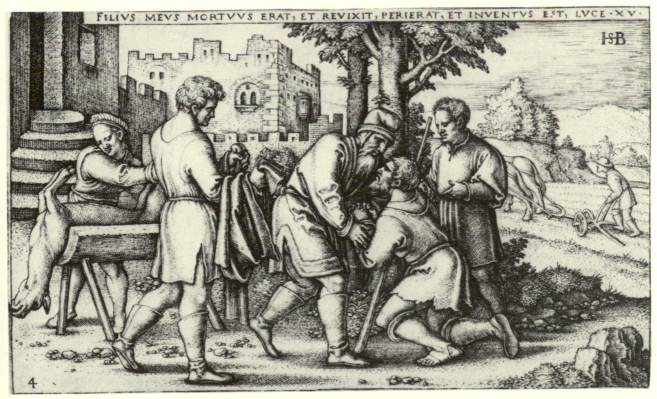

FILIVS MEVS MORTVVS ERAT, ET REVIXIT, PERIERAT, ET INVENTVS EST, LVCE·XV.

FIG. 48d. Hans Sebald Beham, *The Prodigal Son's Homecoming*, from *The Prodigal Son*, engraving.

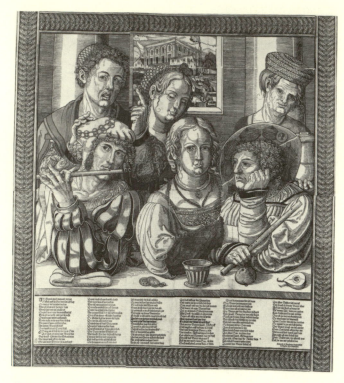

FIG. 49. Jörg Breu the Elder, *The Prodigal Son*, woodcut.

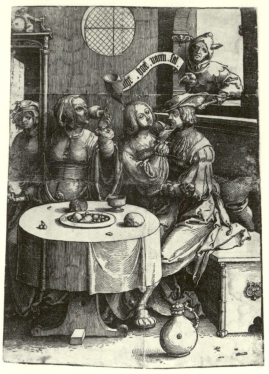

FIG. 50. Lucas van Leyden, *Tavern Scene*, woodcut.

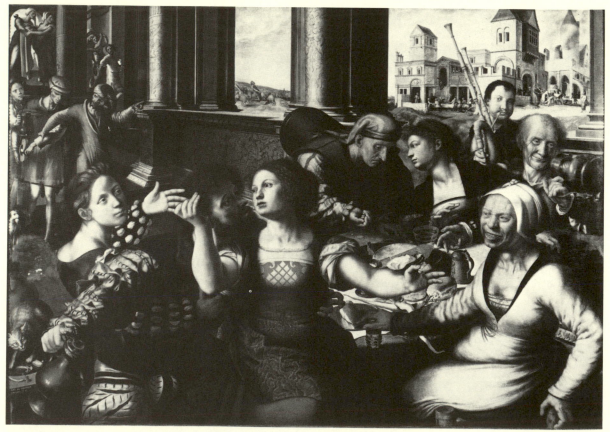

FIG. 51. Jan Sanders van Hemessen, *The Prodigal Son*, panel.

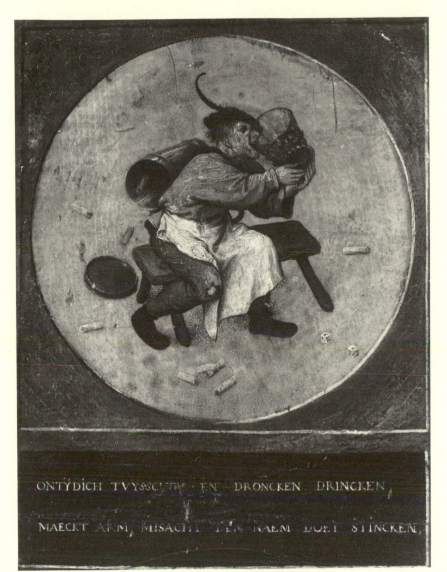

ONTŸDICH TVŸSSCHEN EN DRONCKEN DRINCKEN

MAECKT ARM, MISACHT, DEN NAEM DOET STINCKEN,

FIG. 52. Pieter Bruegel the Elder, *Drinking Crullerman*, panel.

FIG. 53. Anonymous German, *Crullerman Tossing Dice*, illustration from Thomas Murner, *Schelmenzunft* (Augsburg, 1513), woodcut.

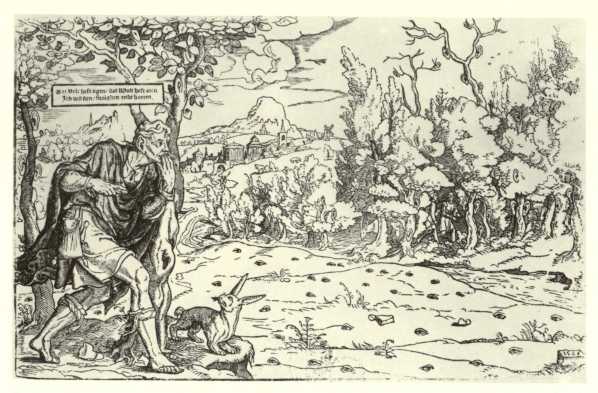

FIG. 54. Anonymous Netherlandish, *The Field with Eyes and Wood with Ears*, woodcut.

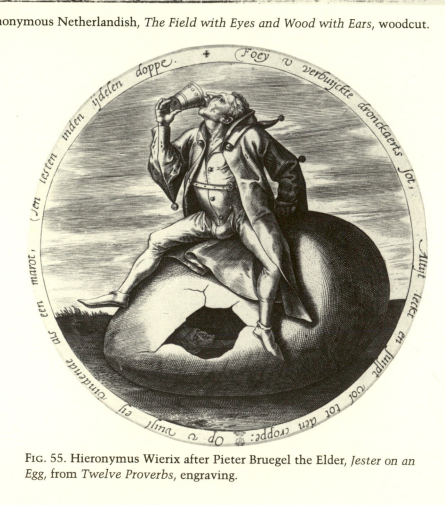

FIG. 55. Hieronymus Wierix after Pieter Bruegel the Elder, *Jester on an Egg*, from *Twelve Proverbs*, engraving.

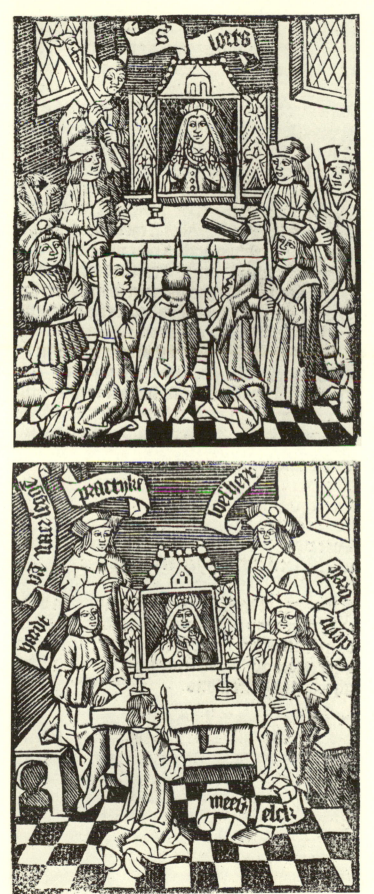

FIG. 56a. Anonymous Neth-
erlandish, *The Worship of
Vrou Lorts*, illustration from
*Van nyeuvont, loosheit,
ende praktike* (Antwerp, c.
1500), woodcut.

FIG. 56b. Anonymous Neth-
erlandish, *Meest Elck before
Vrou Lorts*, illustrations
from *Van nyeuvont, loo-
sheit, ende praktike* (Ant-
werp, c. 1500), woodcut.

FIG. 57. Anonymous, Leiden, *Ship of Sinte Reynuyt*, woodcut.

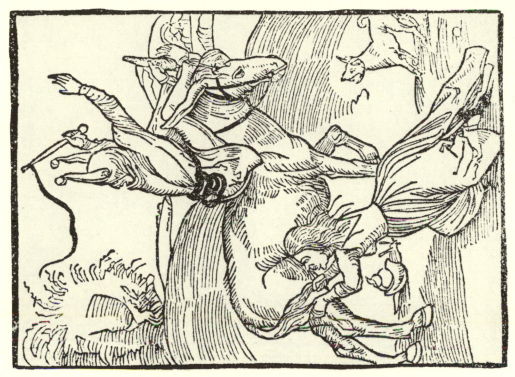

FIG. 59. Anonymous German, *Fool on an Ass*, illustration from Sebastian Brant, *Narrenschiff* (Basel, 1494), woodcut.

FIG. 58. Albrecht Dürer, *Saint Sebaldus*, woodcut.

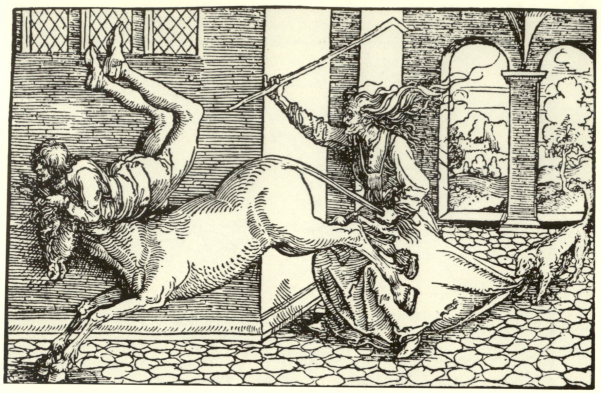

FIG. 60. Anonymous German, *Fool on an Ass*, illustration from Petrarch, *Von der Artzney beider Glück, des guten und widerwärtigen* (Augsburg, 1532), woodcut.

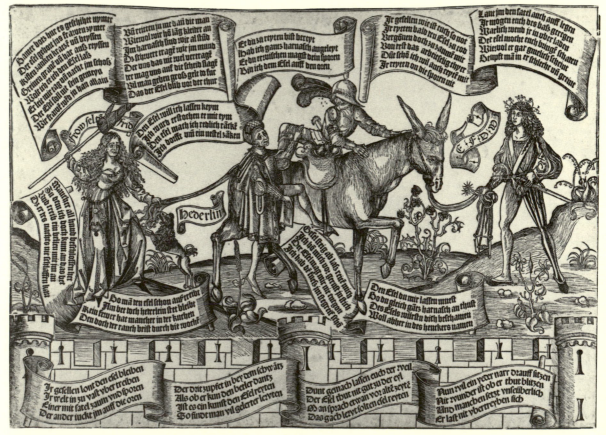

FIG. 61. Anonymous German, *Frow Seltenfrid*, woodcut.

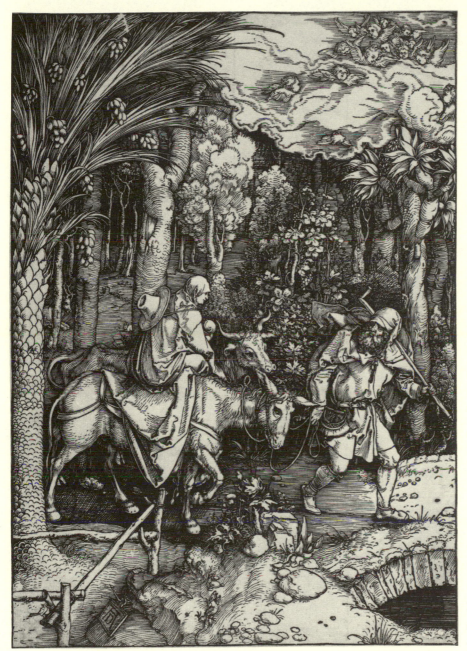

FIG. 62. Albrecht Dürer, *The Flight into Egypt*, from the *Life of the Virgin*, woodcut.

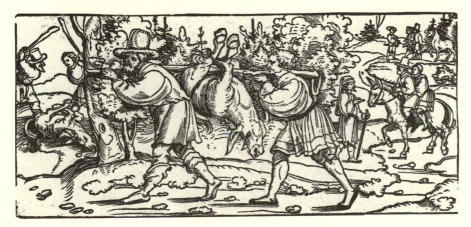

FIG. 63. Erhard Schön, *Fable of the Father, Son, and Ass*, woodcut.

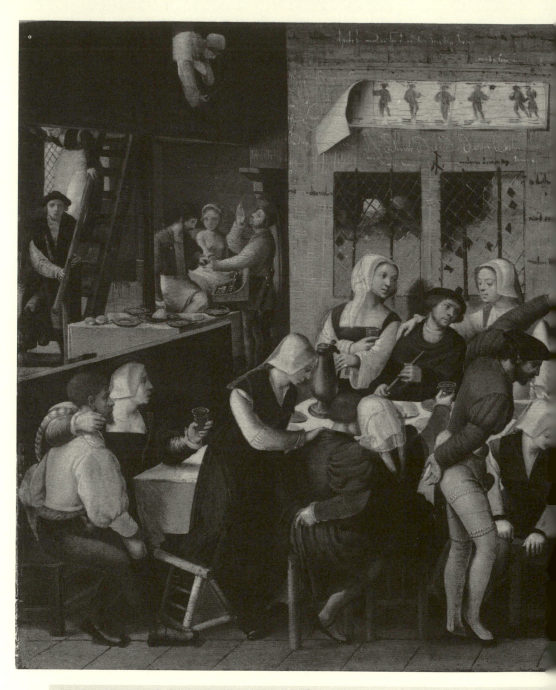

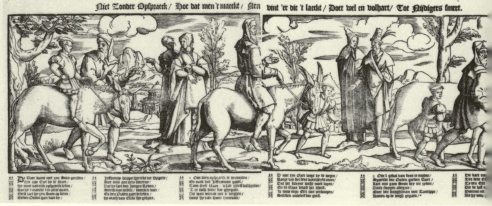

Niet Zonder Opspraeck / Hoe dat men 't maeckt / Men vint 'er die 't laeckt / Doet wel en volhart / Tot Nijdigers smert.

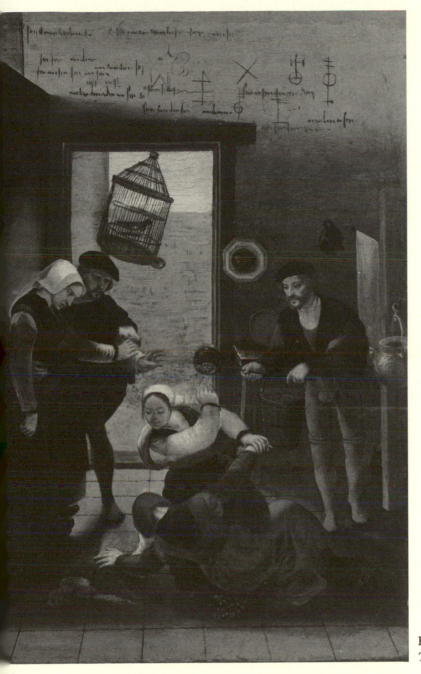

FIG. 64. Brunswick Monogrammist, *Tavern Scene*, panel.

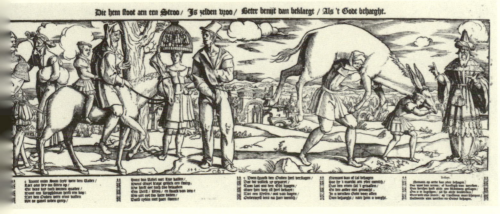

FIG. 65. Cornelis Anthonisz, *Fable of the Father, Son, and Ass*, woodcut.

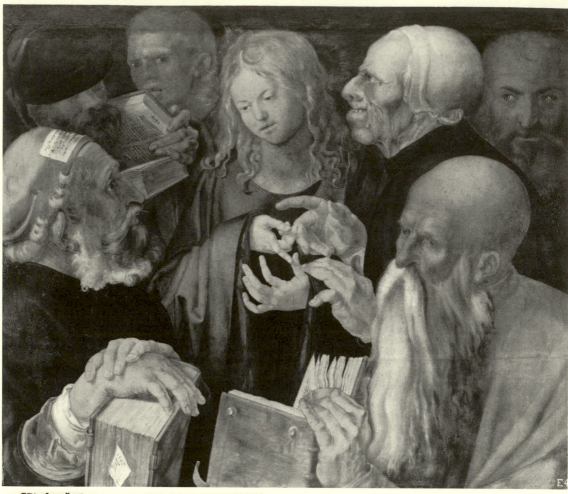

¶ Die gefangen klagen.
¶ O Herre Got lap dich erbarmen
Unser ellend gefangen armen
Erwirgen sich wie unser Kinder
Genumen sind uns Schaff vñ Rinder
Hauß vnd Hoff ist vns verdiendt
Vnd wir gefürt in das ellende
Wee das vns vnser müter trüg
Erst müß wir zieren in dem pflüg
Vnd Gerst. n essen wie die Pferde
Nit vnserm munde von der erde
Auß grymer tode vnd vns erlöß
Von dem graußamen Türcken böß.

Hans Guldenmundt.

FIG. 66. Albrecht Dürer, *Christ among the Doctors*, panel.

FIG. 67. Erhard Schön, *Turkish Warrior*, woodcut.

Opposite page:
FIG. 68. (*top*) Gillis van Breen after Claes Clock, *The Birdseller*, engraving.
FIG. 69. (*bottom*) Hans Sebald Beham, *Peasants' Brawl*, from *The Country Wedding*, engraving.

Hoe duur dees vogel vogelaer? hy is vercocht" waer?
aen een waerdinne claer" die ick vogel tgeheele Jaer.

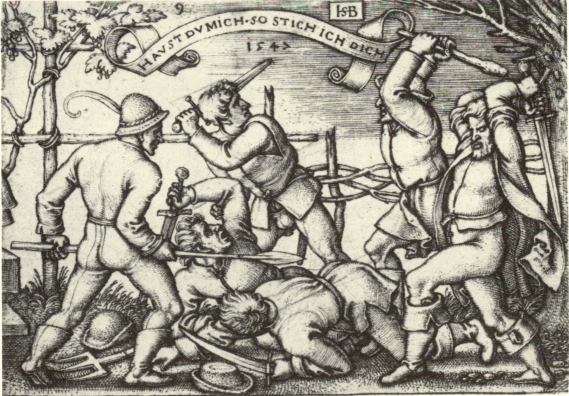

9

HSB

HAVST DV MICH·SO·STICH·ICH·DICH

1542

FIG. 70. Anonymous German, *Crowning of Pig*, illustration from Sebastian Brant, *Narrenschiff* (Basel, 1494), woodcut.

FIG. 71. Anonymous German, *Crowning of Pig*, illustration from Thomas Murner, *Schelmenzunft* (Augsburg, 1513), woodcut.

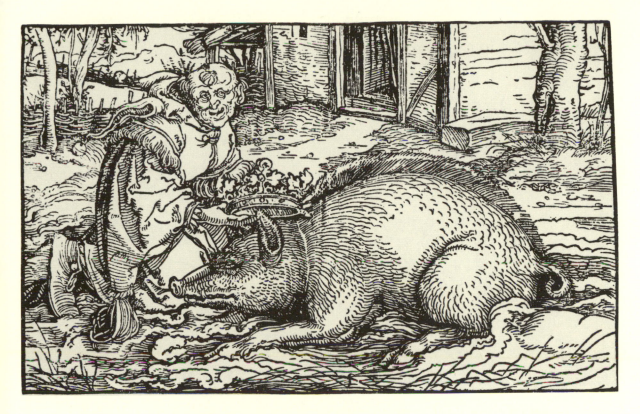

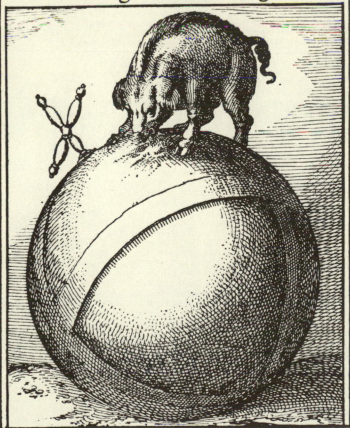

Als my Fortuijn tot hoogheydt voert,
Soo laet ick gheen dreck ongheroert.

FIG. 72. Anonymous German, *Crowning of Pig*, illustration from Cicero, *Officien* (Augsburg, 1531), woodcut.

FIG. 73. Claes Jansz Visscher, *Pig on a World Sphere*, illustration from Roemer Visscher, *Sinnepoppen* (Amsterdam, 1614), etching and engraving.

Eins morgens gieng ich durch ein Wald/
Es het geschneit vnd war grimm kalt/
Neben der strassen hort ich wispern
Etwas hind einem gestreüß laut zispern/
Ich gugt hin durch/sah das da sassen
Etwas in die zwey hundert Hasen/
Hetten sam da jren Reichstag/
Ein alter Haß erzelt die clag
Vber einn gar vralten Jeger/
Der sie teglich in jrem Leger
Vberfiel mit lauschen vnd hetzen/
Mit geschoß/falcken/Hunden vñ Netze/
Da mit sie vilfeltig verstricket/
Vnd sie on all erbarmung knicket/
Darnach mann sie dañ schundt vnd briet/
Jr etlich gar zustucken schmiedt/
Vnd Pickt sie ein zu ein fureß/
Darnach mit zenen zriß vnd freß.
Das mustens leiden vnd jr Kinder/
Vnd wurden jr ie lenger ie minder/
Wiewol sie teglich iunge trügen/
Vnd die außheckten vnd auff zugen/
Vnd wa die leng sie noch da bliben
Wurdens all von jm auß getriben/
Derhalb wer not/das sie alsamt
Dem Jeger theten widerstant/
Wenn er zu nechst mit sein Weidwerck
Widerumb zug auf disen Berg/
Das sie jm solten mit gmainem hauffen
In ainem sturm entgegen lauffen
Gerad zu auff in on alle krumb
Den alten jeger stossen vmb/
Jn dann mit sein waldstricken binden/
Der gleich seine laid Hund vnd winden/
Wenn sie dann also wern gefangen/
Alls vbel vor an jn begangen
Möcht man volkumlich an jn rechen.
Darzu waren all Hasen sprechen/
Sie wolten all jr peltz dran wagen/
Vnd stracks nachkomen dem ansagen/

Ob sie möchten den Jeger fellen/
In dem hört ich ein horen schellen
Vnd auch iauchtzt der Hunde hauffe
Anfiengen die Hasen zu lauffen
Hinab gen thal dem Jeger zu/
Ich stünd ein weil/ vnd in eim nu
Kamen die Hasen in jr leger
Vnd brachten mit den alten Jeger
Mit waldstricke gefange vñ bunde
Mit all seinen winden vnd Hunden/
Sein spieß vnd waidmesser sie trüge/
An aim strick den Jeger auf zügen
An aim baum/zu der strengen frag/
Wie vil er Hasen all sein Tag
Het vmbgebracht mit sein weidwerck
Al hie an dem waldigen Berg.
Da bekant er auf drithalb hundert/
Jeden mit namen aus gesundert.
Mit vleis beschribens sein vrgicht/
Darnach sassen sie zu gericht/
Theten sein Jegerhorn schellen
Vnd vber jn ein vrthail fellen/
Das mann zu straff vmb sein vnthate
On gnad jn an aim spiß solt braten/
Wie er den Hasen het gethan
Wo ers het gfengklich komen an/
Auch gabens ein vrtail den Hunden/
Das sie all solten werde gschunden/
Zerhawen/vnd gesalzen ein
Vnd darnach auffgehangen fein.
Nach dem schürtens ein grosses feur
Namen den Jeger vngeheur
Vnd bunden in an ainn brat spiß/
Der ainen tieffen seutzfen ließ/
Vnd sprach/Erst ich erkennen kan/
Das ich jm hab zu vil gethan/
Darum geschicht mir jetz auch recht/
Ich hab euch gar zu hart durchecht
On schuld/widr alle billigkait/
Wann ich gedacht zu jener zeit

Ich wölt euch drucken wie ich wolt/
Das jr mich alzeit fliehen solt
Nach aller Hasen natur vnd art.
Jetz so jr haltet widerpart
Vnd jr mein Meister worden seit/
Erkenn ich erst mein groß torheit.
Nach dem die Hasen vngeheur
Theten den Jeger zu dem feur/
Vnd dreheten in vmb an dem spiß/
Manichen lauten schrey er lies.
Zu helffen jm ich offt gedacht/
Doch sorg vñ forcht mich daruõ bracht/
Das sie mir nit gleich wie jm thaten/
Lies gleich den alten Jeger braten/
All Hund erschlagen/darnach schinden/
In stuck zerhawen/ich stund hinden/
Sah wies ain thail sie saltzen auch/
Darnach auf hiengen in den rauch/
Ains thails sie in aim Kessel suden/
All Wölff vnd fuchs sie darzu lüden
Mit in zu halten das frümal.
Darnach gieng ich mein straß zuthal/
Vnd gdachte mir bey der geschicht/
War ist es/ wie Seneca spricht/
Welcher Man treibt groß Tyranney/
Macht vil auffsetz vnd schinderey/
Maint zu drucken sein vnderthann
Auff das sie förchten sein person/
Der selb muß jr auch förchten vil/
Vnd wenn ers gar vbermachen wil/
Wirts etwan mit vngstüm gerochen/
Vnd hart gespannterbogen brochen.
Wie Küng Rehabeam geschach/
Auch andren mehr vor vnd hernach.
Wer aber sänfftmütig Regiert/
Von den seinen geliebet wirt/
Thund jm frey willig alles güt/
Vnd setzen zu jm güt vnd blüt/
Vnd die vnderthann gehorsam hend
Befestigen sein Regiment.

FIG. 74. Georg Pencz, *Rabbits Catching the Hunters*, woodcut.

Fig. 75. Anonymous Netherlandish, *The World Upside Down*, woodcut.

FIG. 76. Barthel Beham, *Sleeping Justice*, engraving.

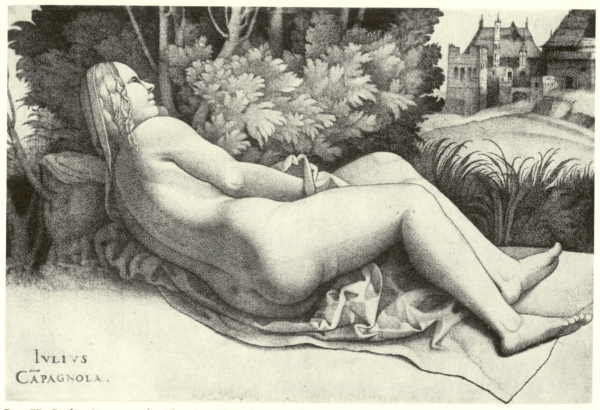

FIG. 77. Giulio Campagnola, *Sleeping Nymph*, engraving.

FIG. 78. School of Albrecht Dürer, *Michelfeldt Tapestry*, woodcut.

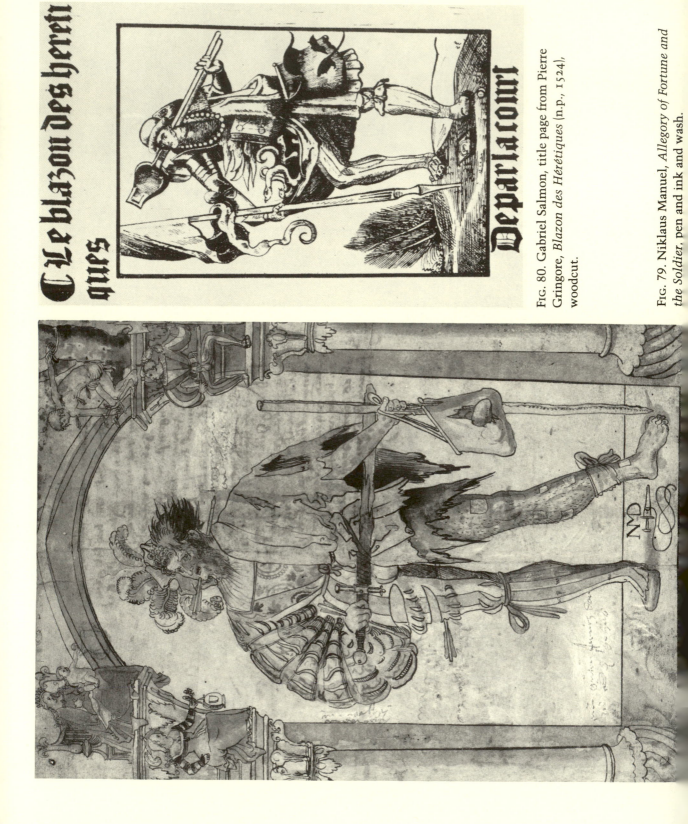

Le blazon des heretiques

Deparlacourt

FIG. 80. Gabriel Salmon, title page from Pierre Gringore, *Blazon des Hérétiques* (n.p., 1524), woodcut.

FIG. 79. Niklaus Manuel, *Allegory of Fortune and the Soldier*, pen and ink and wash.

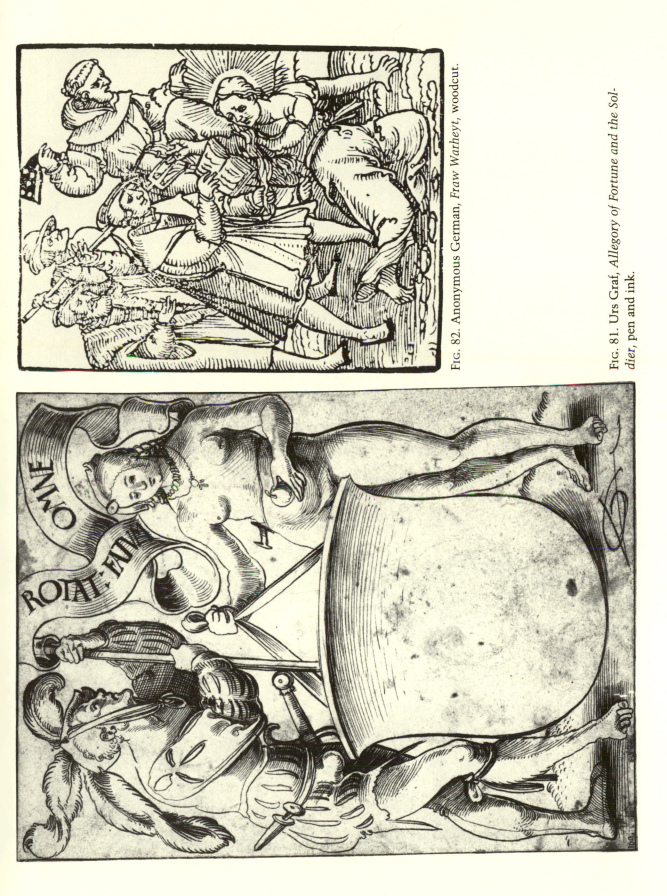

FIG. 82. Anonymous German, *Fraw Warheyt*, woodcut.

FIG. 81. Urs Graf, *Allegory of Fortune and the Soldier*, pen and ink.

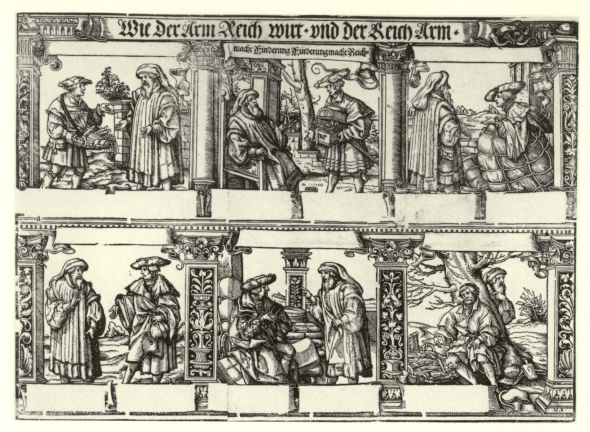

FIG. 83. Hans Burgkmair, *The Cycle of Wealth and Poverty*, woodcut.

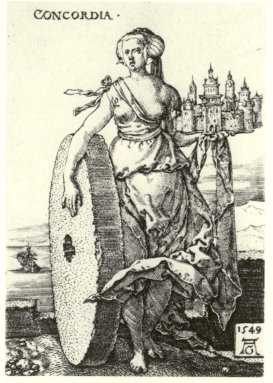

FIG. 84a. Heinrich Aldegrever, *Concord*, from *The Misuse of Prosperity*, engraving.

FIG. 84b. Heinrich Aldegrever, *Christ*, from *The Misuse of Prosperity*, engraving.

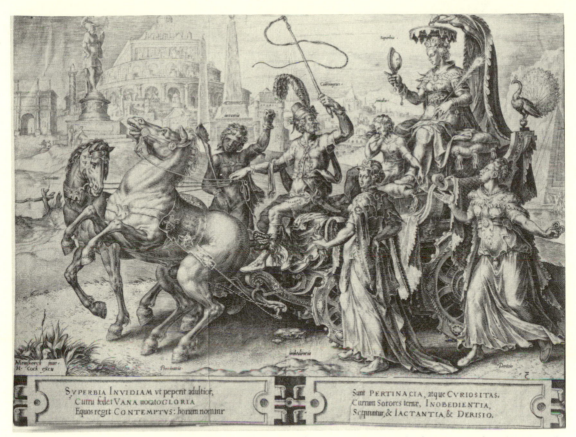

Below the engraving, within cartouches:

SVPERBIA INVIDIAM vt peperit adultior,
Curru ſedet VANA uogtoGLORIA
Equos regit CONTEMPTVS: horum nominr

Sunt PERTINACIA, atque CVRIOSITAS.
Curram Sorores ternæ, INOBEDIENTIA,
Sequuntur,& IACTANTIA,& DERISIO.

FIG. 85. Cornelis Cort after Maarten van Heemskerck, *Triumph of Pride*, from *Circulus Vicissitudinis Rerum Humanarum*, engraving.

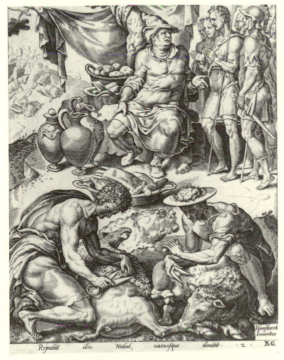

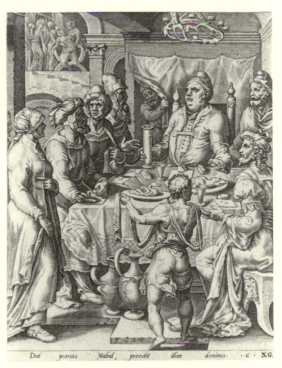

FIG. 86a. After Maarten van Heemskerck, *Nabal and the Messengers*, from *The History of David and Nabal*, engraving.

FIG. 86b. After Maarten van Heemskerck, *Nabal's Feast*, from *The History of David and Nabal*, engraving.

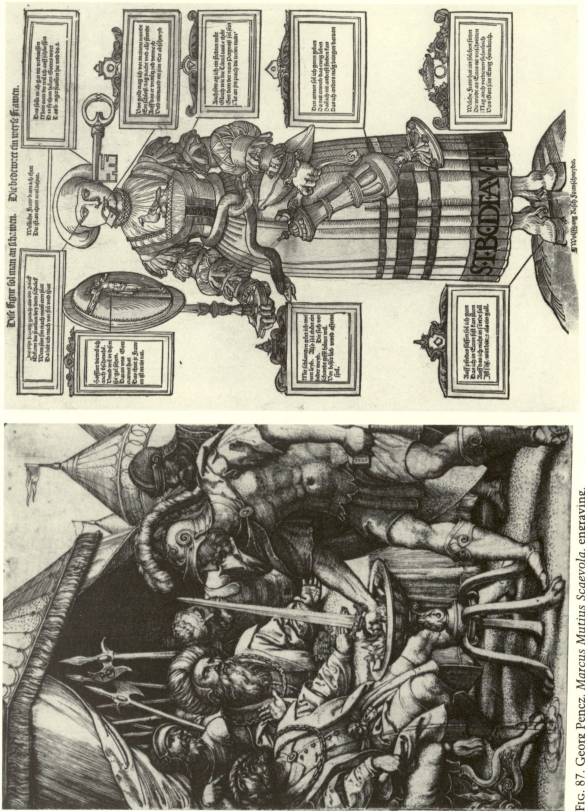

FIG. 88. Anton Woensam, *The Wise Woman*, woodcut.

FIG. 87. Georg Pencz, *Marcus Mutius Scaevola*, engraving.

FIG. 89. Cornelis Anthonisz, *The Wise Man and Wise Woman*, woodcut.

FIG. 90. Maarten de Vos, *Allegory on Vanitas, Death, and Resurrection*, panel.

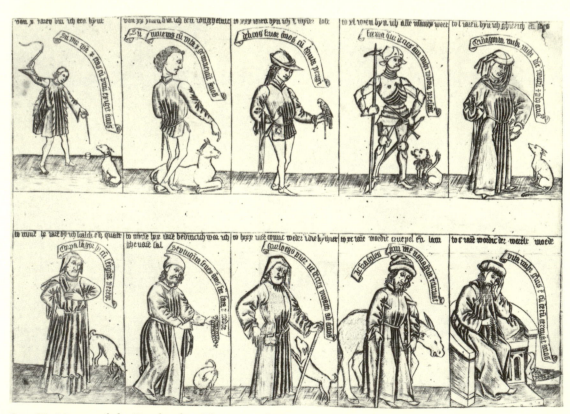

FIG. 91. Master of the Banderoles, *The Ages of Man*, engraving.

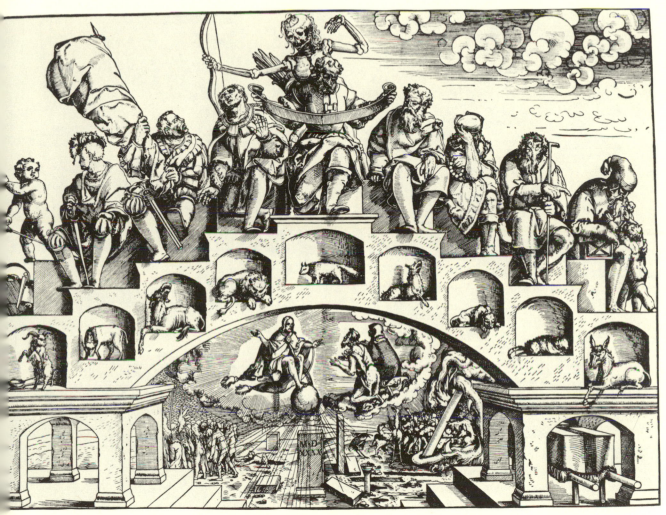

FIG. 92. Jörg Breu the Younger, *The Ages of Man*, woodcut.

De figure van tSpeeltanneel.

WT IONSTE VERSAEMT

FIG. 93. Anonymous Netherlandish, *rederijker* stage, illustration from *Spelen van sinne vol schoone allegatien, loflijcke leeringhen ende schriftuerlijcke onderwijsinghen* . . . (Antwerp, 1561), woodcut.

Right:
FIG. 94. (*top*) Anonymous Netherlandish, triumphal arch, illustration from F. van de Velde, *Arcus Triumphales Quinque a S.P.Q. Gand. Philippo Austrie Caroli Imp. Principi* . . . (Antwerp, 1549), woodcut.
FIG. 95. (*bottom*) Anonymous Netherlandish, *Device of the 's-Hertogenbosch Chamber of Rhetoric*, illustration from a manuscript of 1561, woodcut.

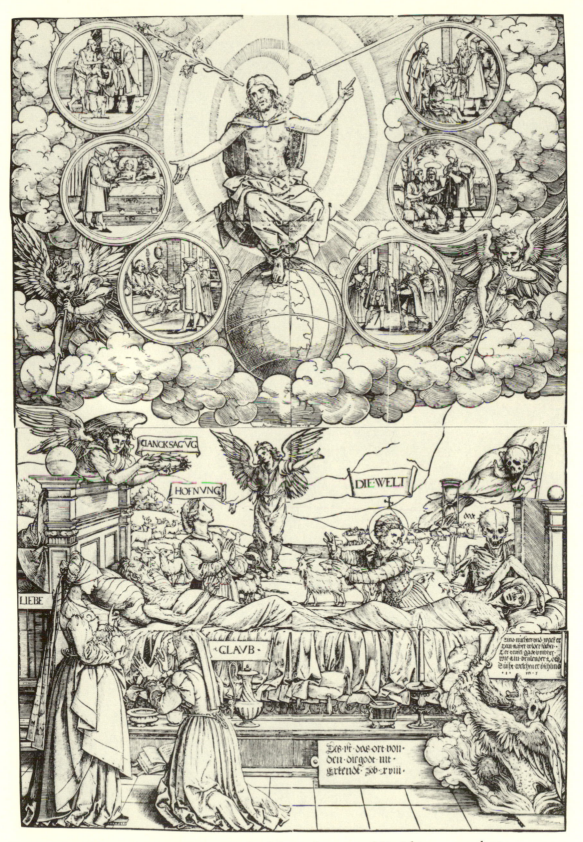

FIG. 96. Jörg Breu the Younger, *Deathbeds of the Righteous and Unrighteous*, woodcut.

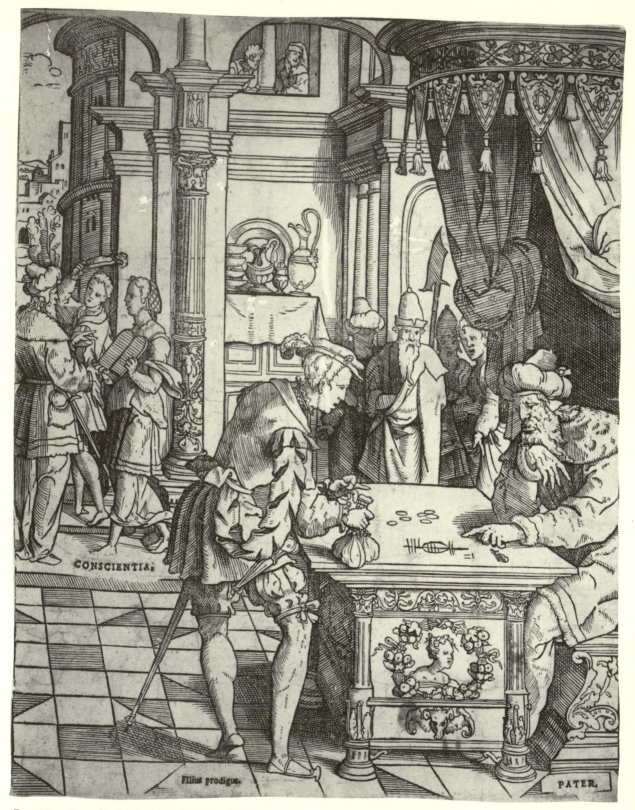

CONSCIENTIA.

Filius prodigus.

PATER.

FIG. 97a. Cornelis Anthonisz, *The Prodigal Son Receiving His Patrimony*, from *Allegory of the Prodigal Son*, woodcut.

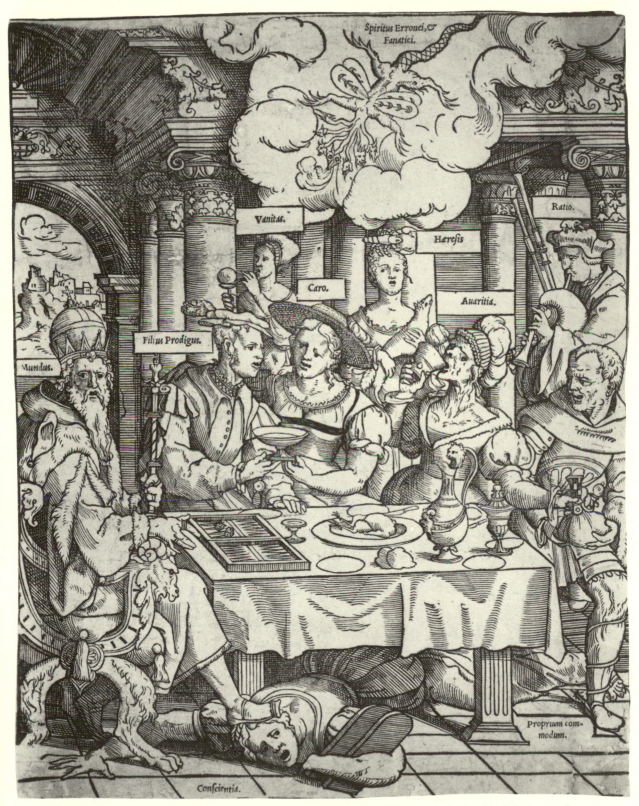

FIG. 97b. Cornelis Anthonisz, *The Prodigal Son at the Inn*, from *Allegory of the Prodigal Son*, woodcut.

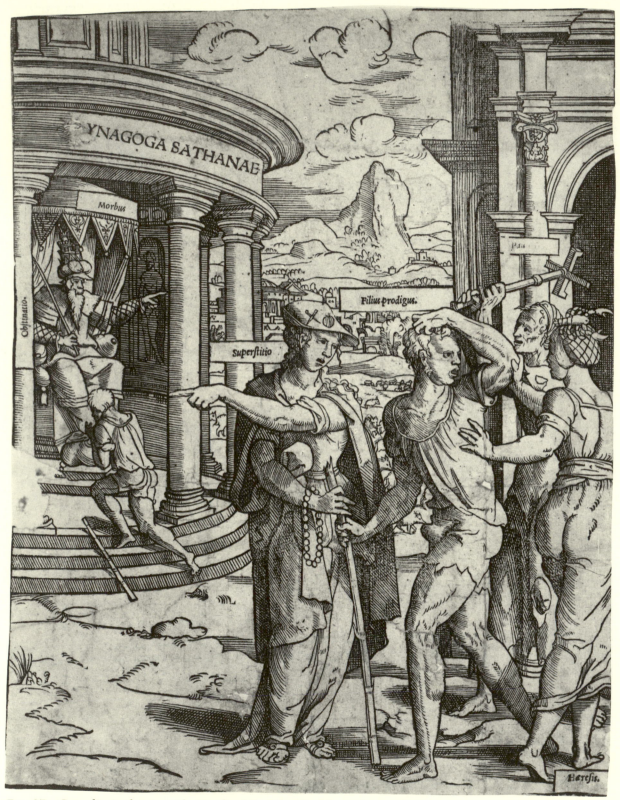

FIG. 97c. Cornelis Anthonisz, *The Prodigal Son Expelled from the Inn*, from *Allegory of the Prodigal Son*, woodcut.

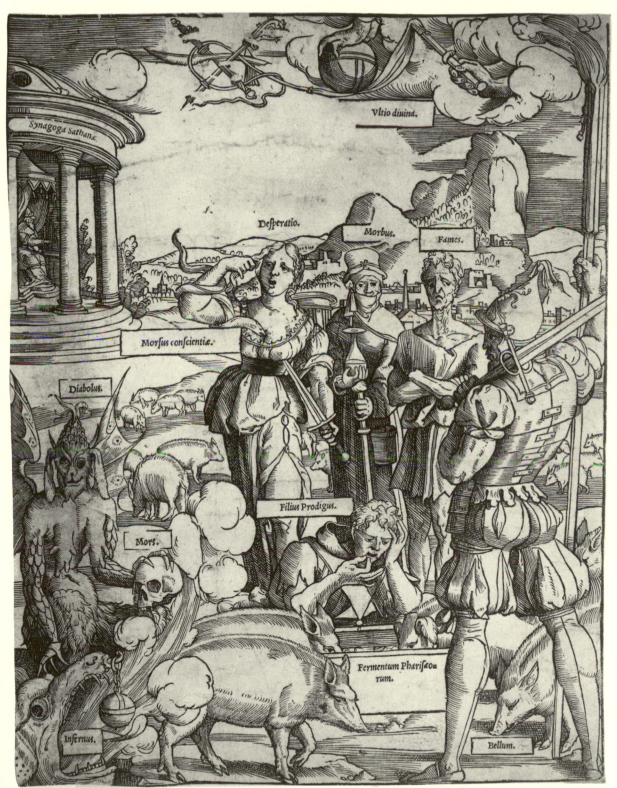

Fig. 97d. Cornelis Anthonisz, *The Prodigal Son Tending Pigs,* from *Allegory of the Prodigal Son,* woodcut.

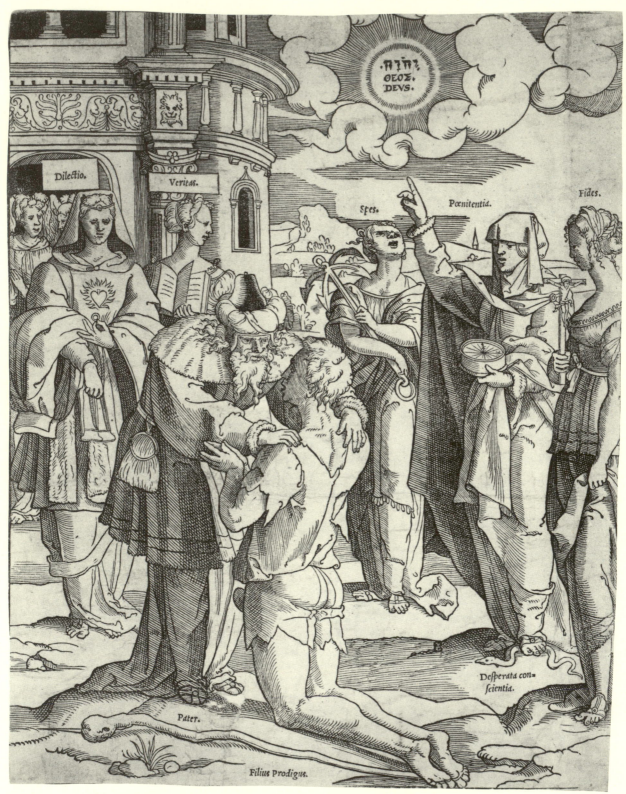

Fig. 97e. Cornelis Anthonisz, *The Prodigal Son's Homecoming*, from *Allegory of the Prodigal Son*, woodcut.

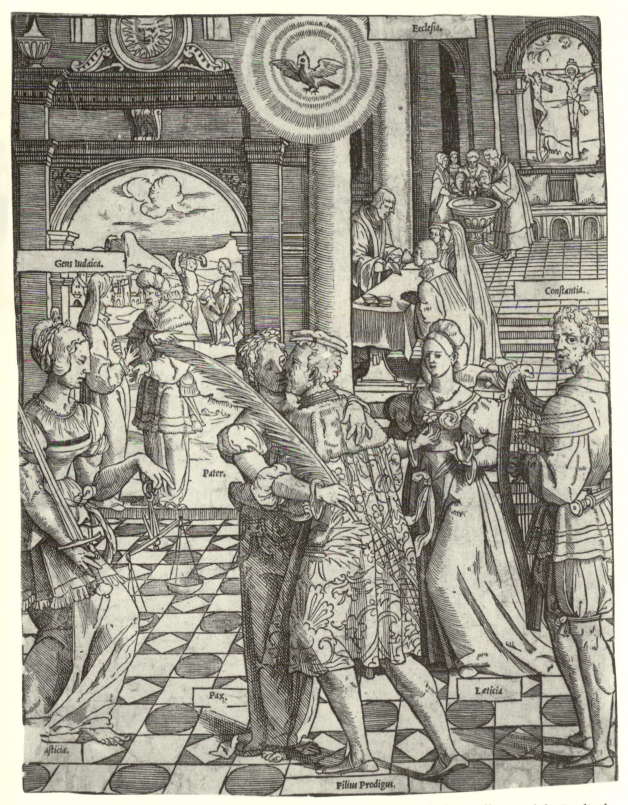

FIG. 97f. Cornelis Anthonisz, *The Prodigal Son Welcomed into the Church*, from *Allegory of the Prodigal Son*, woodcut.

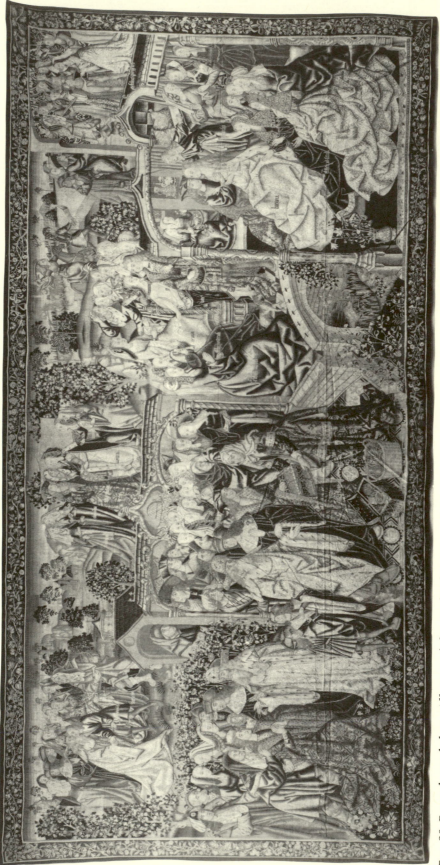

Fig. 98. Brussels workshop, *Allegory of the Prodigal Son*, tapestry.

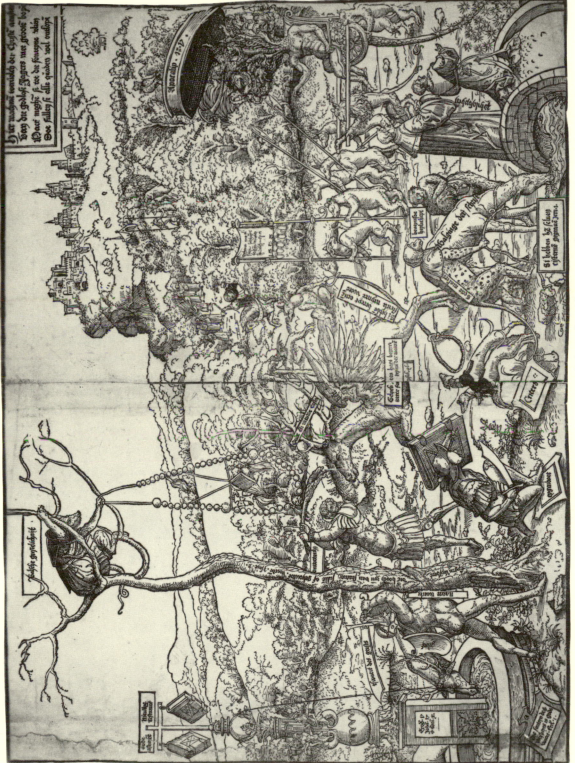

Fig. 99. Anonymous Netherlandish, *The Battle between True Faith and the False Clergy*, woodcut.

Fig. 100. Hans Weiditz, *Blood Witnesses of Christ*, woodcut.

Fig. 101. Anonymous German, *The Origins of Monks*, woodcut.

FIG. 102. Monogrammist AP, *Patience Fighting Anger*, woodcut.

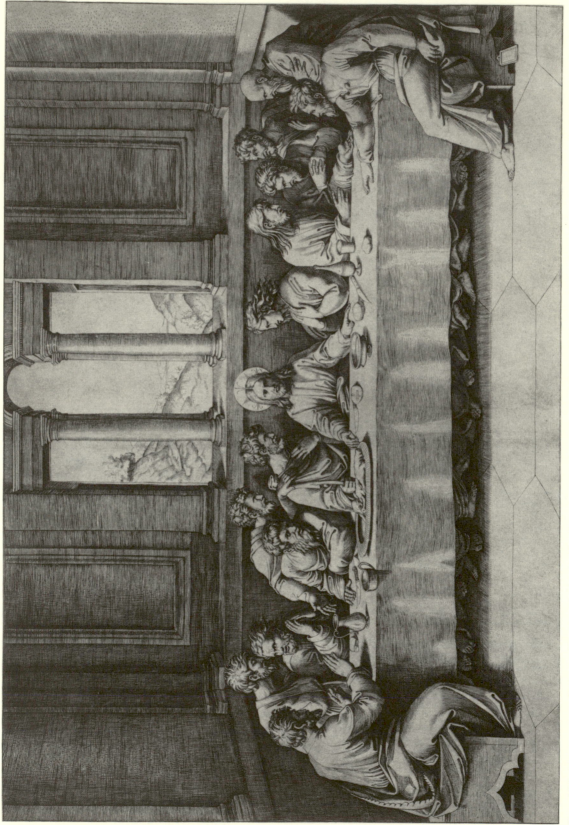

FIG. 103. Marcantonio Raimondi after Raphael, *The Last Supper*, engraving.

Fɪɢ. 104. Lucas Cranach the Younger, *True and False Religion*, woodcut.

Fig. 105. Bernart van Orley, *Satire on the Misuse of Power by the Catholic Clergy*, pen and ink and wash.

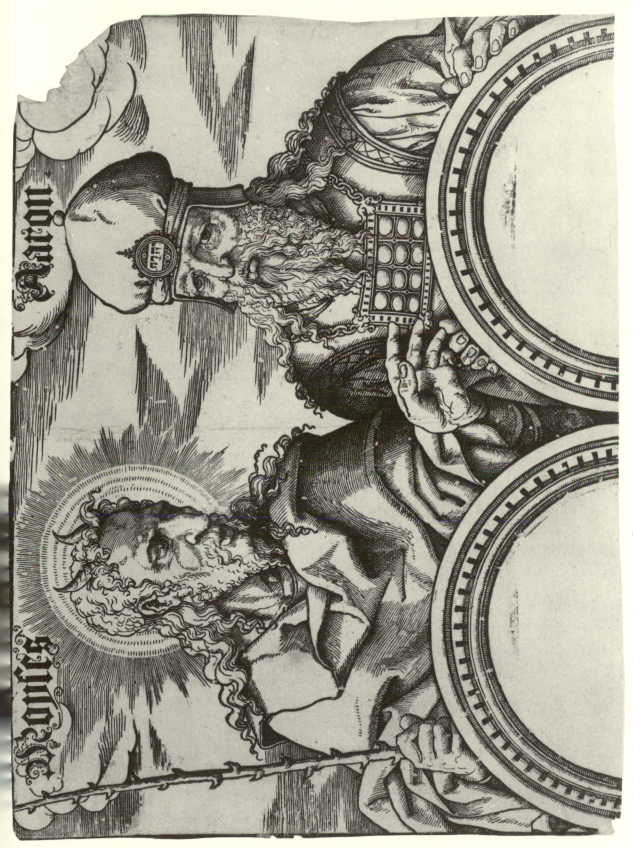

FIG. 106. Cornelis Anthonisz, *Moses and Aaron*, woodcut.

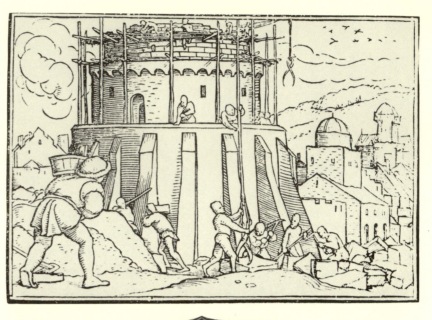

FIG. 107. Hans Holbein the Younger, *The Tower of Babel*, illustration from *Historiarum Veteris Testamenti Icones . . .* (Lyon, 1538), woodcut.

FIG. 108. Anonymous Franco-Flemish, *The Tower of Babel*, miniature from the *Grimani Breviary*.

FIG. 109. Cornelis Cort after Maarten van Heemskerck, *The Triumph of Pride* (detail), from *Circulus Vicissitudinis Rerum Humanarum*, engraving.

FIG. 110. Michael Coxcie, *The Triumph of Time*, pen and ink.

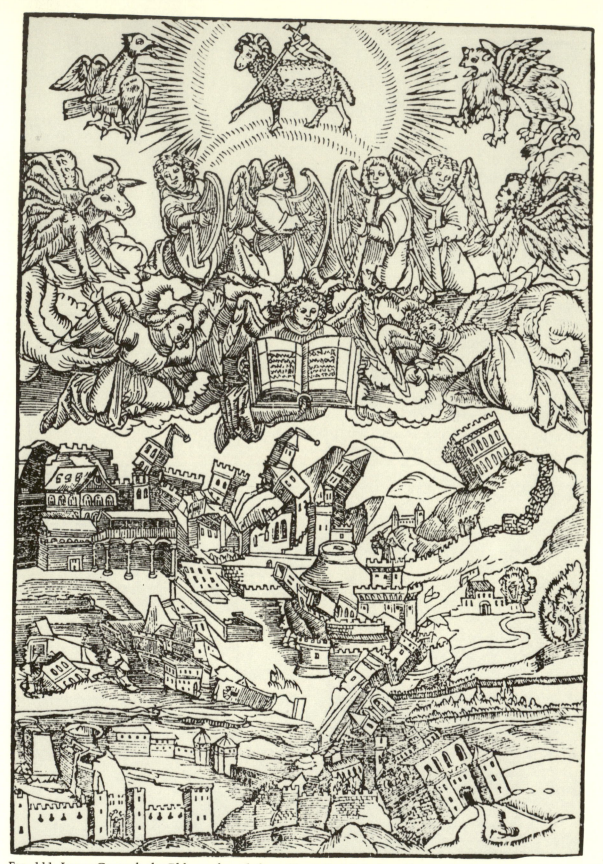

FIG. 111. Lucas Cranach the Elder and workshop, *The Fall of Babylon*, illustration from *Das Newe Testament Deutzsch* (Wittenberg, 1522), woodcut.

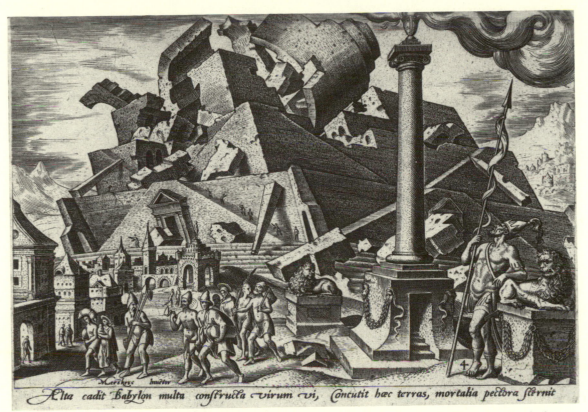

Ælta cadit Babylon multa constructa virum vi, Concutit hæc terras, mortalia pectora sternit

FIG. 112. Philip Galle after Maarten van Heemskerck, *The Fall of the Tower of Babel*, from *Clades Judeae Gentis*, engraving.

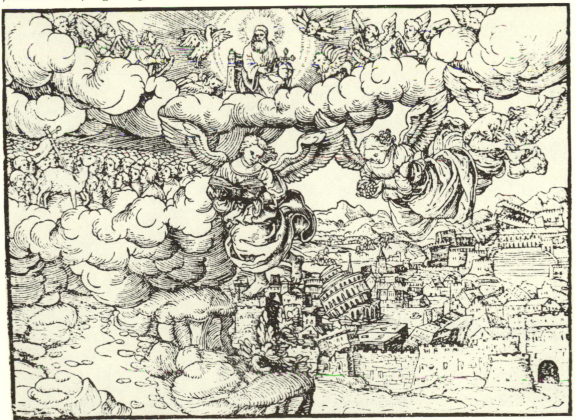

FIG. 113. Anonymous German, *The Fall of Babylon*, illustration from *Biblia, das ist, die gantze Heilige Schrifft Deudsch. Mart. Luth* (Wittenberg, 1534), woodcut.

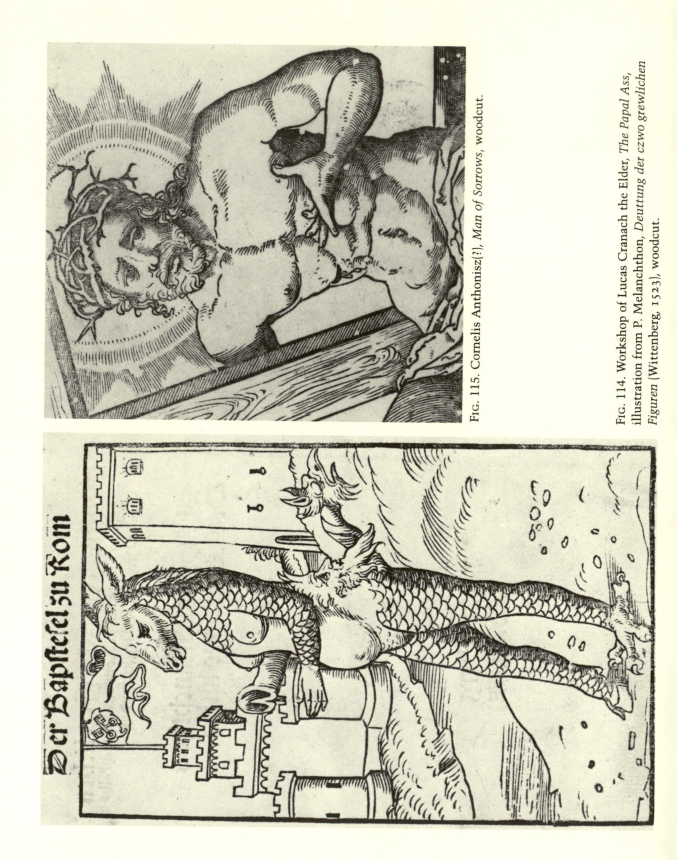

FIG. 115. Cornelis Anthonisz(?), *Man of Sorrows*, woodcut.

FIG. 114. Workshop of Lucas Cranach the Elder, *The Papal Ass*, illustration from P. Melanchthon, *Deuttung der czwo grewlichen Figuren* (Wittenberg, 1523), woodcut.

Der Bapftefel zu Rom

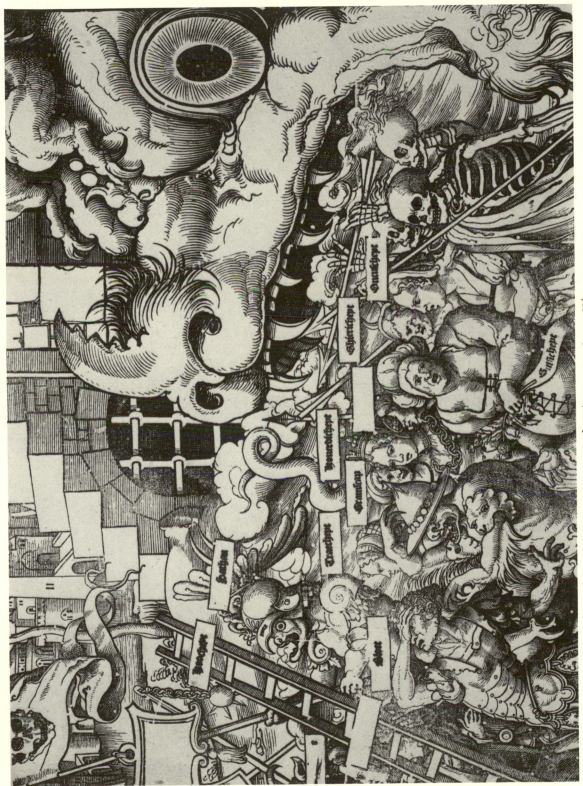

Fig. 116. Cornelis Anthonisz(?), *Defeat of the Seven Sins*, woodcut (see note 56, p. 168).

FIG. 117. School of Bernart van Orley, *Defeat of the Seven Sins*, woodcut (see note 56, p. 168).

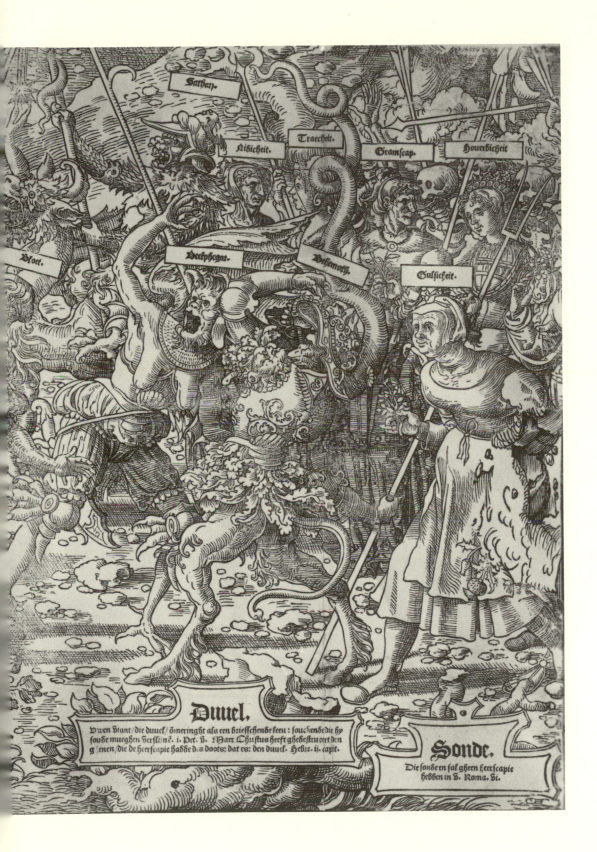

Sathan.

Nidicheit. Traecheit. Gramscap. Houerdicheit.

Bloet. Beelphegar. Behemoth. Gulsicheit.

Duuel,
Dwen viant/die duuel/ omeringht als een briesschende leeu: souckende die hy
soude mueghen verslinē. i. Pet. v. Maer Christus heeft ghedestrueert den
ghenen/die de heerscapie hadde des doots: dat es: den duuel. Hebre. ij. capit.

Sonde,
Die sonde en sal gheen heerscapie
hebben in v. Roma. vi.